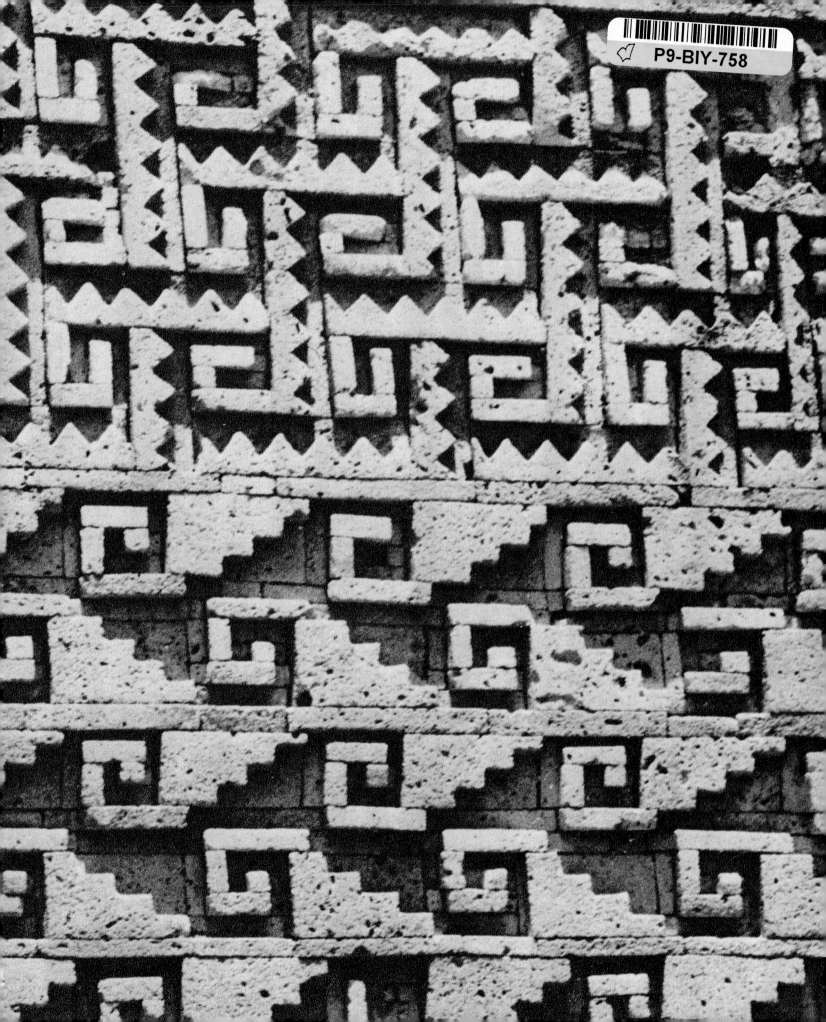

THE ART AND ARCHITECTURE OF MEXICO

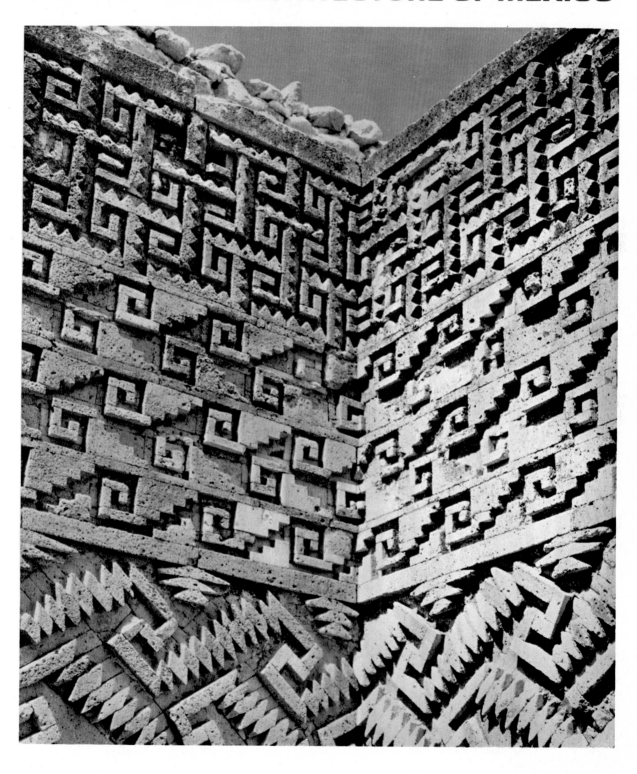

THE ART AND ARCHITECTURE OF MEXICO

From 10,000 BC to the Present Day

By PEDRO ROJAS/Translated by J. M. Cohen

PAUL HAMLYN

ACKNOWLEDGEMENTS

Mike Andrews, cover and plate 137; Jean Bottin, plates 25, 53, 54; Camera Press, photographer Martin Weaver, plate 33; Arpad Elfer, plates 20, 21, 118, 119; Stephen Harrison, plate 10; Irmgard Groth Kimball, plate 42; Mexican Tourist Council, plates 122, 131; Paul C. Pet, plates 56, 121; Paul Popper, plate 11; Constantine Reyes Valerio, plates 41, 46, 55, 56, 89, 101, 122; Roger-Viollet, plates 30, 48; Henri Stierlin, plates 49, 50, 63, 65; ZFA, plate 54. All other photographs were specially taken for this book by Dr. Pedro Rojas.

Published by The Hamlyn Publishing Group Limited
Hamlyn House · The Centre · Feltham · Middlesex
© 1968 Paul Hamlyn
Printed in Czechoslovakia by Polygrafia, Prague
1854

NOTE ON PRONUNCIATION

Náhuatl or Mexican has been the language of large parts of Central America from Toltec times to the present day. The Roman alphabet was introduced by the missionaries immediately after the Spanish conquest, and the sound values of the spelling are therefore the same as they were in early sixteenth-century Spanish. The main sounds for the English reader to note are the following:

MEXICAN		ENGLISH
X	=	SH
HU	=	W
QUE	=	KAY
COA	=	KWA
J	=	H
H	=	WH
QUETZALCÓATL	=	KETSAL-KWATTLE
NÁHUATL	=	NÁ-WATTLE
XOCHIMILCO	=	SHOCHIMILCO
HUEHOTZINGO	=	WHAY-HO-SINGO

CONTENTS

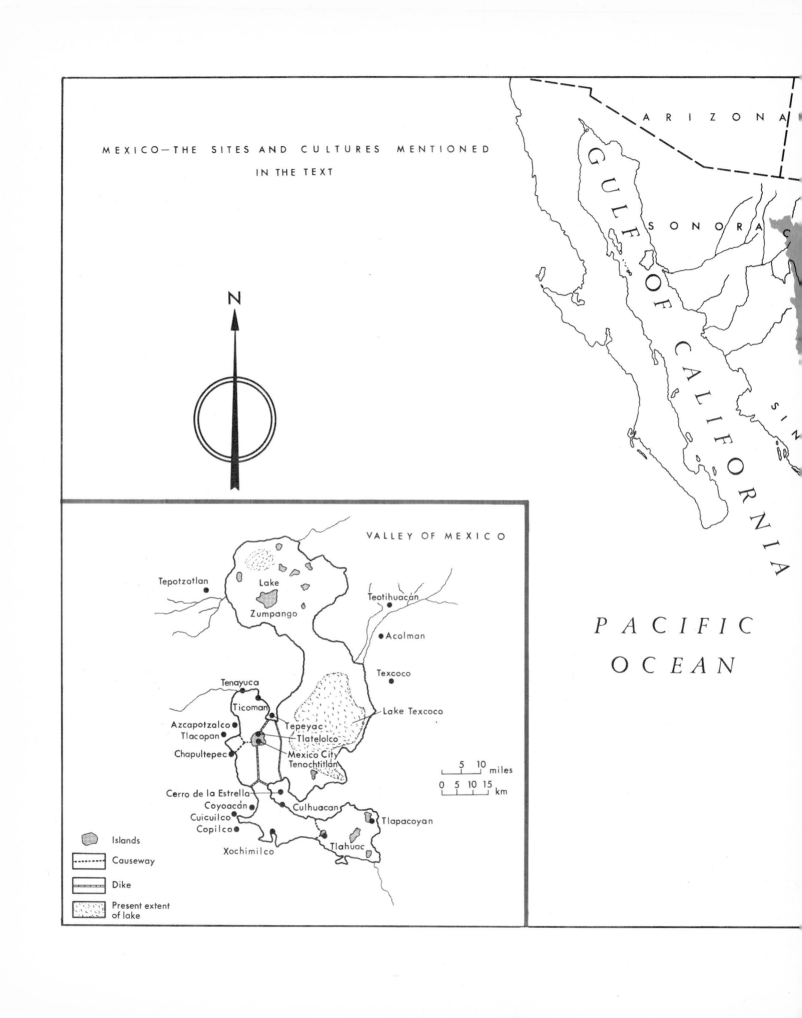

MEXICO—THE SITES AND CULTURES MENTIONED
IN THE TEXT

N

ARIZONA

GULF OF CALIFORNIA

SONORA

S I N

PACIFIC
OCEAN

VALLEY OF MEXICO

Tepotzotlan

Lake
Zumpango

Teotihuacán

Acolman

Texcoco

Tenayuca

Ticoman

Azcapotzalco
Tlacopan

Chapultepec

Tepeyac
Tlatelolco

Mexico City
Tenochtitlan

Lake Texcoco

Cerro de la Estrella
Coyoacán
Cuicuilco
Copilco

Culhuacan

Tlapacoyan

Xochimilco

Tlahuac

5 10 miles
0 5 10 15
 km

Islands
Causeway
Dike
Present extent
of lake

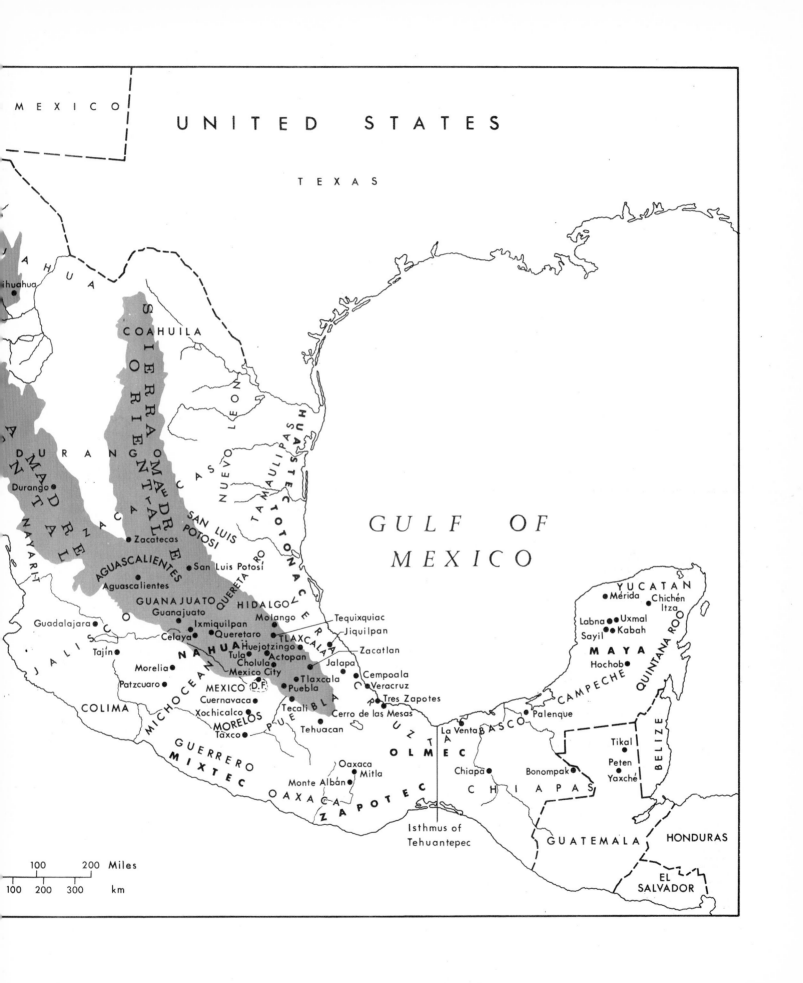

MEXICO

UNITED STATES

TEXAS

CHIHUAHUA

Chihuahua

COAHUILA

NUEVO LEON

TAMAULIPAS

HUASTEC

DURANGO

Durango

SIERRA MADRE ORIENTAL

ZACATECAS

SAN LUIS POTOSI

TOTONAC

GULF OF
MEXICO

NAYARIT

SIERRA MADRE OCCIDENTAL

Zacatecas

AGUASCALIENTES

Aguascalientes

San Luis Potosí

QUERETARO

HIDALGO

Molango

YUCATAN

Mérida

Chichén
Itza

GUANAJUATO

Guanajuato

Ixmiquilpan

Tequixquiac

Jiquilpan

Labna
Sayil

Uxmal
Kabah

Guadalajara

Celaya

Queretaro

TLAXCALA

Zacatlan

MAYA

JALISCO

Tajín

NAHUA

Huejotzingo

Tula

Actopan

Jalapa

Hochob

QUINTANA ROO

Morelia

Cholula

Mexico City

Cempoala

CAMPECHE

Patzcuaro

MICHOACAN

MEXICO

D.F.

Tlaxcala

Puebla

Veracruz

Palenque

BELIZE

COLIMA

Cuernavaca

Xochicalco

MORELOS

Tecali

PUEBLA

Tres Zapotes

Cerro de las Mesas

Tikal

Taxco

Tehuacan

OLMEC

La Venta

TABASCO

Peten

GUERRERO

MIXTEC

Oaxaca

Mitla

Chiapa

Bonompak

Yaxché

Monte Albán

OAXACA

ZAPOTEC

CHIAPAS

Isthmus of
Tehuantepec

GUATEMALA

HONDURAS

EL
SALVADOR

100		200 Miles
100	200	300 km

INTRODUCTION

Modern Mexico is roughly in the form of a cornucopia, the mouth lying between the gulfs of Mexico and California in the north and tapering to the south-east in the direction of the Republic of Panama and northward to include the Yucatán peninsula. The Californian peninsula on the Pacific side is also a part of Mexican territory. Two main ranges of mountains run through the country, the Sierra Madre Oriental on the Atlantic side and the Sierra Madre Occidental on the Pacific side, the two uniting near the isthmus of Tehuantepec in the south and continuing through South America. Between these two ranges lie subsidiary chains of mountains and innumerable river valleys. So the geographical and climatic conditions vary from the dry desert region of the north to the tropical south.

When the Spaniards landed in Mexico, during the second decade of the sixteenth century, they found it densely populated. Having conquered it, they established colonial rule which lasted for three centuries, ending with the formation of the republics of Mexico and Central America, each of them the product of ethnic fusion with and progressive incorporation into the Western world.

When the Spaniards arrived there existed highly developed native organizations, belonging to a single cultural stock, which occupied the area lying approximately between the 17th and 22nd parallels. This is the region called Central America (or Meso America), and the greater part of it is occupied by the modern United States of Mexico.

At the beginning of the sixteenth century in Central America there were native groups or societies representing various levels and types of cultural evolution, from nomadic hunters and food-gatherers to the most complex theocratic and military organizations with control over other groups.

For the proper understanding of pre-Hispanic life, one must take into account cultural developments beginning some twenty-five thousand years BC, the immigrations from Asia into the American continent—across the Bering Straits—and the gradual dispersal of people through its great expanses. Twelve thousand years ago man had reached the centre of Mexico, and 3000 years later waves of humanity were passing through the country towards the south. For tens of thousands of years the immigrants remained in the Palaeolithic stage; they were nomads devoted to hunting and food-gathering. This phase corresponds to the end of the Pleistocene era, which concluded between 5000 and 4200 years ago, with new conditions of climate, flora and fauna, and the introduction of crops, thus opening up the great creative possibilities of the Neolithic phase.

The subsequent phases of the evolutionary process comprise the urban revolution and are known by the names of Lower (1800—1200 BC), Middle (1300—800 BC) and Upper (800—200 BC) pre-Classical; Early (200 BC—AD 300) and Late (AD 300—800) Classical; Early (AD 800—1200) and Late (1200—1521) post-Classical.

The pre-Hispanic world must also be examined for the important cultures which resulted from the Central American cultural process. Amidst the greatest imaginable variety of interrelated ethnic and linguistic groups whose common roots are lost in the remote past, we first distinguish the early cultures of the pre-Classical epoch; the most prominent of which were the ancient Olmecs. These groups were followed by the highly developed Classical and post-Classical cultures: in the watershed of the Gulf of Mexico, the Olmecs of the La Venta complex, the Totonacs and the Huastecs; in the south-east the Maya; in the south the Zapotecs and Mixtecs; in the west the Nayarit, Colima and Tarasca peoples; in the centre the Teotihuacán people and the Nahua.

EARLY ART FORMS

The oldest known example of artistic activity on Mexican soil dates from a very remote period, when great glaciers still covered the high tablelands and mountains. Twelve thousand years ago, a craftsman shaped the sacrum of a species of llama into the likeness of a coyote's head, the form suggested by the shape of the bone. This piece was found at Tequixquial in the river basin of the Valley of Mexico, the Pleistocene strata of which contain remarkable deposits of fossils.

At that time man was already living as a nomad in the centre of Mexico, where he found glacial fauna still surviving, although further to the north it was extinct. In this environment he could hunt and gather food. When the larger animals died out, the emphasis shifted to food gathering and hunting small game.

There are no further traces of artistic achievement until the appearance of the first groups of farming villages of the early pre-Classical epoch. The earliest artistic manifestations of the farmers reveal the circumstances of their life, their physical needs and the ways in which they gradually evolved tradition and environment. As the villagers tried different ways of controlling nature, changes occurred in their social organization; and in order to explain cosmic events and ensure human survival, they invented religious beliefs. This process is illustrated by the groups who settled in the Valley of Mexico whose dawning religious conceptions, with their respective rites and magical practices, already contained all the basic elements and interpretations that were to be developed and completed by later cultures. Their original concepts were strengthened and increased to become extremely complex structures. There arose the worship of natural forces linked with agriculture and the cult of death; that is to say of entities determining life and death, which were invisible and tangible beings and objects. A similar course determined the formation of hierarchies and social customs; the priestly class were dominant up to the end of the Classical period, and that of the warriors in the post-Classical.

Wandering or temporarily settled here and there, the remote ancestors of the present Mexicans who began as hunters and food-gatherers, learned to experiment with new ways of life which would give them a less uncertain livelihood and a better means of understanding and dominating the world, as well as developing practices intended to preserve life after death. Skilled hands reproduced artifacts and created many more refined types than those designed for ordinary purposes; these were reserved for ceremonial use or for the growing hierarchies. At the same time objects and symbols representing human forms, either realistically or in the abstract, as well as others drawn from nature and the domestic scene, began to give material expression to their imagination. For example the "old fire god" was conceived as an old man carrying a brazier. Pottery was invented for the use of the living and for offerings to the dead; at first it took the form of simple vessels without feet but soon became more sophisticated in shape and texture. During the Middle and Upper pre-Classical periods offshoots of the ancient Olmec group came to settle in districts like Tlatilco and Tlapacoya. Their craftsmen developed a high degree of skill in making pots and bowls in the form of both human and animal bodies. The painted ware, *pintaderas*, was further embellished with symbolic designs. Faces and head-dresses of male and female figurines were accurately detailed, but with roughly shaped bodies and mere suggestions of the extremities. Many of these were recognisable portraits of fellow villagers and each differed from the others in almost every detail—earrings, nose ornaments, necklaces, pectorals, bracelets, anklets and tattooings; sometimes they have either skirt or loin-cloth. Details of anatomy and ornament were of the same material as the body of the object, worked up by pinching, incision, application or stamping, on the front of the figure. These were the forerunners of the expressive and very lively sculpture of Central America.

From the middle pre-Classical period, religion developed strongly and monumental buildings were required for worship. So the first temples were built and the foundations were laid of the great architecture of later times. The temples were introduced as features of the villages, set in open spaces and consisting of a base and a chamber similar to those found in the huts of the people. The bases were either truncated pyramids or truncated cones, consisting of one or more stepped elements and with a staircase—usually on the western face. A chamber at the top was surrounded by a wide

space used for the sacred fire and in which officiating priests could move around. The image of the god was placed inside the chamber. Pyramidal bases represented the five cosmic lines of direction: the four points of the compass and the zenith. Conical bases, however, came to be considered proper to the worship of two deities; the god of the wind and the "lord of the heart of the mountains". These bases are thought to have been built in imitation of those natural mounds used long ago for the celebration of propitiatory rites or for summoning up elemental beings, just as caves in those distant times served for the worship of ambiguous and disembodied forces of germination. At Tlapacoya and the hill of Tepalcate the bases are quadrangular in form, in Cuicuilco they are conical.

The building of the temples seems to be associated with consecration by human burials, for under the floors and in tombs forming part of the bases, remains have been found with vessels and figurines. The cult of the gods and the dead was very strong and so the number of temples increased; they became important ceremonial centres and large cemeteries were built there. At the same time the practice grew up of extending the temples and enlarging the bases by superimposition. When extension works were undertaken the builders buried the primitive huts of the gods and rebuilt the graves. Thus an intensely sacred place of immortality was created in which the *numen* (presiding spirit) and the ancestors were mystically present.

THE ANCIENT OLMECS

To explain the first great cultural organizations of Central America, a theory has been advanced for the development of a group which has been called the ancient Olmecs, who transcended the level of archaism by certain cosmological and religious ideas, by a social hierarchy, and by powerful artistic representations of the beings and objects affecting their way of life. Olmec elements spread throughout Central America, either by colonization or dispersed influence.

At a very early epoch the Olmecs broke away from the great ethno-linguistic Maya family, and settled in the highlands on the Pacific slopes of the mountains of Guatemala, from whence they spread later, in about 1000 BC, in all directions, but principally to the wooded, marshy, tropical south-east coast of the Gulf of Mexico.

On the evidence of the portraiture in their sculptures, the Olmecs tended to obesity, were strongly Mongoloid in feature, beardless, flat-nosed and thick-lipped. Their hair was usually straight, though in some cases it was curly. Occasionally, another physical type appears in their sculptures: long-limbed with an aquiline nose and bearded.

This people worshipped a feline deity, which they endowed with great strength and portrayed in shapes that vary between the zoomorphic and anthropomorphic. In the latter form its thick square-cut lips and the downturned corners of its mouth suggest a snarling beast. This is the tribal deity, associated with the heavenly waters, the beneficent rain and the destroying tempest. Small, fierce creatures, like dwarfs or chubby children, later called *chanaques*, are associated with the deity as his assistants. The cult to the god demanded bloodthirsty rites, including the beheading of warriors who were prepared for sacrifice, and whose blood achieved the purpose of the rites: the resurgence of nature, the ripening of vegetable foods and ultimately the rebirth of human life on the other side of death.

To the "jaguar" cult they added that of the god of the wind, incarnate in such birds as the migratory duck, and other minor deities represented generally in zoomorphic form. Sorcerers and officiants wore disguises or masks of these beasts as part of their apparel in order to attract to themselves the powers over the natural and elemental forces which these beasts possessed. This can be seen in the stone or terracotta sculptures portraying them, of which the Tuxtla statuette, dated 162 AD is an example. It takes the form of a priest with a duck's beak and the calendar inscription engraved on his belly.

At Tlatilco the Olmecs introduced the water-snake as a symbol of the element water on earth; this symbol was afterwards fused with the jaguar's claws, to give rise to the concept of the monster of earth and the underworld. Similarly, the sacred snake was derived from the primitive snake, a personification of the water of earth and sky; and later the plumed serpent which united the conceptions of underground, earthly and celestial water, of the precious force which is both the green of vegetation and human blood shed

in sacrifice to ensure the bearing of fruit. The serpent produced more derivatives, and these appeared with the other primitive Olmec gods as they spread to other Central American groups. The Olmecs included in their cult green stones —jade, jadeite and serpentine—which together with certain feathers, leaves, fruit and flowers symbolised the sacred life-element.

The Olmecs' innovations in the fields of knowledge, customs and art-forms were as fundamental and widespread as those in the religious sphere. They made astronomical observations; they introduced numeration by a system of twenties, which gives figures a positional value; they formulated a calendar reckoning, and wrote their numerical concepts in bars and dots, also in glyphs, which they developed for other types of inscription. Their society recognised hierarchies and reverential conduct; they distinguished between the social characteristics of town and peasant life; they kept in subjection the groups or peoples whom they conquered. Olmec art established types and features for deities and natural beings, oscillating between realistic and stylised conventional patterns. On the whole it was the realistic style that prevailed in their culture.

The terracottas found in the cemeteries of Tlatilco and Tlapacoya are among the oldest products of Olmec art. The burial remains are an indication of the complexity of their funerary customs, which included the sacrifice of human beings and dogs; and show that many pots and figurines were laid beside the dead. The figurines represent human types such as sorcerers, dancers, musicians, players of a ball game, dwarfs, pilgrims, pregnant women, mothers with children either in their arms or in cradles, deformed or sick persons and bodies with two heads. All are presented as individuals: some are naked, others almost weighed down by their apparel and head-dresses. Two types predominate, "pretty women" and babies with a half smiling expression. The first are girls about eight inches high, naked, with thick legs and curled hair falling on their shoulders. The second type resemble chubby children, larger than the girls and with delicately modelled features, and ecstatic and satyr-like expressions revealing their half-human, half-feline character. The most outstanding examples of this type have been found at Gualupita and Atlihuayan, in the state of Morelos. Con-

temporary with these are vessels from Tlatilco resembling living creatures or fruit. These are modelled from shapes based on gourds and a variety of small animals such as ducks, fish, tortoises, water snakes, rabbits and dogs. The craftsmen were so skilful that they could make animals with articulated limbs.

Masterly as the Olmec potters were, their stone cutters and sculptors achieved equal refinement and monumentality. Their sculpture in fact was much superior to their architecture, the purpose of which was scarcely more than to house a spiritual presence, celebrated by the appropriate ritual acts and by the erection of statues, steles and altars, and by burials of human remains and offerings in ditches, crypts, sarcophagi, or even beneath simple coverings of earth.

An idea of the development and functions of Olmec architecture can be formed from what is known of the ceremonial centre today called La Venta, which is situated on an island in the Tonalá river, near the sea. Here the Gulf of Mexico "tiger-mask" people set up two groups of buildings, which were dominated by the terraces on which they placed their sculpted monoliths and made their burials. On a descending slope between the forest and the river stand, as on a platform, two rows of huge human heads, altars and steles, and between them lie the two groups of buildings. The more important of the two groups is in the form of a sunken rectangular enclosure of tall, naturally cylindrical pillars of basalt with a mound at the head and an entrance on the opposite side. On either side of the entrance are two small enclosures without entrances. The rectangular enclosure must have been a sanctuary sacred to a mysterious presence, for inside it stood a stele and an altar, and inside the mound were hidden a flagstone crypt, a sarcophagus and an offering of jade. One of the enclosures at the entrance was surrounded with the same cylindrical pillars, and was possibly used as a cage for a captive tiger worshipped as a divinity. Under the floor of this cubicle, at a depth of seven metres, was found an offering of thirty-seven ritual axes of serpentine, arranged in the form of a cross and laid on a mosaic of the same material, the pattern of which represents a huge mask of the jaguar god. This floor was permanently covered with a thick layer of earth. Outside the area enclosed by columns lay a square between two long parallel mounds, with the base of

a shrine or temple at the farther end. In the middle of this square was another mound, a tomb, some buried jades and a stele, and beneath the temple a second buried mask. The second group of buildings stood behind the shrine a little apart and to the south of this complex, and consisted of a circular mound and two parallel mounds containing various altars and a monumental head and column.

Olmec sculptures are found scattered in great numbers throughout a large part of Central America. At Monte Albán are stone slabs of all sizes with incised linear figures and glyphs. These are of naked men, whose expression and attitude suggest that they have been surprised at the supreme moment of some ecstatic rite. Many have a web of small lines in place of the male organ; this has led to the theory that they may be participants in a castration rite. Only one example, at present in the National Museum, displays complete virility. These figures are roughly carved, and their purpose would appear to have been to sanctify the remote spot at which those taking part in the ritual would gather, perhaps under the leadership of one with different features, tall and bearded, instead of squat and fat like the majority.

At La Venta is buried a group of sixteen small jade figures arranged in a circle as if listening to one of their number. These too are officiants, finely carved in the round and with typical Olmec features. Their skulls are smoothed and deformed to a pear shape: their ears and noses are pierced, they have thick "tiger" lips, and bodies half bent in an attitude of attention. They are wearing loin-cloths. Behind them lie six axes carved of the same material; such axes were used as ritual objects. The jade figures found at La Venta are smoothly finished, though generally they take the form of heads or complete bodies of dwarfs with a V-shaped cleft in the forehead, which has been interpreted as signifying a ritual blow on the skull.

The need of the Olmecs to give plastic form to their ideology and to represent the objects around them was expressed on the monumental scale in the form of steles, "altars", statues and stones, as well as in the numbers of small objects such as axes, small images and plaques. These steles are monoliths with reliefs on one or more faces, and represent a personage posing in his theocratic vestments, or several persons performing ritual or civic actions. Some steles contain calendar markings. The most remarkable are those found at Tres Zapotes, Cerro de las Mesas, La Venta and other localities south-east of the Gulf of Mexico. The "altars" are formed of blocks of stone with a cornice on top. Many of them have a niche carved in the base of one of the faces, from which emerges a seated person carrying a dwarf. This may represent a priest offering a child in sacrifice to the rain god. Around the niche and on the edge of the upper cornice of some altars are lineal incisions symbolising the zones and elements of earth and sky. One altar at La Venta not only shows the priest carrying the dwarf but has other persons distributed about the rest of the monolith, executed in relief and each carrying either a docile or a rebellious dwarf. The dwarfs have the characteristic fierce features and deformed skull. Another altar presents a majestic personage with a knife in one hand and the other hand grasping a rope which binds a prisoner, the figure carved on each lateral face. Another variant is an "altar" with two dwarfs on one face acting as Atlantean figures supporting the upper cornice, which represents the heavenly level. Other typical sculptures are beings of fierce expression, generally presented half naked, with realistic faces somewhat individualised, and head-dresses and decorations of precious materials. Thus and in similar ways, in order to transcend the present, the Olmecs sculpted figures of chiefs, participators in rituals, anthropomorphic and zoomorphic deities and also those strange, huge spherical heads with ecstatic, severe or smiling expressions that they placed straight on the ground at the tops of mountains or where water sprang from the soil. It is possible these heads may have celebrated a decapitation rite practised to obtain rain and ensure the renewal of nature. They have been found in many places, among the most notable being San Lorenzo-Tenochtitlán, La Venta, Tres Zapotes and San Andrés Tuxtla.

Among those statues outstanding for their artistic perfection is that of the seated bearded officiant at Uzpanapa, that of the "chief of men" portrayed standing with his robes falling from his shoulders, which comes from Segura de los Cerros, and that of the seated, half naked dignitary from Cruz de Milagro. As for the tomb stones of the Olmecs, it must be stressed that like the steles these served to illustrate the ceremonies of religion and priestly life.

THE MAYA MIRACLE

Inhabiting the thick forest and woodland zones of Central America from the basin of the Usumacinta river in the east to Honduras and the Yucatán peninsula, the Maya covered a territory of more than 300,000 square kilometres. They mastered their environment and, by the extraordinary strength of their physique, social discipline, knowledge and artistic resources, developed elements of the Olmec culture, combined with a culture of their own.

Spread across this vast area, the Mayan culture developed regional differences because of contact with other groups and because of differing geographical surroundings. Even the language underwent changes. One of these regions was the wooded highlands of Guatemala; another the jungle valleys of the Usumacinta and Grijalva rivers, which extend to Petín, and a third the brush-covered chalk plains of Yucatán. In these regions the Mayans built a great number of ceremonial centres which the American scholar, Dr. S.G. Morley, without pretending to account for them all, enumerates as: five large cities and nineteen of primary, thirty-nine of secondary and fifty-four of tertiary importance, classified by size, number of monuments and quality of the shaped monoliths in each.

For several centuries BC, the Maya slowly passed through their formative period; and in the first centuries AD they clearly possessed all the principal elements of Olmec science and religion, and were equipped to increase their own creative activity at a headlong pace. From the fourth to the ninth century was in fact their peak period. After this follows a phase of decline (Late Classical epoch) ending, in a collapse, in the tenth century. At that date many of the ceremonial centres seem to have been in ruins for a considerable length of time and the rest were reaching the same state. One plausible hypothesis explaining the crisis which caused the decadence or destruction of the Maya cities is that there was a rebellion of the peasants against the theocracy. This would seem to have been caused by inadequate agricultural production owing to rudimentary techniques and the heavy burdens laid upon the peasants by the urban societies under the discipline of priests and chieftains. Some proof of this theory seems to be afforded by the mural paintings in the palace of Bonampak which illustrate incidents during an armed repression of peasants and the rejoicing of the victorious urban society. After the disorganization of the tenth century there was a second revival of the Maya culture, chiefly in the Yucatán peninsula, which ended with the Spanish conquest. During this period, the great influence of Toltec invaders is evident from the tenth century to the middle of the thirteenth and of the warlike Aztecs in the fifteenth.

In the fields of science and religion the Maya introduced highly complicated ideas, many of which were taken over by other Central American cultures. They invented a complicated hieroglyphic writing and a series of signs to represent the numbers, including zero. They registered the periodicity of the sun, the moon and the planet Venus. To determine the fate of individual persons and regulate their religious duties, they introduced a horoscope calendar, the *tzolkin*, which marked the order of the deities beneath whose signs the Maya were born. The *tzolkin* was a calendar of 260 days, and it was combined with the solar calendar, or *haab*, of 365 days, to measure cycles of 52 years marked by the periodical coincidence of the two reckonings. Exact dates were determined by the conjunction of the two calendars. The Maya extended the continuity of their computations by use of a chronological series, the beginning of which was reckoned at more than 3000 years before the time at which they began to inscribe dates. They multiplied and systematized the world of deities, conceiving that existence had been created by an incorporeal god, Hunab Ku. Secondary to him, the Maya placed Itzamná, the lord of the heavens; the long-nosed Chac, lord of the rain; Yum Kax, lord of the maize and vegetation; Puch, the lord of death and colleague of Moan, the bird of ill-omen; and Ixchel, the goddess of the moon, floods, childbirth and medicine. They conceived the existence of thirteen heavens and nine lower worlds, each with its own deity. There were also deities of the days, the months and the years. Anthropomorphism prevailed in the representation of these deities.

Art primarily served the purposes of the religion expounded and administered by a powerful priesthood and of a social organization which became progressively more and more hierarchical. There was a tendency towards increasing

15

the number of learned concepts and beliefs, also the liturgy and social offices; this increase was reflected in the excessive complexity of conceptual elements incorporated in plastic representation, and at the same time in the development of architecture, a factor which often contributed to the garishness and excessive decoration of buildings.

Architecture is the Maya's foremost art, and it was conceived as a whole with its attendant sculpture and painting. Mayan buildings were of various kinds, but the temples are outstanding. These took the form of small constructions resting on stepped pyramidal bases, before which lay ceremonial terraces. In this way the Maya fulfilled their need to provide places for the images of their gods, freedom and visibility for the movements of their priests, and room for the spectators to congregate. Their builders perfected the use of their material (including lime), introduced the arch of projecting stones, and achieved the optical advantages of height by stressing the vertical element in their temples. To achieve this aim, they not only rhythmically stepped the sloping members of their bases, but added height to the temples themselves by means of small plinths. In addition, they used a method of construction leading up to an inclined peak, by dividing the elevation into three zones: walls, vault and roof-comb (an ornamental vertical extension of the temple roof). The walls themselves did not slope, but the vault and especially the roof-comb did, though in the Yucatán this aesthetic norm was broken and all three elements were built with a vertical emphasis. The temples generally consisted of an inner and an outer chamber, the second approached through the first, both being narrow on account of their vaults of projecting stones raised in two inclined planes, face to face. They had one or more lintelled entrances in the front, arranged on a central axis which gave a formal balance to the buildings themselves as well as to their bases and the stairways of approach. Temples of this type, with their chambers perpendicular to the main axis, incorporate the principles of all Maya architecture. They were constructed of rubble faced with blocks or ashlar slab, and the surfaces were related by being faced with stucco decorated with coloured symbolic designs. The buildings served to carry statues and masks of the gods, figures of priests, attendants and lords in ceremonial attitudes and also chronological inscrip-

tions, which were placed mainly on the principal façade and on the lintels and interior panels.

Starting from the quadrangular terraced building crowned with a temple, the Maya gradually extended their ritual centres outwards by erecting other temples, each with its walls, platforms and chambers, around and close to the first quadrangle, building up a complex of temples which in some cases finally enclosed the original unit, leaving access to it by stairways and passages. A religious centre planned on an open site could thus grow into a variety of buildings of the kind known as a "complex acropolis". Yaxchilán, for example, finally had a double acropolis. Another process of extending the building complex was by adding to the buildings in the form of new terraces or by means of passageways, all arranged along the original axis.

The architects tackled the problem of building rooms against the back walls of some of the temple-bases, and also against other buildings. In the Classical epoch, at Tikal in Guatemala for example, a series of rooms was successfully built on several floors, connected by stairways and arranged along one or two axes, and all clinging to and supported by the earth core of the base. This is the form taken by such splendid buildings as the "Pyramid of the Magician" at Uxmal, the Castillo at Labná, the palace at Sayil and various others at Edzná and Kabah, all in the Yucatán.

There were two ways of approaching the problem posed in building the palaces. One method was to place the palaces on large bases like temples; this solution was used in the construction of the Governor's palace at Uxmal, the palace at Sayil already mentioned, and the "Nunnery" at Chichén Itzá. The other solution takes the form of rooms built on low plinths, lying upon one or more axes, and approached either externally or by way of antechambers. This form is prevalent and was the solution adopted for the palace at Palenque in the Usumacinta region, for the so-called "Nuns' Quadrangle" at Uxmal, the Codz Pop at Kabah, and the Palace of Labná in the Puuc region of Yucatán.

At the end of the seventh century, the Maya felt the need to give architectural form to the field of the ritual ballgame, the basic requirement of which was a rectangular space, enclosed between two walls on its longer sides. Ball courts were built in Maya and other cultural centres, and

there were several variations of form. As many as seven were built at Chichén Itzá, one of them being the largest and most imposing yet discovered in Central America. Some of the reliefs on this building indicate that the men taking part in the game imitated the struggle of the sun to conquer the forces of the underworld and emerge to shine on the new day. The participants acted out this drama by struggling to pass a rubber ball through one of the two stone rings that were placed half-way up the field. The player who succeeded was then sacrificed, offering his heart and blood to nourish the Sun god and assist him in the movement of the cosmos. This particular ball court dates from the arrival of the Toltecs in the locality and it is planned in the form of the letter I, surrounded by platforms and overlooked by small temples containing mural paintings and typical Toltec decoration. The Maya also built solar and lunar observatories, arched gateways, platforms for rites, dances and spectators, monumental tombs, aqueducts, drains and other sorts of structures, varying in size, height and complexity.

During the Late Classical epoch (AD 300-800), builders in the Yucatán region introduced a column composed of a cylinder and a rectangular block in the form of a capital. This allowed them to extend their avenues of approach, as can be seen at Sayil. The use of the column as such was already known by other Central American peoples. Nevertheless its employment on a large scale, and the invention of the square section type of pillar, are the achievement of the Toltecs who ultimately invaded and succeeded in conquering some parts of Yucatán. This Nahua people (see page 26), who originated in central Mexico, made the greatest use of the column and square pillar at Chichén Itzá and Aké, where they built magnificent columned halls and porticos, roofed with true Maya vaults of projecting stones. The ruins still bear witness to the creative daring of the men who planned the Temple of the Warriors, the Court of the Thousand Columns, the Market and other buildings at Chichén Itzá.

Architectural ornamentation was applied almost exclusively to the façades and generally concentrated within the areas around the niches or shrines. Outside the Yucatán peninsula, the figures of deities and priests and the symbols placed on the outsides were made of stucco, except for some principal features, which were carved in stone. One or more sacred masks or perhaps anthropomorphic figures of gods, were carved at the top of buildings of the Classical era. At Palenque the outer faces of the columns of various temples were decorated also, with charming figures of priests (some of them female) and so were those of the palace. In the limestone region of Yucatán, on the other hand, a smooth finished ashlar was preferred. Here small pieces of stone were set into the walls to form series of motifs made up of planes and projections, and laid in panels and friezes. The use of stucco was reserved for only a few compositions.

In Yucatán, the ornamentation came to have special characteristics, partly because of the choice of motifs, partly because of the stylized geometrical way in which these motifs were represented, and finally because of the use, just mentioned, of stones cut small and laid in the walls in the form of mosaic. The Maya style, therefore, comprises a series of variants from an almost entirely naked surface to a complete covering of the façade. The feeling for rhythm and symmetry was extremely strong in these works. Examples of the various degrees of decorative elaboration are found here and there, and sometimes several examples in the same locality, and the styles followed in the temples are applied equally to other buildings. A classification of the most general formal variants reveals these purely Maya decorative styles in the Yucatán peninsula: the Smooth; the Mask; the Colonnette; the Intricate; and the Imitative. In addition to variations of form, there are also differences in the placing of the decoration, either on the walls, the vaults or the roof-comb of the façade. Thus decoration may be limited to cornices placed above and below the vaulted section; it may take the form of a running frieze applied between these cornices; or of panels alternating with smooth surfaces, a treatment generally applied to the vaulted section but sometimes extended to the walls; it may cover the vaulted section and the walls, occasionally extending to the roof-comb; and finally may be applied only to the crest or high trapezoid wall which caps the buildings as a pediment.

The smooth style has walls faced with flat ashlar, with projecting mouldings or cornices defining the position of the vaults (the Xeth Pool building at Chacmultún, the Palace with Medallions at Kich Mool). The Colonnette style has

friezes or panels formed of ranges of half cylinders, sometimes with "atadura" (or "binder") moulding connecting them in the middle or a third of the way up their shafts (Third House at Kabah, Nohochpak at Kiuik, Palace with columned frieze at Huntichmool, Palace and Cabal Pak at Chacmultún). The Mask style is principally marked by the presence of one or more masks of Chac the rain god, who is at times shown with a very large nose. When the masks are repeated they follow either a horizontal or a vertical line. The distribution was meant to have a religious significance; the masks were placed either above the entrances of the buildings, or as well as above the entrances, filling the whole area of walls and vaults and sometimes even the crest; or a large mask in the form of the god with open jaws marking the entrance. Examples are, respectively, the palaces of Yaxché and Kichmool; the palace of Sabacché; the Codz-Pop at Kabah, and the building adjoining the "Nunnery" at Chichén Itzá; the principal building at Hochob, the temple beside the Palace of Dzibilnocac and the "Temple of the Magician" at Uxmal.

The Intricate style is composed of many motifs, and sometimes includes masks. The outstanding motifs are: huts which act as niches for the sculptures of gods, almond shaped mouldings which perform the same function, lattices, serrated key frets, the "hook and step" fret (or *xicalcoliuhqui*), and the cylinder forms of the Colonnette style ("Nuns' Quadrangle" at Uxmal, the Arch and Castillo at Labná, and the "Nunnery" at Chichén Itzá). The Imitative style consists of buildings situated between massive towers, which are made to resemble temples on their lofty bases (temples of Río Bec and Xpuhil).

Some reference must also be made to the roof-combs or roof-crests, for in some cases these were enormous columns with as many as three bands of standing male figures one above the other (the Castillo at Labná), or were reduced to mere single figures (the Palace at Hochob). In buildings like that of Xelha and the Pigeon Court at Uxmal, the roof-combs are pierced by rectangular hollows or holes for the wind to blow through. In other places, panels covered with masks are arranged at intervals on the parts of the façade corresponding to the vaults, and these take the place of a roof-comb (Nuns' Quadrangle at Uxmal, and the Palace at Xlabnak).

The presence of the Nahua—both Toltecs and Mexica —in Yucatán made itself felt in modifications of the Maya architecture that continued under their influence; in the systematic use of columns and pillars already mentioned, for instance, and in the introduction of a sloping member at the external base of their walls. The serpentine columns on the Temple of the Warriors, the Castillo and the Temple of the Jaguars of Chichén Itzá, the anthropomorphic columns of the Temple of Chichén Viejo (Old Chichén), the pillars with reliefs of warriors on the face in the Temple of the Warriors and the chambers at the ends of the great Ball Court at Chichén Itzá, are all Toltec. In decoration the Nahuas developed not only serpent motifs, but others such as the descending god (the setting-sun), tigers and eagles, the earth monster, and so on. These are found at Uxmal, Sayil, Labná, Chichén Itzá and Tulúm.

Maya sculpture developed considerably, as can be seen in the steles, altars, altarpieces, lintels, urns and minor pieces. The majority of the steles are of the Classical period, and were erected near shrines regularly every twenty years. They represented "true men", the *halach uinic*, or according to the colonial historian, Cogulludo, the priests: "lords, heads and superiors of all men, those who gave punishments and rewards, and were meticulously obeyed." They are shown clothed from head to foot in embroideries of masks, feathers, skins, webs, girdles, paper, shells and jewellery, carefully chosen to show their rank. They carried ceremonial wands, or spears, and sceptres, and were shown alone or in scenes of ritual offerings, such as invocations, sacrifices or the celebration of victories in battle. The altars are monoliths worked on the front face, and like the steles, altarpieces and cornices served to present religious dignitaries or officiants, between rows of calendar and other signs. In Palenque there are some sculptures which attain great naturalistic clarity and have a mimetic purpose; for example, the high relief stucco figures that decorate the pillars and friezes of the Palace, the Temples of the Sun, the Cross, the Branched Cross and the Inscriptions. The semi-nudity of the figures and the solemnity of their movements are brilliantly portrayed. The heads which were laid as offerings in the monumental tomb of the Temple of Inscriptions once belonged to figures like these. In Palenque and other places, ornamental

stones were carved in shallow relief and housed in the interior and occasionally in the exterior walls of the monuments. A superb example of the refinement of design and execution of these tablets is the masterpiece that lay on the stone sarcophagus of the nobleman (*halach uinic*), who was interred in the great funerary chamber contained in the pyramid of the Temple of Inscriptions. The monolithic sarcophagus painted in red cinnabar, the colour of mourning, contained the body of this prince of Palenque. His face was covered with a mask of jade mosaic, and he was decked with a diadem, necklaces, rings and small idols of the same green stone. The tomb stood there as the key or talisman of the forces of vegetable fertility. The reliefs on the tablets are indicative of the deep significance of the tomb. The principal figure is a young man reclining on a seat formed by the masks of the jaguar god, the god of life and the god of death, Ah Puch; before him he sees a strong tree of life rising up. This is connected with the effigies of priests of vegetation sculpted on the outer faces of the sarcophagus, and those of the nine lords, magnificently adorned and wearing emblems of the Sun and Rain gods, which are modelled on the chamber walls.

The Maya were excellent lapidaries, and produced fine and most admirably finished pieces in hard stone, particularly jade. They also reached a high level as potters; some of their vessels are delicate, others inventive in the association of their shapes with those of other objects, and many more notable for their polychrome decoration based on symbols or motifs from life, reproduced in either a geometric or hieroglyphic form. In the north of Yucatán incised or modelled ceramics prevailed. They made urns or other large pieces in a hollow form, with decoration, which consisted of either a person or a mask, applied to the front. On either side of this mask they added vertical lines of smaller masks, and at the sides, small figures of animals or other mythological creatures. The Maya practised cults utilizing small clay figures representing gods and human beings. According to the contemporary Mexican scholar Ruz Lhuillier, these were for offering in the temples, for burying in the fields during the sowing ceremonies, and for accompanying the dead in the tombs. The best examples are those from the island of Jaina; these portray persons, exact in their gestures, expressions and

colouring. The Maya recorded their scientific knowledge on long sheets of paper made from vegetable fibres, and folded them in the manner of a screen. The best preserved of the three surviving books of painting of Maya origin is the calendar, astronomical and ritual Dresden codex.

THE TOTONACS

Some 1200 years ago there appeared in the central region of the state of Vera Cruz a people then without a name, who became known as the Totonacs. They cultivated maize, formed small centres, raised mounds as foundations for their primitive temples (which resembled their common huts), and made clay vessels and figurines which announced the birth of a refined and unmistakeable plastic style, more concerned with the human than the divine.

This early people first appeared in the sparsely wooded region which runs up to the Sierra de Chiconquiaco: a healthy region, favourable to that system of cultivation which depends on clearing and seeding with pointed sticks. From here, displaying definite characteristics which permit their being identified as Totonacs, they appear to have spread to the Gulf of Mexico, and to have climbed in the opposite direction to the cold and misty foothills of the Cofre de Perote and the peak of Orizaba, while to the south they reached the Paploapan river and to the north the Cazones. In these latter directions, the Totonac country bordered on the Olmec and the Huastec domains respectively.

Initially Totonac culture preserved close relations with the ancient Olmec, and perhaps brought to it, and later to other cultures, deities, rites, symbols and their associated ceremonial practices. The Totonacs had many deities, most of which they originated themselves, and rituals which included flaying and mutilations. Their funeral cult required them to put a mask on the face and a jade necklace in the mouth of the dead (in a manner similar to that of the Maya and other groups), and also necessitated offerings of stone mirrors, food vessels, anthropomorphic and zoomorphic figurines and those typical Totonac sculptures known by the names of "yokes", "palms", "axes" and "padlocks".

The Totonacs viewed existence with the cruel solemnity

that is common in Central America, but infused it with a rare sense of humour. They gave therefore the same form to the grave figures of their gods, priests and sacrificial victims as to those of common men in their religious ecstasies and their diversions. They made use of both stone and clay. Notable, and to some extent individualized, are the terracottas portraying men shot to death with arrows and women dying in childbirth.

The type of polytheism practised by Central American cultural groups can be exemplified by that of the Totonacs, as reflected in their sculptures and paintings. Some of their gods were adopted, others were of their own creation. They adopted Huehuetéotl, the old god of fire; Tlacatehutli, the monster and lord of the earth; Mictlantecuhtli, the skeletal lord of the land of the dead; Tláloc, the Central American rain-god; Quetzalcóatl, the god of creation represented as a plumed serpent; Ehécatl, who has a human form and a bird's beak, the god of the wind who was certainly elaborated by the Totonacs; and Xochiquetzal, the goddess of successful love, who was represented as a woman carrying a child on her hip. They created Xipe-totec, "our flayed lord", whom they represented in accordance with the rite as a priest with a facial mask made from the skin of a thigh or completely covered with the skin of a sacrificial victim and Xipe-Tlasoltéotl, who combined with these attributes those of Tlasoltéotl, goddess of the moon, of carnal love, of female fertility, of childbirth and the autumn harvest, and to whom were dedicated human sacrifices killed by arrows. The names of these deities are in the Nahua language.

The Totonacs built important ceremonial centres (Tajín, Tuzapán, Paxil, Vega de la Peña, Oceloapan, Cempoala), fortresses with similar types of buildings (Comapán) and cemeteries with vaults covered by small monuments like shrines (Quiahuiztlán, San Isidro and Comapán also).

The sacred city of Tajín, built between the sixth and the tenth centuries, during the Late Classical period, is a vast expression of their religious feeling, power and inventive genius. It lies in northern Totonacapán, in the full tropical jungle, among hills covered by wild vegetation. The builders reduced their site to a number of levels on which they erected various groups of buildings. One of these is Tajín, with its impressive Niched Pyramid which is a temple base of six

terraces built to match the temple walls, its horizontal bands being punctuated by rows of casements, boldly shadowed by jutting cornices. Their number, 365, corresponds to the days of the solar year. The stairway climbing to the temple conceals some of the niches, without however robbing the hidden ones of their religious significance. The balustrades display the "hook and step" key called xicalcoliuhqui, repeated 13 times on each. This number corresponds to the days of the month in the ritual calendar or tonalpohualli (its Nahua name). The other group, called Tajín Chico, is composed of small palaces raised on low terraced platforms, close to a prominent shrine which had a portico of six thick columns covered with reliefs of warriors. Here the Totonac genius produced the innovation of concrete vaults, with which they roofed the palaces and the Temple of the Columns, thus enabling them to build solid constructions of two floors. The ceremonial centre had six ball-courts, the largest of which lay near the Niched Pyramid. This and another, smaller one have ritual episodes carved on the ends and centres of their vertical arena walls, which show, in the larger, the religious initiation of a young warrior, his acceptance by his seniors, and the stages of the ball-game, which concludes with the sacrifice of the young warrior. All this is framed by bands of interlacing scrolls which are typical of Tajín, and takes place before the gods of heaven, earth and the discarnate state (these last perhaps signifying the presence of the ancestors).

THE ZAPOTECS AND MIXTECS

The Zapotecs, who settled in the warm valleys of Oaxaca, are known as such from the Classical period. They assimilated cultural elements from the Olmecs, who preceded them in occupation of the summit of Monte Albán, where the Zapotecs built their chief sanctuary. During the Classical period they expanded south-eastwards towards the Isthmus of Tehuantepec, and in the years immediately before the Spanish conquest ceded lands in the valleys to the Mixtecs, and not only permitted the passage of Mexica merchants and warriors on their way to Soconusco (which they had conquered), but even accepted a Mexica colony.

The Zapotecs practised agriculture and the domestic

crafts, and at a late epoch worked gold, for luxury purposes, and copper to make axes and knives.

Their religion was served by a priesthood, the Uija-tao, whose chief dignitary exercised authority jointly with the ruling chief. Their principal gods were the jaguar, symbol of the sky, the earth and the underworld, and the rain-god called Cocijo. They practised a cult of the dead, making funerary monuments and offerings for them.

The sanctuary of Monte Albán was erected in the course of five epochs, the first corresponding to the Olmec occupation, the second perhaps Zapotec with Maya influence, the third and fourth Zapotec with some influence from Teotihuacán, and the fifth Mixtec. It was built by levelling the top of a natural hill, some 440 yards above the plain on which the city of Oaxaca now stands. This levelling produced a large terrace, 820 yards by 270 yards, on and around which many buildings were constructed. This large group seems to be dominated by a temple built on a very broad platform overlooking the area of the ceremonial centre on its southern side. Longitudinally, and on a central line, the towers of the lesser temples stand out, punctuating the sublime expanse of the site beneath a vast sky. Behind, on the northern spur of the mountain top, is a group known as the Sunken Court, which consists of a platform on which stand several temples around a square sunken courtyard. This platform is approached by a broad staircase which leads up to a portico, behind which lie the court and the stairs going down to it. The portico was once supported by thick pillars and columns, and was roofed, as was usual at Monte Albán and Mitla, with concrete aggregate. In the court can still be seen a small platform for dancing, as was common in these courts. On the western side of the great terrace are three buildings which can stand as models of Zapotec architecture. Two are temple buildings with all their elements: a stepped base and staircase, chamber and antechamber of the temple, with a courtyard in front surrounded by lateral walls and a high platform, which could be reached by exterior and interior staircases, lying in front of it. The third is the building called "The Dancers", which shows remains of the panels carved with figures of Olmec priests which are a relic of the original occupation of the site by this ancient people (epoch Monte Albán I). This monument comprises a very small palace with rooms around a small court, which lies behind and in the centre of the square base, while in front and at the sides are various small buildings with porticos. The eastern side of the terrace served as a site for three small temples and a palace a little larger than that on the opposite side, also for a ball-court I-shaped in plan, with its playing area bounded by sloping ramps. On a line with the central buildings of the great terrace, Temple J stands apart in a prominent position. This is an old construction, pentagonal in plan, which lies askew from the other buildings, its axis pointing to the north-east, perhaps a point of cosmic significance. It dates from Monte Albán II, and its walls have carved stone inset panels with reliefs showing the subjugation of peoples.

Characteristic of Monte Albán III is the ornamentation in the form of a frieze with rectangles hanging from it at regular intervals. Monte Albán IV is marked by jambs, lintels and columns worked from great blocks of stone; these appear both at Monte Albán and at Mitla.

Mitla or Mictlan signifies in Nahua "city of the dead"; it is called Yoopaa in Zapotec. It was the seat and retiring palace of priests, also the burial place of the chiefs while Zaachila-yo was "the place of government". This religious centre corresponds to Monte Albán III and IV, and consists of five groups of buildings. Two of these include temples, which are of the third epoch. Each group consists of buildings containing very long rooms arranged around two or more quadrangular courts. The most important of the groups is that constituting the unity called the Palace of the Columns, once the residence of the Uija-tao, the chief priest of the Zapotec people. It consists of two courts surrounded by their dependent buildings. The second court is small, and has two fine chambers decorated with panels filled with variants of the "hook and step" fret, which appears on the façades throughout Mitla. This court with its chambers is entered by a narrow passage through the back wall of the largest room on the site, which lies on the north side of the first court of the Palace. It is notable for having six monolithic columns down the longitudinal axis of the chamber, these supports being necessary owing to the extent of its earth roofing. Some other buildings are placed over funerary crypts.

The Zapotecs built monumental tombs in the shape of quadrangular, T-shaped or cruciform crypts. Some were

placed beneath temples built at ground level, and consisted of a cube with a descending staircase which led to a doorway decorated with paintings or pieces of anthropomorphic pottery with attributes of gods, placed above the lintel. The cruciform tombs were perfected not at Monte Albán like the others, but at Mitla. The funeral chambers at Monte Albán still preserve the mural paintings with which they were finished. These represent images of the gods connected with agriculture. At Mitla, on the other hand, the walls had panels with the "hook and step" fret made of small stones, like mosaic on two planes, or were built of large, smooth stones.

Zapotec sculpture is represented by monolithic steles recalling those of the Maya, and fascinating pieces of earthenware, which are most characteristic. The Zapotecs were also fine lapidaries, to judge by the pectoral of the Bat-god, with articulated parts, carved in dark jade. In clay there are life-sized models of the jaguar, in a sitting position, both realistically and stylized in the Olmec manner. Other medium-sized pieces are the urns, which are formed by a kind of wide tube, to which is joined a human figure, standing, seated or reduced to a head alone; such figures are magnificently attired. Masks of sacred animals' heads stand out, their vigorous modelling harmonizing with the strong lines of the other adornments worn by the figures. At the same time there were many anthropomorphic statues which clearly express the Zapotecs' plastic conception of the human body and its attitude, including even that of religious rapture. These pieces demonstrate an evolutionary development from Monte Albán II to IV. The earlier examples show a powerful Olmec influence both in the features and the simplicity of the apparel. Those of epoch III are overloaded, even weighed down by the decorative insignia, and those of IV betray a certain formal degeneration.

The Mixtecs inhabited a region that now belongs to the states of Puebla and Oaxaca. During Monte Albán IV (fourteenth and fifteenth centuries) they invaded the valleys of Oaxaca and took possession of this Zapotec sanctuary, and left traces of their sojourn in the form of precious objects placed in the tombs of their noble families, whom they buried in crypts built by their predecessors. The Mixtecs were capable of making exquisite objects such as their famous "codices" or painted books, their polychrome and lacquered pottery, their delicate carvings in precious stone and their masterpieces in metal, particularly gold, which they cast by the *cire perdue* (lost wax) method. The burial in Tomb 7 of Monte Albán, which is Mixtec, tells much about the customs and mastery of these craftsmen, for besides the human remains were a great number of wonderful offerings, made of gold, silver, copper, rock-crystal, jade, turquoise, onyx, shell and bone.

TEOTIHUACAN, CITY OF THE GODS

In the centre of the lake-basin of the Valley of Mexico, somewhat towards the east, lies a region less fertile today than it was in the first millennium BC when an agricultural people appeared who had connections with Ticomán and other pre-Classical sites near the lake of Texcoco. In the last centuries of this epoch, these settlers began the construction of a ceremonial centre which was to be of great size and in which the cults of foreign groups came to be observed in addition to those which grew up locally. The people of Teotihuacán were at the same time to have influence in other parts. The most notable feature of this centre is the urban rationalization applied to the principal architectural system. The backbone of this architectural system was a succession of terraces forming a wide, long and straight avenue, the course of which determines the spatial sequence. The dominant axes of the buildings on either side are related to this avenue, being laid transversally to it.

Teotihuacán continued to flourish into the seventh century. It finally consisted of the principal building complex and other contiguous groups. The great energy devoted to building and decorating the temples, the platforms for spectacles and spectators, the palaces and pilgrim houses, can be judged from the ruins and the remains of their decoration discovered in the rubble. So great were the labours of the people of Teotihuacán themselves, their subject peoples in the region and groups from outside, that they succeeded in creating a sanctuary for all those dedicated to the worship of the gods of life and the forces of nature that sustain it. These deities were symbolized by animals and ritual objects. The

builders of Teotihuacán maintained cults devoted to the Olmec jaguar, the quetzal and other birds of the parrot family, and the plumed conch and volutes of the Totonacs, and established highly conventionalized personifications of the plumed serpent god (afterwards Quetzalcóatl) and the rain-god (afterwards Tláloc).

Teotihuacán was destroyed at the end of the seventh century, but later settlers in the central region of Mexico, in particular the Toltecs and the Mexica, paid respect to the ruined city. It was the Mexica who called it Teotihuacán, "the place of deification", for they buried their chiefs there, whence they were transformed into deities. The Mexica called the terraced avenue Miccaotli or "street of the dead", and they associated the bases of the two large temples with the sun and the moon. For their myths told them that these gods had been created in that locality by a sacrifice of other supreme beings.

There is nothing comparable to the rectilinear solemnity of Teotihuacán. The complex of buildings on an inclined plain to the south of the Cerro Gordo is dominated by the Pyramid of the Moon, at the foot of which lies its ceremonial plaza with a platform for dancers in the middle. The side of the square is about 150 yards (140 metres) long, and it is surrounded by the bases of smaller temples and their related platforms, which give it its quadrangular form. From in front of this Pyramid and its quadrangle, runs the Street of the Dead on which lie numerous bases and their related platforms, also the terrace of the Pyramid of the Sun, some groups of houses and, further on, the architectural unity known as the Citadel (la Ciudadela). This street, which runs from north to south, is 45 metres wide and several kilometres long.

The Pyramid of the Moon was the base of a temple which has disappeared like all the other temples. It is formed of five stepped members, with sloping walls and a stairway to the ceremonial plaza. Like that of the Sun, this pyramid dates from the first epoch of Teotihuacán. During the second epoch, a lower terrace of four descending levels was added to it. This faces the plaza, and its levels are built in the characteristic manner of Teotihuacán II: with a ramp *talus* as base, and a vertical panel above, the latter capped by a projecting cornice. In front of the Pyramid, on its staircase side, stand two smaller platforms which form a group with the three that were built on the eastern and western sides of the plaza and the two on the south, near where the plaza opens on to the Street of the Dead. On the western side, and behind two of the platforms facing the plaza of the Moon, are many housing complexes, one of which is the Palace of Quetzalpapalotl, the "quetzal butterfly". This combination of courts, porticos and chambers is typical of the housing for priests.

Three buildings on the Street of the Dead are particularly important. The Temple of Agriculture, which stands on the west side, is notable for the fresco paintings found in its ruins. The Pyramid of the Sun with its ceremonial plaza rises on the eastern side and is a gigantic mass, 245 yards (225 metres) on each side and 71 yards (65 metres) high. Built of earth faced with stones and lime-plastered, it consists of five stepped and ramped members varying in dimensions, and is provided with a staircase facing west which is backed by a terrace of three levels lying at its foot. The Pyramid follows the orientation prevailing in the principal buildings; its axis is approximately in line with the evening sun as it passes at its zenith. The Citadel is a huge monument, so called by the Spaniards because it is an enclosure framed by square platforms. Its sides are 440 yards (400 metres) long, and it is situated on the east side, at the lower end of the Street of the Dead. The inner court of the Citadel is on two levels; at the centre and rear of the lower level is the platform called the Temple of Quetzalcóatl, erected during Teotihuacán II to dominate the square and its surroundings. This base has six stepped members, faced with "*talus* and *tablero*" (ramp and apron panel), and a staircase on the west. The members have a lengthwise ornamentation of boldly carved undulant serpents, whose plumed heads jut outwards, alternating with masks of the rain-god. The staircase balustrades also have serpents' heads placed at intervals. Between the serpentine meanders appear *caracoles marinos* (sea-snails). This monument was covered over by another of Teotihuacán built during the third epoch, the period at which ornamental sculpture disappeared and pure painting was the only means of finishing "*talus* and *tablero*". The platform surrounding the Cuidadela square has fifteen small pyramids of two stepped members, the majority with access only on the inner face. Their design and distribution give an impressive feeling

of symmetry and rhythm. There are four pyramids at the front and on each of the sides, and three at the back.

Housing complexes were built at Teotihuacán on the plan of a Greek Cross; that is to say, they consisted of four chambers placed at the cardinal points around a square court designed to catch the rain. Frequently they were extended to include more rooms, passages and additional courts, as can be seen in the ruins of the Vicking and Xolalpan groups. The builders introduced the column, which made it possible for them to construct doorways and courtyards with porticos. They made their roofs of aggregate pebbles on to which they piled earth. The recently reconstructed palace of Quetzal-papalotl and the palace of Tepantitlá are examples of this architecture.

It is known that Central American builders invariably covered their surfaces with clay or stucco, and painted them with symbolic colours or polychrome figures. In Teotihuacán they used stone carving to make reliefs such as those in the Temple of Quetzalcóatl, and those that decorate the pillars of the court of the palace of Quetzalpapalotl (butterfly quetzals, eyes of heaven and bunches of feathers). And in addition there are plumed sea-snails with mouths to blow the feathers, and quatrefoils carved in flat relief, which form part of the façade of a temple found underneath the palace of Quetzalpapalotl. But fresco painting was much more widespread around Teotihuacán. The Temple of Agriculture, for example, had mural panels showing stylized gardens and a picture of men and women with offerings for flower-covered mountains. In the temples and chambers buried under the palace of Quetzalpapalotl, in the palace itself, on certain platforms and small buildings along the Street of the Dead, and in the priestly houses of Tepantitla, Tetitla and Atetelco, paintings survive of zoomorphic gods, religious symbols and priests.

Iconographically, the paintings found beneath the temple of the Quetzal Butterfly are remarkable: they include the Central American jaguar, sometimes shown walking, and with plumed *caracoles* or conches with which to play music to attract the rain, and at other times it is carried in the arms of priests in the ancient Olmec fashion. Here also is seen the *caracol* adorned with great quetzal feathers, the sign of the truncated *caracol*, and the "hook and step" motif, figures of birds of the parrot family with drops of rain and rings which are pictorial allusions to jade beads and to fertility. The frescoes of Tepantitla represent Tlácoc's paradise, that is to say the activities of those who come to the kingdom of the god of rain, of plants and of human rebirth. They are seen playing, singing, weeping and healing their sicknesses. Many of them bear a branch which is turning green, a sign of their resurrection.

In relation to the size of the sanctuary, little sculpture remains at Teotihuacán. The figure of the Water-goddess, which stood before the Pyramid of the Moon, demonstrates the conception of the deities on a large scale. The statue is a megalith, "cubist" in form; face, ear-pendants and apparel are magnificently and hieratically schematised. This contrasts strongly with the freedom of form of the sculpture incorporated in the architecture, which is bold and angular in outline, but independent of the rectangular block. It is in even stronger contrast to the smaller carved or clay pieces, supposed to have been made as funerary offerings. Among these smaller objects is one unmistakable product of the locality: the mask worked in jadeite, diorite, serpentine and other stones. These masks represent the human face, cut off at the hair-line of the forehead, perhaps to take some temporary head-dress. Another local product is the small "portrait" head. These were made from clay and evolved towards an eventual decay, marked by production in moulds and an over-extravagant head-dress. Following the destruction of Teotihuacán a group of potters migrated to Azcapotzalco, on the western side of the Texcoco lake, where they made last works in this style. From this town also come complicated clay braziers, consisting of pots on an hour-glass shaped foot, and with a front on which was modelled a human head surrounded by personal insignia. The potters of Teotihuacán achieved extremely refined shapes and special qualities of finish. From Teotihuacán II come the beautiful polychrome "flower-pots", and from Teotihuacán III cylindrical vases on tripods and with lids, richly decorated.

THE TOLTEC BUILDERS

The Toltec Builders and Warriors were members of the great Nahua family, who fought their way from the fabulous

Huehuetlapallan, somewhere in the north-east, to the high-lands of central Mexico. The Toltecs were a society of warriors, wise men and craftsmen. The warriors were divided into orders, each with a ritual function. The Toltecs' know-ledge and craftsmanship seem to have been based on the assimilation of elements from preceding high cultures. These they interpreted and diffused in the form of a new and flourishing historical movement. The Toltecs settled for a while in various places, and finally founded Tula Xicotitlan in the ninth century. There they made contact with survivors from Teotihuacán and were influenced by the builders of Xochicalco, a great ceremonial centre erected on a natural eminence which contains among its many buildings and plat-forms a splendid I-shaped ball-court with *talus* walls, and a temple, the façades of which were covered with figurative reliefs of plumed serpents, dignitaries, truncated *caracoles*, eagles and other signs indicative of some very important religious and military event.

Tula was built as a ceremonial centre, on a natural rise, and consisted of a large plaza with a platform for dancers, on the eastern side of which stood a temple facing westwards on a pyramidal base. On the northern side was a series of buildings, the chief of which was called by the later Mexica Tlahuizcalpantecuhtli, the "house of the lord of the dawn". In addition there are three enclosures, aligned along the same side of the plaza, and consisting of boundary walls, porticos and central courts. On the inner side of the walls are long seats, still covered with the military and religious ornamen-tation peculiar to Toltec society: a line of warriors along the top rail of the benches, and a succession of celestial serpents on the upper edge. Behind the "house of the lord of the dawn", a wall decorated with symbols of a cult seems to have served as a magical barrier against the powers of the north—the direction of death. A little further on, in the same direction, is the Ball-Court which, after the pattern of Xochicalco, has an I-shaped plan and sloping walls.

The Tlahuizcalpantecuhtli is one of the finest works of Central American architecture, inferior only to the Temple of the Warriors built by the Toltecs themselves at Chichén Itzá. It stands before a plaza and consists of three architectural elements: a low portico, the base for the "house", with the "house" itself on top. The portico had three rows of pillars, with a wall behind and on the sides, and stretched broadly from the foot of the pyramid (on which it was built) giving access to the staircase in the middle. The portico would have had an aggregate roof, and benches against the walls like those of the nearby portico courts. The base still retains parts of the original five decreasing members, orna-mented with a horizontal frieze covering a third of the height of each, with periodical pendants covering another third. The lower part was left smooth and slightly sloping. The upper frieze and the panels which determine the spacing of the pendants have sequences of eagles and tigers (or equi-valent *zopilotes* and *coyotes*); fewer in number and alternating with the eagles are figures of the "earth-monster" from whose jaws emerges a human face, and also the armoury with the lances symbolic of the planet Venus, which was mythol-ogically linked with Quetzalcóatl, the Toltec divinity and civilizing priest whose name was taken by the Toltec kings. (The birds represented in the frieze are known to have fed on blood.) On the upper level of the pyramid was a room which opened on the south side through a wide lintelled doorway. The lintel rested on pillars and a pair of inter-mediate columns carved in the form of plumed serpents, with their heads projecting along the ground and their ver-tical bodies turned at right angles in order to support the flat upper moulding with their rattles. The room would have originally had a horizontal pebble roof, resting on two rows of pillars, the front row formed by four great statues of war-riors of the Sun, sumptuously attired and carrying dart-throwers, darts and bags of seeds; the back row was formed by four pillars, square in section and ornamented with bas-reliefs of warrior chiefs, armoury and schematized serpents' heads. At the back of the room was a throne or seat made of slabs and resting on the raised hands of small warriors. The temple was perhaps a sanctuary of these warriors whose duty it was to nourish the sun with the blood and hearts of captured enemies in order to ensure mystically the continued existence and movement of the cosmos. The sun was swal-lowed by the monster of the underworld; he fought against the stars, his brothers and rivals, and re-emerged as a corpse at dawn. The myth applied also to the bright star Venus, associated with the sun and identified with the god Quetzalcóatl (the plumed serpent). The wall behind the

Tlahuizcalpantecuhtli contains reliefs and a crest referring to this myth. A frieze on either side represents the earth by means of the step-fret motif, and the resurrection of the sun, represented by serpents which disgorge the corpses of men. The crest consists of truncated *caracoles*, the symbol of Quetzalcóatl.

As for sculpture in the round, the Toltecs carved some steles in weak imitation of those done in the south-east, and also of jaguars which became the symbol of the terrible god Tezcatlipoca, lord of the night and patron of an order of warriors. The Toltecs also made anthropomorphic standard holders and *chacmools*, the latter being reclining male figures, with a cup or dish on the belly to receive offerings.

Tula flourished between 856 and 1168; then it was destroyed by Chichimec invaders. About two centuries before its destruction, a group of Toltec colonists reached Yucatán, crossing the frontiers that had been maintained with the Maya in Xicalongo. They went by land and sea to the northern part of the peninsula, carrying with them their superior arms and the secret of the pictographs with which they recorded their knowledge. Taking possession of Chichén Itzá, they built there an apotheosis of their distant capital. There Tula was reborn.

THE LAST NAHUA

The last great achievement of Central American civilization was the work of the historic Nahua, groups of savage hunters and warriors who came from the north-east. From the eighth century they had at intervals broken into the territory of the higher cultures. Through contact with them the Nahua assimilated their systems of organization, their social activities and knowledge, tempering the strength of the vigorous Nahua stock.

It is believed that the Toltecs created the first great Nahua culture and the Mexica the last, the dazzling splendour of which was witnessed and destroyed by the Spanish invaders.

After Tula was destroyed the Nonoalca Toltecs, the stock which provided the chieftains, priests and craftsmen, dispersed throughout the regions of Puebla, Oaxaca and the Valley of Mexico, and performed various services for the

barbarians who began to appear in these regions. In this way the most important element of Toltec society survived among the subsequent emigrants, and the name Toltec came to mean craftsman.

The Mexica group was said to have come from Aztlan and to have wandered for a long time before settling at Chapultepec, and finally (in 1370), founding Tenochtitlán on an island in the lake of Texcoco. This people had a tribal god, Huitzilopochtli, identified with the sun, whom they represented as a man-eagle. Once the group was established, their social organization comprised two highly dynamic classes which promoted a Mexica expansion throughout Central America and the conquest of other peoples. The two main social classes were the warriors and the merchants. Combining forces with a growing number of local craftsmen and peasants, they were able to make Tenochtitlán into the splendid city which the conquering Spaniards discovered at the height of its flowering.

Tenochtitlán which began as an island, was expanded by reclaiming land from the lake of Texcoco by means of *chinampas*, or terraces, suitable for cultivation formed by lines of stakes driven into the lake bottom with channels left between them. The Mexica built earth roads and waterways for traffic. They also built aqueducts to bring drinking water to the city, which was connected with the mainland by three causeways: to Tepeyac in the north, to Tacuba in the west, and to Ixtepalapa in the south. To the east the lake and landing stages were very close. These causeways formed two transverse axes which crossed at the point chosen as the site of Tenochtitlán's chief ceremonial centre.

This centre was a wide-walled enclosure, quadrangular in plan and with an entrance in the middle of each side. It comprised temples, a ball-court, a *tezmalácat* (platform for gladiatorial sacrifices) a *tzompantli* (platform for skulls), various porticos, and the houses in which the priests taught: the Calmecac for nobles and the Telpochcalli for commoners. On the southern side of the walled enclosure was the market square, on which stood the palaces of the monarchs Axayácatl and Moctezuma, described by the Spaniards. The city of Mexico stands on the site of Tenochtitlán, and preserves some of its ancient features. The principal streets leading into the Plaza de la Constitución (known popularly

as the Zócolo) follow the original lines, and the Plaza itself occupies the place of the market.

The plan and architecture of the great ceremonial centre of Tenochtitlán is sufficiently well known from the remains and from the Spaniards' reports, to show that it varied very considerably from earlier Central American sanctuaries. The buildings were placed close together, separated by straight streets, passages and platforms leading in fixed directions with a certain feeling for unity. This led to the abandonment of terraced perspectives in favour of a view of the buildings in groups. The Great Temple was built as a central point.

An idea of some of the buildings of the Sanctuary is given not only by the writings and drawings of the Spaniards, but also by the remains of monuments similar to those of Tenochtitlán found in places whose inhabitants (like the Chichimecs of Tenayuca) were influenced by the Mexica, or colonized or ruled by them. Tenochtitlán can consequently be described by reference to places where ruins are still standing. The surrounding wall of the sanctuary was thick and battlemented (as at Huexotla). The Great Temple consisted of twin pyramids with stairways and balustrades side by side (as at Tenayuca and seen, even more clearly, in the temple of Santa Cecilia, near Tenayuca, which has been restored recently). These bases supported two temples, aligned together and approached from the west; the northern and southern temples were for the gods Tlaloc and Huitzilopochtli respectively, who were represented with human faces. Tlaloc wore a mask of stout rings in front of his eyes, and had exaggerated upper canines as befitted a rain-god; Huitzilopochtli displayed the insignia of a knight-eagle, associated with the Sun. The god to whom the shrine was dedicated was indicated by signs along the high pediments placed above walls and lintels in Nahua architecture. The temple of Tlaloc had vertical blue and white bands; that of Huitzilopochtli white stone balls alternating with red skulls, to symbolize the heaven of dead warriors and the stars into which they were transformed (as at Santa Cecilia). The temples were battlemented; Tlaloc's with truncated *caracoles* (the symbol of the wind-god Ehécatl-Quetzalcóatl—as at Tula), and Huitzilopochtli's with butterflies which represented flames. The temple had a magic ring of snakes surrounding it below, and on the north-ern and southern sides sculpted fire-serpents (*xuihcóatl*) with heads oriented to the evening sun on the days of the equinox (as at Tenayuca). There was also a round temple, the entrance to which was through the open jaws of the serpent of the underworld. This was sacred to Tepelloyotli, the "lord of the heart of the mountains" (as at Malinalco). In addition there was a *tezmalacatl* or platform for gladiatorial sacrifices (as at Malinalco) and a skull-platform or *tzompantli* (as at Chichén Itzá). The round temple of the god Ehécatl-Quetzalcóatl was like that of Calixtlahuaca.

It is known that the Mexica represented the gods in a great variety of ways. They made stone or clay figures, which they decorated by adding the proper regalia of each, and also, at festivals, impermanent ornaments of feathers, painted paper, foliage and flowers, seeds and fruit. Many sculptures were covered with mosaics of shell, turquoise, obsidian and other materials. The Mexica also made carvings in rock crystal, obsidian and onyx. Certain skulls they covered in as though they were idols. Copper and gold were also used, not only for the decoration of their images but as ornaments for noblemen.

Outside the temples were stones of sacrifice on which the Mexica laid their victims in order to tear out their hearts. They also had "heart-cups" or *cuauhxicallis*, large stone bowls of various shapes in which their bloody offerings were laid; there were statues of standard-bearers: *chacmools* (reclining warriors with a bowl or plate on the belly) and clay braziers like gigantic hour-glasses, with a rope and knot in the middle.

Some images and monuments show ideographic complexity and great power of plastic expression. One masterpiece is the so-called Stone of the Sun; a stone shaped into a vertical disk of vast dimensions, and carved with reliefs dedicated to the solar cult including an intricate arrangement of calendar signs and ciphers. Another most important monument is the Tomb of the Years, a stone casket covered with a relief of skulls, in which the Mexica buried the sheaf of arrows representing the end of their cycle of fifty-two years. Another is the Teocalli of the Holy War, which is a miniature temple sculpted with reliefs illustrating the wars waged in order to capture prisoners for sacrifice to the Sun. Another imposing monolith is the Tízoc stone in the shape

of a mill-wheel, on the vertical edge of which can be seen the procession of warriors captured by the monarch of that name. Among the statues of deities, those of the goddesses Coatlicue and Yolotlicue are remarkable for their intricate symbols inscribed on cruciform anthropomorphic figures. Coatlicue was Tonantzin, the mother of gods and men, and the principle of the cosmic force which the warriors sustained by their battles and the blood of the sacrifices. Other statues are just as pregnant with meaning as these most impressive monuments: for instance the severed semi-spherical head of Coyolzauhqui, who was the sister of the god Huitzilopochtli, which represents the divine war waged by him for the preservation of the cosmos; and the statue of Xochipilli, god of music and dancing, a magnificent, seated male figure in the act of music-making.

CONQUEST, CHRISTIANITY AND THE ARTS

The conquest of the native peoples by the Spaniards began in 1519 and three years later the principal centre of resistance, the Mexican capital of Tenochtitlán, was overcome. The *conquistadores* then imposed a colonial regime which lasted till about 1821.

Before 1519 soldiers of fortune had taken possession of the West Indies in the name of the King of Spain and from Cuba they landed on the continent, where they gradually subdued the native peoples by alliances and by force of arms. The first Franciscan missionaries arrived in 1523, the Dominicans in 1526 and the Augustinians in 1533. The Crown had set up a special political administration for its new American vassals, whereby authority and possession of lands was retained by the Crown; the Americans were thus vassals and subjects of the king. But for the benefit of the conquerors it was stipulated that the Indians should render them personal service in exchange for the efforts made to convert them to Christianity. So the *encomienda* was instituted, and two domains were established, that of the Spaniards and that of the Indians. The division was so thorough that the Indians were forbidden to settle in Spanish towns, or to make collective bargains or sales of land except through their own authorities. For the most part, it was they who

constituted the agrarian peasant class of Mexico, with a supporting economy based on handicrafts.

The Spanish campaign to bring culture to the natives was founded on a long historical experience of fighting and subduing infidels, gained in the reconquest of Spain from its Moorish occupiers, which was completed in 1492, just as Columbus was landing on American soil. The experience was applied to this second episode of conquest and conversion.

On entering a town, the invaders set up a cross or religious image to preside over the temples they invaded, threw down the idols, and occasionally refuted the native lords who spoke in defence of their well authenticated and beneficent deities. The soldiers of fortune and their chaplains, combining Christian zeal with practical sense of conquest, could be termed the forerunners of spiritual victory, which was to be consolidated a few years later by the friars, when they had made the hazardous Atlantic voyage and journeyed ceaselessly throughout this vast country. And there were positive aspects of this missionary undertaking. The friars brought the sacraments to the converted, set up charitable institutions, joined with the natives in their struggle against the *encomenderos* and studied their traditions in order to write their history. They also studied the languages and cultures of the natives in order to give more meaningful expression to the truth which guided their actions.

As missionaries spread throughout the country they set up houses in the centres of Indian population. Though small and lightly built at the beginning, these friaries were later transformed in most cases into imposing monuments. For the few missionaries who could attend each convent scattered over this vast newly conquered country, the buildings consisted of a church, cloisters and a garden; for the many Indians there was a quadrangular walled court, with processional chapels at the corners and an open chapel used for the office of the mass and for preaching. The large court was used for church ceremonies and for the teaching of church doctrine to the people, thus serving the same purpose as the open air terraces on which the native rites had been performed in the past.

The convents dominated the native towns, being almost always erected at a central point. The churches were solidly built and very tall, with battlements, and sometimes turrets

and covered sentry-ways. The cloisters also bristled with battlements. The church of Tepeca is the most imposing construction of this sort. These buildings served as bulwarks of Spanish domination within the potentially hostile fields of the natives.

The processional chapels consisted of vaulted cubes, open on one or two sides to face the processional avenues of the court. Those of Huejotzingo still show angels of the passion carved in the Gothic manner on the spandrels, and those of Tlaxcala and Calpan exhibit historic reliefs which instructed the faithful on religious questions.

These Indian chapels were an architectural invention of New Spain, and were placed near convent buildings or adjoining the walls of churches or convents. They began as arbours facing the court, but soon they were given a formal construction, the majority being designed as apses or as loggias, and a few in the form of mosques. The first and largest of the mosque type was San José de los Naturales, built beside the Franciscan convent of Mexico city. Another example is at Cholula, which is still standing. Tlamanalco is of the *loggia* type with a gallery in front of the apse profusely decorated with Gothic-Plateresque reliefs. So also is the one at Cuitzeo, built into the front of the convent building and consisting of an apse lying centrally behind a fine Renaissance gallery overlooking the outer court. Notable examples of chapels consisting only of an apse are at Actopan, which is a spacious half-cylinder open at the front, and at Epazoyucan, built as a small preaching gallery with a carved roof crowned by a border of fleurs-de-lis.

Only in Chiapa, Coyoacán, Quecholac, Tacali and Zacatlán did the convent churches take the form of three-nave basilicas; those of Yuriria and Tlatelolco had one nave with transepts, and the rest a rectangular nave in which the principal arch and presbytery were accented. All had a high choir at the end. These churches had large towers, as can be seen at Actopan, Ixmiquilpan and Yuriria, or tall, shapely belltowers of which the royal chapel at Cholula, the basilica at Zacatlán and the church of Zempoala provide examples. In Yucatán the Franciscans introduced belfries instead of towers, and these appeared occasionally in other places, such as at Acolman, Meztitlan and Tlayacapan. The convents consisted principally of square courts surrounded by galleries and apartments. The apartments were arranged along corridors, on the three sides that did not adjoin the church. Whether large or small, intended for superiors, vicars or visitors, the walls, vaults and arcades were massive, though the last were sometimes lightened by substituting a colonnade for thick pillars and arches. The churches were equally heavy, with thick walls reinforced by buttresses and flying buttresses. They were roofed with half-round vaulting either continuous or broken by Gothic moulding. The church of Tlaxcala differs from the rest by not looking like a fortress. It has a fine carved wooden ceiling. The fact that the Tlaxcalans were loyal allies of the Spaniards may explain the difference in the structure.

In the massive convent buildings, structural and ornamental elements of Romanesque, Gothic, Plateresque, Mudéjar and Classical styles were moulded into a sturdy architecture with popular and monastic characteristics determined by the specific social organization of the colony and by the period of transition from the Mediaeval to the Renaissance. Portals of various kinds, and the arcading of cloisters and porters' lodgings allowed more scope than other parts of the buildings for the two styles to be combined in works of singular beauty. Figurative sculpture, applied to some portals and to monumental pieces such as the crucifixes standing in the *atria*, and baptismal fonts, also mural painting, helped to give a religious feeling to the insides and outsides of the churches and chapels and to the passages and apartments of the cloisters.

The need to provide a religious, or sometimes a secular atmosphere, and to teach religion by pictures, set the friars painting. With the help of the Indians, they covered the walls of their widely scattered convents with murals, and sometimes even attempted sculpture. They did not always choose subjects from religious history, or figures of saints for their paintings, but illustrated incidents from the lives of the missionaries whom the Indians knew, made portraits of philosophers and other intellectual figures, or indeed and why not?—Plateresque fantasies or imitation panelling. There was no reason why these could not appear in the same context as symbols of religion and other strictly Christian forms.

The enlightened and humanitarian activities of the

missionaries declined at the end of the sixteenth century owing to the progressive shrinking of the native population through epidemics, and to royal decrees which substituted secular for regular clergy in pastoral work. The Franciscans and Jesuits continued their work for some centuries more in the north of New Spain, where conditions were different. About three hundred imposing buildings were left, as monuments to the unique co-operation of friars and Indians. They still stand defying decay.

COLONIAL BAROQUE

The first artistic manifestations of the new culture on Mexican soil were the plans of new towns and the building of fortresses, churches and secular edifices. The first constructions were impermanent, but the plans endured. They were the product of Renaissance ideas present not only in the minds of the Spanish kings, but in those of the conquering captains who, even though they were sons of the common people, did not lack the sense to see that good prospects of a living were opening up for them. They therefore produced from their cultural baggage a mixture of mediaeval traditions and modern ideas — the best building plans they could devise.

To plan the first Spanish city in Mexico, the *conquistador* Hernan Cortes employed the services of the 'geometrician' Alonso Garcia Bravo, who made the design for Villa Rica de la Veracruz in Quiahuistlan. Cortes was afterwards entrusted with the planning of Mexico City and Antequera (now Oaxaca). He was guided by the Renaissance idea of designing cities like chessboards, or a Roman *castrum*. The Plaza de Armas was to be the centre of each town, and the Plaza of Mexico was to be one of the greatest in the world. Many other cities and towns on a similar plan were built throughout the huge country.

Architecture followed the Spanish advance, though with regional variations. Secular buildings were planned around quadrangular courts, with cloisters between the yards and the rooms. In the sixteenth century large residences were built on two floors, with loggias and with turrets at the corners of the roof which established precedents for the design of eighteenth-century palaces. The stylistic evolution was reflected principally in the decorated parts of the buildings such as buttresses,

mouldings dividing the surfaces of the façade, doorways, arcades and roof-copings. In Mexico City houses built in the sixteenth century were in the Renaissance style, though with Gothic overtones. Among them were the Viceregal Palace, the Cabildo buildings, the Archbishop's palace and the residences of the *conquistadores*. All these disappeared under the reconstruction of later times. But outside the capital some examples survive, though marred, to represent this period. Examples of the interpretation of Gothic, Plateresque or Classical forms are Cortes' palace at Cuernavaca, the Casas Reales or Governor's palace at Tlaxcala, the doorways of the Public Granary, the houses of the 'Slaughterman', the Charity and the Dean Plaza at Puebla, or Andres de la Tobilla at San Cristobal las Casas, and of Montejo and Santiago Mendez at Merida.

During the course of the seventeenth and eighteenth centuries secular buildings bore witness to the increasing prosperity and security of the colony. The Baroque influence predominated, corresponding very well to national development, though it was used mainly to provide sensational effects with a few structural elements only. Thus, the type of house planned on passages around a central court was maintained. Changes to suit the new Baroque manner were made in the elaboration of doorways and the bolder design of the arcading and principal staircases (for which showy experiments were devised), and of balconies and cornices. One widespread innovation was to raise the lower floor so as to divide it in two, using the lower part for services and the mezzanine for the offices and living quarters of the administrators of country estates. By raising the height of the roofs also, servants' quarters were created which included "bread and board" dwellings with offices below and bedrooms above, similar to those which still exist as part of the great Colegio de las Vizcaínas in the capital, Mexico City. Outside the capital, towards Tacuba and in Coyoacán and Tlalpan, gentlemen built country houses in which they enjoyed the quiet luxury of colonial life.

During the eighteenth century the secular buildings of Mexico City were rebuilt. The new architecture followed the prevailing lines of the Spanish Baroque, but was distinguished by the use of contrasting colours in the street elevations. Grey stone was used to accent buttresses, mouldings, portals and window-frames, and *tezontle*, a porous red stone

of volcanic origin, was used to fill the panels. In a more extreme case, that of the house of the Conde del Valle de Orizaba, stonework and tiled panels are used alternately, and the building is crowned with finials of polychrome ceramic. The Conde's country house, on the other hand, which is known as the "House of the Masks", is entirely of stone, though covered with the richest Churrigueresque carvings. Another feature which emanated from the capital and spread widely through the provinces, was the prolongation of the jambs beyond the lintels or archivolts to meet the horizontal mouldings which always divide the façades, marking the different floors.

Mexico City still preserves many palaces, though now adapted to new purposes. Among them are those which formerly belonged to Mayorezgo de los Guerrero, to the Condes de Heras Soto, de Miravalle, de San Bartolomé de Xala, de la Torre de Cosío, de la Cortina, y de San Mateo de Valparaíso. Others belonged to the Marqués de Jaral de Berrio, to the Marquesa de Uluapa and to Lieutenant Cebrián y Valdez. Another palace, which belonged to the Marqués del Apartado and dates from the last days of the Colonial period, shows the radical change brought about in Mexican architecture by the introduction of academic Classicism.

In the provinces also there was an important development in secular architecture. The city of Puebla was the first to have solidly built houses, characterized externally by their heavy lintels and delicate Renaissance balconies placed at the corners of the upper floors, and internally by the gently flowing vaulting of the courtyards, which was supported by heavy stone brackets. During the eighteenth century the most picturesque ornamentation in the country was produced in Puebla by the intensive use of polychrome, stone or stucco elements in combination with panels of brick, or brick and tile. In the second architectural phase of Puebla, Baroque lead and shell ornamentation appears and Churrigueresque pilasters, volutes and other curious decorations, all of which lend movement to the frames, arcading, pediments, cappings, niches, mouldings and pinnacles. Some residences in this style—the most distinguished being the Alfeñique house, the "Dolls' House" and the House of the Cannon—are still standing. In central Mexico

also, there grew up a new nobility whose wealth was founded on the possession of mines, factories and landed estates, and who built fine Baroque houses with stone extensions. Typical are those of the Señores de Ecala and of the Marqués de Villa del Villar del Aguila, at Querétaro, that of the Señor de la Canal at San Miguel de Allende, and those of the Conde del Valle Suchíl and the Conde de Zembrana at Durango; there are others at Guanajuato, Oaxaca and Taxco, which resemble noblemen's houses in Spanish cities.

Hospitals and colleges which also adhered to the system of rooms arranged round galleries and courtyards, were decorated in the prevailing Colonial style. The palace of the Audiencia de Nueva Galicia in Guadalajara, an outstanding example of the mid-eighteenth century, is a monument which still stands almost intact. Another of the same type is the Cabildo at Aguascalientes, with its fanciful window and door-framing and the arcading formed partly by straight and partly by curved lines. This follows the regional style of the *Bajio* (low country) which derives from eastern Spain. In Mexico City the buildings of the Inquisition, the Real Aduana (Royal Customs House) and the Mint survive as examples of the severe and sumptuous Colonial Baroque of the first half of the eighteenth century. Of the many hospitals there remain in the capital only the ruins of the former Hospital de Jésus and those of San Juan de Dios. In the provinces the hospitals of Atlixco and Tehuacan still stand, and at Guadalajara the Hospicio del Obispo Alcalde, which belongs to the neo-Classical epoch.

Bishops' palaces had an obvious architectural importance, an idea of which can be gained from those still standing in Mexico City, Puebla and San Luis Potosí. The importance of colleges was so great in the colony that the magnificent and functional buildings of the colleges of San Pedro y San Pablo, of San Ildefonso, de Cristo y de las Vizcaínas (built for the education of young ladies) have earned lasting admiration. In the interior of the country the original splendid Jesuit buildings for the novitiate at Tepozotlan have survived, and the seminaries at Valladolid (now Morelia), Puebla and Querétaro, are also well preserved, as are the former secular schools of Guadalajara and Morelia.

ECCLESIASTICAL ART
IN THE SPANISH ORBIT

The intense religious life of the Spaniards rapidly adopted the same characteristics in the colony as it had displayed in the motherland. The secular clergy installed themselves in the new centres of population alongside the regular orders, and in course of time cathedrals, parish churches and chapels rivalled the convents in art and luxury. Half-way through the sixteenth century the needs and resources of the colonists made large projects possible, and monumental buildings were begun. At the same time the number of churches and religious houses increased throughout the country. An increasing number of master craftsmen and artisans crossed the ocean to apply themselves principally to church and convent building and to the making of objects of religious devotion—altarpieces, paintings, plasterwork, furniture, metalwork and ceramics. In the early days they employed Indian assistants, who were both deft and inventive, and afterwards creoles and *mestizos* (mixed Spanish and native), among whom were some outstandingly good craftsmen. These artisans also provided luxury articles for the houses of the wealthy. Trade with China by way of the Philippines yielded certain kinds of precious objects both for churches and private houses.

The largest religious buildings in the colony were the cathedrals and certain important churches. During the colonial period, ten bishoprics were set up, eight of them between 1519 and 1620. These were at Puebla, Mexico City, Antuquera (now Oaxaca), Valladolid (now Morelia), San Cristóbal, Guadalajara, Mérida and Durango, to which were added in 1777 and 1779 Linares and Sonora. In the first eight cities fine cathedrals were built on a broad three-nave plan, with details of construction and decoration taken from Spanish buildings and textbooks of the different periods in which the cathedrals were planned and constructed. In the same century various other cities and towns attained importance and their citizens erected large parish churches suitable for later transformation into cathedrals. Among those which later became cathedrals are the basilicas at Aguascalientes, Chihuahua, Jalapa, Saltillo, San Luis Potosí and Zacatecas. The national cult of the Virgin of Guadalupe was honoured by the building of the sanctuary at Tepeyac towards the end of the seventeenth century; its architecture is strongly creole in style. In Mexico City the established clergy built such large churches as those of San Agustín, Santo Domingo and the Jesuit church of La Profesa, and in the provinces, the Dominican church at Oaxaca and the Jesuit church at Puebla.

The first of the eight cathedrals to be finished was that of Mérida (1599), which is the most Classical. It has *vaídas* (square cut vaults) all of the same height, supported by Tuscan columns, with a Byzantine cupola at the crossing, and coffering both there and on the rest of the vaulting. The next was Guadalajara (1618), also of the hall type without a transept and recalling the school of Siloé in its internal supports, which take the form of Tuscan half-columns crowned by entablatures.

To judge by the Classical elements of its interior, the next cathedral built was probably Oaxaca but its final length and west doorway date from a drastic reconstruction between 1702 and 1728. Like the Cathedrals of Mexico and Puebla, Oaxaca has three naves varying in height, a transept with a cupola, and lines of side-chapels in voluted niches; its choir is in the middle of the central nave.

The cathedral of Puebla was consecrated in 1649, with its towers and doorways not yet built. It belongs to the same family as those of Mexico and Valladolid (Spain). The interior has pillars and Tuscan columns back to back, fluted arches and half-round vaults with coffering, the centre vault with lunettes (small round windows), and the lateral vaults square cut.

Mexico Cathedral was consecrated in 1656, almost a century after it was begun; it was not finished for another 157 years. Owing to the long history of its construction it displays, in its architectural detail, also in its retables, and other works of art, almost all the styles of Colonial art. Gothic vaulting can be seen side by side with square cut vaults, lunettes and groined vaults, and externally Classical doorways (in the manner of the Escorial) beside Baroque ones with Solomonic (barley sugar) columns. The towers display in their two members the Tuscan and Ionic orders respectively and have bell-shaped cupolas. These cupolas, the alettes (ornamental buttresses) of the façade and some other

decorative features are the work of the important creole architect, Ortiz de Castro, and show the influence of the Louis XV style which also appeared later in that part of the cathedral designed by the Valencian academician, Tolsá, i. e. the dome, clock-casing, balustrades, torch-holders, pinnacles and statues that crown the building. The altarpieces are Solomonic, Churrigueresque and neo-Classical. That of the Chapel of the Kings is outstanding, and is the work of Jerónimo de Balbas, who brought from Spain the style of the brothers Churriguera with its preference for the *estípite* column with ornamented shaft.

The cathedral of San Cristóbal is also a rectangular basilica, with naves, a timber roof and a doorway designed in the seventeenth century Baroque style of Guatemala. Morelia Cathedral, designed in 1660 and consecrated in 1705, is the most recent of the eight. Its interior is very severe, and its plan that of three naves of unequal height, crossing-vault and dome. Colonial Baroque detail is confined to the exterior. The great towers, the dome with its polychrome mosaic, the portals and the pinnacles display all the feeling and resources of New Spanish Baroque in the first half of the eighteenth century. The portals have the usual reticulated form (with an irregular network pattern) with historical reliefs in the central portions. They are remarkable also for their *estípite* column and pelmet motifs. By certain breaks in the architectural design and by applying linear counterpoint to the mouldings, the architect of this cathedral achieved the plastic appearance demanded by the age, without forfeiting either size or the local respect for traditional forms which dictate the general outline of the building and its ornamentation.

The many smaller churches in the colony were generally rectangular "halls", or were planned as a Latin cross with a cupola at the transept and towers at the ends which form part of the front elevation. The nunnery churches also had rectangular naves with very wide spaces for the high and low choirs in the counterpart of the apse. They were generally planned longitudinally to the streets, to allow for the entrance of the congregation through two adjoining doors. The bells were housed in a tower or belfry. Church plans seldom departed from these forms, of which the great Dominican temples of Mexico and Oaxaca, and the Augustinian and Jesuit churches in Mexico City are fine examples. The first

three have one nave, a crossing-vault and vaulted side-chapels, and the last has three very ample naves and a crossing-vault. Notable among those which broke with the simplicity of the rectangle or Latin cross in their plan and the corresponding parts of the elevation is the Sacristy of Mexico Cathedral, planned as a Greek cross, with roofs and portals, rising in stages to culminate in the central cupola. Also remarkable are the church of the convent of La Enseñanza, planned as a half octagon crowned with a cupola, attached to a small nave which opens on to the street and the picturesque, multi-coloured Pocito chapel at Tepeyac, the jewel of Mexican eighteenth century Baroque, being a broad oval crowned by a dome, the planes, shapes and ornaments of whose walls match those of the vestibule and sanctuary; and finally the church of Loreto, a neo-Classical building dominated by a splendid dome, resting on pillars, illuminating the area which is joined by a short flight of steps to a small rectangular nave lying towards the image front. These buildings still stand in Mexico today.

The decoration, concentrated on the doorways, towers and cupolas, was the most elaborate and most rapidly changing part of the architecture. It broke up the reticular composition, first by the use of the Classical orders, then, in the seventeenth century, by incorporating Bernini's Solomonic column, and in the eighteenth by the preponderant use of the Churrigueresque *estípite*. In many churches, however, Baroque "improprieties" appeared side by side with a correct use of the ancient orders and proportions. Disproportion, broken mouldings and linear contrast prevailed in portals, where solid forms alternated with intrusive decorative foliage, shields, medallions and figures of saints of varying sizes. Among the many admirable examples of Baroque portals, some of the most original are those of the great church of the city of Zacatecas, of the Asunción at Puebla, of Santa Prisca at Taxco, of La Valenciana near Guanajuato, and the church of Ocotlán, near Tlaxcala. A local revival of the Plateresque style (following the fashion in Spain at the time of the first Bourbon kings), took place at Oaxaca, where it is seen in the portals of San Felipe and the Jesuit church.

While the number of aesthetic solutions was extremely rich, the architecture of New Spain produced certain features which gave it a character of its own. For example

great historical reliefs were employed for the centres of portals; the liturgical subjects, sometimes used, harmonized with the sculptures of saints and emblems which filled the niches, and with the accompanying medallions and foliage. Cupolas were introduced with false drums; that is to say with windows or clerestories arranged at intervals around them and perforating the shell which covered the crossing. It developed small, graceful lanterns to crown cupolas and towers, and experimented with pear and pyramidal shapes to cap the pinnacles. On the exterior, cupolas and capitals were brightened by multicoloured materials, which were also sometimes used to decorate portals and façades. To give religious and artistic warmth to the interiors, splendid gilt retable altarpieces in the shape of portals, were always applied to the walls. These retables were delicately carved, becoming progressively more elaborate as the Baroque style developed, and were used to display paintings and ornamented statues of saints.

Occasionally the interior decoration of seventeenth and eighteenth century churches includes stucco work. Foliage, shields and scrollwork, alternating with symbolic figures, angels and saints, spill all over the vaults and sometimes over pillars and walls also. This plasterwork appears in churches, sacristies and *camarins* (the robing chamber behind the altar), chiefly in the areas of Puebla and Oaxaca. Outstanding examples are to be found in the church of Santo Domingo at Oaxaca, in the Rosary Chapel at Puebla and in the church of Santa María Tonantzintla.

Painting was another of the arts which received special attention, pictures being used to decorate altar pieces. Canvases were hung in the panels of reticulated surfaces, and filled large spaces in the churches, sacristies and visible parts of the cloister. Private individuals employed artists to make them statues of saints, portraits, landscapes and genre paintings, with which they adorned their mansions. Painting of real importance began with the work of immigrant masters like the Fleming, Simon Pereyns, and the Spaniard, Baltazar de Echave Orio, men who knew their craft and were familiar with the fashions that flourished in late sixteenth century Spain. In the course of the years more painters came to Mexico and creole artists were trained. Chief among the immigrants were Sebastián López de Arteaga, Pedro Gar-

cía Ferrer and Cristóbal de Villalpando, and among the Mexicans, Echave Ibia, Echave Rioja, Juárez, Rodríguez Juárez, Correa, Tinoco, Ibarra, Cabrera, Vallejo and Alcíbar.

Painting achieved its apotheosis in the seventeenth century when, following the spirit of the Counter-Reformation, late Renaissance styles were strongly modified by a Baroque influence. The Colonial masters preferred a palette graduated to suit the subjects they painted. But in the seventeenth century some felt the attractions of *chiaroscuro* and others opted for grandiloquence, leaving examples which influenced the following century. As Francisco de Maza has recently pointed out, the painters of New Spain based their pictures on European engravings of Italian, Dutch and Spanish pictures, adding colour and details of their own invention. In addition, the immigrant painters were acquainted with master or studio works of important European artists, and lessons could also be learnt from a few canvases imported into the country. In this way the great demand in colonial society for sacred pictures was satisfied.

The Baroque style, with its prevailing desire for formal elaboration and the recording of physical movement, its emphasis on imitation and on effects of colour, light and shade reached its peak at the end of the seventeenth and in the first decades of the eighteenth centuries. The representative painter of this period is Cristóbal de Villalpando, whose considerable output includes paintings of the quality of his *Gloria* on the vault of the Chapel of the Kings in Puebla Cathedral. After this period of apotheosis came one of simplification and sometimes of artificial sweetness. Such weaknesses prevailed and affected even such good Colonial painters as Ibarra and Cabrera. Finally, in 1781 traditional painting and the workshop method were dealt a death-blow by the founding of the Academy and the new approach to school training.

THE HISTORICAL CONTEXT OF THE ARTS

Mexico gained its independence in 1821, eleven years after the outbreak of a revolutionary movement in which the bulk of the population had taken part and which the Spanish army had been unable to suppress. Independence itself, however, differed from the revolutionary battles in that the

masses were now pushed into the background; independence resulted from a coalition between the privileged classes of the old Colonial epoch and the native *petite bourgeoisie*. This uneasy alliance soon led to a series of quarrels; a crisis which followed the loss of Texas (1836) and the North American invasions of 1846—47 cost Mexico a further loss of northern territory—New Mexico, Arizona and California (1848). The dispute was between Liberals and Conservatives and, to put an end to it, the Liberals advocated La Reforma (the Reform); that is to say the separation of Church and State, freedom of worship and the nationalization or disentailment of Church property. When Reform was achieved, the Conservatives received a mortal blow; their chief support, the Church, lost its power. The laws of the Reform were promulgated to take effect from 1855, and their enactment unleashed a Civil War which was won by the Liberals, who shortly afterwards had to face French intervention, which gave fresh encouragement to their inveterate rivals (1862). The army of Napoleon III took possession of a large part of the country and promoted the formation of an imperial regime headed by the Archduke Maximilian of Habsburg, which was unable to maintain its power for long once the invading troops had withdrawn (1867). This episode strengthened the national *petite bourgeoisie*, which was finally able to consolidate its power and promote the economic development of Mexico by allowing foreign capital to exploit the country's natural resources and reviving internal markets. The *bourgeoisie* reserved for itself some industries and control of national territories and those of the ancient Indian communities. This economic development took full effect in the last two decades of the nineteenth century and the first of the twentieth, under the dictatorship of General Porfirio Díaz, a dictatorship cloaked by democratic and liberal procedure. The peace that ruled throughout those decades was broken in 1910 by an uprising of the common people directed against the dictatorship, the big landowners and the mining and industrial capitalists and in favour of effective democracy and social justice. This armed revolution quickly defeated Porfirio's regime but the fight against national and foreign reactionary forces continued for years. The final outcome of the struggle was modern Mexico, inspired by progress with a democratic equilibrium of opposing interests.

The artistic activities which developed in this last great epoch of Mexican life have suffered under political vicissitudes and the economic depressions inevitable in a country that, in order to gain independence and find its own way of progress, had first of all to abandon many elements of the past and transform itself by adapting the most advanced ideas and historical models in the international field. Afterwards, as a result of the experience gained, Mexican realities had to be taken into account and recognised as a determining factor in politics, no less important than the necessary understanding of the forces and currents of world history. The Enlightenment, the independence and federal structure of the United States, the French Revolution, Spanish Liberalism and later Positivism, all exercised an influence in Mexico. This last source of ideas and actions remained powerful up to the second decade of the twentieth century, until it was displaced as a result of the Mexican Revolution, which in a libertarian spirit opened the doors to all the ideological tendencies of the time, which in Mexico were tempered by the popular and progressive character of the Revolution.

The impulse towards progress and modernisation had shaken the country when it was still a colony, had led it to fight for its independence and determined later political readjustments. Its effect on artistic development was also powerful and has remained so to the present day. The first institutional manifestation of the new movement was the foundation of the Academy. People in New Spain wanted to take part in the progressive movement which was making itself felt in the mother country and had led to the establishment of academies in Madrid and other Spanish cities. In Mexico, the initiative came from Jerónimo Antonio Gel who had come to the colony as engraver to the Mint. With general approval, this artist established a school of engraving, which was soon converted into the Real Academia de Bellas Artes de San Carlos, which started classes in 1781 and was officially opened in 1785. Whites, *mestizos* and Indians were free to attend the school and received equal treatment. Artists, of the traditional school, who were living in the colony, were employed as masters, among them José de Alcíbar and Francisco Clapera. Very soon the Crown sent out from Spain academic professors to take charge of architecture, sculpture and painting. Among them were Antonio Gonzáles

Velazquez, Manuel Tolsá and Rafael Ximeno y Planes. Thus academic instruction began in the country. The example was followed and outside the capital academies and schools of fine arts were founded, the first of which was founded in 1814 at Puebla. Among its students was José Agustín Arrieta, who became an excellent *costumbrista* (*genre*) painter.

Being dependent on the government, the Academy had a troubled existence, for it was affected by political changes and economic depressions. During periods of political equilibrium it produced generations of artists sufficiently equipped to satisfy the demands of the upper classes. Once national independence was won, architecture had little chance to flourish, but began to revive during the second decade of this century. The figurative arts had greater scope; they served the old and the new rich and eventually the demands of the government itself.

During the nineteenth century the emphasis was mainly on overcoming colonial backwardness and placing Mexico on the level of the most civilized countries, though this could only be achieved by those at the summit of the social pyramid. Inevitably, therefore, architecture had to be neo-Classical and to follow French styles, culminating at the end of the last and the beginning of the present century in an eclecticism which allowed for reminiscences of both the Spanish and the native past.

The evolution of sculpture and painting was firmly linked to the newly formed academies. Romanticism in the themes of historical, biblical, Christian and allegorical paintings was accepted. Portraits and landscapes invariably showed Classical influence in the drawing and technique resulting from academic training in design and the careful study of models. To achieve a high technical level, foreign masters were once again engaged to direct teaching.

In 1843 a reorganization of the Academy was decreed. Fresh efforts had then to be made to attract good artists, as a result of which two Catalans, Pelegrín Clavé and Manuel Vilar, came to Mexico to take charge of painting and sculpture, Juan Santiago Bagally to teach die-casting, the Englishman, George Agustín Periam, for plate-engraving and from Italy came Eugenio Landesio for landscape and Javier Cavallari for architecture. Reorganization took place in other important cities; students were sent to Europe, and annual exhibitions were held, with prizes for the best works. A reform in 1867 initiated the separate study of architecture which was shortly afterwards made completely independent. The last notable European engaged was the Catalan painter Antonio Fabrés, who was in charge of the Escuela de Bellas Artes from 1903 to 1906.

The Mexican Revolution, the violent phase of which lasted from 1910 to 1917, opened the way to a new phase of national life, characterized by a desire to achieve political and social reconstruction on a popular basis. Once the armed conflict was over, the Revolution became a political force in the government of the nation, and remains so to this day.

The Revolution had its effects on the teaching of the arts. In 1921 the painting and sculpture classes of the School which was then substituted for the ancient Academy, were abruptly converted into open studios. This was followed by throwing open to all comers all similar institutions in the country. The most important development after that was the upsurge of mural painting on public buildings. This was inspired by the enthusiasm of a few artists who were young enough to capture the revolutionary spirit that was sweeping Mexico and the rest of the world in the second decade of our century. This enthusiasm was so widespread as to affect the administration and painters were given opportunities to illustrate on a large scale the vigorous and enlightened vision of man and his history which inspired them.

From 1922, mural painting was used to express man's conscience in plastic form and it still continues to do so although, inevitably, some decline is apparent. With the passage of the years the number of painters—including both traditionalists and those who try to interpret the restless, day-to-day changes of the modern world—has grown enormously. With the impact of the revolution there were considerable developments in engraving, a medium which very closely and faithfully expressed the life of the people and the struggle for liberty. Architecture took a new course, recognising first the values of the national past and certain affinities with other countries, then realising the virtue of functional solutions, and finally mastering and using the formal and material developments in the international field to achieve its own aesthetic solutions. The result is some highly original buildings.

NEW IDEAS
AND THEIR EXPRESSION IN ART

Before Independence and as a forerunner of it, the eloquent language of the Enlightenment reached Mexico, and the urge to change outworn habits of thought and life became irresistible. Artists aimed to raise their art to the level of the most civilized countries, to overcome the limitations of cloistered colonial traditionalism, and to follow a rational, Classical and universal style.

The effect of this period of transition from the colonial epoch to independence is to be found in the works of the Mexican architect, José Damián Ortiz de Castro, who designed the upper portion and spires of the towers of Mexico Cathedral, and most of the decorative details of the principal façade, in the Classical manner influenced by the style of Louis XV. For his reconstruction of the parish church of Tulancingo, with its large scale neo-Doric façade, he received the title Académico de Mérito.

Following his example various Spaniards designed the last monuments of the colonial epoch; the military engineer Miguel Costanso was responsible for the Encarnación convent, now the Ministry of Public Education; the engraver Jerónimo Antonio Gil designed the great retable of the church of San Francisco (in 1792, completed in 1962); the architect Ignacio Castera built the Loreto church with its dominant cupola (1809—1816) and the sculptor Manuel Tolsá, accepted as an architect by the Mexican academy, added to Mexico Cathedral the cupola, balustrades, pinnacles and clock case with its sculptures of Faith, Hope and Charity, also the sixteen sculptures on the corners of the towers. His architecture shows the influence of Louis XV, and his sculpture follows the Classical style. Tolsá also designed the Colegio de Minería (College of Mining), 1793—1813, in Mexico City, the functional Cabañas hospice at Guadalajara, and the main retable of the Profesa Church in the capital, also the magnificent "Cypress" in Puebla Cathedral (1797—1818). As a sculptor, Tolsá produced two outstanding works, the statue of the Virgin of the Cypress at Puebla, and the equestrian statue of Charles IV which was intended for the Plaza Major in Mexico City. The first architectural director of the Academy, Antonio Gonzáles Velázquez, planned the large To-

bacco Factory (1807—1810), a modest replica of that at Seville. In the interior of the country the engineer, Manuel de Santiesteban, constructed the monumental Perote Fort, and José Alejandro Durán y Villaseñor the Public Granary (1798—1809) of Guanajuato. The sacristy of Guadalajara Cathedral was the work of José Gutierrez, a Spaniard who was given a scholarship to study at the Academy. In these years of colonial prosperity, which saw the erection of so many fine neo-Classical buildings, Francisco Eduardo Tresguerras, a creole of genius, famous as an architect, painter and polemicist, undertook the rebuilding of the Carmen Church (1802—1807), in his native town of Celaya. He also designed the bridge over the river at La Laja, near Celaya, the palace of the Conde de Case Rul at Guanajuato and other equally fine works.

Among figurative artists (in addition to Tolsá and his pupils) there was the painter Rafael Ximeno y Planes who designed the Plaza Mayor in Mexico City. He painted portraits of his fellow academicians Gil and Tolsá, and drew the cartoons for the flat ceilings of the chapel of the College of Mining on the themes of the Assumption and the Miracle at the Well, and also for the cupola of Mexico Cathedral with an Assumption of Mary against a perspective of sky. Other notable painters were José María Vázquez, one of the first salaried students of the Academy, who distinguished himself as a portrait painter, and José Luis Rodríquez de Alconedo, a portrait painter from Puebla who sought to achieve fidelity and characterisation in a classical sense and with a certain Goyaesque influence.

These works were the product of the last epoch of landed prosperity in the country's economy, which was followed by a long period of decline. The taste for neo-Doric forms persisted though without much vigour. Here and there zealots, convinced of the virtues of neo-Classicism, inveighed against such objects as Baroque retables, which they replaced with a kind of portico made of cheap materials representing marble. One or two works of originality resulted from this development; for example, the Santa Anna theatre now demolished, or the inside arrangement of Puebla Cathedral undertaken by José Manzo, who adapted the altarpieces to the prevailing style, and embellished the plaster of altars, columns and vaults with gold fillets. Half-way through the

nineteenth century, a single work brought fame to its architect: the cupola of the church of Santa Teresa la Antigua, begun in 1855 by Lorenzo de la Hidalga. This Spanish architect made a design for a monument to Independence, which was never carried out but served as a basis for that of Antonio Rivas Mercade (built between 1900 and 1910).

The middle of the nineteenth century saw the director of painting of the Academy, Pelegrín Clavé, training excellent painters in the secrets of sound Classical craftsmanship. In academic circles the influence of Romanticism was limited. Figurative artists were compelled therefore to paint portraits, scenes from the Bible, the lives of the saints and historical scenes, in the Classical manner. They aimed to demonstrate their accomplished technique and to arouse emotion by an idealised treatment of objects and dramatic scenes. This period was marked by the emergence of such painters as Santiago Rebull, José Salomé Pina, Felipe Gutiérrez, Joaquín Ramírez, Rafael Flores, Juan Urruchi, Ramón Sagredo, José Obregén, Petronilo Monroy, Francisco Díaz de la Vega and Felipe Castro, also the landscape painters Jesús Cajide and Anacleto Escutia. To judge by his painting of the architect, de la Hidalga, with his Santa Teresa cupola in the background, Clavé was a pleasing portraitist. His dual subject gave inspiration to later masters, among them Saturnino Herrán. With his cartoons for the decoration of the dome of the Profesa church on the subject of the Seven Sacraments and a painting of *Isabel the Catholic in early youth beside her sick Mother* (1855), Clavé provided what the society of his time demanded.

The development of ideas during the second half of the nineteenth century is notable for the force of Romanticism and the move towards Positivism. The outstanding artist of this period was the painter Juan Cordero, who returned to Mexico in 1853 after studying in Rome. From Italy he had sent his canvases, *The Woman taken in adultery, Columbus before Ferdinand and Isabella* and *Portrait of the Sculptors Pérez and Valero*. The first two display the unquestionable mastery achieved by Cordero and in the third he showed by his technical perfection in painting *mestizo* figures, that he had not lost touch with Mexican reality. On his return, he brought with him the enormous, theatrical and dramatic tour de force—*The Redeemer and the woman taken in adultery*. Once in Mexico City, he opposed Clavé and made an unsuccessful claim to the directorship of the Academy. Cordero painted easel works and launched into mural painting, decorating the vaults of Our Lord's chapel in the church of Santa Teresa, and the dome of San Fernando. The most important of his paintings, now destroyed, was the allegorical mural on the theme of progress painted for the Escuela Nacional Preparatoria in 1874 on the invitation of the founder Doctor Gabino Barreda, who introduced Comte's Positivism into Mexico. Cordero painted remarkable portraits of his family and friends, finest among which are the equestrian portrait of the President General Antonio López de Santa Anna, and the portrait of his wife Doña Dolores Tosta.

Two other painters stand out among those who florished after the turn of the century. Santiago Rebull, apart from his fashionable portraits, painted the Bacchantes that decorate the terraces of the Castle of Chapultepec and *The Death of Marat*—the picture shown in the exhibition of 1875 with which he regained his academic prestige. Felipe S. Guttiérez was a traveller, writer and painter who, after visiting Europe and the United States, returned home in 1875. He painted religious pictures and portraits distinguished for the accuracy of their characterization. His *Rider in the Andes* was the first picture of a female nude in the history of Mexican art.

In the provinces there were artists who, thanks to some contact with academic studies, were able to develop their faculties of observation and their skill as portrait and *genre* painters. Outstanding were José Augustín Arrieta (1802 to 1897) of Puebla, noted as a *costumbrista* (*genre* painter); José María Estrada (1810?—1862?) of Guadalajara, painter of portraits and popular *ex voto*, and Hermenegildo Bustos (1832—1907) of Guanajuato, a painter of local types, noted for the exact observation of his inn scenes and his still-lifes of sliced fruit, painted with great realism.

After the epoch of Tolsá and his pupils, sculpture languished. But the arrival of the Catalan master, Manuel Vilar, in 1846 gave impetus to a group of artists belonging to the Academy. Vilar carved religious images, but went beyond the limits of purely religious sculpture. In his large-scale statue of Tlahuicole, the hero of Tlaxcala, he adapted the form of the Classical human figure to the native type. Also by Vilar is the statue of Christopher Columbus, which has

stood in the Buenavista gardens since 1892, the year in which it was cast. His pupil Martín Soriano made the sculpture of St Luke for the Escuela de Medicina (school of medicine), where it still stands, and Felipe Sojo sculpted a bust of the Emperor Maximilian, which demonstrates the standard of quality required by Vilar of his pupils. The most gifted of them however was Miguel Noreña, who produced his finest works rather later in the nineteenth century.

New and significant developments took place in the second half of the last century, when art began to reflect immediate reality, putting aside ideas, ideals and stereotyped formulae, and converting into poetry what was actually seen. There was a strong tendency for both painting and lithography to reflect the immediate surroundings: landscape, manners, familiar objects.

In the Colonial period there were painters like Pérez de Aguilar, who painted an occasional inn scene, and other anonymous craftsmen who decorated screens of furniture, perpetuating a fugitive reality in the form of art. Now art was life itself made into a document, an illustration, a profound representation of the course of history. The subjects were real people caught at their occupations or amusements. This vision of the world as it was, born of true experience, was finally revealed in all its fullness to Mexican artists. The many foreigners who swarmed about the country after Independence contributed to the new trend by illustrating their impressions of the nature, antiquities and customs of Mexico in paintings and lithographs. In addition, on the arrival of the Italian master, Eugenio Landesio, in 1855, the teaching of landscape painting was begun in the Academy. His stay lasted till 1877. This made possible a development in landscape painting, painting from nature and still-life, which has lasted till the present day; also for the production of lithographs and afterwards of woodcuts, which more or less deliberately mirror the human circumstances and background.

The form of landscape painting was definitely established by Landesio, who had been trained in the Accademia di San Lucca. He had a profound knowledge of perspective, of detail drawing, of the harmonic and tonal value of colours, and of methods of producing the natural illusion of space, form and light. He found in the Mexican landscape a liberal fount of inspiration for such pictures as his *Valley of Mexico*, and for *The Aqueduct at Matlala* and *The Columbus House*, the last two being landscapes with architecture. In 1862 Landesio published *An Excursion to Cacahuamilpa*, an album of drawings engraved by his pupil Velasco. The Italian master trained and influenced such excellent landscape painters as Luis Coto and Gregorio Dumaine. But his best pupil by far was José María Velasco, a painter of genius.

Velasco (1840—1912) was born at Temascalcingo, a small town in the highlands of central Mexico. In his youth he studied science, which he later applied to his painting, thus gaining an accurate knowledge of natural objects. Under Landesio's guidance he discovered and developed his own abilities and became a teacher of others. His paintings of nature revealed at the same time the grandeur of huge and distant vistas, and the poetic force of what lies to hand— of what lies still or grows; the beauty of human beings and their creations contrasted with the immensity of nature. He painted successive versions of the Valley of Mexico; the mountains, chains of hills, outcroppings of rock, woods and watercourses; scenes that included such monuments of human activity as the railway crossing in *The Bridge of Metlac* (1881); or buildings as in his early *Patio of the former Convent of San Agustín* or the *Country House of Chimalpa*. His self-portrait in charcoal and the series of canvases painted to illustrate the evolution of life on sea and land, commissioned for the Instituto Geológico de Mexico, are the product of the master's great sensibility and objective knowledge.

Lithography had been introduced into Mexico by Claudio Linati, the author of *Costumes Civils, Militaires et Religieux du Mexique, dessinés d'après nature* published in Brussels in 1828, and half way through the nineteenth century, great developments took place in this art. In 1841 Pedro Gualdi published *Monumentos de México*, and from that time there began to appear views of cities with their characteristic corners and monuments, executed by groups of Mexican artists: the review *El Museo Méxicano* (The Mexican Museum) in 1844 and 1845; *Los Méxicanos pintados por sí mismos* (The Mexicans portrayed by themselves) in 1853; *México y sus alrededores* (Mexico and its surroundings) in 1855 and 1856. Somewhat later, lithography became an adjunct of literary expression, devastating in the field of political satire, and

providing illustrations for books and miscellaneous journalism.

The last decades of the nineteenth century and the first of the twentieth were peaceful; the government of President Porfirio Díaz lasted for thirty-four years. Thanks to foreign investments in the exploitation of Mexico's natural resources, the building of railways and the development of trade, progress which had been so long needed, became a reality. There grew up at the same time a national bourgeoisie and a landowning class. In the countryside the ancient native communities were deprived of their land, and there arose a proletariat of miners, factory hands and railway workers. Culture followed the positivist slogans of "Love, order and progress". Cities began to grow again and new buildings were designed in the French style, though occasional concessions were made to the ancient styles of Mexico itself. In the capital there appeared aristocratic residential areas in which the houses, like those lying on the south side of the Paseo de la Reforma (laid out by the short-lived Emperor Maximilian to join the city to his castle of Chapultepec), are designed with mansard roofs. Styles of architecture derived from the Parisian l'Ecole des Beaux Arts, and Art Nouveau, and only rarely from the neo-Gothic and neo-Mexican, which were stigmatised by the reigning critics as being in "bad taste". In the countryside landowners built large and comfortable country houses with courtyards and enclosed gardens, protected by turrets and loopholes. These residences included a chapel and, on one wing, rows of poor houses for the labourers. To meet the unprecedented needs of business enterprises and public services, iron and stone were employed for the building of stations, railway bridges, factories, warehouses, markets and office buildings. The new suburban centres and architectural developments demanded public monuments, ornamental sculpture and luxury products to provide a fitting background for prosperity and the pretensions of the new aristocracy attracted by all things European. The social process which resulted in this building activity produced increasingly sharp contradictions which were to result in the uprising of 1910.

Until then the unrest which was generated expressed itself in the graphic arts. Mouthpieces of the discontented people were the journalists, draughtsmen and engravers.

Various publications included cartoons of a political nature, continuing the precedent of the Yucatán journal, *Don Bullebulle* of 1847, in which illustrations by Gabriel Vicente Gahona—*Picheta*—castigated the local bourgeoisie. Outstanding among the many new cartoonists was José Guadalupe Posada (1852—1913), master of a direct style at once intelligent and entertaining. Coming to Mexico City from his native town of Aguascalientes, Posada was a tireless illustrator of the most diverse popular literature, with an incisive understanding of the motives which inspired it, particularly those of a political nature.

Under President Díaz the Mexican capital came to have such luxurious buildings and monuments as the Chamber of Deputies (architect Mauricio Campos) with a Classical porch and an interior theatrical in plan; the palace for the Secretaría de Communicaciones (Secretariat of Communications) by Silvio Conti in the Italian Renaissance style; the Palacio de Correos (Headquarters of the postal services) late Spanish Gothic with ironwork made in Italy designed by Adamo Boari, who was also responsible for the National Theatre (now the Palacio de Bellas Artes), designed in the Art Nouveau style. The Palacio Legislativo was barely begun and later was transformed into the monument for the Revolution, by the French architect Émile Bernard—his was the winning design in an international competition. The new Palacio Municipal (Town Hall) of Mexico is in the Spanish Renaissance or New Colonial style, by Manuel Gorospe; the building for the Inspectorate of Police is neo-Gothic by Federico E. Mariscal; and the palace now occupied by the Secretaría de Gobernación (Department of the Interior) was designed by Emilio Donde, who was also architect of the neo-Romantic church of San Felipe de Jésus. Another church of this period is the Sagrada Familia, designed in the neo-Romanesque style by Manuel Gorozpe.

Outside Mexico City, architecture followed the fashions of the capital. Perhaps one of the most successful provincial buildings is the Juárez theatre at Guanajuato, a splendid edifice with a Renaissance entrance front and interior in Moorish style. Among the monuments to national figures and events put up during the "Porfirian" epoch were the Columna de la Independencia, (Independence Column), designed by the architect, Antonio Rivas Mercado, with sculptures

by the Italian, Enrico Anciati; the Doric Hemiciclo al Benemérito de las Américas (Colonnade to the Benefactor of the Americas) President Benito Juárez, by Guillermo Heredia. Probably the most famous is the monument to Cuauhtémoc, the last Mexica chief, a work remarkable in its time for its attempt to represent the distant native past in the modern idiom. The architecture is by the engineer Francisco M. Jiménez and the sculpture (with the exception of the relief of the *Torture of Cuauhtémoc* by Gabriel Guerra) is by Miguel Noreña. Also by Noreña is the seated statue of President Juárez, now in the National Palace, and the imposing Hypsometric Monument commemorating the colonial scientist Enrico Martiñez. In 1892, to celebrate the fourth anniversary of the discovery of America, the statue and monument to Christopher Columbus was unveiled in the Plaza de Buenavista. This was a work of Vilar, designed many years previously and cast in bronze in honour of this occasion.

Mexican society welcomed the erection of these grandiose buildings and patriotic monuments as indications that Mexico had at last attained the desired cultural incorporation in the European scene. For a while Mexico was satisfied with the academic work of these sculptors and painters, especially since many of them were the result of studies in Europe. The intellectual wing of the aristocracy, and of the *petite bourgeoisie* which followed it, appreciated religious themes and those which inspired noble sentiments, the representation of persons and events famous in the history of Europe and Mexico, the use of allegory and the portrayal of persons, places and customs. This idiom was mastered by the sculptor Jésus F. Contreras (1866—1902), who executed the equestrian statue of General Ignacio Saragoza, conqueror of Napoleon III's French armies, which was intended for the city of Puebla, the scene of his victory; the statue of General Ramón Corona for Guadalajara; of President Juárez for Chihuahua and of four national heroes for the Paseo de la Reforma in the capital. Also by Contreras is the monument to Peace in Guanajuato (1898), and the marble sculptures *Malgré Tout* and *Désespoir* which ornament the Alameda Park in Mexico City. Contemporary with these is the seated statue of *La Corregidora* in the Plaza of Santo Domingo by the Academy professor, Enrici Alciati. Painters of

merit whose works pleased this social mentality include Manuel Ocaranza, José Ibarrarán, Gonzalo Carrasco, Felix Parra, José María Jara and Leandro Izaguirre.

But while the public was still satisfied with this art, a new generation of artists was developing new ideas both in their works and in their attitudes to life, ideas which were to be the immediate forerunners of the style that has persisted from the twenties to the present day. These are such artists as Julio Ruelas (1870—1907), draughtsman, engraver, avant-garde painter and satirical contributor to the *Revista Moderna* (Modern Review); and Saturnino Herrán (1887 to 1918), an exuberant personality who expressed his sensibility in the form of paintings that recorded dramatic scenes in the familiar life of his country, or pretty girls seen in the countryside or before some colonial monument. His chief canvases are *The Offering*, *Tehuana*, *The Shawl*, *The Syrup Sellers* and the *Cofrade* (member of the guild) *de San Miguel*, also his cartoon for a mural *Our Gods Coatlicue and Christ* intended for the National theatre. Contemporary with him were the Impressionists Joaquín Clausell (1866—1935), a self-taught painter of land and seascapes; Gilberto Chávez (born 1875) and Francisco Romano Guillemín (1884—1950), who was influenced by Pointillism. At the same time there arose a painter of restless and visionary genius, Gerardo Murillo, known as Dr Atl (1875—1964), a tireless world traveller all his life, an intellectual and social revolutionary, who was instrumental in giving Mexico the masterly impulse which awoke its new generations. Dr Atl was outstanding as a landscape painter.

THE IMPACT OF THE NATIONAL REVOLUTION

The Mexican revolution of 1910 interrupted the development of official building for more than ten years. During that time if the *bourgeoisie* did not send their accumulated capital abroad they invested it in houses or commercial buildings. The revolutionary army of peasants forced the landowners to abandon their many fortified country houses and to increase urban investment with their accumulated wealth. During the second and third decades of this century therefore, many houses were built in all the principal cities

of the country, in styles which, following the habits of the immediate past, aimed at reproducing any European or even Oriental style that came to hand.

With the end of revolutionary fighting, successive governments began to put up public buildings. Their first preference was for a "New Colonial" style, but later they also favoured advocates of "neo-Indigenism". Many varieties of style were available at first; but growing needs of various kinds very soon made urgent the finding of other solutions imperative. So functionalism was introduced with its contemporary formulae based on the use of steel and reinforced concrete. Later for the building of markets, sports arenas and for general economic purposes where large areas had to be covered, building systems involving reinforced concrete shells and light metal structures came into use.

When, in the 1950s, the neo-Colonial style went out of fashion similar systems were applied to church building. Private enterprise also accepted these general solutions for housing, shops and factories, arriving at different solutions for each project. Public and private initiative alike satisfied social and private needs with all the resources and processes at their disposal. The Mexican state has followed the policy of providing everything that private enterprise has shown itself incapable, unwilling or reluctant to supply. The functions of government have therefore increasingly embraced the public services of education, social assistance, communications, sport and amusement, and the production and distribution of merchandise and electricity, to cite a few examples.

The last decades have witnessed a vast growth of cities. Architects, chief among them the urban planners, Mario Pani and Luis Barragán, have had opportunities of planning new suburbs and large architectural units. Mario Pani has been responsible for several blocks of flats surrounded by green lawns: the Miguel Alemán unit (1947), the President Juárez urban centre (1950), the social service and housing unit of Santa Fé (1957) and the immense urban project of Nonoalco-Tlatelolco. His large scale planning of the Satellite City (1958) is however his outstanding achievement. In 1948 the bold and intelligent understanding of Pani and his partner, Enrique de Moral, was applied to the problem of building the University City of Mexico; the general scheme and the basic siting of the buildings was entrusted to them.

Luis Barragán has laid out sections both of Guadalajara and Mexico City. He built the Jardines del Pedregal suburb (1949) on the outskirts of the capital in a desert of volcanic rock where he made dramatic use of the peculiar characteristics of the site.

Many other architects have shown great vision in resolving concrete problems of urbanism and architectural planning. Among them are Enrique Yánez, designer of the Centro Médico (Medical Centre 1943); and Alejandro Prieto, who has been responsible for the housing blocks and medical and social centres of the Instituto Mexicano del Seguro Social (Mexican Institute of Social Security), built during the last six years.

Mexican Architecture from the twenties onward has advanced by periods of varying length during which specific concepts were subjected to various interpretations: the colonial tradition, adaptation of native, pre-Hispanic forms, Californian colonial, functionalism, cubism with its rectangles and suppression of ornament, structuralism with the accentuation of the vertical and horizontal elements of façades and structuralism with independent glass screens and moveable internal walls; dynamism of volumes and vertical planes; spatial dynamism of interiors and exteriors, organic integration of natural and architectural space, plastic integration, and continuity of architectonic space broken up by patches of vegetation or pools of water.

Architects capable of applying these various concepts within the framework of art have been trained in Mexico, though they often completed their studies abroad. In one way or another they have kept in touch with the international sources of creation and knowledge. Mexican architects have made use of building materials of the country, such as timber, and brick or stone with exterior finishes in a variety of plasters and other materials for which the industrial raw materials had to be imported fifty years ago, but which are now manufactured in greater variety in Mexico itself.

A number of bold and inventive planners stand out in the field of Mexican architecture from the many good professionals. The Departamento de Salubridad (Health Department) building of 1926 by Carlos Obregón Santacilia is a model of the architecture of spatial arrangement; in keeping with this conception are Mario Pani's designs for the

buildings of the Conservatorio Nacional de Música (1944), the Escuela Nacional de Maestros (1947) and the Universidad Nacional Autónoma de México (1950).

Alberto T. Arai, an advocate of functionalism, was responsible for planning the open forecourts of the Ciudad Universitaria, with a feeling for the region and for the volcanic material at his disposal, and some reference to the pyramidal bases of the ancient native temples. Manuel Parra, who has concentrated on domestic architecture, began in 1939 to use material from old buildings which were being demolished. By skilful use of popular architectural themes and details he has achieved surprising combinations partly traditionalist, partly modern in character.

Juan O'Gorman, an artist of many skills, who started as an aggressive functionalist, solved the problem of the exterior finish for the Central Library of the Ciudad Universitaria by sheathing the walls of the building with a mosaic of multi-coloured stones, in the form of four huge pictorial compositions. O'Gorman's house in the Avenida San Jerónimo shows, to an even greater extent than those he designed between 1929 and 1934 for the painters Diego Rivera and Julio Castellanos, the extreme boldness of his imagination, combining volcanic stone with mosaics of natural colour to form both the exterior and the interior of a picturesque sort of grotto. Felix Candela, master of the "eggshell" roof, has designed or assisted in the building of distinguished projects by applying his system of reinforced concrete in paraboloid, hyperbolical and various other shapes. His work can be seen in the church of the Medalla Milagrosa (1954), the restaurant at Xochimilco (1958), designed by Joaquín Alvarez Ordóñez, and in the roofing of the Bacardí bottling-factory (1958).

The concept of integration, which combines the figurative arts with architecture, has given Mexico some fine monuments. Two great buildings by Mario Pani established in the 'forties the Mexican form of this concept which has been developed in so many different ways throughout the course of history. Both are in brick and concrete, externally and constructionally. The Conservatorio Nacional de Música (Conservatory of Music) has a prominent group of five statues illustrating the art of music, which stand above the great angular glass façade; the Escuela Nacional de Maestros (National Teachers' College) has a broad frieze with high

relief sculptures displayed like a concrete facing on the principal façade. There are mural paintings by José Clemento Orozco in the vestibule and at the back of the open-air theatre of the training school. The Secretaría de Communicaciones y Obras Públicas (Department of Communications and Public Works) by Raúl Cacho and Agusto Pérez Palacios is clothed in great mosaics by the painters Juan O'Gorman and José Chávez Morado, and decorated with statues by Rodrigo Arenas Betancourt and Francisco Zúñiga.

Religious architecture has developed both in a neo-Colonial manner, and also progressively, in that it takes advantage of the great possibilities of structural steel, or laminated concrete roofing, in combination with glass or vitreous sheets. Enrique de Mora built the church of the Purísima in Monterrey in 1943, and from that time paraboloid or pointed roofing has been applied to church construction. Outstanding are the chapel of the Misioneros del Espíritu (the Missionaries of the Holy Ghost) at Coyoacán, D.F. by Enrique de la Mora with structural engineering by Felix Candela and glass by Kitzia Hofmann (1956), and the chapel for the Jansenist sect at Zoquiapan, by Israel Katzman (1954).

The qualitative and quantitative achievements of Mexican contemporary architecture have been considerable, nevertheless the most notable achievement of the last ten years has been the display of initiative by the painters and engravers. This has developed in two major phases; the first following and reflecting the events of the second decade of the century —the first World War, the Russian revolution, the Mexican revolution—and the second founded on the economic advances, social reforms and liberalism which came to the Republic in the years after the second World War. Those artists who were in their prime during the first phase had the opportunity to project on the walls of public buildings a large scale picture of the Mexican philosophy of life, interpreted artistically in the critical moments of the destruction of a decaying past as well as their reflections on the present and their zeal for action and the need to take up an attitude towards the future. They were free to apply the mastery they had acquired years before, and to attempt forms and techniques suitable to the particular methods of expression which were their response to the demands of their world. They invented an idealistic painting based on allegories, incidents

from history, scenes from peasant life, satire and exaltations of those positive forces in the nation and the class struggle that could be contrasted with the negative forces of world history. They represented the human benefits to be gained by manual, teaching or scientific labour. In these ways and by using figures exalting the beauty of the Mexican people, culture and landscape, these artists conveyed an intense emotional and intellectual fervour. Those of the first phase attempted to rouse in the people a positive and strenuous attitude to the reality and significance of their lives. Those of the second phase, who were numerous, used their great creative powers to keep mural painting on a high level of creation, taking their inspiration from poetry, folklore or surrealism. Among them were figurative and some abstract painters. During both phases, the engravers devoted themselves to the realistic illustration of books, periodicals and broadsheets, thus continuing to serve the cause of the people. Leopoldo Méndez (born 1902) and Alberto Beltrán (born 1922) have won well deserved acknowledgement both in Mexico and beyond its frontiers, as has also the work of the Taller de Gráfica Popular (Studio of Popular Graphic Art).

The first mural paintings of post-revolutionary Mexico were those for the Escuela Nacional Preparatoria (National Preparatory School); and the future developments both of form and content were to some extent determined by these murals. Various artists contributed to the great work executed in this revered monument of colonial architecture. Each applied his creative power to this historical opportunity. Associated in the Sindicato de Pintores (Painters' Union), they endeavoured to work in the spirit of its manifesto:

> To socialize art... to execute only monumental works for public buildings.... This being an historical moment of transition from a decayed to a new order, to produce an art of use to the people in place of one for individual pleasure.

In time some of them proved to be planets, others shooting stars. The first murals were done in 1922 by two painters, Ramón Alva de la Canal (born 1898) and Diego Rivera (1886—1957). The first contributed an historical episode,

The Landing of the Spaniards, and the second an allegory, The Creation. They were soon joined by José Clemente Orozco (1883—1949), David Alfaro Siqueiros (born 1896), Fermín Revueltas (1903—1935), Fernando Leal (1900—1964) and Jean Charlot (born 1898), who decorated the halls, staircases and corridors. The work of this group of artists had the impact of a revolutionary painting produced by a revolutionary country. Its importance was understood by advanced circles in Mexico and many other projects were offered to these and other artists in the capital and the other states of the Republic. This provided opportunity for the development of the profound and mysterious genius of Orozco, and the clear intelligence, broad inventiveness and sensibility of Rivera.

Orozco expressed his genius in mural and easel paintings and in drawings and engravings. His violent murals, which are both emotionally convincing and remorseless in their critical sense, can be admired in Mexico City, Orizaba, Guadalajara and Jiquilpan. In the Escuela Preparatoria he executed four series of paintings between 1922 and 1927, including a classical Maternity. The others express a cosmic vision of the making of the nation, the missionary piety of the sixteenth century, the contradictions between the symbols of humanity and the condition of man, the calm and tragic poetry of the Mexican peasant in the face of the recent revolution. Others of his paintings are in the Casa de los Azulejos (House of the Tiles 1925), the Escuela Industrial (Industrial school) at Orizaba (1926), the Palacio de las Bellas Artes (Palace of Fine Arts 1934); the assembly hall of the University, the staircase of the Palacio de Gobierno (Government palace) and Cabañas hospice at Guadalajara (1936—1939); the library at Jiquilpan (1940); the Suprema Corte de Justicia (Supreme Court of Justice 1941), the church of the Hospital de Jésus (1942), the open-air theatre of the Escuela Nacional de Maestros (1947—48), the Museo Nacional de Historia (National Museum of History 1948) and the legislative chamber of Jalisco (1948—1949).

Such was the genius of Diego Rivera that nothing was alien to him. He could capture the essence of whatever was before him and could use his imagination. His many murals combined classical unity with luminous colour. Rivera's forms, whether reduced to their elements or executed in

minute detail with faultless skill, whether forming part of a great figurative composition or a simple allegory, were always miraculously successful. He had a deep and unfailing historical sense and a fine response to all that he found beautiful. After the *Creación* mural in the Bolívar amphitheatre of the Escuela Preparatoria (1922), he painted six series of murals and some single panels along the corridors and staircases of the Secretaría de Educación Pública (Department of Public Education) 1923—1928. Rivera painted the walls and ceilings of the ceremonial hall of the Escuela Nacional de Agricultura (National School of Agriculture) at Chapingo (1926—1927); the masterly triptych on the staircase of the Palacio Nacional (Presidential Palace 1925—1935, 1944—1945); the council chamber of the Departamento de Salubridad (Health Department 1929—1930); the gallery of Cortes' palace at Cuernavaca (1929); a panel for the Palacio de Bellas Artes (1934), which had originally been painted for the Rockefeller Center in New York; panels for the Hotel Reforma and Ciro's Bar (1936—1943); a mural for the Instituto de Cardiología (Institute of Cardiology 1943—1944); a large mural for the Hotel del Prado (1947—1948); the water-tank at the end of the Lerma aqueduct and the adjoining fountain, this last in painted sculpture (1951); also in painted sculpture, part of the exterior decoration of the stadium of the Ciudad Universitaria (1952—1954); a great mural executed in vitreous mosaic for the façade of the Teatro de los Insurgentes (Insurgents' Theatre 1953), and another great mural in fresco for the hospital of Zone No. 1 of the Seguro Social (Social Security), completed in 1954.

While Orozco and Rivera were expressing their genius in painting, their contemporary, Siqueiros, worked by posing a problem and looking for a solution. A political agitator by nature, Siqueiros has tried to be a revolutionary in every way. Influenced by synthetist and futurist styles, he delights in the bold use of foreshortening, linear projections and violent colours. His murals are dynamic, being composed on multiple axes and from multiple viewpoints. By combining angles and curves he tries always to convey the feeling of movement, of high tension in his groups and in his individual figures, both human and mechanical. Indeed many of them are so placed in order to be seen when walking past or even beneath his pictures. In his *Proletarian Burial* mural

for the Escuela Preparatoria Siqueiros established the characteristic human figure that was to appear in his later works. After his extraordinary mural for the Sindicato de Electricistas (Electricians' Union 1939), his most representative works are those for the former Aduana (Customs House building 1945); those in the Palacio de Bellas Artes (1945 and 1951); one in the Instituto Politécnico Nacional (National Polytechnic 1952); one in Hospital No. 1 of the Seguro Social (1952—1954); those in the Ciudad Universitaria (1952—1956), and one in the Centro Médico (Medical Centre 1958).

In the 1940s Rufino Tamayo (born 1899) made his appearance as a muralist. After painting the hall of the Museo de Antropología (Anthropological Museum 1930) and the staircase of the future Conservatorio Nacional de Música (National Conservatoire of Music 1933) with large simplified figures in the prevailing fashion, Tamayo adopted a highly individual style of painting that had hardly been suggested in his earlier works. This unmistakable semi-abstract style with its rich colours and cursive use of essential lines was established in the two great murals for the Palacio de Bellas Artes (1952—1953). Tamayo's most recent mural is the allegory of *The Cosmic Struggle between Good and Evil* painted for the new Anthropological Museum, in which he makes use of symbolic pre-Hispanic figures. In his easel painting he has shown how much a painter of talent can achieve by utilising the inherent beauty of colours and tones, using few lines and suggesting the metamorphoses of living beings.

The works which have been mentioned, and many others by other hands, provided decoration of considerable aesthetic quality for many buildings. The initial force of the Mexican muralist movement, however, decreased during the years of the second World War. The end of the war, the overthrow of Fascism and the greatly increased rate of national development provided new conditions, no longer heroic and incisive, and difficult to sense and understand in their effects on the present and future. Recent artistic achievements reflect these new circumstances. Nevertheless some artists have been able to escape prevailing tendencies towards a bureaucratized art or a merely decorative, repetitive and exhausted craftsmanship. The names of Juan

O'Gorman (born 1905), Jorge González Camarena (born 1908), Alfredo Zalce (born 1909) and José Chávez Morado (born 1909) are prominent in the present-day artistic world.

The sculptors of present day Mexico, freed from academic limitations by the Revolution, introduced forms based on a variety of concepts. Individual choice of subject and method of execution have resulted in some significant works. One indication of the prevailing anti-traditionalist and anti-academic climate was the foundation in 1927 of the Escuela de Talla Directa (School of Direct Carving) by Guillermo Ruiz (born 1896). This sculptor, an academician by training, made a gigantic statue of the Revolutionary Morelos for Janitzio, a lake island, (1935); and, among those of smaller size one of the heroine, Gertrudis Bocanegra, for the town of Pátzcuaro. Ruiz favoured "essential" and compact forms.

Ignacio Asúnsolo (born 1890), who had also had an academic training, has carried out such "essentialist" monumental sculptures as the allegories on the mausoleum of General Obregón. Juan Olaguíbel (born 1897) carved an equally simplified figure for his great statue of the insurgent hero *El Pipila*, which dominates the city of Guanajuato. *The Huntress*, on the other hand, which he cast in bronze for the fountain near Chapultepec, is academic in form. Luis Ortiz Monasterio (born 1909) whose work decorates the façade of the Escuela Nacional de Maestros and who also sculpted the group that forms El Monumento a La Madre, is another essentialist, but he handles volume with more feeling for formal analysis and explicit statement. Francisco Zúñiga, (born 1913), and Rodrigo Arenas Betancourt (born 1919), both display their somewhat idealistic styles in the sculpted groups in the Secretaría de Communicaciones y Obras Publicas. The sculptures on Hospital No.I of the Seguro Social and the fountain at the foot of the Torre de Ciencias (Tower of Science) in the Ciudad Universitaria are also the work of Betancourt. Jorge González Camarena and José Chávez Morado are notable sculptors as well as painters. Camarena shows the same feeling in sculpture as he does in his paint-ings which are based on physical masses. Examples of his sculpture stand at the entrance of the central offices of the Seguro Social. Morado sculpted the large frieze in relief that encircles the lecture hall block of the hospital of the Centro Médico. Expressionism is represented by the works of Matias Goeritz born in Germany in 1915. His religious works are outstanding, particularly that of the gigantic hand of the Creator over the apse of the church of San Lorenzo, which has recently been restored. Manuel Felguérez (born 1929), produces dynamic sculpture in iron and other media, somewhat in the futurist manner.

The past few years have been a period of economic and cultural development for Mexico and there has been a considerable increase in population. The spatial arts have been powerfully affected by the pressures of the modern world, in particular by advances in international communication and the impact of historical change. Even folk art has been affected since, inevitably, it has become more dependent on industry and tourism.

Artists are more sensitive and more aware of the currents and undercurrents of the age in which they live. The lyricism, humour and drama inherent in the human condition transcend naturalism, social allegory and the historical context. The artist seeks to communicate his vision to his fellows.

Vincente Rojo (born 1932) is an abstract lyrical painter, creating his effects by a brilliant mastery of space, colour and texture.

José Luis Cuevas (born 1934) conveys his highly individual sense of humour in line drawings and etchings portraying cynical beings, as much anthropomorphic as drawn from the bestiary.

Arnold Belkin (born 1930) is both a mural and an easel painter with an incisive feeling for drama.

These are but a few of the many artists working today, observing man in his triumphs and tribulations, each assessing and interpreting what he sees according to his vision.

CHRONOLOGICAL TABLE

HISTORICAL DATES	HISTORICAL EVENTS	DATES OF ARTISTIC ACHIEVEMENTS	ARTISTIC ACHIEVEMENTS
PRE-HISPANIC c. 10,000 BC c. 2,500 BC	Pleistocene era Beginning of primitive agriculture	10,000 BC (found 1870)	Carved bone, found at Tequixquiac
LOWER PRE-CLASSICAL 1800—1300 BC	Village husbandry		
MIDDLE PRE-CLASSICAL 1300—800 BC	Archaic settlements, among others, at Tlapacoya (Lake Texcoco), Copilco (Mexico DF)	1300—800 BC	Pottery and stone objects at Copilco Figurines, possibly Olmec, at Tlapacoya
UPPER PRE-CLASSICAL 800—200 BC	Archaic settlements at Cuicuilco (Mexico DF), Tlapacoya, Teotihuacán Period I, Monte Albán Period I, II, La Venta	800—200 BC	Beginning of monumental religious architecture at Cuicuilco Teotihuacán, one of the great cities of early Mexico: Period I ante-dates the pyramids Monte Albán I, site of classic Zapotec city. Monte Albán II, no essential changes, but refinement of some art forms

HISTORICAL DATES	HISTORICAL EVENTS	DATES OF ARTISTIC ACHIEVEMENTS	ARTISTIC ACHIEVEMENTS
EARLY CLASSICAL **200 BC—300 AD**	Teotihuacán II	200 BC	Early Maya architecture
			Teotihuacán Period II culminates in building of Temple of Quetzalcóatl
		162 AD	Tuxtla statuette, possibly of Olmec origin, and the earliest dated object
LATE CLASSICAL **300—800**			
Before 700	Destruction of Teotihuacán	300	Beginnings of Maya cult of dated steles
	Monte Albán III	400—500	Teotihuacán III. Building of Palace of Quetzalpapalotl
c. 700	Early Nahua tribes appear in Central Mexico	683	Funerary chamber at Palenque
		692	Mural paintings of Bonampak
		c. 700	Pelota courts first constructed
EARLY POST-CLASSICAL **800—1200**			
c. 800	Rise to importance of Xochicalco	889	Stele at Uaxactún, last datable record of Mayan culture
c. 856	Foundation of Tula, ceremonial centre	c. 1007	Building of Uxmal
c. 1000	Appearance of Toltecs at Chichén Itzá	1168	Fall of Tula
c. 1200	Foundation of Tenayuca Beginnings of Mitla	c. 1200	Codices, jewellery
LATE POST-CLASSICAL **1200—1521**			
1370	Foundation of Tenochtitlán, site of modern Mexico City	c. 1370	Aztec architecture, sculpture, jewellery, featherwork
c. 1450	Uxmal abandoned		
1502—1520	Reign of Moctezuma II		
1520—1521	Last Mexican Kings, Cuitláhuac and Cuauhtemoc		
1521: 13 August	Tenochtitlán taken by Hernan Cortes		

HISTORICAL DATES	HISTORICAL EVENTS	DATES OF ARTISTIC ACHIEVEMENTS	ARTISTIC ACHIEVEMENTS
COLONIAL			
1519—1521	Spanish conquest by armies of Hernan Cortes	1522	New city, Mexico-Tenochtitlán, planned
1523—1524	Arrival of fifteen Franciscan lay brothers, first missionaries	1539	Introduction of printing
1526—1533	Arrival of Dominican and Augustinian missionaries	c. 1540—1580	Monastic missionary buildings, combined Gothic, Mudéjar and Renaissance
1535	Antonio de Mendoza appointed first Viceroy of New Spain	1555	Inauguration of Universidad Real (Royal University)
		c. 1560—1700	Baroque, Cathedrals
		1718— c. 1800	Churrigueresque. Mansions and many parish churches
		1781	Foundation of Real Academia de Bellas Artes de San Carlos
		1783— c. 1900	Neo-Classical
INDEPENDENCE			
1810: 16 September	War of Independence begun by Hidalgo		In architecture, period of transition from Colonial to cosmopolitan
			In painting, Academic-Romantic. Landscape and portrait: Velasco, Estrada, Bustos
1821	Juan O'Donojú, last Spanish governor		
1821	Independence achieved		
1862	Invasion by army of Napoleon III		
1910: 20 November	Outbreak of Revolution against dictatorial regime of General Porfirio Díaz	1922	Mural paintings on public buildings: Rivera, Orozco, Siqueiros, Tamayo
1917	Governments based on tenets of Mexican Revolution	From c. 1947	Scope for modern architecture in planning new suburbs and public buildings: O'Gorman, Candela, Pani

NOTES ON THE PLATES

1 Head of a Coyote.
Tequixquial, Mexico state. About 12,000 BC.

The oldest known Mexican sculpture, contemporary with the Pleistocene fauna. The resemblance to the head of a coyote was suggested by the original shape of the bone from which it was carved, the sacrum of an extinct species of llama. The effect was achieved by cutting, filing and piercing. This piece was found near Mexico City, at a depth of 40 ft (12 metres) and was about 12,000 years old, but it has since been lost.

2 Human Figurines of Olmec Style.
Tlapacoya, Mexico state. 1300—800 BC. Private collection.

The ancient and well defined cultural system known to present day archaeology as Olmec has various branches throughout Central America. The population to which it belongs left many examples of its artistic production, chiefly in the form of sculptures which reflect its ethnic features and ideology. The sculptures classed as Olmec mark stages in an evolution from archaism to mastery. These archaic figurines were excavated in the region of Tlapacoya, the site of a waterside village on Lake Texcoco. Some of them are of the type called "pretty girls", charming nude or semi nude statuettes with thick legs; some are smiling and their simple grace is enhanced by elaborate head-dresses.

3 Olmec Figures from Tlapacoya.
Tlapacoya, Mexico state. 1300—800 BC. Private collection.

Olmecs of high rank used penis-covers, or wore skirts secured by a belt or sash, short cloaks knotted round the neck, and belts with buckles or plaques and ornaments of fine quality. Ornaments included round or tubular ear pieces of clay, bone or stone, and earrings, bracelets and other objects, generally of semi-precious stone, chiefly jade. These were among the many objects found in the cemetery of Tlapacoya. Olmec burial customs appear to have been extremely elaborate, including sacrifices of human beings and of dogs.

4 Archaic Ex Votos.
Cuicuilco, Mexico D.F. 800—200 BC. Private collection.

Many human burials in association with receptacles and figurines have been found around the ceremonial centre of Cuicuilco. Though rudimentary in technique, the figurines portray persons from real life in various attitudes and costumes. The receptacles are still very simple.

5 Duck Bowl.
Tlatilco, Mexico state. 1300—800 BC. Private collection.

A supposed Olmec colony in the present day region of Tlatilco, west of the lake basin of Mexico, left traces in the form of numerous burials with ceramic offerings. Anthropomorphic and zoomorphic figures have been found with human remains, as well as pieces like this bowl in the form of a small duck. These demonstrate the association of ideas characteristic of the Central American mentality.

6 Twin Dogs.
Colima state. 800—200 BC (?). Private collection.

In the Colima region great numbers of clay figures for funerary uses have been found. Their expression is direct, both in form and purpose, from the earliest and crudest to the most perfect. One of several styles followed by these craftsmen was to give their receptacles the shapes of living creatures. This led to the production of rotund figures in botanical, animal and human forms. These puppyishly playful twin dogs are examples of hollow effigies evolved from bowls. The conversion of bowl into hollow figure marks the perfection of the third and final phase of this creative current. This is one of the finest achievements of the Colima potters.

7 Talus Stages of The Temple-Base at Cuicuilco.
Cuicuilco, Mexico City, D.F. 800—200 BC.

Near the foothills of the Ajusco range, on the edge of the dried out lake bed of the valley of Mexico, a group of villagers

who worshipped the sun-god, erected a temple on a platform. This finally consisted of four conical stepped stages with a flight of steps giving access from the east and a ramp or *talus* on the opposite face. After the addition of three superstructures to the original monument, the base in its final form measured 453 ft (135 metres) in diameter and was 26 ft 3 ins (8 metres) high. A volcanic eruption caused a lava flow which surrounded the monument and scorched the locality. The *talus* steps to be seen today correspond to the third superstructure on the archaic base. This shows that the builders understood the natural angle of descent of piled material and adopted it for their retaining-wall.

8 Stylised Jaguar Mask.

La Venta, Tabasco state. 800—200 BC. Park of La Venta, Villahermosa, Tabasco.

Deep in the ground in two different parts of the ceremonial centre of La Venta, the Olmecs laid geometrically stylized jaguar masks in the form of floors made of serpentine flagstones. They covered them with earth, on which they laid offerings of figurines carved in hard stone. The mask illustrated is composed of 498 small slabs. By creating and then burying these masks, the Olmecs endowed the place with an aura of sacred mystery, which was perhaps associated with their desire to ensure the eternal renewal of life.

9 Altar of the Victorious Warrior.

La Venta, Tabasco state. 800—200 BC. Height 5 ft 10 in (1.80 metres) approximately. Park of La Venta, Villahermosa, Tabasco.

One of the monolithic altars carved for the cultural centre of La Venta was dedicated to a victorious soldier. His solemn figure, seated in the Olmec manner, emerges from a niche almost naked but with a plume or leaf-covered helmet, a collar in the form of a serpent and a pectoral indented as if to accommodate a jade plate. In his right hand he grasps a rope, in his left a dagger. The rope runs to either side of the altar and appears to bind two conquered captives. The niche is framed by lines denoting bands of earth and vegetation. On the upper edge of the altar can be seen a jaguar mask with open jaws, showing between the fangs two crossed bars, the symbol of movement.

Another, very similar altar was found at San Lorenzo, Tenochtitlán, Vera Cruz. It is interesting to note that the Maya also carved huge altars, using this same device of a human figure ensconced in a niche. This seems to lend support to the theory that the Maya inherited the Olmec culture.

10 Enclosure of Basalt Pillars.

La Venta, Tabasco state. 800—200 BC. Park of La Venta, Villahermosa, Tabasco.

At La Venta, on an island near the mouth of the Tonalá river, the Olmecs built a ceremonial centre of indifferent architecture, but with fine monuments and remarkable offertory objects buried in the ground. The ceremonial centre comprises two architectural groups, the more important of which contained a quadrangle surrounded by cylindrical basalt pillars, transported from the distant region of Las Tuxtlas. The quadrangle has a single entrance and a small enclosure on each side. One of these is roofed by horizontal cylinders like a sealed cell, which is often a feature of these sacred places. The reconstructed cell in the park of La Venta is shown here.

11 Olmec Head.

La Venta, Tabasco state. 800—200 BC. Park of La Venta, Villahermosa, Tabasco.

Many large male heads have been discovered in the Olmec regions of Tabasco and Vera Cruz. They may have played a part in the ritual systems for attracting the rain by offering sacrifices consecrated by decapitation. These heads, like the altars, were placed directly on the earth, and seemed to spring out of it. Prominent cheekbones, a short nose and thick mouth are characteristic features of these heads. A helmet which follows the spherical shape of these monoliths covers the hair. The faces are generally severe and ecstatic; a few are smiling.

12 Small Seated Statue.

Cerro de las Mesas, Veracruz state. 300—800 AD. Instituto Nacional de Antropología e Historia, Mexico City.

The Olmecs inhabiting the lowlands to the south-east of the Gulf of Mexico applied their great talent to carving figures from small and large stones and to making them in clay. This small figure, stained a funerary red with cinnabar, has a mirror of magnetite fixed to its chest. It is one of the numerous masterpieces of the Olmec sculptors. Carved in jade, it represents a woman with an ecstatic expression, the body carved without much detail. It was an offering related to the cult of the dead, and the mirror signified what was most precious: the heart, movement or life.

13 Olmec Dwarf and Maya Glyph.

Cerro de la Mesas, Veracruz state. 300—800 AD. Instituto Nacional de Antropología e Historia, Mexico City.

This small jade figure of a weeping dwarf or child (whose tears are to attract the gift of rain) is carved in the Olmec

anthropomorphic convention. The figure stands out against a Maya glyph modelled in stucco. This juxtaposition shows the Olmec influence on all other Central American cultures, among which the Maya was outstanding.

14 Neck of Olmec Urn.
Catemaco, Veracruz state. 300—800 AD. Jalapa Museum.

This is the neck of a spherical shaped urn, faced by the mask of an old man who may represent the ancient fire-god, the sun in the underworld. The mask has incrustations between the brows and also on the cheeks. The breadth and relief of the brows are typically Olmec, so are the short aquiline nose, the long moustache and the thin beard. The half open mouth shows a feline expression and the eyes seem to flash lightning. The mask recalls those of the lords of hell in the mythology of South East Asia.

15 The Jaguar God.
Jalapa Museum, Veracruz state. 300—800 AD.

It was the native custom to represent ideas in the form of living creatures. The Olmecs portrayed the god of earth, rain and fertility in the form of a jaguar, a beast which was common in the tropical region of the Gulf of Mexico. This stone sculpture represents him with tremendous realism, exalting the strength of the seated beast in the act of roaring. It is no mere imitation of nature. The symbolic columns or torrents falling from his jaws emphasize the strength and menacing appearance of the deified animal. Its origin is unknown.
This feline deity appears in many and varied forms, always powerful, but some with greatier emphasis on the anthropomorphic aspects.

16 Altar of the Dwarfs.
Portrero Nuevo. Veracruz state. 300—800 AD. Jalapa Museum.

This is an Olmec altar with two dwarfs supporting the upper edge. They are typically Olmec in physique and wear only loin-cloths and head-dresses. The head-dresses show clearly the characteristic hair style, like a wig, cut close to the skull and with strongly carved vertical lines.

17 Chief with Diadem.
La Cruz del Milagro. Veracruz state. 300—800 AD. Jalapa Museum.

The full dignity of a native chief is reflected in this seated statue of a young Olmec, shown almost entirely naked and in the act of speaking.

18 Head of a Young Maya.
Palenque, Chiapas state. About 683 AD. Instituto Nacional de Antropología e Historia, Mexico City.

This superb stucco head of a young man was one of the offerings laid in the funeral chamber in the crypt of the Temple of Inscriptions at Palenque, the most sumptuous so far discovered in Central America. It was removed from a statue and laid beside the sarcophagus. This head is a classical work in the refined, naturalistic Palenque style. The young man appears to be softly intoning a chant in the manner of an officiant in propitiatory rites intended, first, for the fertility of the fields, but ultimately for the rebirth and maintenance of all life. The nose has a superimposed plaque, which runs up into the forehead; the ears are pierced to take threads which hang down as tassels; the forehead is deformed and flattened according to a practice traditional since the Olmecs. The beautiful head dress appears to be of maize leaves, cotton and flowers. A plume sweeping forward from it aesthetically counter-balances the deformed forehead.

19 The Temple of Inscriptions.
Palenque, Chiapas state. 683 AD.

The Temple of Inscriptions is similar to many Mayan temples. The lower part is often solid, but here there is a flight of steps which was blocked up when found. When cleared it was found that the steps led to a magnificent funeral chamber containing a sepulchre surrounded by highly dramatic liturgical objects relating to vegetable fecundity and hope in life itself. The dead person must have attracted good, like a talisman. On the walls of the Chamber were modelled the figures of nine splendidly dressed priests, carrying the sceptres and emblems of the gods of sun and rain. There were other sculpted priestly figures on the exterior face of the sepulchre, carrying plants and their fruits. The sarcophagus was sealed with a stone rather more than eight square metres in area, covered with low reliefs of glyphs and figures. The central motif of the stone is a youth who appears to be reclining on a throne consisting of the terrestrial symbols of death and fecundity. The Mayan youth has a sacred maize plant, sacred because from its seeds the gods made the paste from which they created men.

20 The Panel of the Slaves (fragment).
Palenque, Chiapas state. 730 AD.

This is a masterpiece of Mayan sculpture. The central figure is in the act of receiving offerings from a man and a woman seated on either side of him. He reclines on two slaves of another race. The dignitary is gravely accepting the offering of a diadem crowned with a bunch of feathers from Quetzal.

21 A Mayan Lord (detail).
Palenque, Chiapas state. 730 AD.

The detail of the gravestone, known as the panel of the Slaves, shows the naturalism of the art of Palenque in representing the human figure. The nose seems to have been modified by a piece of precious stone which corrects the natural curve and has made this part of the face straight. The figure is a "Lord of Men" who appears to have been depicted in the moment of accepting offerings which single him out as a chief. His facial adornment is made up of ear-flaps and rings of jade, and he wears a diadem. Here one can see the skull deformation which denoted social rank.

22, 23 Façade of the Codz-Pop Building.
Kabáh, Yucatán state. 800—1200 AD.

The ornamental fashion of stylized masks of the rain-god reached its maximum expression in this palace façade. Here the cult of Chac appears at its most obsessive, closely patterned and pervasive. Mask after mask, line after line, leaves no part of the front wall uncovered. The god's huge nose, open jaws and ear-pieces are repeated more than 250 times in seven horizontal bands.

24 The Nuns' Quadrangle.
Uxmal, Yucatán state. 600—1000 AD.

The ceremonial centre of Uxmal is made up of numerous buildings, many of them distributed in quadrangles. The Nuns' Quadrangle has been partially restored so that the magnificence of its design can be more readily appreciated. The structure on the north side is on a higher level than the others. The friezes are exceptionally fine, representing houses surrounded by masks of the rain-god. Other friezes project from the top of the building.
The Maya excelled in architecture and these buildings, collectively known as Las Monjas (the Nuns' Quadrangle) confirm this.

25 Arch of the Nuns' Quadrangle.
Uxmal, Yucatán state. 800—1200 AD.

The ceremonial centre of Uxmal illustrates the urban architectonic and decorative ideas of the north of the Yucatán peninsula. Through a monumental arch cut in the centre of the south wall of the Nuns' Quadrangle a ruined ball-court can be seen, with the Governor's Palace in the background. The structure of the arch, which is clear in the picture, is characteristically Maya. It is built of projecting stones supported by heavy walls. At the top, on either side of the corbel, a string of horizontal slabs is applied to them, completing the arch.

26 Reliefs in the Nuns' Quadrangle.
Uxmal, Yucatán state. 800—1200 AD.

The Maya of northern Yucatán developed many decorative styles, employing rather small pieces of stone which they cut and set in the walls forming, in relief, the details of the figures and objects they wished to portray. As can be seen from the façades of the Nuns' Quadrangle the prevailing style at Uxmal was intricate. The corner of the south building is shown on the right and that of the east building on the left. The façade of the walls is smooth; but the part corresponding to the vaults is decorated with *atadura* (rope-like) mouldings, from the ends of which fall heads with reptilian features, very unlike the Maya style (that on the right is very rough), masks of the large nosed rain-god with his square ear-pieces with feathers behind them. The motif of the toothed lattice, is perhaps suggestive of lightning; bands of half-cylinders and, on the left-hand panel, the jutting figure of a bird with a human face emerging from his open beak. This, according to Eduard Seler, may be the image of the young god of the maize, of life and of music.

27 Temple of the Warriors.
Chichén Itzá, Yucatán state. 800—1200 AD.

This supreme work of pre-Hispanic architecture unites the construction systems and sculptural forms of Toltec and Maya. It reproduces the temple of Tlahuizcalpantecuhtli at Tula. On emigrating from Central Mexico to Yucatán and seizing Chichén Itzá at the end of the eleventh century, the Toltecs re-created on a larger scale the military and theoretic institutions of their former capital. This magnificent ceremonial monument combines a lower portico with a temple on a base of five stepped terraces. There are also lines of Toltec columns, once crowned, as can be seen from the ruins, with Maya vaulting. The walls and pillars present reliefs of both traditions. Chac, the Maya rain-god, and the Toltec "Lord of the Dawn" appear on the walls and Toltec warriors on the pillars.

28 Entrance to the Temple of the Warriors.
Chichén Itzá, Yucatán state. 800—1200 AD.

The great temple of the Toltec warriors was dedicated to the "Lord of the Dawn" (the planet Venus rising before the sun). Parts of the ceremonial hall are still standing. The entrance is flanked by two serpent columns, in the form of rattlesnakes carrying a flat moulding, which once supported the lintel. Inside, the roof is supported by square-cut pillars with polychrome reliefs of military chieftains. At the back there are still the remains of a platform or throne in the form of a slab supported by small statues of warriors. In the foreground

is a Chacmool, a reclining man, who is the supernatural bearer of offerings to the gods of heaven.

29, 30 The Caracol.
Chichén Itzá, Yucatán state. 800—1200 AD.

This circular tower is an example of Toltec-Maya architecture. It rests on two rectangular terraces and has an inner spiral staircase leading to a small room, the upper part of which was constructed for celestial observations. In the part of the building that is preserved, there is an entrance, as well as two holes in the thick masonry wall. The purpose of these has been established: through one the Maya astronomers could determine the moment of the equinox by observing from the opposite interior and exterior angles the passages of the sun and moon at sunset; and through the other, the geographical south.

31 Great Pelota Court.
Chichén Itzá, Yucatán state. 800—1200 AD.

The great Pelota court at Chichén Itzá is the largest known and reconstructed in Central America. The field of play, overlooked from one side, is I-shaped and bounded by vertical walls along which the rubber ball had to be passed by the participants in the rite here celebrated. Putting the ball through a stone ring set in the wall at a height of 18 feet symbolized the passage of the sun to or from the underworld. On the benches beneath the rings the Toltecs sculpted panels representing the mysteries of the rite, which is thought to have culminated in the sacrifice of the warrior who succeeded in passing the ball through the ring. On the eastern wall or platform can be seen the building now called the Temple of the Jaguars. Its structure and decoration combine those of the Tlahuizcalpantecuhtli at Tula with the analogous Temple of the Warriors at Chichén itself. At the back is the ruined Northern temple with the Maya vault generally found in Toltec buildings in this region. Both temples contain remains of pictorial decorations which are invaluable for the light they throw on contemporary life. The pelota court is 334 feet (168 metres) long and about 120 feet (36 metres) wide.

32 The Castillo viewed from the Temple of Venus.
Chichén Itzá, Yucatán state. 800—1200 AD.

The majestic Toltec temple called the Castillo commands the plain of Yucatán and the buildings which were successively erected in its neighbourhood by the Maya, the Toltecs and the Mexica. Viewed from one side of the platform called the Temple of Venus, also Toltec, the Castillo displays its nine stepped terraces together with one of its four stairways and the serpentine supports at its base. The temple on the top has its entrance flanked by two columns, also in the form of snakes, as in other Toltec temples.

33 A "Tzompantli" in Yucatán.
Chichén Itzá, Yucatán state. 1200—1521.

The *tzompantli* or skull-platform formed part of the ritual buildings of the Mexica. When this warrior people occupied Chichén Itzá they left, as a sign of their occupation, this huge platform, the only one of its kind still standing. It served as a base for poles which transfixed the skulls of sacrificed persons. The way in which they were arranged is illustrated on the walls of the platform. Bernal Díaz del Castillo, the *conquistador* who himself saw the *tzompantli* standing at Tlatelolco (which was like that in the Mexica capital of Tenochtitlán), described it as "full of skulls and large bones, so numerous that you could not count them. The skulls were in one place, and the bones in separate piles".

34 "Palm" with Hands.
El Sabino, Veracruz state. 500—900 AD. Jalapa Museum.

The artistic imagination of the Central American could be as fully expressed in a few lines as in sculptures loaded with detail. In this example of a "palm" carved as a Totonac funerary object, the hands may be associated with those offered by a warrior in the rite of mutilation practised throughout the area.

35 Votive "Axe".
500—900 AD. Instituto Nacional de Antropología e Historia, Mexico City.

The Totonacs made delicate sculptures of different stones—basalt, andesite, diorite and serpentine—for funerary purposes. These include "yokes", "palms", "axes" and "padlocks", all named according to their shapes. These objects were skilfully decorated with anthropomorphic or animal figures. The sculpture illustrated is an "axec", with a human head, covered with a head-dress or bird emblem, exactly conforming to the shape of the ritual object. "Axe" are of Olmec origin, and the Totonacs continued to carve them in increasingly refined forms. Its origin is unknown.

36 Woman in Childbirth.
Remojadas, Veracruz state. 500—900 AD. Jalapa Museum.

Cihuateteo or "valiant" women were those who died in childbirth. These Totonac figures in hollowed clay were funeral offerings. This little figure reflects the juvenile beauty of a

dead woman, exaggerated by the semi-circular spread of her *quechquemitl* or cloak, on which she wears a necklace of thread and precious stones. Her head-dress appears to be a fringed bonnet from which her hair falls in locks. The fringes are indicated by the modelling and by black resinous paint. The teeth are filed according to the Totonac custom.

37 Woman in Childbirth.
Dicha Tuerta, Veracruz state. 500—900 AD. Jalapa Museum.

This is another version of the "valiant" women who die in childbirth. They were supposed to accompany the sun each evening in his setting and to sing, dance and imitate the actions of war.

38 Funerary Figure.
Remojadas, Veracruz state. 500—900 AD. Private collection.

The Totonacs are also remarkable for their modelling in clay. Although produced under an intensely compelling religious influence, their terracottas convey a strong feeling for human life, and so reveal social customs. This piece shows a dead man lying shrouded on his bed. His face has the smiling and corpse-like expression of a traveller on the long road to the under-world. The pre-Hispanic custom was to prepare corpses for mummification and burning, although in some cases there was merely a funerary interment of the remains. Possibly this figure records the last moment of the dead man's existence in the bodily state.

39 Pyramid of the Niches.
Tajín, Veracruz state. 600—700 AD.

The great ceremonial centre of Tajín, situated in northern Totonacapan, is one of the few sites that attracted the attention of students of Mexican "antiquities" from the seventeenth to the nineteenth centuries. Among the ruins which had deteriorated into shapeless mounds covered by tropical vegetation, the platform called the Temple of the Niches stood out boldly. At present it can be seen cleared of vegetation and partially reconstructed. It stands in front of the ceremonial platform, and near it are the platforms of other temples and a ball court. These form a variegated architectural group. The pyramid consists of six terraces with part of the temple wall still standing on the top. It is ornamented with niches on all sides to the calendar number of 365.
The broad stairway that leads to the upper part appears to be interrupted by a series of plinths, and on the balustrade can be seen the "hook and step" pattern called *xicalcoliuhque* in the Nahua language.

40 Platform of Buildings.
Tajín, Veracruz state. 600—700 AD.

Near the "niched" pyramid stands this triple platform built on a rectangular plan. The top and bottom members have typical Tajín niches and cornices. Between the two staircases leading from the first, stands the figure of a deity, perhaps representing Quetzalcóatl (the planet Venus), carved from a cube on a triangular base. The figure is anthropomorphic and fleshless, with one arm raised and the other clasped to the chest. The volute forms covering it are typical of the sculpture of the region.

41 Warrior Chiefs from the Temple of the Columns.
The Tajín Chico Group, Tajín, Veracruz state. 1000—1100 AD.

The temple of the columns stands out among the buildings of the ceremonial centre of Tajín, as a very high platform once crowned by a temple in front of which stood a portico of six thick columns entirely covered with reliefs. To judge by the remains which can be seen of the completely disrupted drums, they contained a priceless record of the religious and civil life at a period in which Toltec influences were making themselves felt in Tajín. These two warrior chiefs of different races and facial characteristics appear to be engaged in conversation.
El Tajín Chico, which means Little Chico, is one of the two sections which formed the magnificent ceremonial centre of the ruined city. Tajín Chico is composed mainly of small palaces built on low terraced platforms.

42 Reliefs on the Small Pelota Court.
The Tajín Chico Group, Tajín, Veracruz state. 900—1100 AD.

This ball court is enclosed by two vertical walls of large stone blocks, along which run friezes of sculpture with religious motifs. At either end and in the middle are panels with ritual scenes. These reliefs are in the classical style of Tajín, characterized by their naturalistic design and the occurrence of the volute (cloud) motif. On the upper edge is seen the image of the sun rising among clouds, with claws in place of hands—these associate him with the night monster—and the mask and divided tongue of the rain-god, which indicate a troubled dawn on a stormy day. In the panel appears a figure in grand apparel, seated as a sign of eminence. In his hand he carries a shield with the sign "movement" and between his legs, as skirt pieces, two interlaced snakes whose tails end in the zone of the lower volutes. These snakes in isolation would be a symbol of the heavenly powers, perhaps the rain and lightning.

43 Bearded "Dancer".
Monte Albán, Oaxaca state. 200—100 BC.

The figures known today as "dancers", carved on stones of various sizes and found in different parts of the Zapotec ceremonial centre of Monte Albán, are the work of the ancient Olmecs, the primitive occupants of the place. These may have served to mark a sacred zone and were associated with the rite of sexual mutilation, since only one of these numerous naked figures appears physically intact. The two male physical types portrayed are those common to Olmec sculpture: one, with beardless face, short nose, large cheekbones, and a tendency towards obesity; the other, long limbed with aquiline nose. The first type appears often, the second seldom. This may perhaps suggest two different classes.

44 The Building of the Flooded Patio.
Monte Albán, Oaxaca state. About 200 AD.

This stands to the north of the great plateau of Monte Albán. The palace is a platform twelve metres high, ranged round a rectangular patio, reached by a broad flight of steps flanked by a large balustrade. The way to the flooded patio lay through a vestibule, the ceiling of which was held up by six columns and two solid blocks of rough hewn stone. The patio has a small platform for dances. Behind and on both sides of this building are a number of ruined buildings which belonged to a group of temples.

45 Terracotta Jaguar.
Monte Albán, Oaxaca state. 300—800 AD.

The most important influence on Zapotec culture was that of the Olmecs, who worshipped the jaguar, which the Zapotecs therefore adopted as a symbol and badge of honour. This model of baked clay is one of many realistic portraits of this animal. The collar shows that he was worshipped alive and in captivity.

46 Zapotec Urn.
Monte Albán, Oaxaca state. 300—800 AD.

In Monte Albán III, the Zapotecs celebrated a cult of the dead, whom they buried in monumental tombs built around the flat hill-top on which the great sanctuary stood. Among the funerary offerings were clay urns of cylindrical form, on the front of which appeared a face or complete human figure in the apparel of the deceased. The oldest show an Olmec influence which was disappearing during Monte Albán III. The urn illustrated represents a figure richly attired in a fringed skirt, necklaces and earrings. His head-dress bears the masks

of an eagle and jaguar, a plume and leaves. He preserves the slit eyes and "tigerish" expression of the mouth, which are Olmec in origin. This figure is related to the maize-god.

47, 48 Walls at Mitla.
Mitla, Oaxaca state. About 1200 AD.

Mitla was a Zapotec religious centre, the residence of the Uijatao, the highest order of their priesthood. It consists of five groups of buildings arranged around rectangular courts: the smaller were intended as temples, the larger as habitations and covered assembly halls. The basements of some of the former had funerary crypts. The architects of Mitla combined the system of courts surrounded by rooms (which can be seen in the magnificent Maya centre at Uxmal), ornamental frieze and pendent as used by the Zapotecs themselves at Monte Albán, and panels covered with the "hook and step" key dear to the builders of Teotihuacán, Tajín and various Maya ceremonial centres, particularly in the Yuacatecan region of Puuc. In Mitla this last was practised with a wealth of variations, as can be seen in the differences between one panel and another of the façades.

49 Court of the Palace of Quetzalpapalotl.
Teotihuacán, Mexico state. 400—500 AD.

As a result of the last restoration works at Teotihuacán, the courts, passages, chambers, porticoes and temples lying behind Building 5, to the west of the court of the Moon, can now be seen. The buildings discovered and reconstructed belong to the former residential zone of the priesthood. Here the buildings were superimposed on older ones. The most remarkable is the Palace of Quetzalpapalotl, which was placed above the temple of the "Plumed Caracols". It belongs to Teotihuacán III, and consists of a regular court surrounded by passages, from which open the chambers, arranged in the form of a Greek cross; a pattern typical of Teotihuacán. The illustration shows the north side of the court, with pillars, cornice and finials. The finials represent the sign of the year.

50 Pillars of the Court of the Palace of Quetzalpapalotl.
Teotihuacán, Mexico state. 400—500 AD.

The pillars facing the palace courtyard present figures of the quetzal butterfly, full-face and profile, in flat relief. Each figure fills the central part of one of the three ornamented faces of the pillar. Between them are bands of circles denoting the stars, volutes denoting the clouds and, at the extreme top and bottom, strings of feathers.

51 Funerary Mask Decorated with Turquoise, Coral and Shell.
Tlapa, Guerrero state. 160—650 AD.

The funerary masks of Teotihuacán were carved in hard stone and occasionally covered with semi-precious materials. The carving is masterly, capturing the noblest features of the people in a state of hieratic exaltation. The incrustation of this mask, which was found at a great distance from Teotihuacán, somewhat mars the perfection of its sculpture, but gives it a ceremonial dignity. There is a vizor attached to the nose and a plant sign, which may be maize, on the forehead.

52 Teotihuacán, from the Pyramid of the Moon.
Teotihuacán, Mexico state. 100 BC—650 AD.

The top of the structure known as the Pyramid of the Moon commands a view of the whole architectural plan of this sacred centre. In the foreground, the court of the temple, which stood on the pyramid top, is surrounded by small platforms on which stood other temples. From here springs the straight Street of the Dead, along which lie other temple bases and platforms. To the left is the gigantic Pyramid of the Sun, and in the background is the Ciudadela.

53 Head of the Plumed Serpent.
Teotihuacán, Mexico state. 150—450 AD.

The heads that adorn the balustrade of the building are similar to those that stand out in the panels of the temple of Quetzalcóatl. The representation of the plumed serpent corresponds to the water that is on the earth, whereas the mask of the god Tláloc alludes to the god of rain.

54 Base of the Temple of Quetzalcóatl.
Teotihuacán, Mexico state. 140—450 AD.

In the middle of the square known as the Ciudadela stands the front portion of a temple platform. On the evidence of its sculptures, this temple is thought to have been dedicated to the plumed serpent god, subsequently known as Quetzalcóatl. This base consisted of five stepped terraces, constructed on the *talus* and *tablero* (ramp and panel) system. The wave-like ornamentation is of undulant plumed serpents (whose heads project at right angles), alternating with masks of the rain-god. Among the decorations can be seen caracol and shell forms. The staircase balustrades also show heads of plumed serpents spaced regularly along their length. These figures relate to the cult of rain and fertility. The temple was built during Teotihuacán II, but the platform itself belongs to the third epoch.

55 Pelota Court.
Xochicalco, Morelos state. 700—800 AD (?).

The ceremonial centre of Xochicalco has a large pelota court on an I-plan, 229 feet (69 metres) long and surrounded by platforms. The central part, on which the rite was performed, has an inclined platform on either side raised above ground level and sloping up to the boundary wall. In the middle of the field, at the point where the inclined planes meet the wall, are the stone rings through which the ball had to be passed. The court is like those in the Maya area, a fact which confirms the theory of Maya influence on this Central Mexican site. These buildings are thought to have served as models for those erected by the Toltecs at their capital, Tula.

56 Main Pyramid (Restored).
Xochicalco, Morelos state. 700—800 AD.

In the Lake basin of the present state of Morelos, a hill was levelled to form a series of platforms on which was constructed a ceremonial group of buildings. On the principal terrace stood a temple of peculiar importance, both for its architecture, which somewhat recalls Tajín, and for its reliefs, which completely covered the façades of the temple and its base. It must have commemorated a particular event, perhaps a correction of the calendar, for which personages assembled from different places.
The most arresting feature of this document in stone, is a gigantic serpent which is repeated twice on each of the four sides of the platform *talus*. With its long quetzal feathers and reduced caracols, it probably represented the powers of wind and water. Two kinds of figure appear between the serpent's undulations: the hieroglyphic of fire, and priests sitting as if in conversation. Along the *talus* is a frieze divided into panels containing the figures of other personages of less importance, to judge by their apparel. They are, however, accompanied by their names in hieroglyphics, and the rod of speech protrudes from their mouths. These façades are trimmed by a cornice of reduced caracols.

57 Atlantean Columns of the Temple of Tlahuizcalpantecuhtli.
Tula, Hidalgo state. 856—1168 AD.

The ceremonial centre of Tula contains an exceptional building, now known as the House of Tlahuizcalpantecuhtli (the Lord of Dawn), which consists of a lower portico, and a hall resting on a platform of five terraces. The hall was a sumptuous sacred apartment, with a single entrance flanked by two columns in the form of plumed serpents, with their heads to the ground and their rattles outlined against the cornice. The roof of the hall was supported inside by two files of columns,

the back row square-cut with reliefs of warriors, and the front row anthropomorphic in the form of warriors of the Sun in magnificent ritual apparel. At the back of the chamber was a seat of honour in the form of a bench supported by small figures of warriors. This temple is thought to have been earlier than the Temple of the Warriors (plate 27), also built by the Toltecs, after their migration to Chichén Itzá.

58 Eagle Cup in the Shape of the God Tláloc.
Tula, Hidalgo state. 856—1168 AD. Instituto Nacional de Antropología e Historia. Mexico City.

A *cuauhxicalli* or "eagle-cup" received the hearts and blood of the sacrificed warriors, taken as sustenance for the sun. This is similar to dishes on which offerings were carried to the temples. According to custom among the Toltecs, this vessel rests on the abdomen of a man who carries it as a messenger of the gods. Some of these receptacles were very large, being carved like fonts out of single stones. Others appear as vessels resting on the bellies of reclining statues known as Chacmool. The bearer of this dish of hearts takes the form of Tláloc the rain-god, whom the sculptors represented with his characteristic mask with bared teeth and protruding fangs. He is shown splendidly bedecked in precious feathers and jewelled earrings, necklaces, pectoral, bracelets and anklets. On his sandals can be seen the oval obsidian knives used for sacrifices.

59 Small Statue of Coatlicue.
Mexico, D.F. About 1400 AD. Instituto Nacional de Antropología e Historia. Mexico City.

Mexica mythology assigned a primary role to Coatlicue, the goddess with the "skirt of snakes". She was the mother of the countless warriors, who are the stars, and of Coyolxauhqui, the moon. After them, she magically conceived the sun god Huitzilopochtli, who encountered the hostility of his elder brothers and sister and fought and conquered them. He cut off Coyolxauhqui's head with the lightning. Coatlicue was endowed with many attributes as befits a complex and terrible personage. But in this statue she appears only as a woman with a skull for face and claws for hands. In this and other more complicated forms, she represented the dreadful goddess of earth and primal generation, who was also the destroyer. She lies in wait for one and all. "The whole earth is a tomb and nothing escapes it, nothing is so perfect that it does not fall and vanish..." (Poem of Netzahualcoyotl).
The symbolism of Coatlicue, in the various forms in which she is portrayed, is highly complex: an eagle indicates the sun, the skirt of snakes signifies mortal life, the necklace of hands and hearts refers to human sacrifice, and the two rattlesnake heads emerging from her neck symbolise the

duality of masculine and feminine. On her back appears a reference to her son, Huitzilopochtli, who is also the god of war.

60 Small Coyote's Head and Warrior's Face.
Tula, Hidalgo state. Instituto Nacional de Antropología e Historia. Mexico City.

A jewel formed of a mosaic of mother of pearl laid on stone. This is a semi-realistic model of a warrior's face with a coyote's head for helmet. In Tula the coyote was the equivalent of the jaguar formerly worshipped in Central America.

61 Onyx Vessel with Monkey.
Huastec region of Veracruz state. Instituto Nacional de Antropología e Historia. Mexico City.

The artistic skill and ingenuity of the Central American lapidaries is shown in countless ritual objects carved in onyx, obsidian, rock-crystal, jade and many other semi-precious stones. This vessel, formed in the shape of a monkey, is an example of their craft. The monkey had various significances for the peoples of Central America: among the Maya it symbolized the god of the Pole Star, and among the Nahua it presided over one of the days of the month. In this precious vessel, a product of the Huastec group which lived in the northern part of the land draining towards the Gulf of Mexico, the monkey was probably related to the Maya symbolism. A monkey is climbing on the back of the largest known Huastec statue, that of a youth found in Tamuín.

62, 63 Eagles, Jaguars and Tlaltecuhtli.
Temple of Tlahuizcalpantecuhtli, Tula, Hidalgo state. 856—1168 AD.

The walls of the terraces which form the base of the temple of the "Lord of the Dawn" are decorated with friezes showing processions of jaguars (and their local equivalents—coyotes). Under the friezes, tablets with figures of eagles (or their equivalents—vultures) devouring great clots of human blood, alternate with the plumed tiger god or earth monster, from whose jaws emerges a human face. This god is Tlaltecuhtli, lord of the underworld, and the face is that of the sun, or perhaps the planet Venus which preceded him at dawn, when the struggle between these celestial gods and the cosmic darkness is concluded. The figures symbolize the rites of sacrifice in which warriors are offered for the spiritual nourishment of the sun, which feeds on their blood and hearts. In this way the corpse-like god of the daybreak recovers the strength he lost in the underworld, his life is renewed and his power of movement is restored.

58

64 Talus, Balustrades and Staircases.
Tenayuca, Mexico state. About 1400.

The Chichimecs, who migrated to the valley before the Mexica, established their political and religious capital at Tenayuca, a small town which they had taken from the Toltecs. Here they erected a ceremonial centre with a large temple, of which the ruins remain. This temple, very small at first, received five additions, which Walter Krickeberg has compared to the successive skins of an onion. The temple is composed of twin platforms, that is to say of two platforms so related as to unite at the point where the respective staircases and balustrades meet at the centre of the west side of the architectural composition. On the base thus formed corresponding temples stood side by side.

This centre at Tenayuca may have been begun about the year 1200; it established the pattern of twin temples which the later Nahuas were to follow for the shrines of their chief gods. The staircases and balustrades shown are of the fifth reconstruction, and the *taluses* that were placed before them when the base was renewed at the sixth reconstruction.

65 Coatepantli.
Tenayuca, Mexico state. About 1400.

The line of serpents which encircles three sides of the base of the temple of Tenayuca is a magic wall which may allude to the deities worshipped in the area just above the foundations. The serpents' bodies on the southern side and halfway along the eastern side were painted blue, and those of the other half of the eastern side, along with the northern, are red underneath, and black on top. This is interpreted as a dedication of the temple to day and night, and to the northern and southern quarters, namely to Time, the Poles and the Gods of Life and Death.

66 The Plateresque Entrance of Acolman.
Acolman, Mexico state. 1560.

The entrance of the Augustine Church in Acolman is a prototype of the Plateresque in New Spain. It is worked in stone following the classical design of pairs of columns at the sides, with recesses in the inter-columns, and entablature joining the columns. The architectural composition is complemented with niches for sacred figures, placed on top of the entablature, and a small doorway with a single column on the side for the window of the choir. The profuse decoration is characteristic of the Plateresque, which here is not merely limited to the adornment of the columns, but includes figures, medallions, plaques, garlands, strings of pearls, ribbons and grotesque fantasies. The façade of Acolman is a fine example of the Plateresque,

literally 'silversmith-like', i.e. the ornamentation of buildings with Renaissance or other motifs, popular then in Spain.

67 Indian Chapel.
Teposolula, Oaxaca state. About 1579.

The great *atria* which the missionaries included in their convents and evangelisation centres were designed to collect the natives in large numbers for sermons and the sacraments. They had the double merit of being large enough for big congregations and of filling the function previously performed by the open courts in front of the old temples. At first the missionaries improvised arbours in which to say mass, but these were later replaced by Indian chapels, which for lack of any obvious European models were free in their planning and design. One of the largest and most original of the many in New Spain is that of Teposcolula in the Mixtec country, where the Dominicans built such splendid convents as those of Coixtlahuaca and Yanhuitlan. The chapel itself stands on the northern side of the convent church, and faces the enormous *atrium*, which is like a monumental loggia, markedly Renaissance in style and broken in the centre by a hexagonal space, which was used as a presbytery and covered by a fine Gothic vault.

68 Processional Chapel.
Huejotzingo, Puebla state. 1550.

At each of the four corners of the *atrium* a processional chapel usually stood, the design of which varied considerably. Each of those at the convent of Huejotzingo takes the form of a cube covered by a tall pyramid. The façades of the two open sides still show some of the original decoration. This consists of a frieze edged with the cord of the Franciscan girdle, which serves as a frame for a pair of Angels of the Passion designed in the Gothic manner, and a shield with monogram and crowned cross. Above the frieze is a panel with more shields showing the Franciscan insignia of the keys and the five bleeding wounds of the Crucifixion.

69 Gothic Angel.
Molango, Hidalgo state. About 1538—1563.

On the façade of the little convent church of Molango, the Augustinians followed the Gothic tradition of decoration, though applying it to a building that was closer to the Renaissance style. Here is one of the angels bearing a cross. During the sixteenth century the native sculptors generally followed drawings brought by the friars, thus transferring to stone, in their own surroundings, a fresh version of the gospel for those who could not read.

70 Buttresses.
Yanhuitlan, Oaxaca state. 1550—1575.

The thick walls, heavy buttresses, even flying buttresses, used by the friars when building churches and convents in Indian country seemed to defy destruction. The missionaries canalized the force and disciplined labour of the natives, who had been used from time immemorial to serve their lords and gods in order to maintain their existence, and led them into hard physical labour in the hope of winning salvation. One of the many monuments to their labours is the church of Yanhuitlan, imposing in mass but refined in detail, for centuries a landmark in the Mixtec mountain country.

71 Battlements.
Yecapixtla, Morelos state. About 1560 AD.

Fear of Indian risings led to the missionaries fortifying their convents, which were built as solid fortresses dominating the native huts. The most frequent indication of the Spanish authority which supported the friars was the crenellation of the outer walls of churches and convents, serving more as a warning than an effective protection.

72 Sixteenth Century Cloister.
Acolman, Mexico state. About 1550—1571.

The Franciscan, Dominican and Augustine monks were charged with the task of converting the Indians. They built about three hundred convents, of which this is a typical example. Most of them were sited in the centre of native settlements. The convent of Acolman has archways showing the primitivist style of the period of the viceroy, Antonio de Mendoza (1535—1550).

73 Basilica of Tecali.
Tecali, Puebla state. 1569 AD.

The three-naved basilica is exceptional among the convent churches in Indian territory. A few however follow this plan, among them Tecali, which is now in ruins. The skeleton remains as evidence of the breadth of the architectural conception and the monumental Renaissance arcades that formed the naves. In the background stands the original apse, the only part of the church covered by a vault; the rest originally had a pitched timber roof.

74 The Cloister of the Augustinian Monastery at Actopan.
Actopan, Hidalgo state. Begun in 1550.

The convents of the evangelising friars should have been small and simple. But with a few exceptions they were on a grand scale, built in two storeys around an arcaded court. The convent of Actopan is representative of this kind of colonial architecture, with thick walls and vaults and lighter construction in the arcades of the square cloister. The friars who built it used the Gothic and Renaissance styles indiscriminately; which explains the pillars and pointed arches of the ground floor of this Augustinian cloister and the columns and rounded arches of the first. In the background can be seen a formidable tower which served the combined purpose of look-out, fortress and belfry.

75 House of the Condes de Santiago de Calimaya.
Mexico City, D. F. 1779.

Few examples are preserved of the civil architecture of the sixteenth and seventeenth centuries. Those of the eighteenth century, on the other hand, are fairly numerous. One of these is the palace of the counts of Santiago de Calimaya, which they entrusted to the architect Francisco Guerrero y Torres or a pupil. Its owner's rank is marked by a coat-of-arms above the principal balcony and a line of cannon on the cornices. The façade is characteristic of the Baroque architecture of the capital; the ornamental work is in grey stone and the walls in a red porous stone. A notable feature of the façade is the main door with balcony above, framed by mixtilinear mouldings. It is flanked by two pairs of Ionic columns supporting a cornice with lintels below, which act as a floor for the balcony. The adjoining balconies have the door jambs extended to the cornice—a typical feature of the civil architecture of the century.

76 Courtyard of the House of the Condes de Santiago de Calimaya.
Mexico City, D.F. 1779.

The main court of this building consists of a large open space bounded on three sides by wide passages and rhythmical arches. The two floors of the living quarters are joined by a grand staircase of Baroque proportions. The beauty of the court depends on the clear and careful manipulation of its architectural elements, and on the light and shade of such details as the capitals, mouldings, brackets and gargoyles.

77 Solomonic Retable in the Church of San Francisco.
Tlaxcala, Tlaxcala state. About 1700.

The demand for the retable increased during the seventeenth century. It was not only necessary as a framework for religious

painting and sculpture but, shining like molten gold, enriched the church interior. The Plateresque style was eventually replaced by the Solomonic, and the structure and background were progressively covered by decorative foliage. An example of this style is the side altar in the sanctuary chapel adjoining the church of San Francisco in the city of Tlaxcala. The Baroque character of this retable has gone far beyond the mere use of Solomonic pillars; the shafts have been transformed into pairs of spiral garlands.

78 Plateresque Retable.
Huejotzingo, Puebla state. About 1570.

The oldest examples of a retable altar-piece made in the colony followed the Plateresque style. Like the façades (unless they are Gothic or Mudéjar) they were designed in a reticulated form divided by columns, entablatures and cornices. This style lasted well into the eighteenth century when the final demands of the Baroque required a different style. The larger side wall of the convent church of Huejotzingo has its retable still intact. It is a monumental construction of five parts above a table on which stand the busts of the apostles. The seven panels between columns contain alternately statues and paintings, except for the central one intended for historical reliefs (of which one is preserved—of St Francis with the stigmata). The images are related to theology in subject, and above them presides the Pantocrator. The columns and other architectural elements of this retable are in the purest Plateresque, dressed and decorated to conform with the statues of the saints.

79 Casa "Alfeñique" (The "Almond Paste" House).
Puebla, Puebla state. About 1790.

Former residence of a prosperous master ironworker for whom it was built by the architect Antonio de Santa María Inchaurregui. This is one of the supreme works of colonial Baroque, with all the most characteristic ornamentations of the Puebla region, including the *estípite* column, mixtilinear mouldings, subtly capricious brackets, small roof tiles, applied pinnacles and leafwork, the whole modelled in stone and stucco, and whitened as if it were iced almond paste (alfeñique). This framework strongly contrasts with the walls which are of brick alternating with tiles. The house follows the characteristic form of secular architecture in the colony during the eighteenth century. Its ground floor and mezzanine are planned for commercial purposes and as domestic offices while the owners lived in the upper floor. The illustration shows the rich decorative detail and ornamental ironwork of the façade.

80 Patio of the "Casa Alfeñique".
Puebla, Puebla state. About 1790.

The rectangular patio was planned to afford communication between the offices. It is dignified but capricious in form, providing, as Diego Angulo observed, a scenic display. The columns are on high plinths, and together with their mixtilinear arches create a portal that relates the square of the door to the grand staircase and patio. The court has a Baroque fountain, and doors, windows and balconies open on to it, as does the upper corridor with its system of brackets and small arches common in Puebla. The door and window frames and ironwork, contribute to the decoration of the patio which also includes shells and rosettes worked in stucco.

81 Larger Sidechapel in the Church of Santa Prisca.
Taxco, Guerrero state. 1748—1757.

The mining centre of Taxco, in the mountains south of Mexico city, produced a great deal of silver in the eighteenth century. José de la Borda, who discovered the deposit, devoted part of the fortune yielded to the building of a fine church for the town. The architect was Diego Durán Berruecos. Santa Prisca is a work of luxuriant originality, with a remarkable artistic unity. Owing to the speed of its construction, it was in fact, realized as a whole. As is usual, it has many gilt retables, that of the presbytery being an important wooden sculpture in the colonial Churrigueresque style, with *estípite* columns of colossal size and very complicated panels between columns in the lower section. *Estípite* supports continue in the second section, though here they are smaller and alternate with other elements. There are no paintings. All the images are in the round; and these include large statues of saints with busts between, and angels of various sizes. This whole theological assemblage surrounds the Virgin, and is presided over by the Creator.

82 Inner Portal of the Chapel of the Virgin of the Carmen.
San Luis Potosí, San Luis Potosí state. 1749—1764.

This retable arch which leads to the Lady Chapel in the church of the Carmen is colonial style Churrigueresque. It has three architectural members supported by *estípite* columns, very elaborate panels and an infinite number of mouldings on different planes which unite to contain the door. In this framework stands a monstrance, a niche for a cross, and above it a window containing an archangel with a small space for a bust of the Creator at the top. Here there are hardly any figures, only a few of angels and two saints, male and female, of the Carmelite order. All is a vibration of lines and masses, pro-

jection and recessions, which contribute to the general ascending movement of the columns.

83 Mexico Cathedral.
Mexico City, D.F. About 1563—1813.

Once the heroic age of the conquest and consolidation was over, the form of the religious architecture of the colony was established by the large scale works, principally cathedrals, undertaken in the cities founded by the Spaniards. The forms of the three-nave basilica and Latin cross were adopted, according to the type of church (though nunnery churches were limited to one rectangular nave). The cathedral had two towers one at each corner of the front, and a cupola at the crossing. The exterior of the building was almost completely bare, the ornamentation being generally confined to the portals and the upper parts of the walls, towers and cupolas. Occasionally the interiors were decorated with polychrome stucco, which was also applied to some chapels and shrines. The stylistic development of the ornamented parts began with an advanced Classicism, passed by way of Berninian Baroque to the ultra-Baroque of the Churrigueras, and simplified into an academic, Gallicised Classicism at the end of the eighteenth century. The principal portal of Mexico cathedral, built in 1674, is a masterly example of the Classical form; to its reticulation of columns and entablatures was added an element which had a wide diffusion in the colony: the historical relief (in this case of the Assumption of Mary), which is the principal motif of the architectural decoration.

84 Detail of the Portal to the Church of the Assumption.
Puebla, Puebla state. 1676—1687.

The detail of the doorway calls for appreciation of the fine work of these sculptors, who were able to give strong definition and *chiaroscuro* to the undulant fluting of the columns, to the foliage on their lower portions, to the mystic vines, to the strapwork and interlaced *cartoneria* (scrollwork) of the jambs, pilaster caps and arches. A bust of a child peering out among the *cartoneria* of the top of the pilaster, and a pair of children emerging from the keystone of the door arch call attention to the purpose of the hospice.

85 Portal of the Loreto Chapel.
San Luis Potosí, San Luis Potosí state. About 1700.

Another portal of singular beauty is that of the chapel dedicated by the Jesuits to the cult of the virgin of Loreto, in the city of San Luis Potosí. The structure comprises two Solo-monic columns with their pedestals, and an entablature with a curved and broken cornice, enclosing a bas-relief monogram on a medallion. Two fine octagonal clerestory windows act as stops to the ascending lines of the columns, with their associated brackets and pinnacles. Between them stands a niche containing the image of the Virgin. The octagonal windows are an element of Baroque surprise in the portal.

The combination of these elements has a singular charm which is accentuated by the carving of the central medallion and the foliage and mystical birds which decorate the jambs, spandrels, columns, frieze and other parts of the portal. The total effect is of deeply incised and delicate ivory work.

86 Detail of the Portal to the Loreto Chapel.
San Luis Potosí, San Luis Potosí state. About 1700.

The vine climbs the spirals of the Solomonic shafts, and the symbolic royal peacock displays his miraculous plumage amidst the stems, leaves and flowers of the mystical plant in which he dwells. The sculptor invested the intrinsic beauty of his design with sharp and powerful highlights.

87 Detail of the Guadalupe Portal.
Guadalupe, Zacatecas state. 1730—1760.

The portal arch is the jewel of New Spanish Baroque and its columns owe much to the side entrance of the present cathedral of San Luís Potosí. Between the columns are sculptures of St Francis and St Dominic. In the spandrels of the arch is a relief which relates the Mexican miracle of the appearance of the Virgin of Guadalupe at Tepeyac, to whom the church is dedicated. She is flanked on one side by St Luke, shown painting her, and on the other by Fray Juan de Zumarraga, archbishop of Mexico, who recognised the miraculous apparition. Above the door, on either side of the window, are two sculpted panels of the Annunciation, with St Gabriel in one and the Virgin in the other. Between them, and on a higher level, the Creator stands among clouds with a choir of angels.

88, 89 Interior of the Church of Tonantzintla.
Tonantzintla, Puebla state. 18th century.

The inside of this church, dedicated to Tonantzin, "our little mother", was executed in stucco by native craftsmen, who wished to honour the holy patron of their village with a shrine that would be as beautiful as the Rosary chapel at Puebla. Figures of saints and angels, the faces and dresses of native children and the Christian symbols stand out from luxurious and highly coloured masses of incised medallions, and the

foliage, flowers and fruit of the country that seem to spill down from the top of the cupola at the crossing. The form of this decoration has a precedent in the stucco-work of the chapel of Our Lady of Victories at Málaga in Spain, but its greatest attraction lies in the frankness and ingenuity of the local interpretation.

Plate 89 shows the interior of the cupola.

90 Portal of the Church of Cata.
Cata, Guanajuato state. About 1770.

The small church of Cata, near some mines in the mountains of Guanajuato, has a most curious colonial Churrigueresque portal, in an unfinished state. The carving of the pilasters and counter-pilasters, of the much broader pilasters that fill the intervals, and of the restless, vibrating multiplicity of mouldings, foliage, valances, niches, medallions and small figures, is as intricate as filigree. Seldom has stone yielded more obediently to a delicate conception. The small figures in the medallion relate the life and passion of Christ, those of the keystone portray the theological virtues.

91 Cupolas of the Pocito Chapel.
Villa Gustavo A Madero, Mexico City, D.F. 1777—1791.

In the early days of the evangelization, the Virgin Mary appeared to the Indian, Juan Diego, beside a small spring in the region of Tepeyac. Here a chapel was erected centuries later for the cult that had arisen. This chapel (by the excellent colonial architect Francisco Antonio Guerrero y Torres) was designed in the classical Roman style to stand between a vestibule and a sacristy. The roof and ornamentation of the chapel are very Mexican. The domes are inlaid with a fanciful design which resembles cupola drums. The clerestories take the form of stars of mixtilinear outline. The delicate lanterns, the ceramic dome covering, and the combination of coloured materials—grey and red stone and zig-zag blue and white tiles—lend a picturesque richness to this remarkably beautiful example of Mexican architecture.

92 Canopy in Puebla Cathedral.
Manuel Tolsa. Puebla, Puebla state. 1797—1819.

Among the practitioners of the neo-Classical style, which swept away the exaggerations of the extreme Baroque, was the Valencian architect and sculptor Manuel Tolsa, who settled in Mexico in 1791. Among his most notable works is the monumental canopy in Puebla cathedral, built in late Renaissance style of marble of various colours with bronze and stucco applications. Nobly sculpted saints, angels and sym-

bolic figures impart a religious feeling. Within the shrine stands a bronze of the Assumption of Mary modelled by Tolsa.

93 Equestrian Statue of Charles IV.
Manuel Tolsa. 1803. Mexico City, D.F.

In this equestrian statue (intended to stand in the principal square of the viceregal capital), King Charles IV was glorified as a Caesar by a colonial society suffering from the effects of the decay of Spanish government but nevertheless forced into adulation. The statue was modelled and cast in Mexico, by the sculptor Manuel Tolsa, who had been trained at the Academia de Bellas Artes (Academy of Fine Arts) in Madrid, and was a former pupil of Juan Pascual Mena.

94 Tlahuicole.
Manuel Vilar. About 1852. Escuela Nacional de Arquitectura, Mexico City, D.F.

The neo-Classical reaction against the traditional style of colonial Mexico began before the country won its independence, and its effects lasted for more than a century. Though the themes and forms of the neo-Classical style had no national flavour, there was one exception which was to have many and fortunate consequences: a figure executed by the Catalan sculptor, Manuel Vilar, shortly after taking up residence in Mexico and assuming responsibility for sculpture at the Academia de Bellas Artes (Academy of Fine Arts) in 1846. In this statue of Tlahuicole, a Tlaxcalan hero of pre-Hispanic times, Vilar attempted to express the features of the native peoples in Classical terms.

95 The Horchata Sellers.
Augustín Arrieta. About 1865. Instituto Nacional de Antropología e Historia. Mexico City, D.F.

Many *genre* painters and lithographers lived in Mexico during the last century, among them some foreigners: Claudio Linate, Carlos Nebel, Juan M. Rugendas and Eduardo Pingret, and the Mexicans: José María Estrada, Hermenegildo Bustos, Casimiro Castro, Manuel Ocaranza, Primitivo Miranda and Antonio Serrano. But perhaps the most illustrious, who best understood the pictorial and human values of national life, was Agustín Arrieta. Evidence for this is provided by such canvases as *The Horchata Sellers*. The scene, a true document of local customs, is a domestic looking setting with a mirror and pictures on the walls. Some *mestizo* girls are minding their refreshment stall, invariably a feature of feast days and holidays. A maid is pounding pineapple to make *tepache*, and the

two stall-keepers are selling the fermented juice and other concoctions prepared from seeds and fruits. These they take from great jars which are covered with damp sand and decorated with green alfalfa and flowers. Beside the girls there is a range of jars of decreasing size which serve as ornaments, also the water-carrier and a young couple who are taking a cup of *horchata* (a drink made from chestnuts).

96 The Hacienda of San Lorenzo.
San Lorenzo, Hidalgo state. 1910.

Before 1910, the year in which the people revolted against the oligarchy headed by President Porfirio Díaz, the Mexican *bourgeoisie* and foreign capitalists devoted part of their increasing wealth to beautifying the cities. Meanwhile the peasants suffered at the hands of the landowners. Never were the estates of the vast landowners so grand, nor the peasants, turned into homeless *peons* quartered in barracks, so miserable. To protect themselves from attacks the landowners fortified their estates, displaying their power in crenellated towers. The *hacienda* of San Lorenzo was one of many on the plains of Hidalgo. The Mexican Revolution began as a peasant uprising against this injustice.

97 The Chamber of Deputies.
Mexico City, D.F. 1910.

This is another example of architecture in a European style, although designed by the Mexican, Mauricio Campos. The exterior was designed in the composite Ionic style, and the entrance was given monumental treatment with a frontal staircase placed in a corner position. An allegorical group of the law and its beneficiaries ornaments the frieze of the portico.

98 The Discovery of Pulque.
José Obregón. Instituto Nacional de Bellas Artes. Mexico City, D.F.

The first painting to evoke the pre-Hispanic past was the work of José Obregón, who studied at the Academia de Bellas Artes in Mexico City. It illustrates the charming legend of the maiden Xochitl who discovered the intoxicating juice that is extracted from the heart of the *maguey* (cactus). She offered it to the king of Tula who, as a reward, made her his wife.
José Obregón was one of the excellent painters of the mid-nineteenth century trained in the neo-Classical style by Pelegrin Clavé, director of the Academia. The European Romantic movement, however, was soon to make its influence felt on the academic art of Mexico.

99 Columbus before Ferdinand and Isabella.
Juan Cordero. 1850. Instituto Nacional de Bellas Artes. Mexico City, D.F.

During rather more than the first half of the nineteenth century, a number of foreign painters and lithographers exploited the aesthetic qualities of Mexican life and landscape, which finally came to interest the Mexicans themselves. But academic artists seldom concerned themselves with these qualities. This is clearly the case with one of the outstanding Mexican painters of the time, Juan Cordero, who studied at the Academia de San Carlos in Mexico, and spent years perfecting his talents in Italy and Spain. A few of his canvases are concerned with Mexican subjects. One is the *Portrait of the sculptors Pérez and Valero*, and another *Columbus before Ferdinand and Isabella*. In the former he depicted the features and complexion of two young men of *mestizo* blood, and in the second introduced the figures of American Indians, (brought by the Admiral to the Spanish court) into an historical picture.

100 The Estate of Chimalpa.
José Mariá Velasco. 1893. Instituto Nacional de Bellas Artes. Mexico City, D.F.

This Mexican artist combines the mastery based on serious academic study with a knowledge and love of natural beauty. José María Velasco was born at Temascalcingo, in the highlands of the central Mexican plateau, where the air has a rare transparency. This no doubt influenced the sensibility of this exceptional artist. His pictures present the poetry of the landscape in the background and foreground, in all its variations of light and shadow, a poetry born from the contemplation of reality, fugitive or eternal. In this poetic harmony of cool tones can be seen the outcroppings of rock and the *maguey* (cactus) fields of the estate of Chimalpa, a light cloud of dust and, in the far background, the snowy summits of Popocatépetl and Iztaccíhuatl, all beneath the quiet beauty of a superb sky.

101 Monument to Independence.
Antonio Rivas Mercado. 1910. Mexico City, D.F.

This monument to Mexican independence was inaugurated during the centenary celebrations. Designed in a polished Classical style by the architect, Antonio Rivas Mercado, it is a triumphal column, with the novel feature of eagles instead of acanthus leaves on the capitals, eagles being the national emblem. On top is a winged victory bearing a laurel crown and a broken chain. Heroes of the Independence stand at the foot of the column, and female personifications of History and the Fatherland bear on high the Father of his Country, the priest

Miguel Hidalgo y Costilla. At the corners of the base are four seated statues, representing Law, Justice, Peace and War. The sculpted group of heroes was by Enrique Alciati and the allegorical figures were cast in bronze by the architect himself on his return from Florence.

102 Hemicycle to Juárez.
Guillermo de Heredia. 1910. Mexico City, D.F.

To honour the memory of President Benito Juárez (d. 1872) a hemicycle in the Doric style was erected in the Alameda gardens. The seated statue of the great man appears between two vigorous female figures, representing History and Glory, on the top of the central platform of the monument.

103 Day of the Dead.
Saturnino Herrán. 1913. Palacio de Bellas Artes, Mexico City, D.F.

As revolutionary fervour permeated society, academic painters became aware of new movements in art. This awakening is best represented by Herrán who was the first, not only to introduce new forms of expression, but also to realise that fresh subjects lay at hand in the daily life of the people of Mexico. At the beginning of the twentieth century their lives were still governed mainly by local tradition. With characteristic lyricism he portrays a typical scene in *Day of the Dead*: a family going by canoe across the lake of Xochimalco, laden with *zempoalxochitl* flowers with which to deck the tombs of the dead.

104 The Festival of Our Lord of Chalma (detail).
Fernando Leal. 1922—1923. Escuela Nacional Preparatoria. Mexico City, D.F.

On the staircase wall of the Escuela Nacional Preparatoria, Fernando Leal recorded the traditional and popular scene of the annual festival of the Black Christ at Chalma. Pilgrims are seen approaching the shrine with offerings and banners. Dances, masks and robes are faithfully depicted, and the pilgrims are drawn with Indian and *mestizo* features.

105 "Stylish" Skull.
José Guadalupe Posada. About 1900. Woodcut. Mexico City, D.F.

The regime of "bread and cudgels" maintained by President Díaz between 1876 and 1911, was supported by a ruling society which despised the poor. Popular sentiment opposed it with criticism which ran to satire, as its best means of protest. One of the sharpest and most spontaneous critics of this society was José Guadalupe Posada, who used engraving as his medium. A tireless worker, he devoted himself to the illustration of books, pamphlets and broadsheets of various kinds. Death has always been a familiar figure to Mexicans, whether as a thing of dread or of sport. Its skeleton form has inspired deep religious feeling, but has also become a thing of mockery; on All Souls' Day, the sweetmeats take the form of skulls. Posada used the death's head ironically. He saw the powerful, the insignificant, the dogs and everyone else carrying their skeletons around with them. The "stylish skull" is directed against a well-dressed *fin-de-siècle* lady, charming in her coquetry.

106 The Slaves.
Leopoldo Méndez. Woodcut. About 1950. Mexico City, D.F.

Conscious of the possibilities of engraving as an art form and a means of political propaganda, the new artists devoted themselves to this medium when the armed phase of the Mexican Revolution was over. They took up again the craft in which Picheta, Manilla and Posada had once distinguished themselves, but under very different social and ideological conditions. There were new techniques and materials. Work was done in a communal spirit and groups formed, like that of the Taller de la Gráfica Popular (Studio of Popular Art). A great part of this production was concerned with the struggle for socialism. Leopoldo Méndez, an engraver of this period, devoted his art to the war against oppression. *The Slaves*, which records the extraordinary state of oppression to which the native peasants were subject, is representative of his rare artistic and human qualities.

107 The Creation (detail).
Diego Rivera. 1922. Escuela Nacional Preparatoria. Mexico City, D.F.

The development of painting for the masses became possible after 1922, when the walls of schools and other public buildings were painted by artists whose way of thinking was broadly humanistic. One of them was Diego Rivera, whose first mural was executed in encaustic on the walls of the "Bolívar" hall of the Escuela Nacional Preparatoria. *The Creation* may be described in this way: beneath the cosmic fire and space prepared for it at the command of Being, anthropogenesis takes place. Alfa and Omega, signs indicated by the fingers of two female figures, preside over the formation of man. At the centre of the composition stands the Man of the Tree of Life and the four elements. At the sides are grouped the virtues

and muses each displaying a particular temptation to the astonished eyes of the first human pair, whose flesh has hardly awakened from the animal state. The figures, drawn with strong and simple lines, were prophetic of the extraordinary power of expression that this artist was to develop in his later work.

108 The Mother's Farewell.
José Clemente Orozco. 1922—1927. Escuela Nacional Preparatoria. Mexico City, D.F.

This picture is one of a series devoted to the peasants' participation in the Revolution. Both the figures and the scenery of the backgrounds are painted in dull colours suggesting the dust of the fields. This colouring, recalling that of the popular polychrome print, gives these pictures an air of dramatic poetry. They express José Clemente Orozco's vision of the deep emotion of the Mexican peasants in face of this crisis in their existence. Earth, mother, the bonds between men and women: all were affected by their critical awakening, their struggle, and their hopes of survival and a better future. *The Mother's Farewell* is on the third floor of the main court of the Escuela Nacional Preparatoria.
The series of frescos for the National Preparatory School, of which this is one, marks the beginning of Orozco's first main period which culminates in the Prometheus of 1930 which is in the Pomona College, California.

109 The Palace of Fine Arts.
(Palacio de Bellas Artes). Mexico City D.F. 1904—1934.

In the early years of the twentieth century economic conditions in Mexico favoured the undertaking of works of some magnitude. Intellectual colonialism still prevailed, and the privileged classes of society tried to live in a European manner. In the architectural field very few attempts were made, or could have been made, to incorporate elements of indigenous character in new buildings. The historical styles of Europe were preferred. In 1904 the plan of an Italian architect, Adamo Boari, was accepted for the construction of a national theatre, which is now the Palacio de Bellas Artes. His design was to be carried out in steel and Carrara marble. The central sculptures of the main façade were entrusted to Leonardo Bistolfi, and those on the sides to Boni. The Catalan, Agustín Querol, moulded the "Pegasus" figures which were to have crowned the back part of the building, but now they stand in the square in front. As a result of the Revolution which broke out in 1910 work on the building was suspended in 1916. It was completed between 1932 and 1934 under the direction of the architect Federico Mariscal.

110 Man at the Cross Roads.
Diego Rivera. Palacio de Bellas Artes. Mexico City. 1934.

The original of this mural was designed for Rockefeller Centre, New York, but the inclusion of the dominating portrait of Lenin seen on the right caused offence and the work was destroyed. Diego Rivera reproduced it for the Palacio de Bellas Artes. The central figure is a technician, an allusion to modern man, the creator of culture. The group of workers surrounding Lenin represents socialism, and on the opposite side the night club scene is taken to signify capitalism.

111 Simon Bolívar the Liberator.
Fernando Leal. 1932. Escuela Nacional Preparatoria. Mexico City, D.F.

During the third and fourth decades of the twentieth century an enthusiasm for liberty and the brotherhood of the Latin American nations spread through Mexico. Admiring tribute was paid to the leaders of Independence and honour rendered to the figure and ideals of Bolívar. This enthusiasm is illustrated by the mural paintings of Fernando Leal in the entrance to the Escuela Nacional Preparatoria. This one is dedicated to the triumph of the Liberator.

112 The Fall of Tenochtitlán (detail).
Jean Charlot. 1922—1923. Escuela Nacional Preparatoria. Mexico City, D.F.

Jean Charlot, Paris-born artist and traveller, came to Mexico in 1921 and joined the movement for monumental painting which was in process of birth. As assistant to Diego Rivera, he had the opportunity of painting a mural to face that of Fernando Leal across the staircase of the Escuela Nacional Preparatoria. *The Fall of Tenochtitlán* is an historical scene of great vigour, the theme of which was inspired by the word inscribed beneath it: "Such was the shouting and wailing in the city that the very mountains echoed and the stones broke for pity and grief..."
Father Durán, LXXVI.

113 Sculptures on the Monument to the Revolution.
Oliverio Martínez. 1933. Mexico City, D.F.

The revolution and the new ideas of life furnished by the events of the twentieth century required the creation of a new art to replace the dead forms of the past. This new art had to be revolutionary in form and content: direct, economical and capable of making an impact at first sight. The change is evident in the sculptural groups high on the corners of the Monument to the Revolution, the work of Oliverio Martínez.

These great anthropomorphic forms represent activities. This particular group stands for Justice and a knowledge of the laws by the common people. The monument replaced an earlier iron structure, and is the work of the architect, Carlos Obregón Santacilia.

The group in plate 114 represents the indigenous people of Mexico.

114 Sculptures of the Monument to Obregón.
1934. Villa Obregón. Mexico D.F.

A mausoleum was raised to the memory of the revolutionary general, Alvaro Obregón. The author of the project is the architect Enrique Aragón Echegaray, and the sculptures are by Ignacio Asúnsolo. They exalt the life and work of the Mexican people.

115 The Five Phases of Man.
José Clemente Orozco. 1936. Guadalajara University. Guadalajara, Jalisco state.

For the dome of the hall of Guadalajara University, José Clemente Orozco used faces and hands as a powerful expression of man's attitudes in his search for knowledge. One of the figures in his mural reveals the scientific spirit by five simultaneous movements of the head; another, the most important, is the thinker whose mind acts as a catalyst for the actions of the rest (including a hanged man) who are surrounded by diagrams and who brandish scientific instruments.

116 Hidalgo.
José Clemente Orozco. 1937. Governmental Palace. Guadalajara, Jalisco state.

On the vault above the staircase of the government palace of the state of Jalisco stands the figure of the priest, Miguel Hidalgo y Costilla, the first leader of the movement for independence. He rises above the men of the people who are destroying one another in chaotic struggles. He stands gigantic among the flames, brandishing a burning torch and, with the gesture of a dreamer and man of action, cries for independence. Here José Clemente Orozco has converted the father of his country into a universal figure. To increase this effect, Orozco painted on the lateral walls two pictures illustrating the darkness of the Mexican past and the state of the world at that time. His themes are *The Dark Powers* and *The Contemporary Arena*. Here fanaticism with the trappings of religion rides on serpents, and the personification of evil whips Humanity.

Orozco's visit to Europe in 1932 marks a new phase in his artistic development which is clearly demonstrated in the series of magnificent frescos for the city of Guadalajara.

117 Mural in the National Palace.
Diego Rivera. 1929—1935—1945. Mexico D.F.

Diego Rivera has decorated the staircase of honour in the National Palace with a series of visions of Mexican history in highly coloured simultaneous scenes with many figures. On the north wall he has created an evocation of an indigenous pre-Hispanic world presided over by the ancient gods of fire and water. With studied precision he has brought to life the religious, political, commercial, agricultural and artistic activities of the Indians.

118, 119 Tláloc Fountain.
Diego Rivera. 1950. Lomas de Dolores, D.F.

The Lerma aqueduct ends elegantly in a pool and a fountain. Diego Rivera was responsible for embellishing it. On the walls he has depicted biological themes on the creation of mankind, and in the pool he constructed in high relief the gigantic figure of Tláloc, the Nahua god of rain and fertility, endowing the face of the god with his ancient attributes, and placing vegetable forms on the soles of his sandals. This is a "sculpture-painting", executed in a mosaic of marbles, basalt and majolica.

120 Our Present Day Image.
David Alfaro Siqueiros. 1947. Palacio de Bellas Artes, Mexico D.F.

This painting in piroxiline on masonite, a form of fibre board, is of a direct expressiveness appropriate to the vigorous modern man, whose gigantic hands stretch out insistently, demanding the fulfilment of needs which have not been met. His head is of stone without features. It is an easel painting with bold rough textures and in colour very characteristic of the artist.

121 "The People for the University, the University for the People".
David Alfaro Siqueiros. 1952—1956. Ciudad Universitaria, D.F.

This large mural on the exterior south wall of the Pupils' Hall dynamically portrays "the men of science, the humanists and the artists offering the fruit of their labours to the nation", to quote Siqueiros' biographer, Raquel Tibol.

122 The Siqueiros Mural seen as a Whole.
Ciudad Universitaria, D.F. 1952—1956.

The artist wished to accentuate the dynamism of his mural painting with forceful lines and high-lighting, with a few figures in order to achieve a powerful impact. The foreshortened

figure of a student is emphasized by another with outstretched arms, pointing towards the future. Various large figures represent the academic world; whilst the smaller ones on the upper part represent the People carrying the banners of strife. This is a particularly fine example of the work of Siqueiros.

123 The Eruption of Paricutín.
Gerardo Murillo. 1946. Mexico D.F.

Gerardo Murillo, also known as Dr Atl, is one of the great landscape painters of Mexico. He was not only a great painter, but also an indefatigable traveller. He was, moreover, a source of great inspiration during the period of transition in Mexican painting which began in the early nineteen-twenties. The subject of this picture was particularly well matched to his temperament and his artistic genius. Paricutín, in the mountainous region of Michoacan, erupted before his very eyes. He devoted a whole series of paintings to this subject.

124 Elevation.
Francisco Eppens Helguera. 1952. Ciudad Universitaria, D.F.

A mural panel in vitreous mosaic by Francisco Eppens Helguera for the School of Dentistry, takes as its subject man's intellectual and spiritual activity. Two diagonally placed figures accentuate the feeling of "elevation". The first is of a man rooted in the fertile ground; the gestures of his hands indicate struggle and hope. In place of a head he has a cloud which signifies elevation by the intellect. The second figure suggests a friar, and behind it appear wings: this refers to the moral and mystical ground of the impulse which drives man. Between the two figures glides the old native symbol of a plumed serpent, against a background of rocks and fire.

125 The Conquest of Energy.
José Chávez Morado. 1952. Ciudad Universitaria, D.F.

The second mural in vitreous mosaic by José Chávez Morado is in the hall of the Faculty of Sciences. Here on the garden front, he depicted man's efforts to emerge from primitive fear and impotence, beginning with the conquest of fire and followed by the scientific discoveries whereby he has contrived to make use of Nature. These have culminated in nuclear fission, which has given rise to the new fear of the atomic bomb. Nevertheless its enormous energy can be changed into a hope for the peace and happiness of the world.

126 Life.
Francisco Eppens Helguera. 1952. Ciudad Universitaria, D.F.

Another of the great pictorial compositions which adorns the National University is that of Francisco Eppens Helguera on the Faculty of Medicine, executed in a durable mosaic of stone, glass and paint. The plumed serpent surrounding the mural symbolizes infinity (a continuous circle). At the top the flames stand for fire. Earth appears in the shape of Coatlicue, the mother goddess of the ancient Mexicans, here represented by her hands. The profiles are of the three populations of modern Mexico: Indian, Spanish and *mestizo*. The god Tláloc with the mask in front of his eyes is presenting his gift, the water element. The circles are raindrops. Death is being eaten by a maize cob, which in native thought symbolized life, since from its paste the gods made mankind. The plants refer to the native herbal medicine. On one of Coatlicue's hands is a seed of maize germinating and on the other pollen; twin symbols of the origins of life.

127 Central Library of the University City.
Juan O'Gorman. 1950—1952. Ciudad Universitaria, D.F.

Juan O'Gorman was head of the architectural team which designed the box on pillars which houses the library of the National University of Mexico in the University City. It was he who solved the problem of the external appearance of its great walls. Having already shown himself an excellent and inventive painter of murals, he executed four enormous designs in a mosaic of natural stones, one theme on each face of the cube, composed of figures and emblems drawn from the cultural antiquity of Mexico. Unique of its kind, the work provides a visual chronicle of Mexican culture, the culmination of which has been the University from its foundation in 1553 to the present day.

128 The Return of Quetzalcóatl.
José Chávez Morado. 1952. Ciudad Universitaria, D.F.

For the new home of the National University, on the Pedregal (lava field) south of the capital, the painter José Chávez Morado designed two mural panels in vitreous mosaic. One, for the building of the Faculty of Sciences, takes the theme *The Return of Quetzalcóatl*, the mythical hero of the ancient Toltec culture, a priest and deity who was wisdom incarnate. The painter has given the following explanation of his mural: first and foremost it presents the universality of our culture. It sets out to show how our ancient pre-Hispanic civilization was blended with the basic cultures of Europe, Asia and Africa to produce modern, *mestizo* Mexico. The figures are travelling in the mythical ship of intertwined serpents, each carrying the symbols of his respective culture, and in the act of offering them to the New World. In the background a pyramid, pierced by arrows, spears and swords, and crowned with a light, signifies that culture survives the barbarism of war.

129 University, Family, Peace and Sport.
Diego Rivera. 1952. Ciudad Universitaria, D.F.

The monumental frieze covering the outer ramps of the stadium in the University city is by Diego Rivera. It was designed as coloured sculpture and the artist himself directed the work of choosing natural coloured stones and arranging them on the site. The part illustrated represents the university shield before which stand a man and a woman who are placing the dove of peace in a child's hands. Beside them, two young athletes are lighting the Olympic torch. At the base appears the native plumed serpent dotted with maize cobs, symbolizing the ancestry of the Mexicans and their staple food.

130 The Theatre, Political and Artistic, in Mexican History.
Diego Rivera. Teatro de los Insurgentes. Mexico City, D.F. 1951—1953.

The frieze on the façade of the Teatro de los Insurgentes takes the form of a single design covering the whole surface. The artist gave first place to events and personalities on the political stage of Mexican history, and secondary treatment to the secular arts flourishing since pre-Hispanic times. Thus, above the central hands and mask he places the comedian Cantinflas receiving gifts from the rich, who are shown treading on gold bars and dividing them among the multitudes of the needy.

131 Unidad de Conreso del Instituto Mexicano de Seguro Social.
Mexico D.F. 1943—1958.

The architectural group which makes up the Medical Centre of the Mexican Institute of Social Security was originally designed by the architect José Villagrán. Construction was considerably delayed and finally the present series of hospital units was planned by a team of architects led by Enrique Yáñez.

132 Medicine in the History of Mexico.
José Chávez Morado. 1958. Mexico D.F.

These mural panels decorate the façade of the Seccion de Aulas del Hospital General, and part of the Centro México del Distrito Federal. The artist has recorded events in the history of Mexican medicine and its function in maintaining public health. Morado uses coloured stone for the figures in relief.
This is one of many brilliant examples of the successful integration of art and architecture achieved in Mexico.

133 La Anahuacalli.
Diego Rivera. San Pablo Tepetlapa, D.F. 1945.

Diego Rivera was fascinated by the pre-Hispanic cultures and devoted a large part of the fruit of his labours to collecting archaeological pieces. Wishing to leave them to the nation, he built a museum to contain them. Several times in his life he acted as architect, and for the "Casa de Anáhuac" built a monument which recalls native architecture. The material is volcanic rock excavated on the site.

134 La Escuela Nacional de Maestros.
Marío Pani. Mexico City, D.F. 1947—1948.

After the violent phase of the Revolution, experiments were made in working towards a national architecture. At first buildings had been designed in Aztec and neo-Colonial styles; then architects sought other solutions, from the purely functional to those combining stylistic elements deriving from the Mexican tradition with new industrial materials imaginatively used. One distinguished building is the Escuela Nacional de Maestros by Marío Pani. It comprises two wings and a central semi-circular building grouped around a triangular court. Behind the central building are the classrooms of the attached primary school, disposed on either side of another triangular space which is used as an open-air theatre. The tower, and the porticos and covered passages dependent on the central building, are particularly successful. The architect used a masterly combination of traditional brick and stone with modern glass and concrete. In the central building he incorporated the plastic element of a large frieze of figures in high relief. Those on the right illustrate the basic activities of man; those on the left depict decisive moments in Mexican history. The sculptures were made by Luis Ortiz Monasterio. There are also two mural frescoes in the entrance hall by José Clemente Orozco: *The People approaching the School Gates*; and at the back of the open-air theatre, a "futurist" encaustic mural entitled *National Allegory*.

135 Vertical Architecture.
Marío Pani and Enrique de Moral. (La Secretaría de Recursos Hidráulicos.) Mexico City, D.F. About 1946.

In all parts of the world the principles of modern architecture are applied to the construction of office or apartment blocks in urban centres. Architects and engineers, relying on new techniques and industries, design vertical buildings which in the city of Mexico encounter particular problems arising from the spongy soil and the occurrence of earthquakes. Nevertheless, a solution was found and these modern towers are firmly based. Among the various fine office blocks on the

Paseo de la Reforma is the Secretaria de Recursos Hidráulicos (Department of Hydraulic Resources), planned on a particularly small site by the architects Marío Pani and Enrique del Moral.

136 Insurance Building, Seguros la Comercial, S.A.
Héctor Mestro and Manuel de la Colina. Mexico City, D.F. 1958.

With Mexico's new economic development the appearance of weight and mass in architecture has been abandoned in favour of skeleton structures and the greater use of free horizontal spaces; the flow of light is broken only by the barriers of floor and ceiling. Representative of this new development is the office block for Seguros la Comercial S.A. in the Paseo de la Reforma. The façade is a great skin of polarised glass, resting on a portico and a frieze of roughly hewn stone. The architect is Héctor Mestre, in association with Manuel de la Colina.

137 Pabellon Para Rayos Cosmicos.
(Pavilion for Cosmic Ray Research.) University City, Mexico D.F. 1952.

The architects were Jorge Gonzáles Reyna, Rafael Arozamena and Felix Candela. This small building is an impressive sight, composed of slabs of stone and undulating drums which the architects designed in thin sheets of reinforced concrete.

138 Medalla Milagrosa Church.
Felix Candela. Mexico City, D.F. 1954—1956.

In this church Felix Candela expressed for the first time the engineering genius and knowledge that have made him internationally famous. The building is little more than a roof composed of very thin concrete shells, in the shape of hyperbolic parabolas. It has been said that the use of angles to make sharp contrasts of light attains perfection in this Church of Our Lady of Miracles.

139 The Pedregal Animal.
Matías Goeritz. Villa Obrégon, Mexico D.F. 1957.

The expansion of Mexico City is continuous. The Pedregal (lava field) of San Angel, which for centuries seemed uninhabitable, has been found to be an ideal site for architecture and gardens incorporating the natural beauty of the volcanic rock and the vegetation that has sprung up in it. The work of the architect Juan Barragán has thus transformed an area once only inhabited by reptiles into the Fraccionamiento Jardines del Pedregal (The Pedregal Garden city). At one of the approaches to this garden city stands a symbolic and poetical sculpture by Matías Goeritz. Once more man's urge to express in creative work his intuitions and his sense of living in a world of history has impelled the artist to re-create in modern terms this ancient and revered symbol of the reptile which, with half-raised head, expresses in so masterly a manner the sense of the inheritance of the ancient world being carried forward into the present.

140 The Abolition of Slavery.
José Chávez Morado. 1955. Alhóndiga de Granaditas. Guanajuato, Guanajuato state.

The fine mural on the staircase of the Alhondiga de Granaditas (Grain Exchange) in the city of Guanajuato is by José Chávez Morado. The town is historically important as the scene of a victory over the Spaniards at the beginning of the war of Independence. In this mural the priest Hidalgo, father of his country, liberates the people from their fetters and points the way to the coming struggle.

141 Celebration of the Future Victory of Medical Science over Cancer.
David Alfaro Siqueiros. 1958. Medical Centre, Mexico City, D.F.

The master, David Alfaro Siqueiros, painted for the hall of the cancer hospital in the Medical Centre a composition in his habitual angular and futurist style, in which appear doctors, crowds, monstrosities and mechanical objects. Patches of colour are used, limited for the most part to the scale of reds. The picture celebrates the successful use of cobalt radiation in the treatment of cancer.

142 Air is Life.
Luis Nishizawa. 1958. Medical Centre, Mexico City, D. F.

Luis Nishizawa chose a palette of exquisite colours for his four-section mural on the staircase and landings of the lung and thorax hospital in the Medical Centre. He used acrylate solutions to decorate the walls. The illustration is of the upper flight of the stairs on which Nishizawa painted an allegory of the celestial, terrestrial, and mechanical forces from which man and woman emerge. Mechanical forces are represented by the wild horse broken to the bridle. The hands stand for the primal functions of gathering a golden maize cob, clasping the woman to the man and taming the headstrong animal. On the left of the picture a working woman holds up a healthy child.

143 La Plaza de las Tres Culturas.
Marío Pani and Partners. Mexico City, D.F. 1959—1965.

In view of the urgent housing shortage in the capital, the Government and various dependent credit institutions have undertaken large scale building in areas specifically set aside for the purpose. One of these areas is Nonoalco-Tlatelolco in a decayed suburb of the old city; it consists of blocks of flats and shops arranged in large squares. As the project affected a site containing pre-Hispanic remains (the ruins of the city of Tlatelolco), also the ancient church and convent of Santiago, these were incorporated in the plan. Thus the remains of the past can be viewed in the new framework of these housing blocks. Marío Pani and Partners were responsible for this great exercise in architecture and town-planning.

144 Wall of Mechanical Forms.
Manuel Felguérez. 1964. Bahía swimming pool, Mexico City, D.F.

Manuel Felguérez has constructed striking walls and mural panels in abstract or mechanical forms. In the Bahía swimming pool he has worked in the two media. The outer wall makes play with lines and volumes which appear to be suspended. The wainscoting of the inner wall is clothed with forms suggesting the sea, a suggestion reinforced by the use of white and mother-of-pearl shells.

145, 146 Ornamental Towers.
Matías Goertiz and Luis Barragán. Flaza de las Cinco Torres, Satellite City, Mexico, D. F. 1957—1958.

On the road leading into Satellite City the sculptor, Matías Goeritz and the architect Luis Barragán, placed a group of triangular concrete blocks varying in height between 37 and 51 metres (120 and 170 feet), painted with plastic based paint "The intention was to construct a monument whose function should be purely aesthetic", Goeritz stated. "They make a sculptural statement." These soaring towers express both the vigour and serenity appropriate to their position at the entrance to the Satellite City which is about nine miles from the centre of Mexico City.

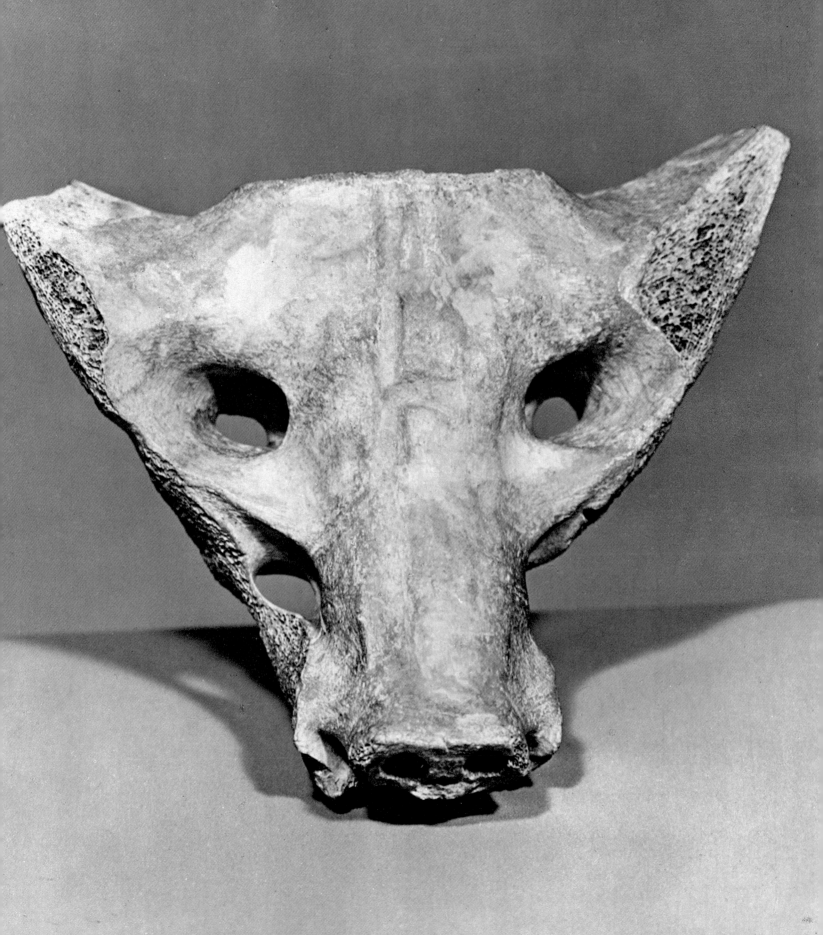

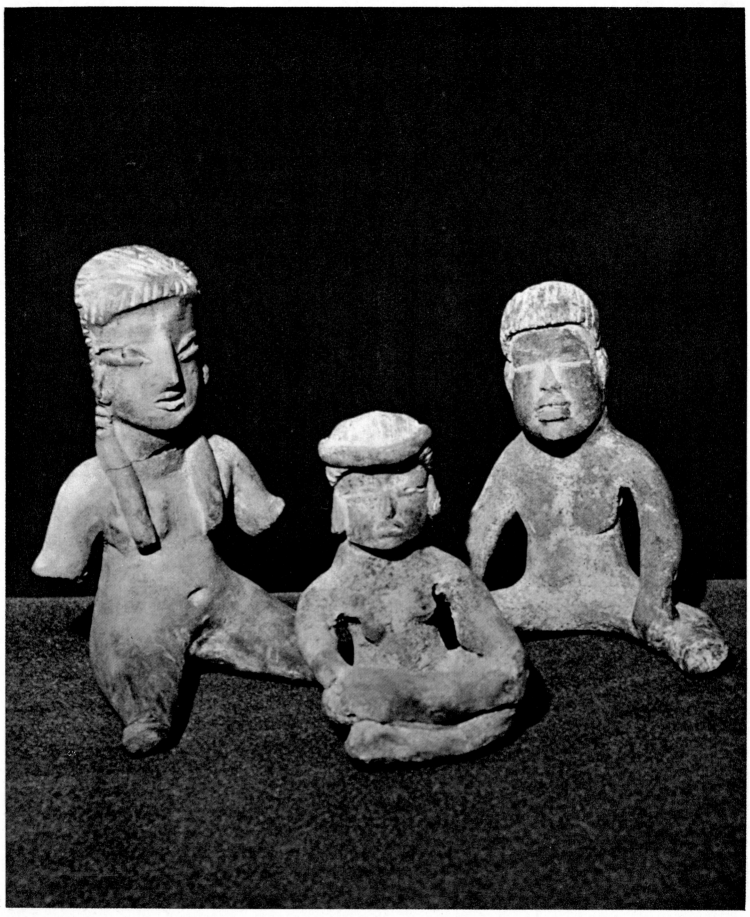

2

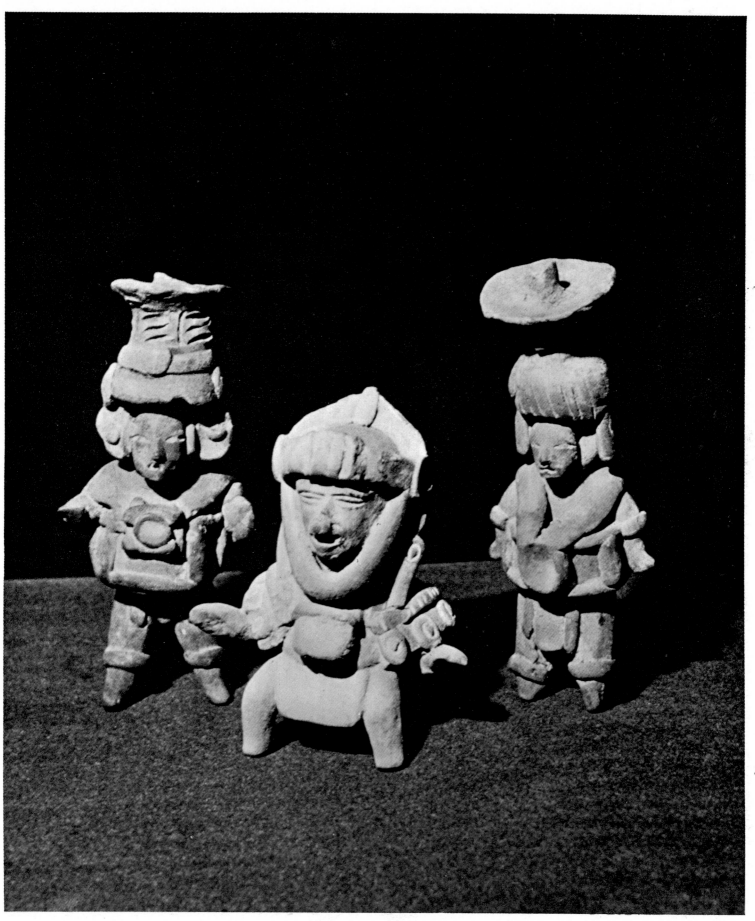

3

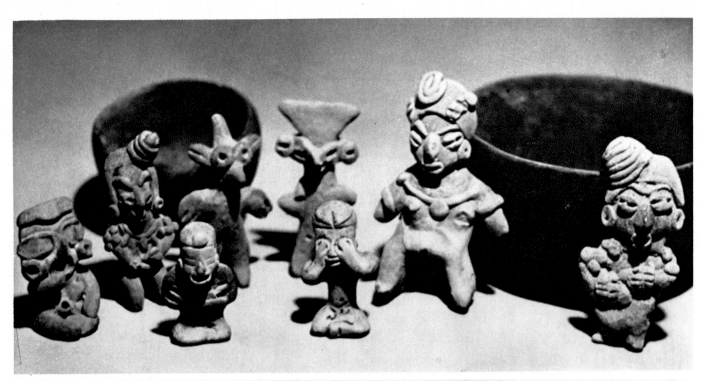

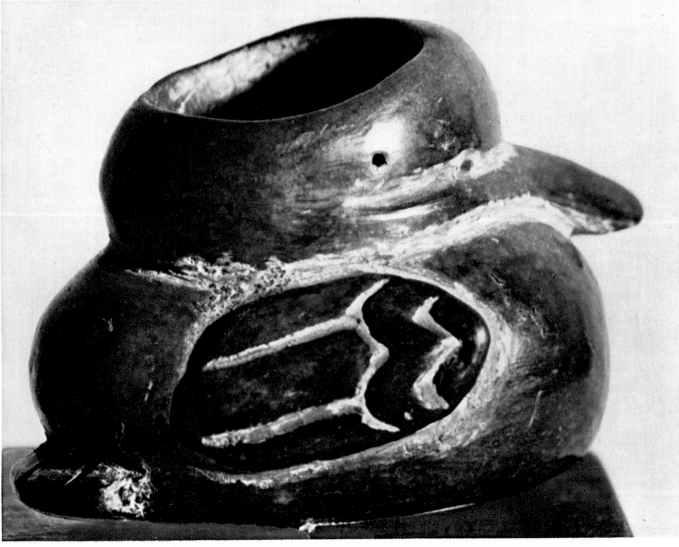

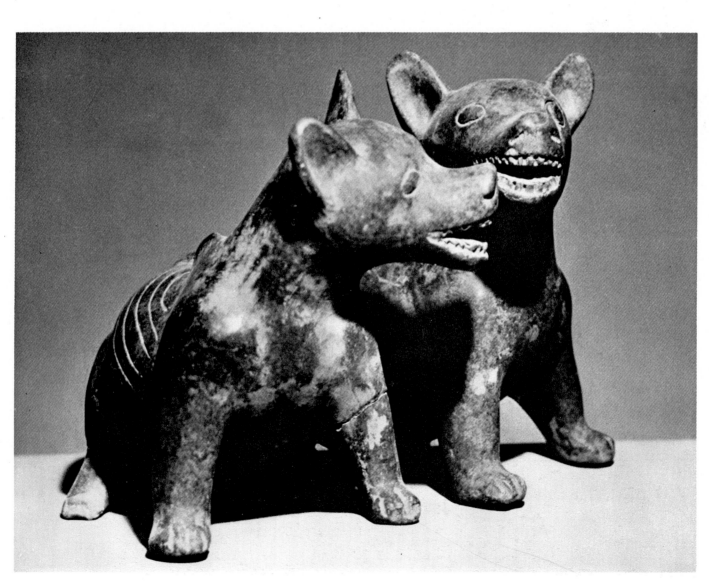

6

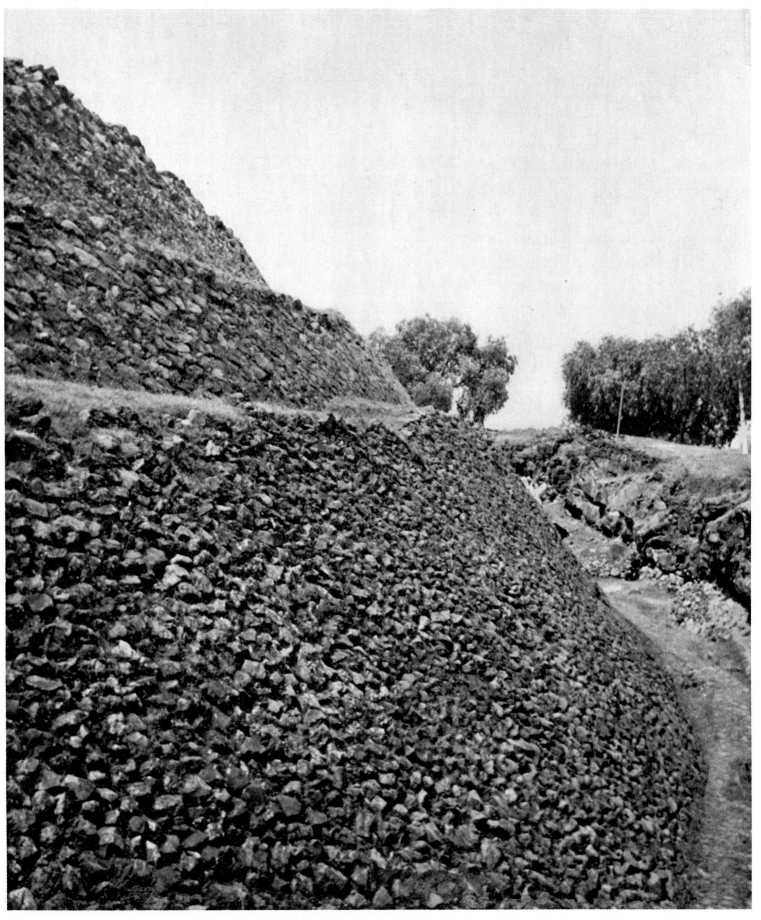

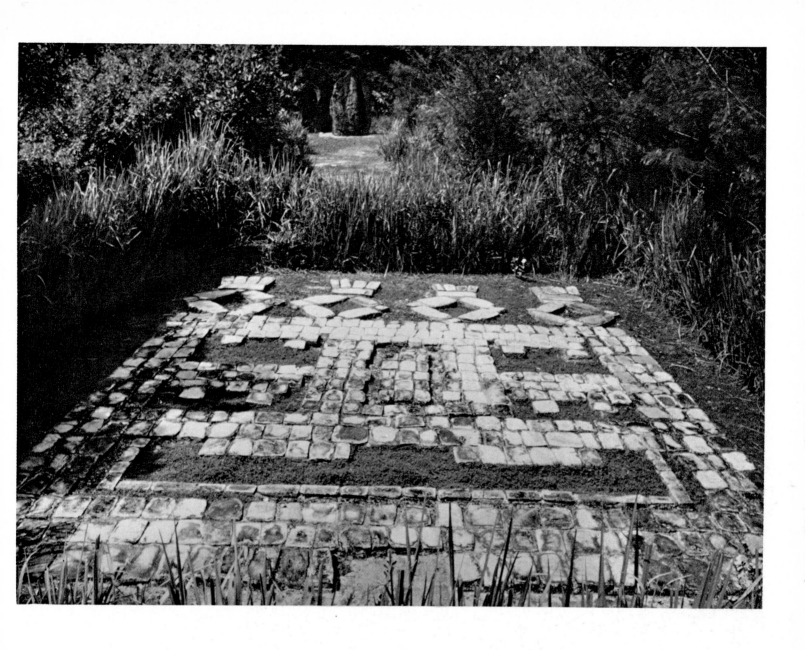

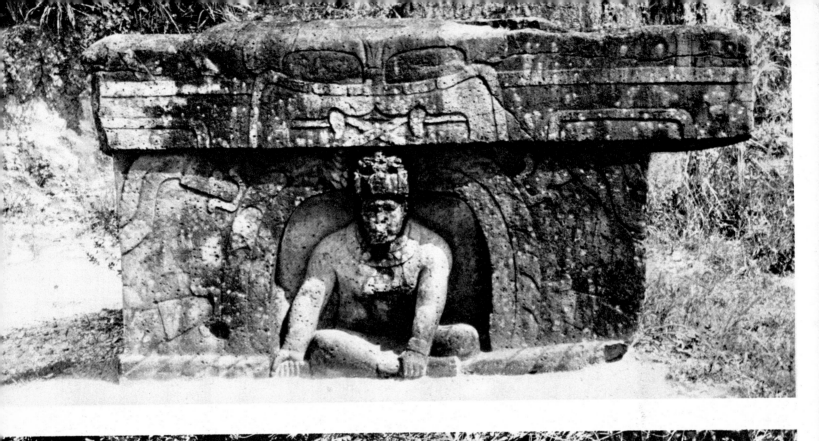

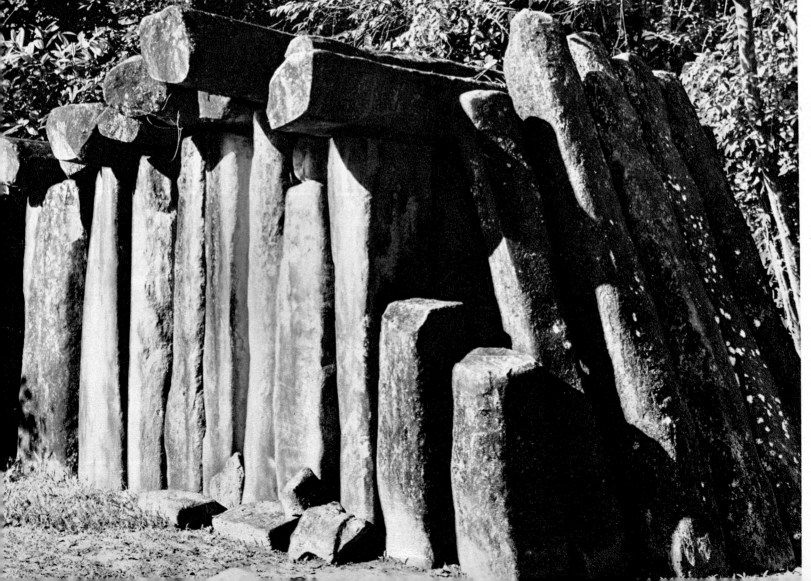

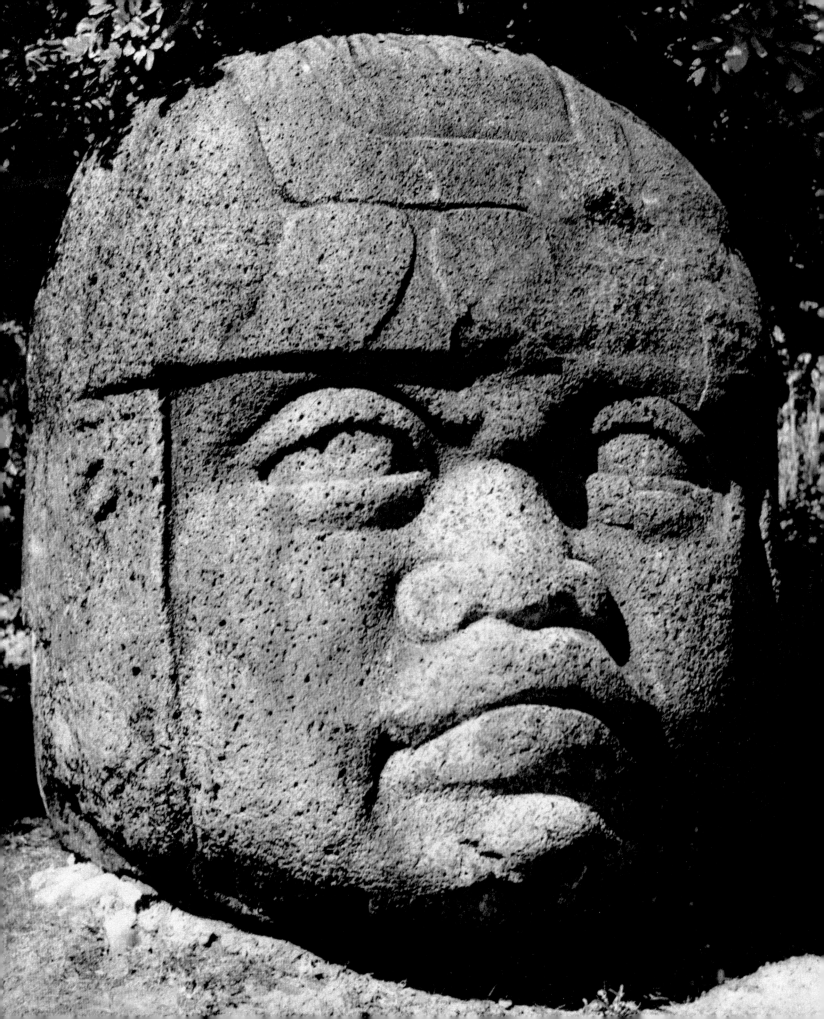

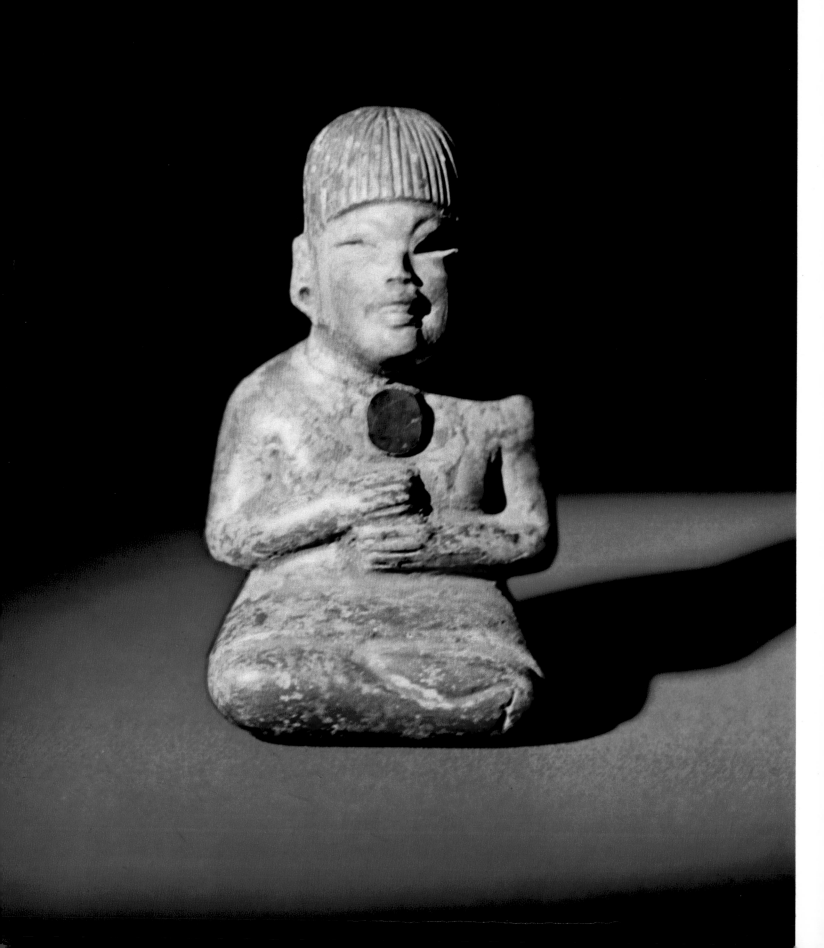

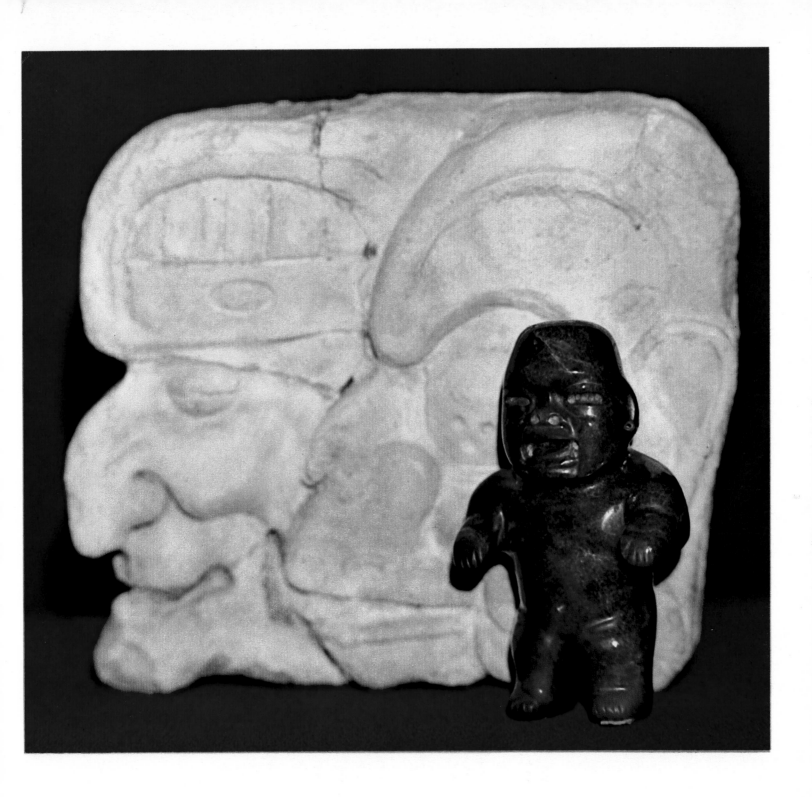

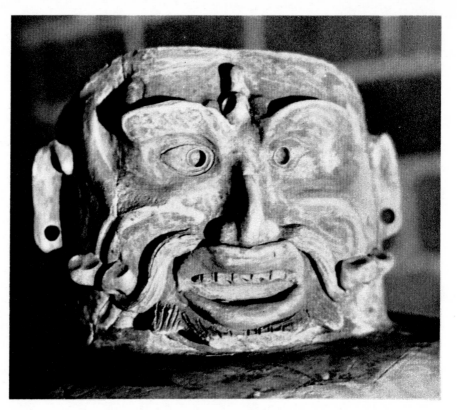

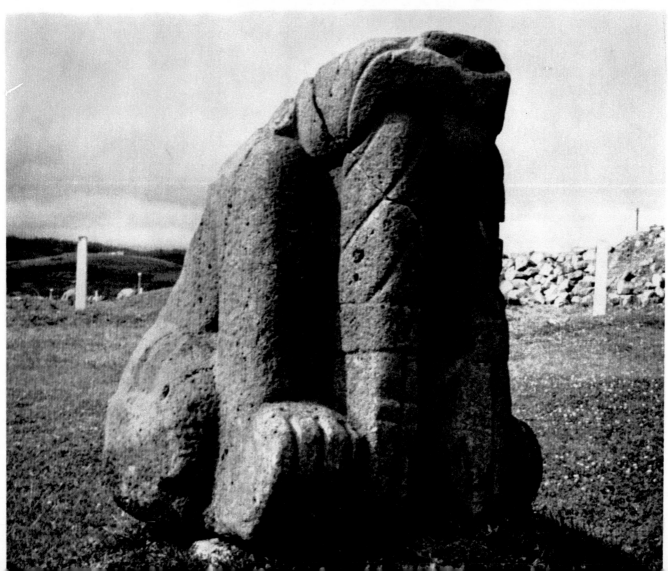

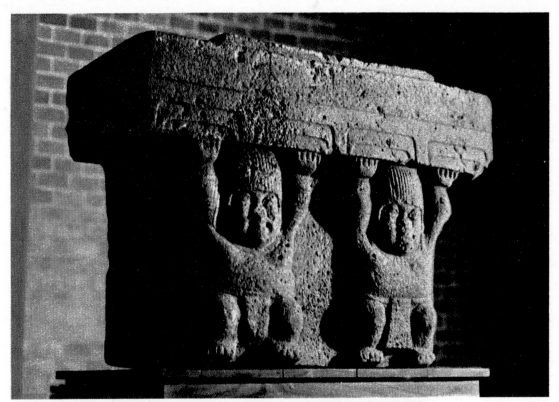

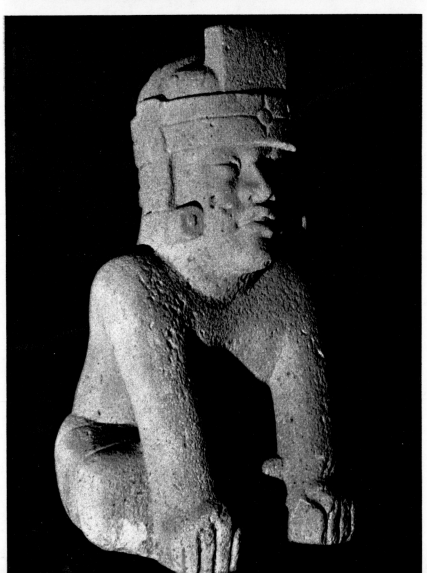

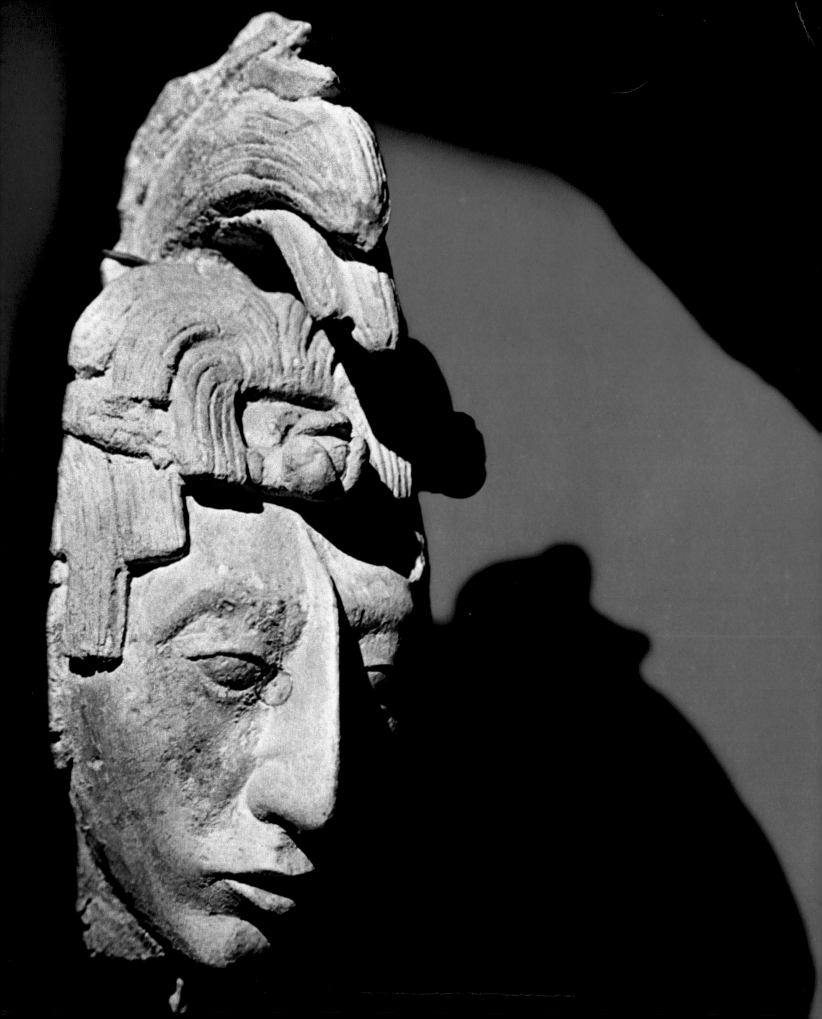

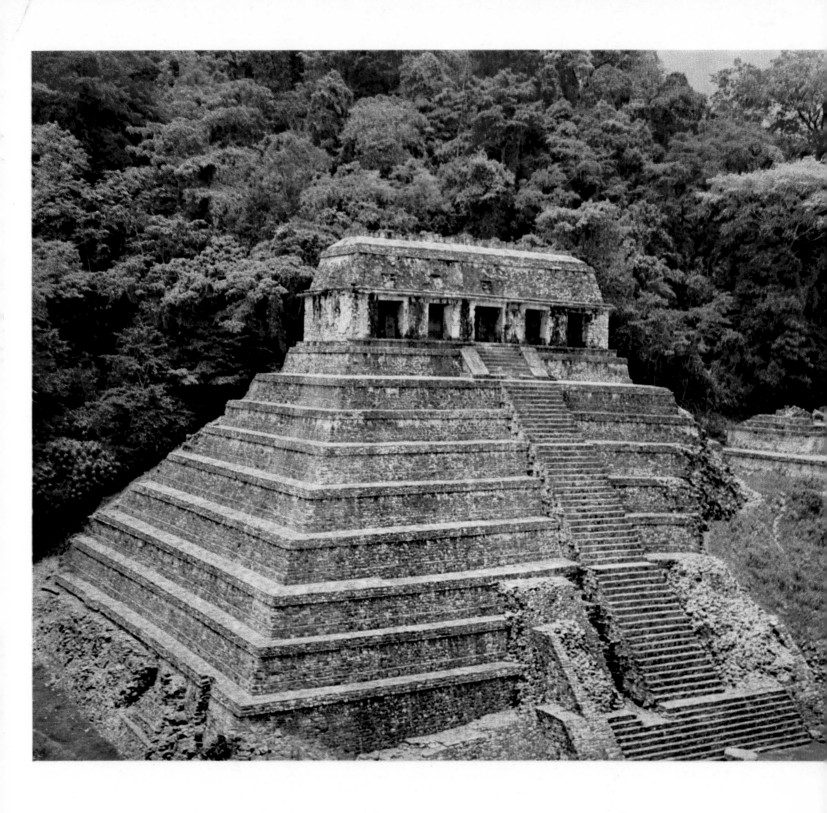

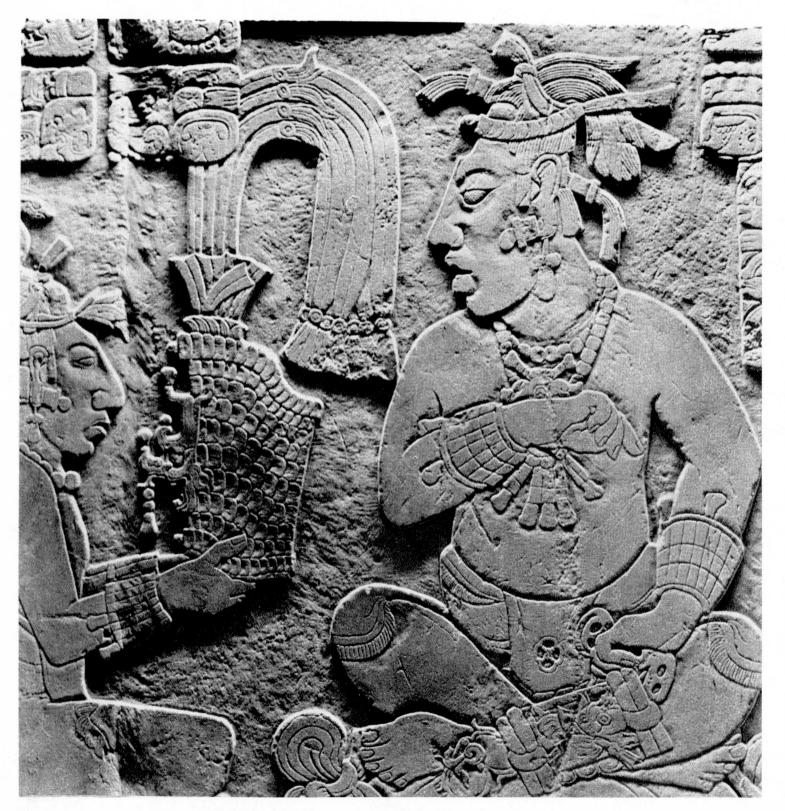

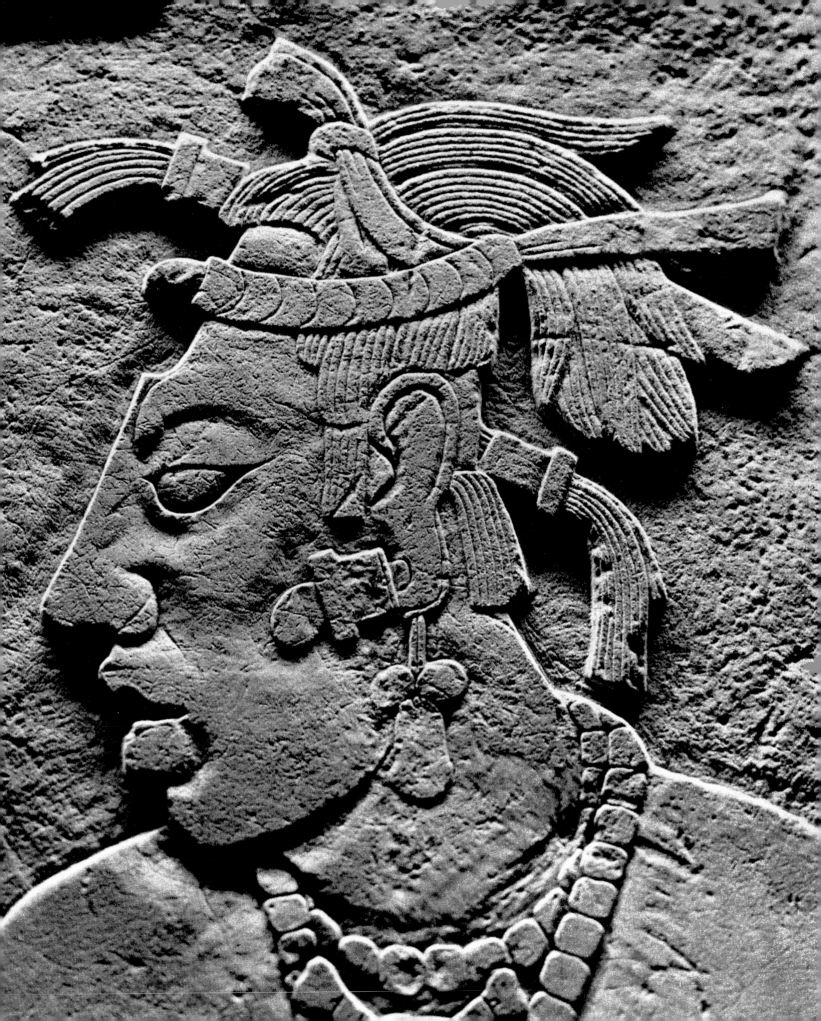

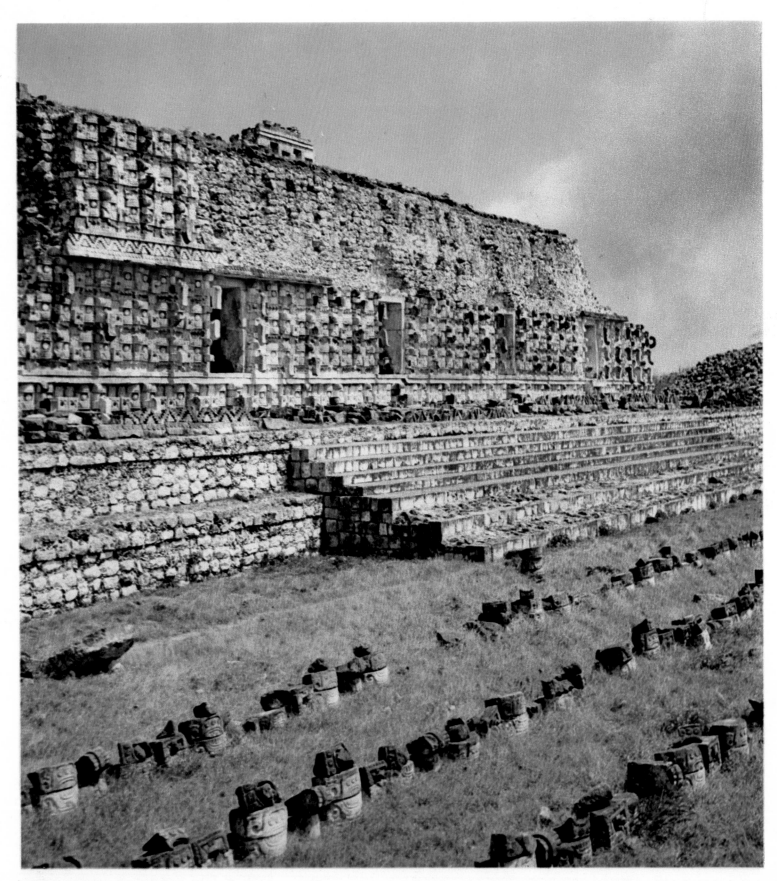

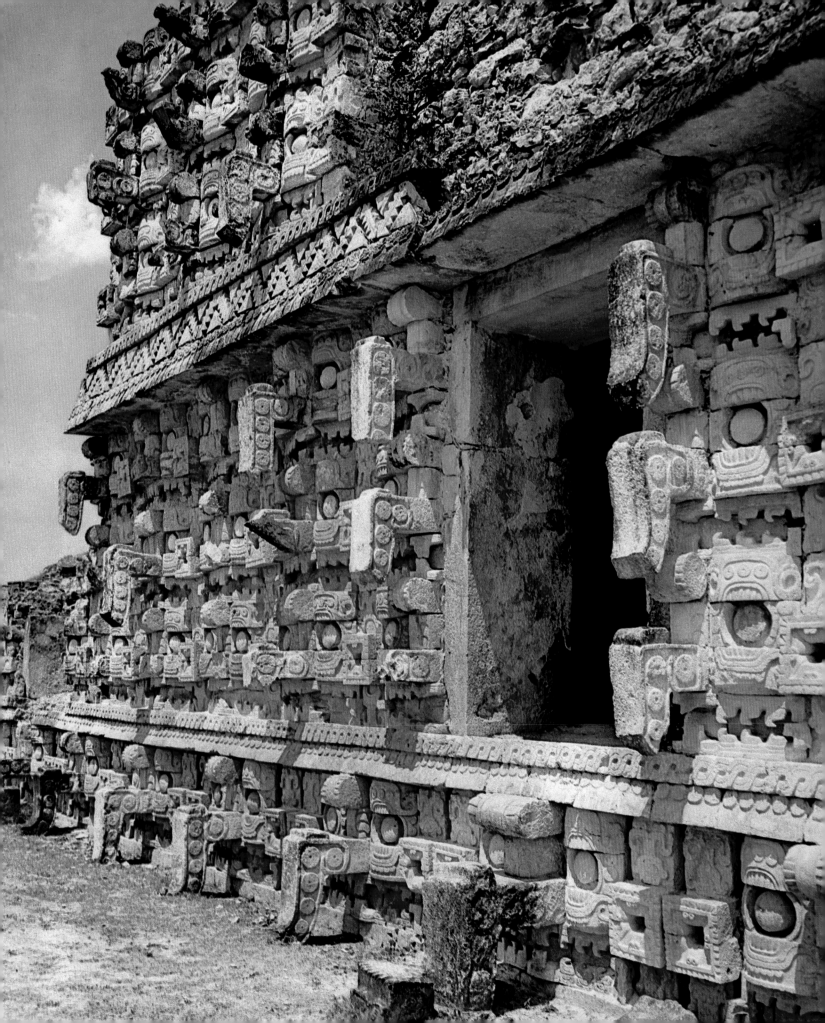

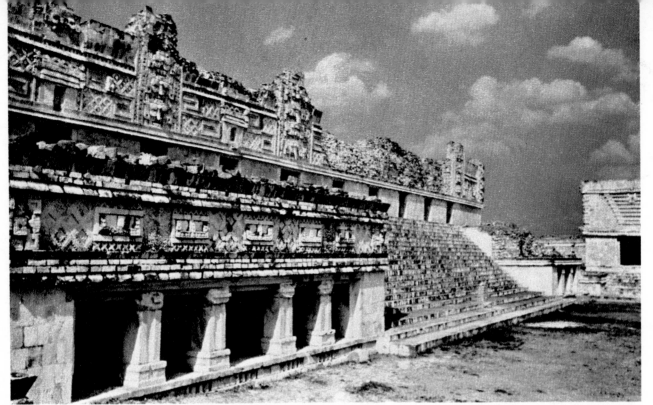

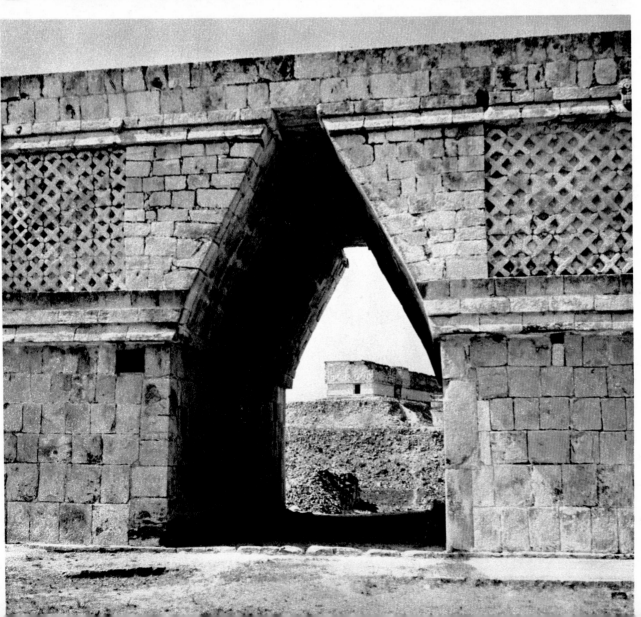

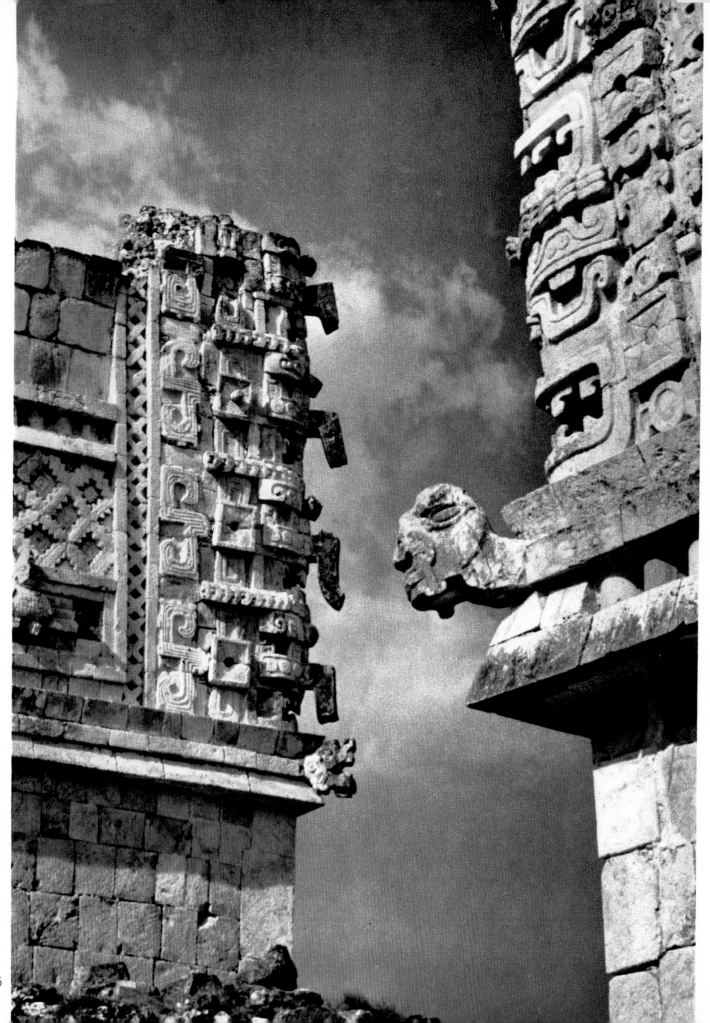

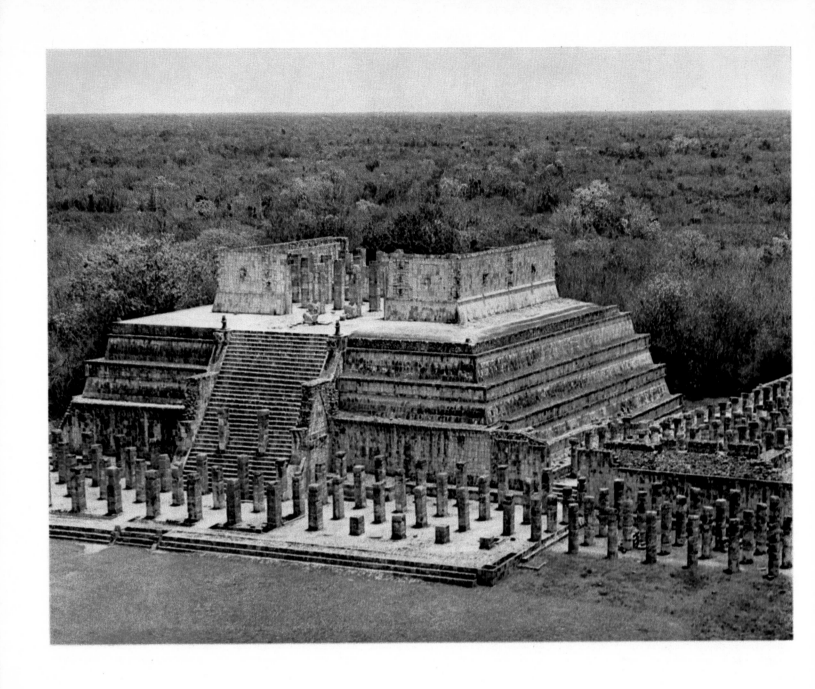

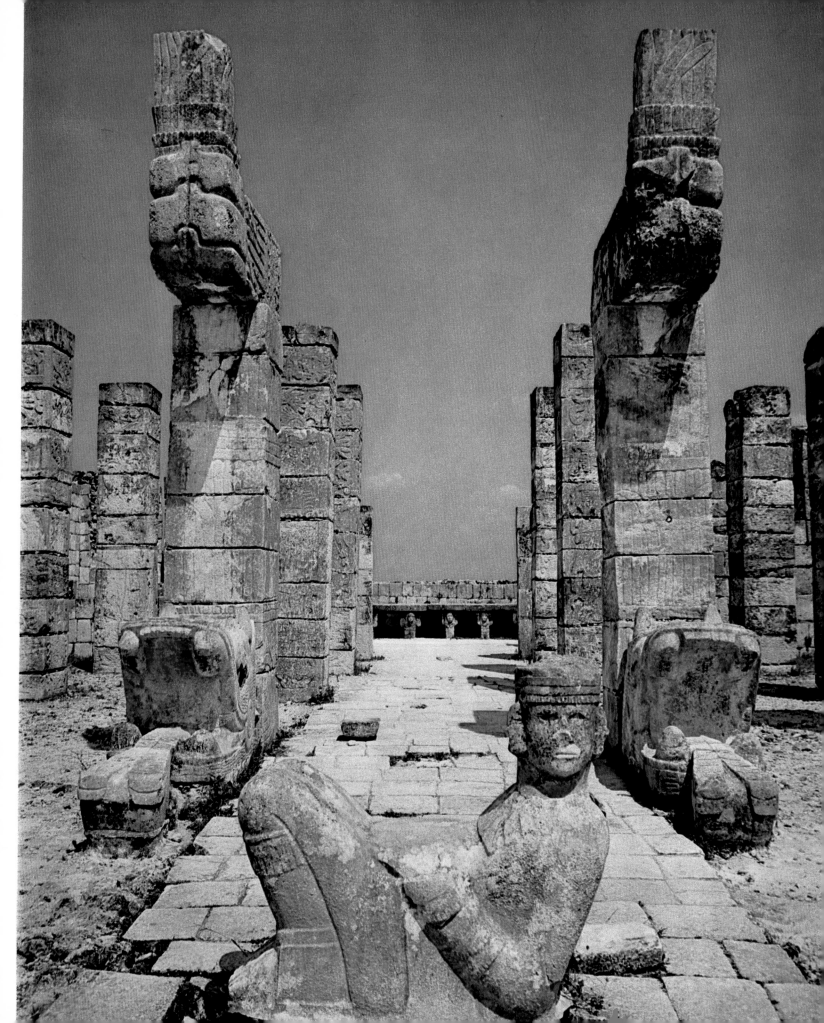

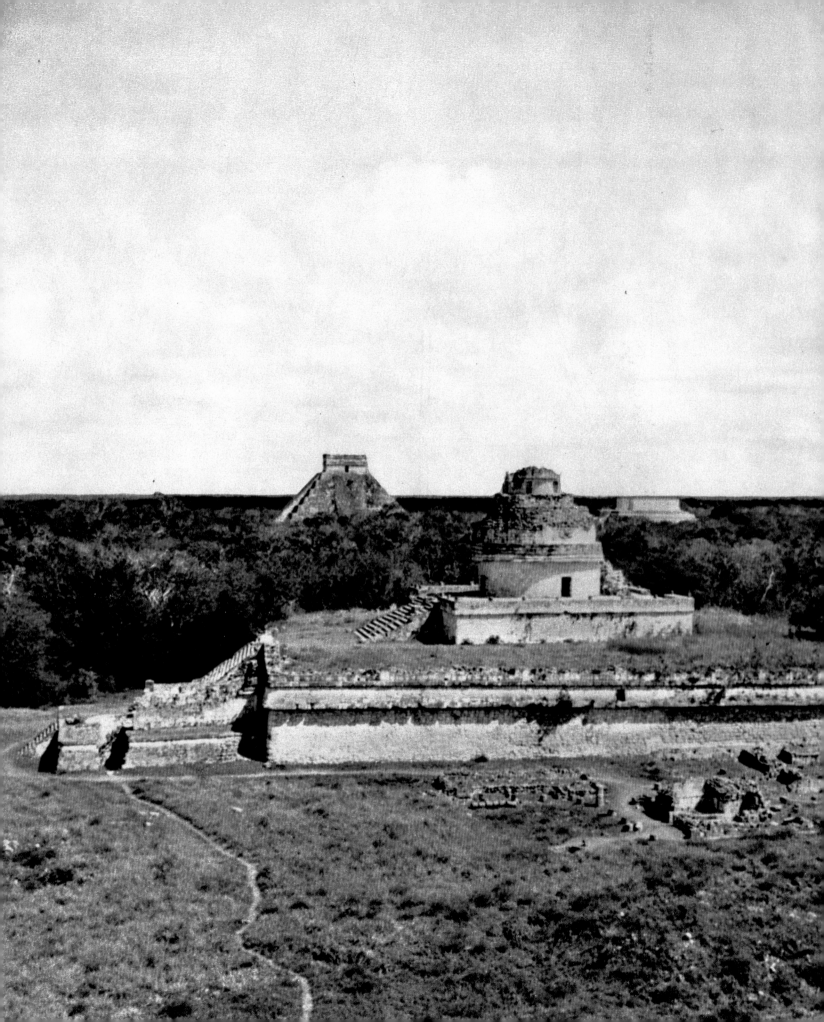

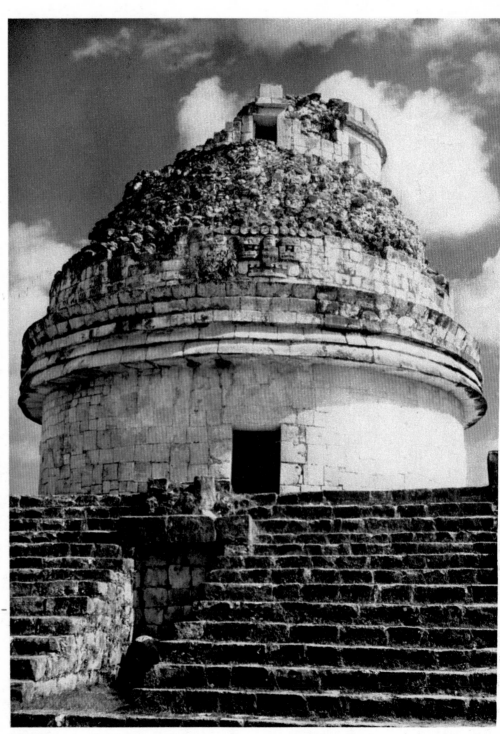

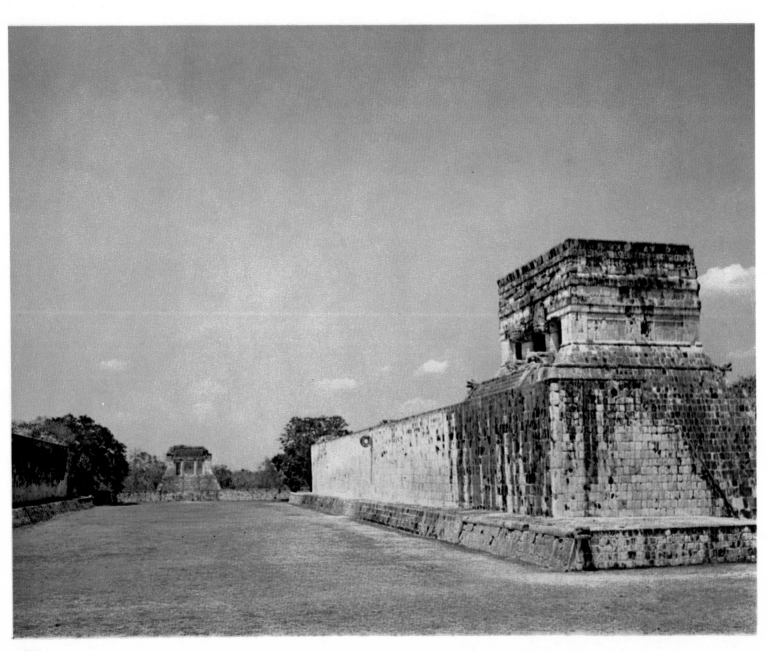

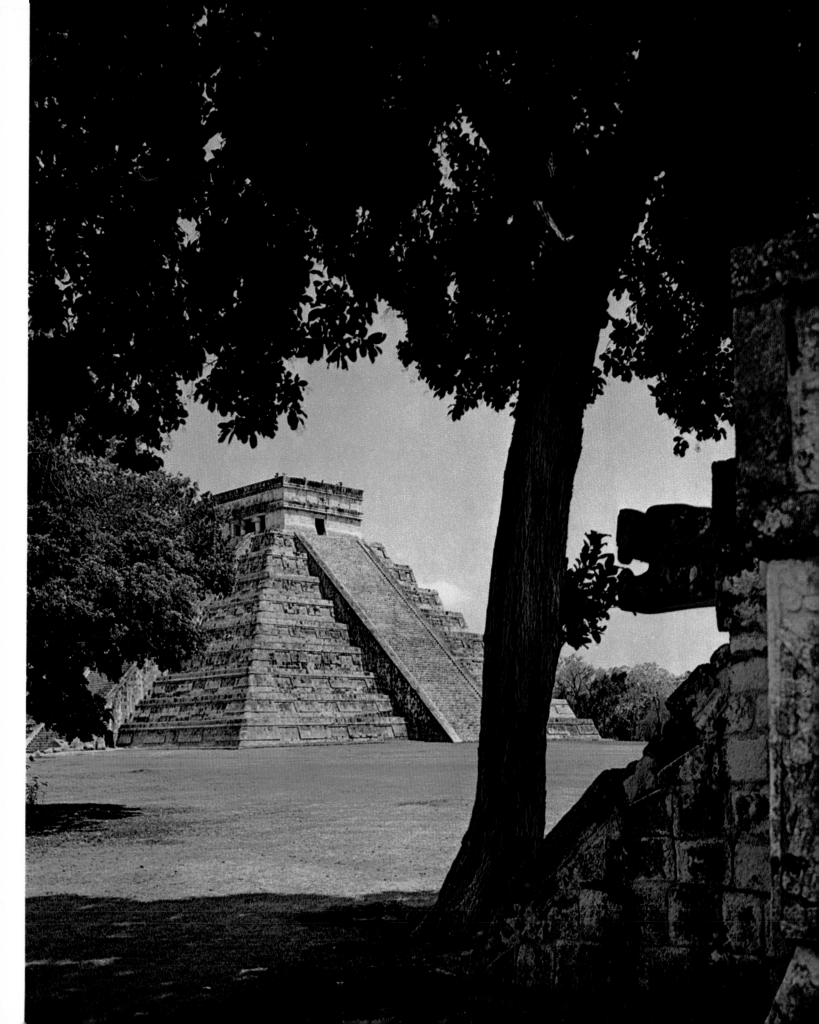

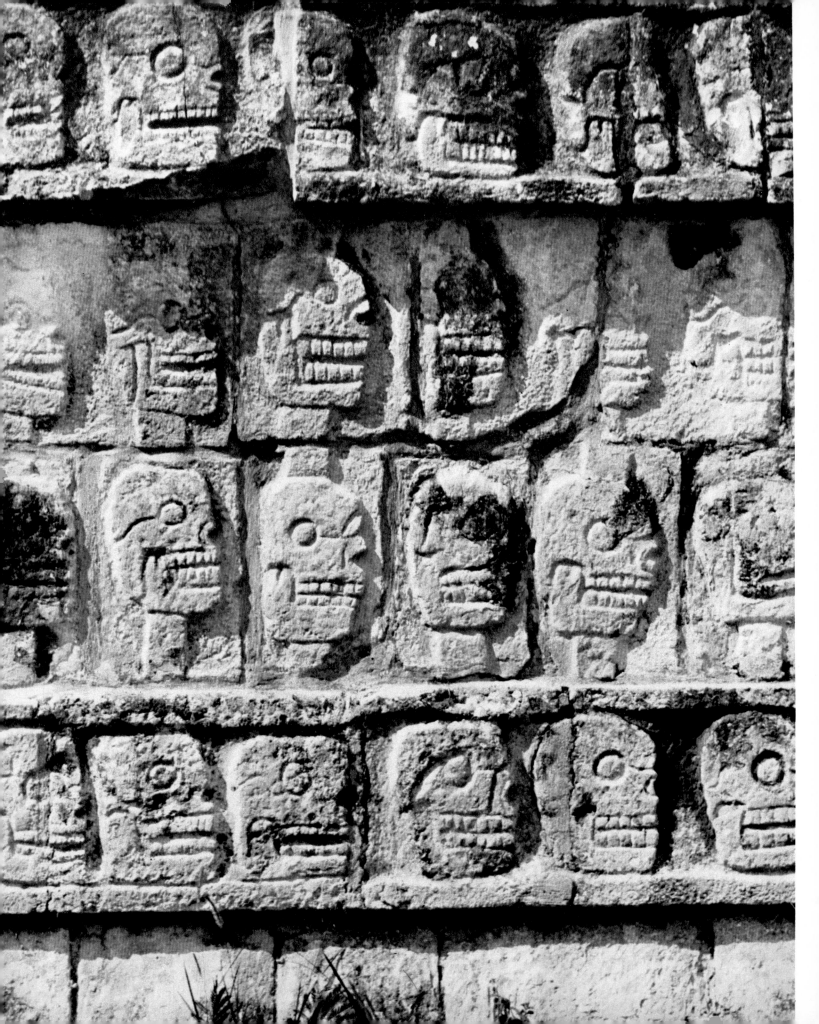

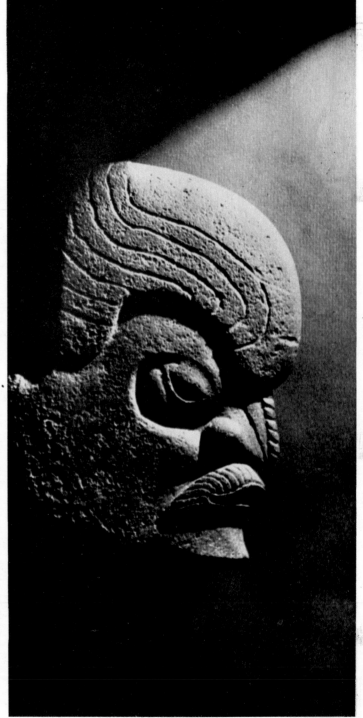

33/34/35

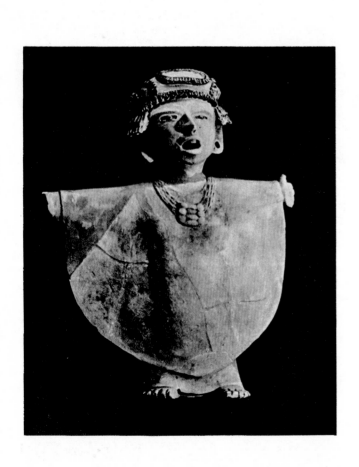

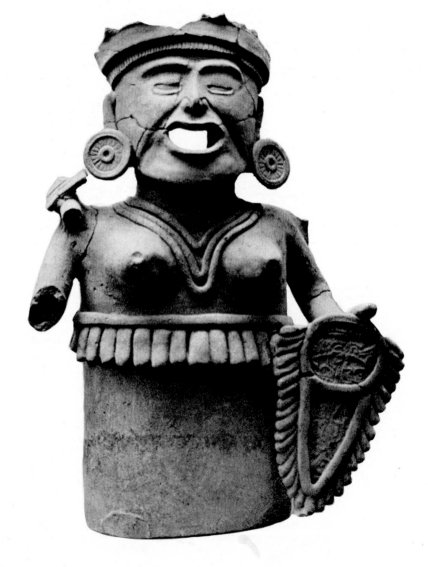

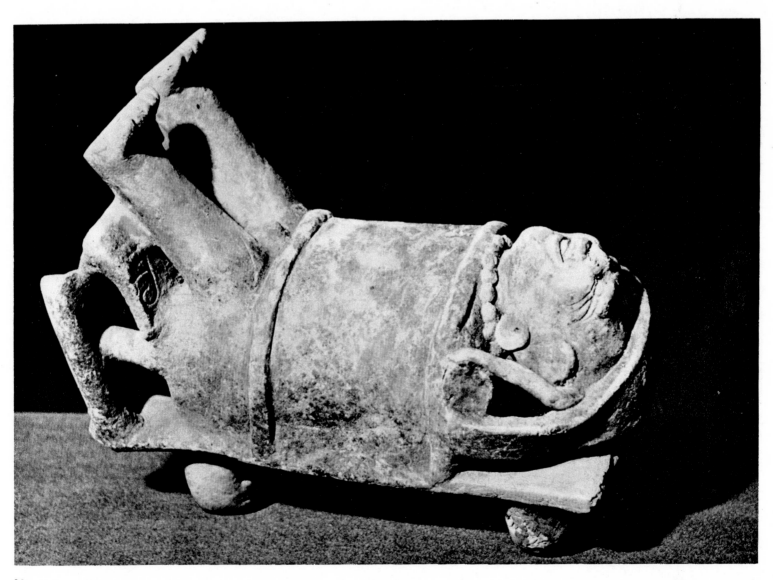

38

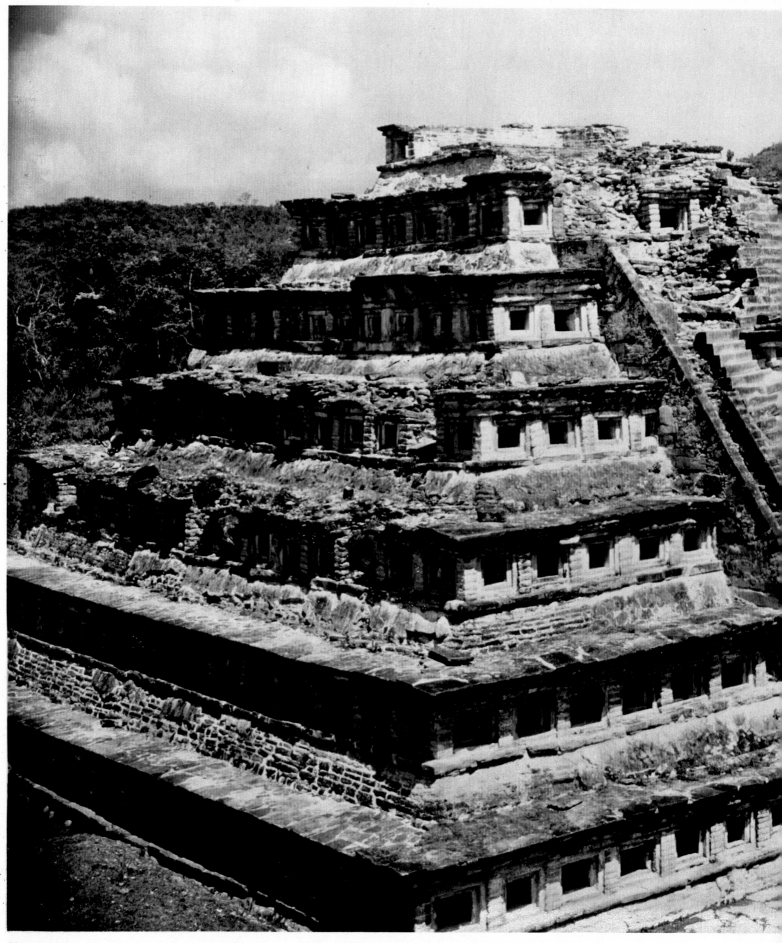

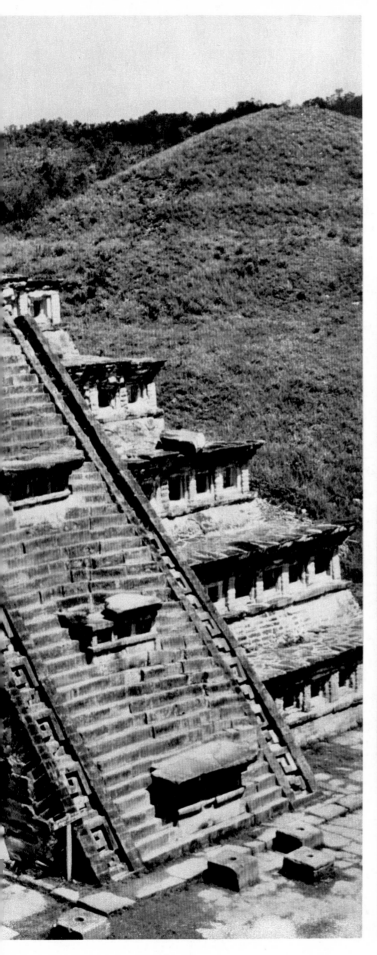

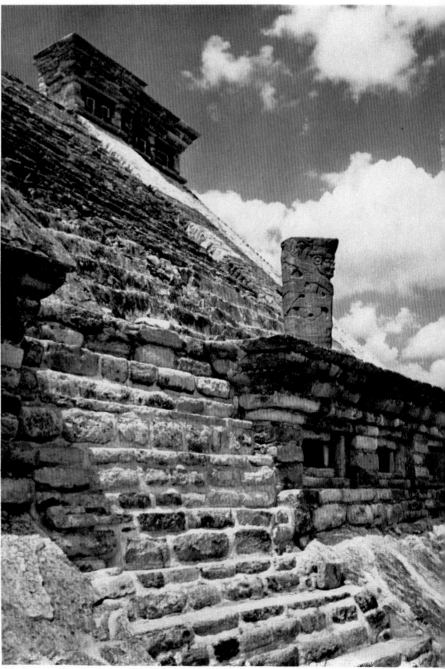

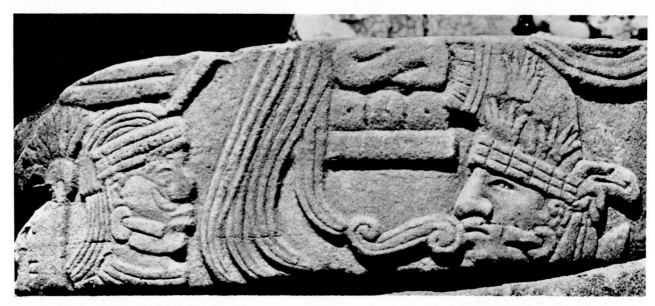

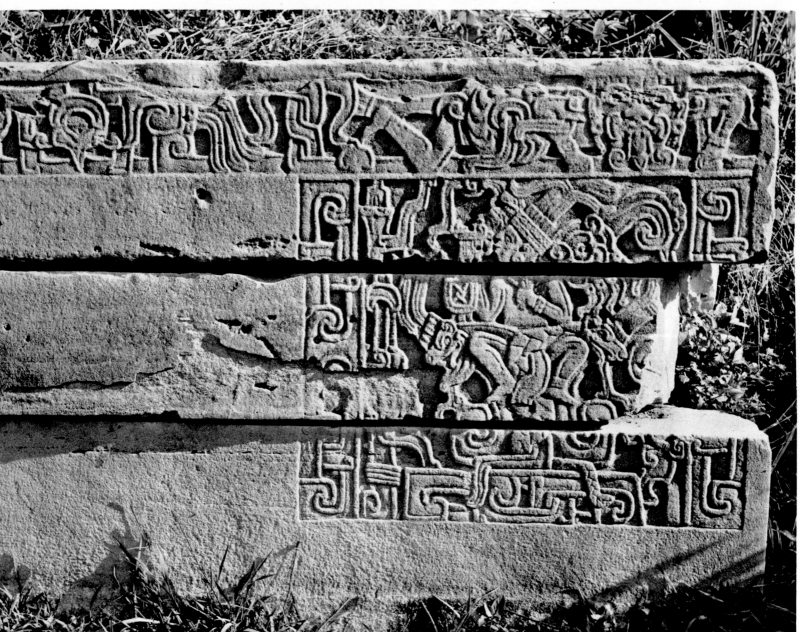

41/42

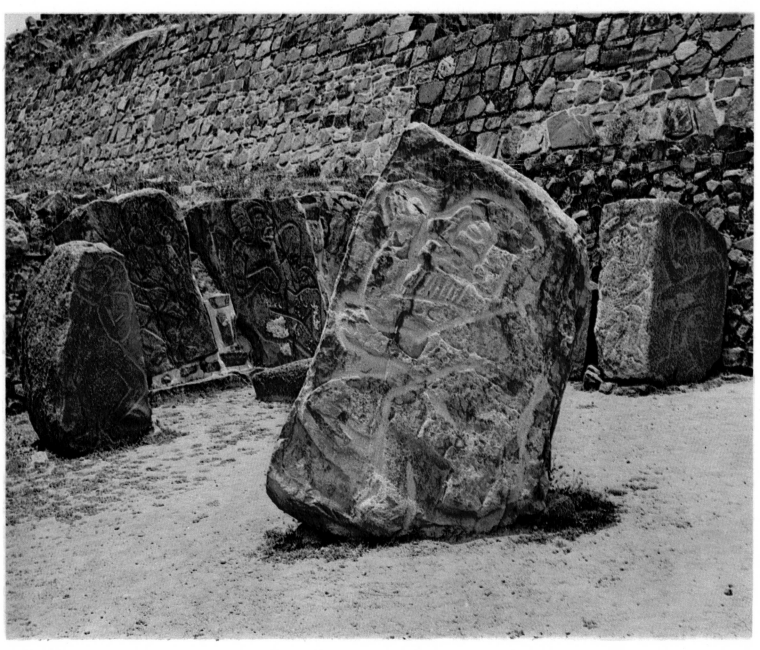

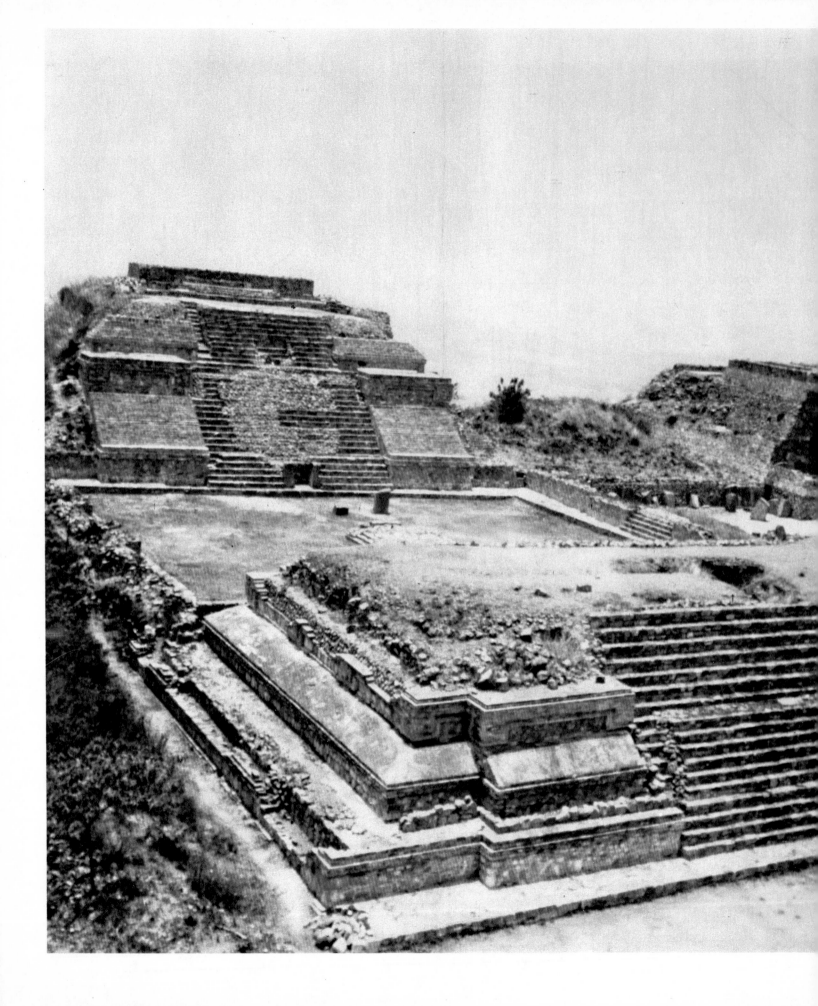

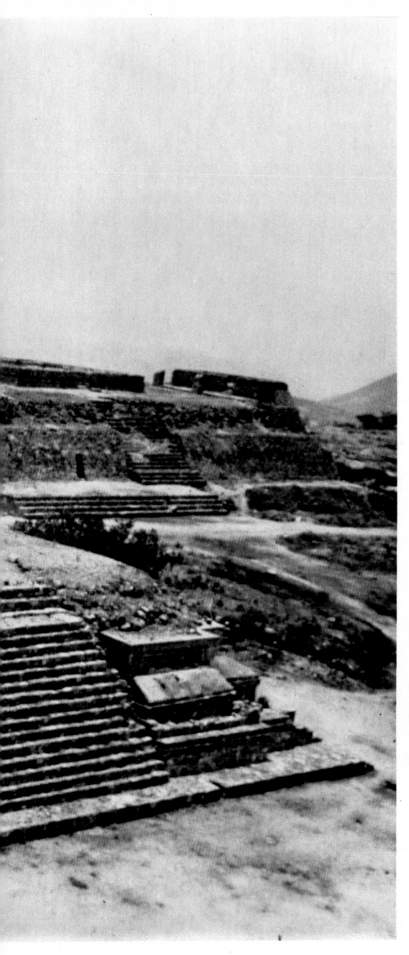

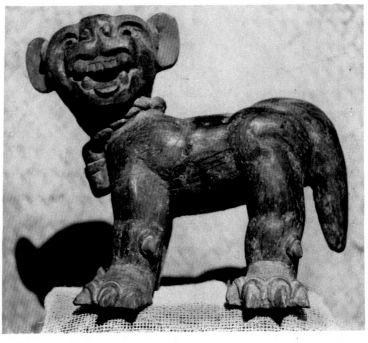

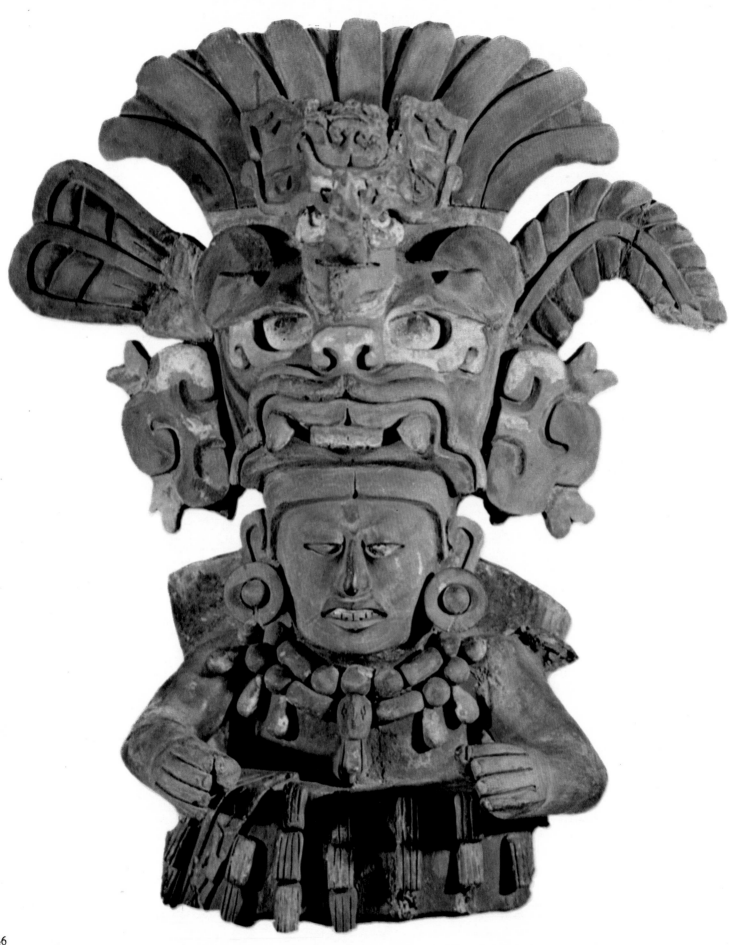

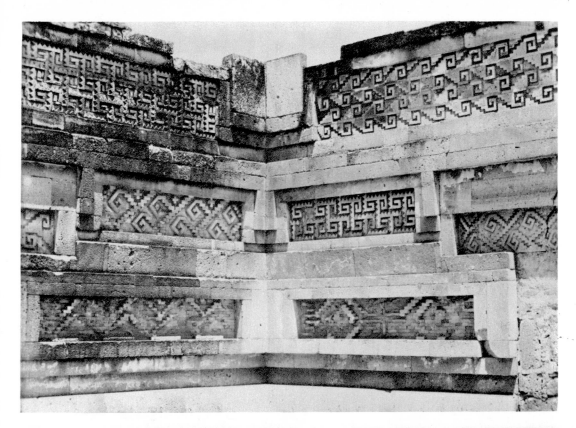

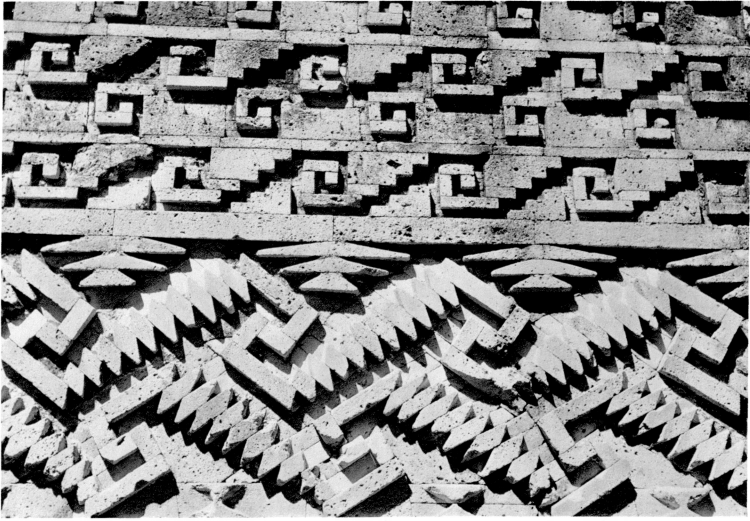

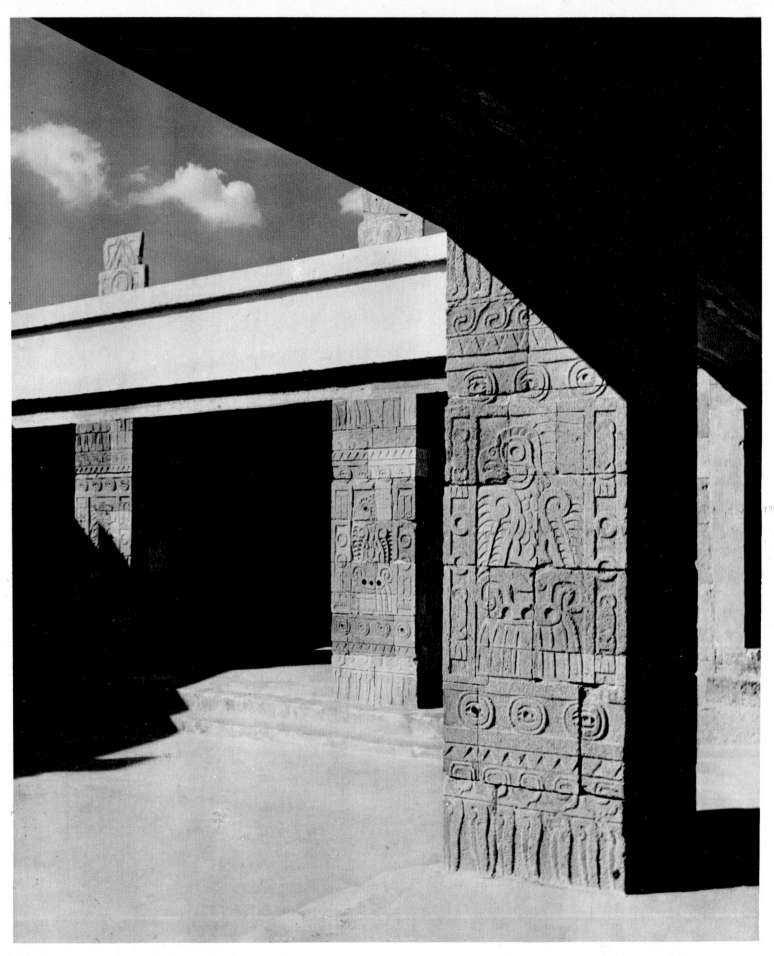

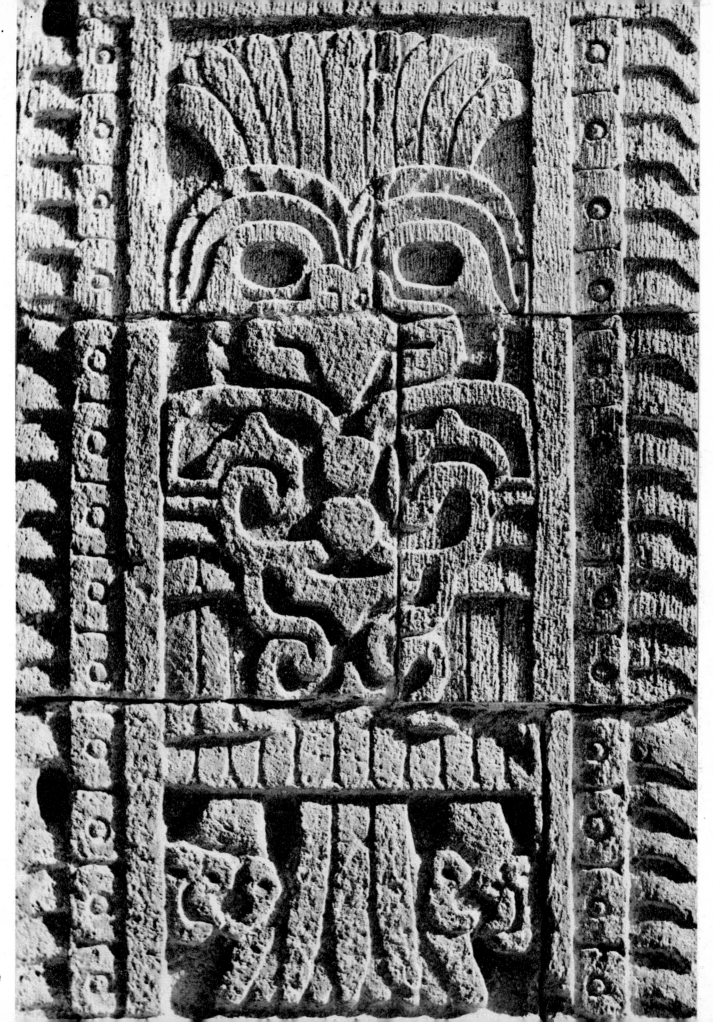

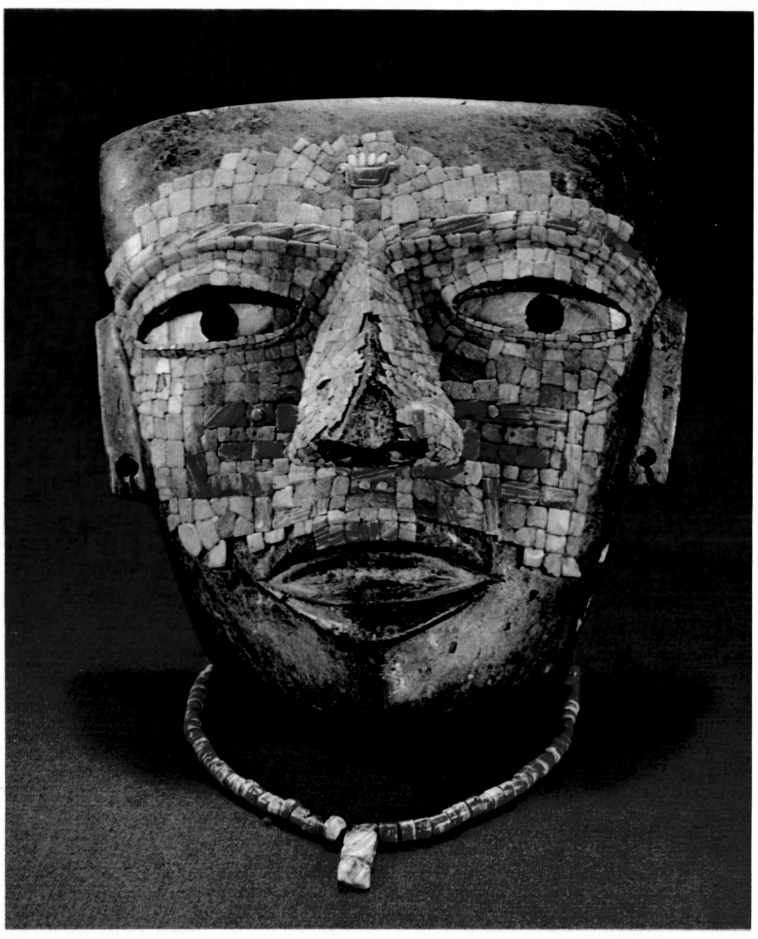

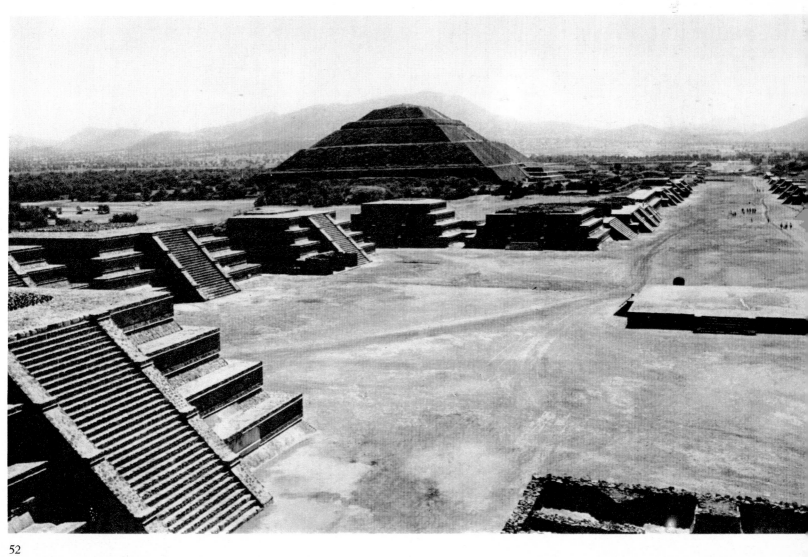

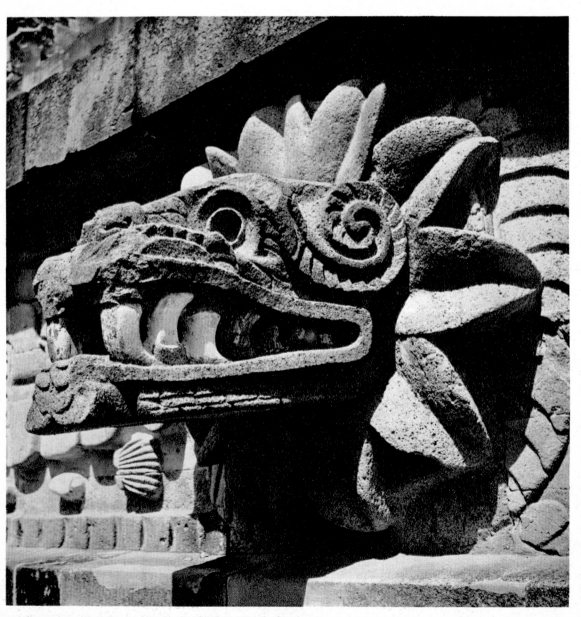

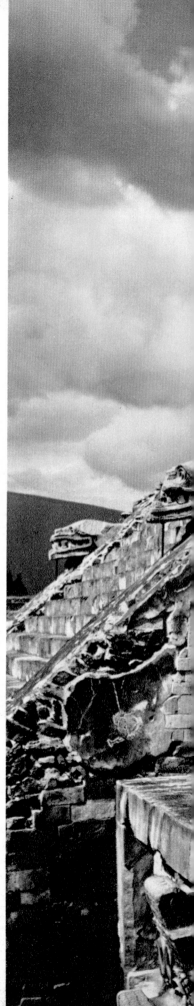

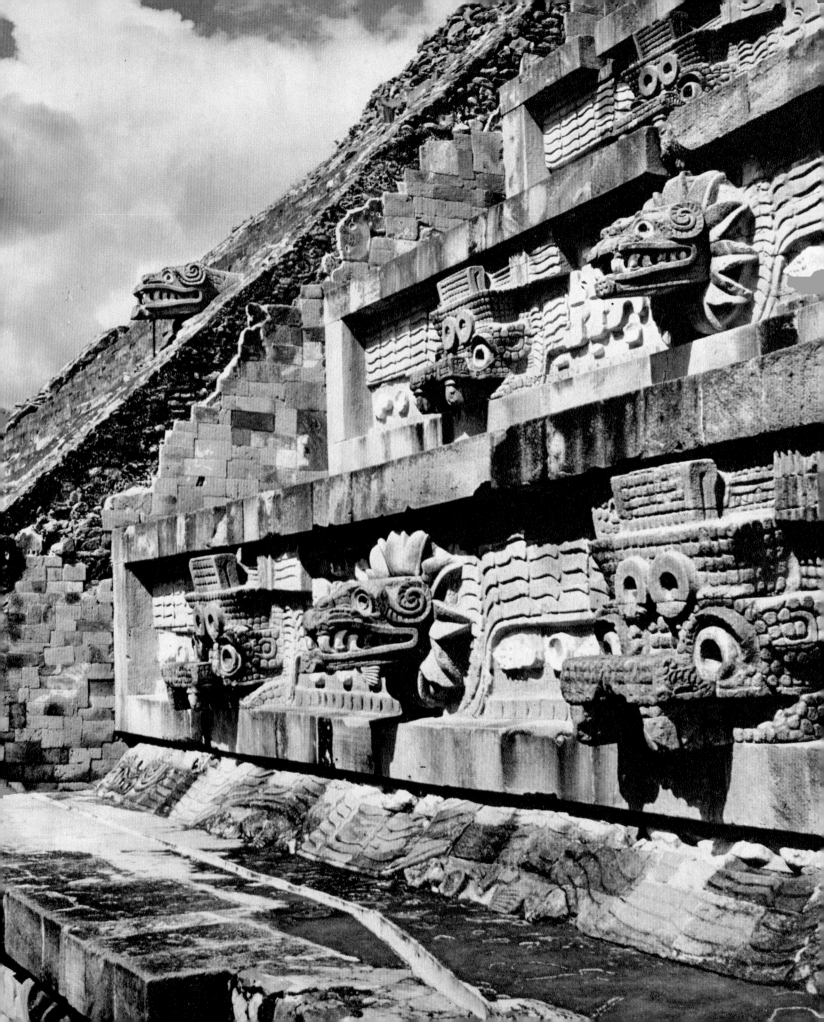

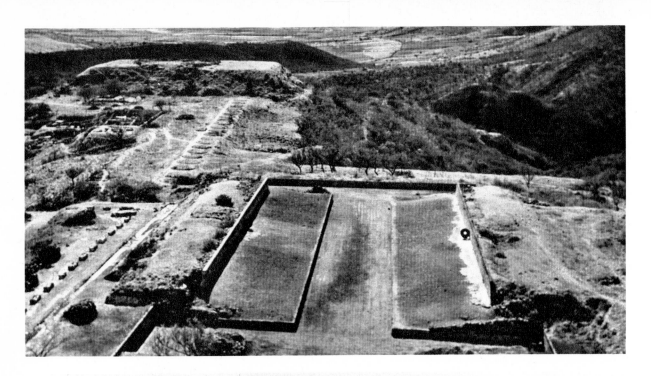

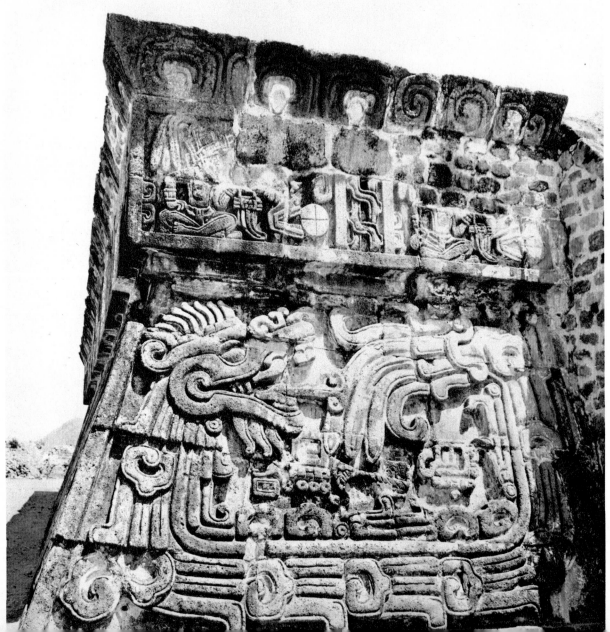

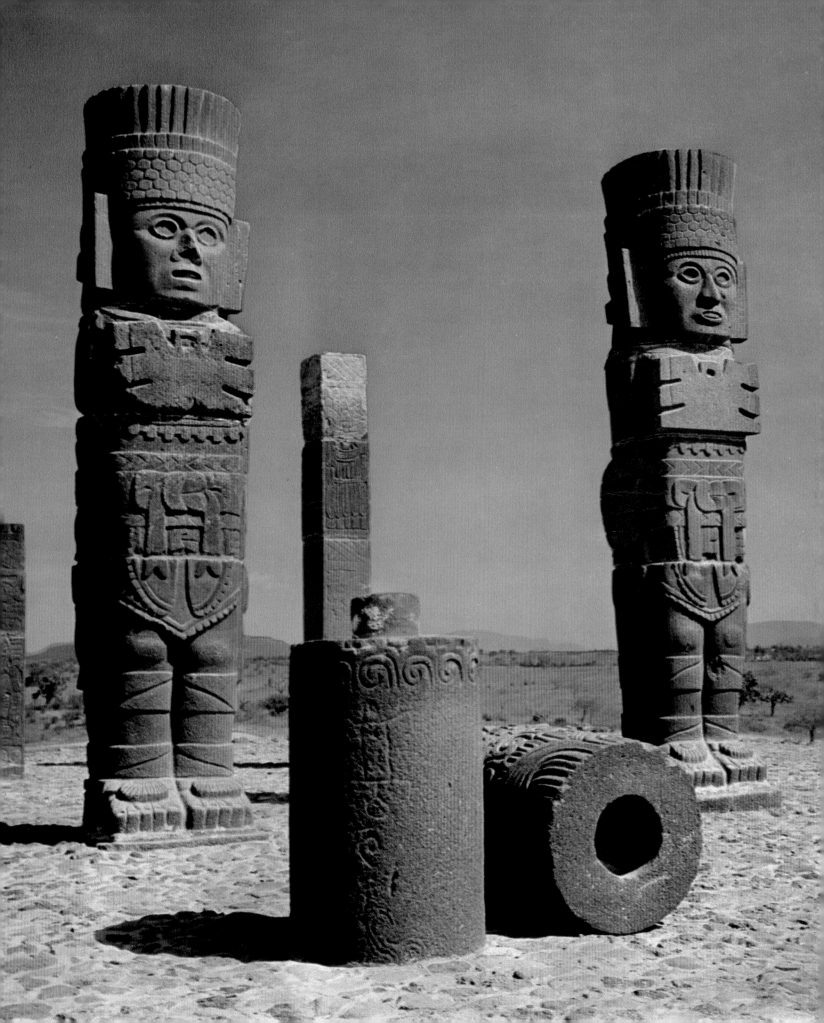

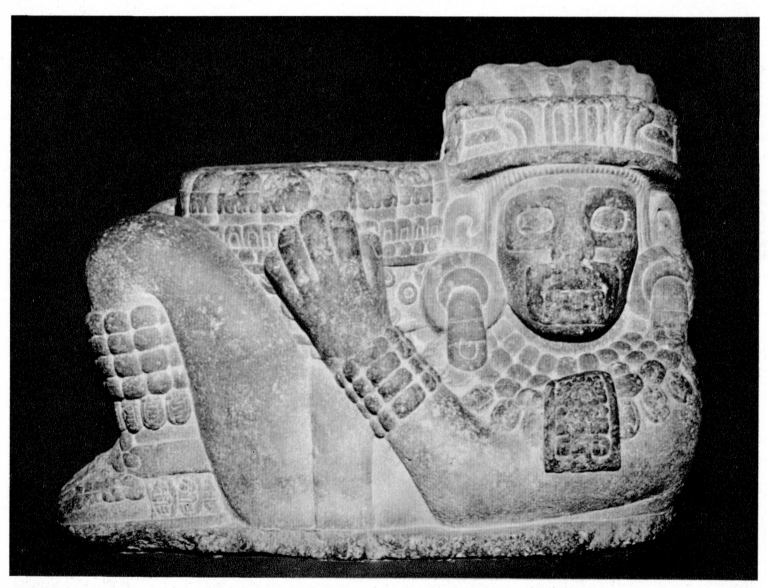

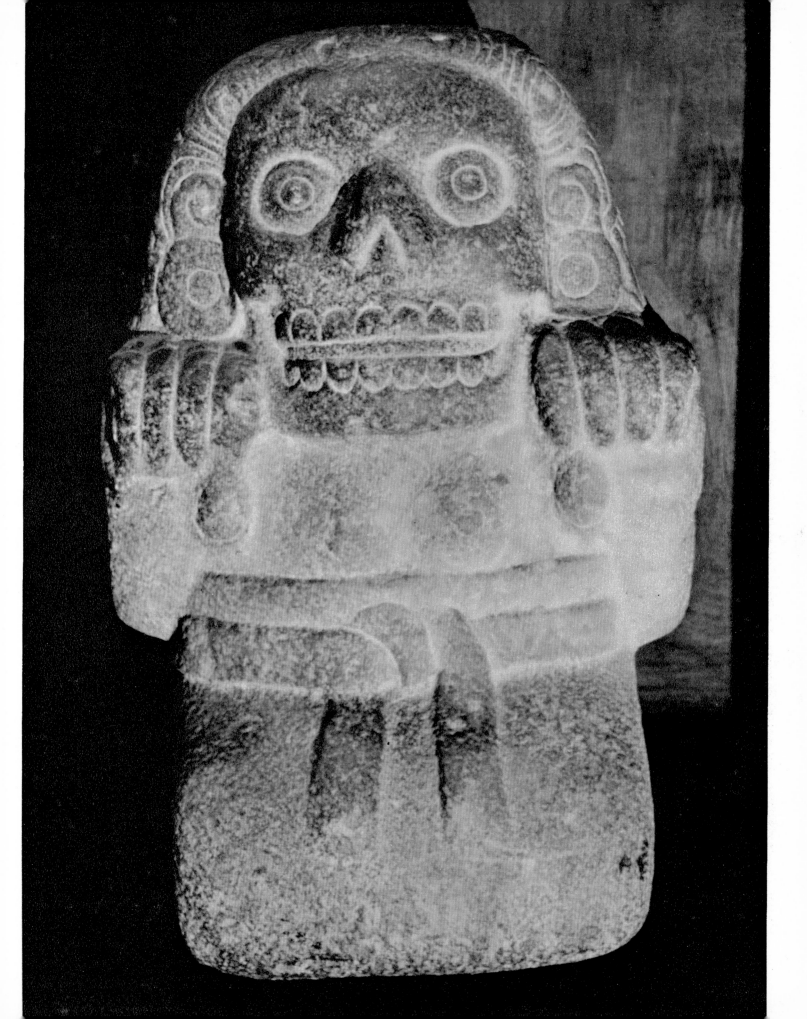

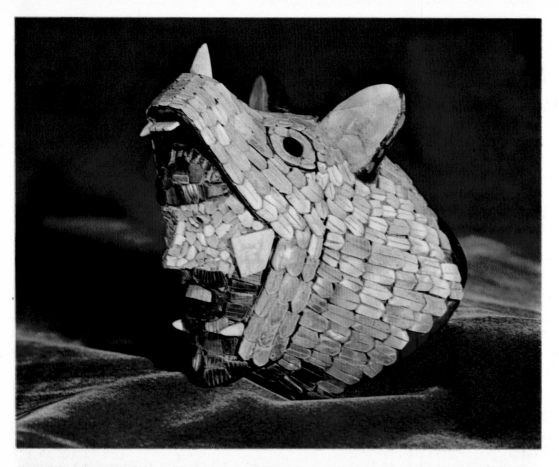

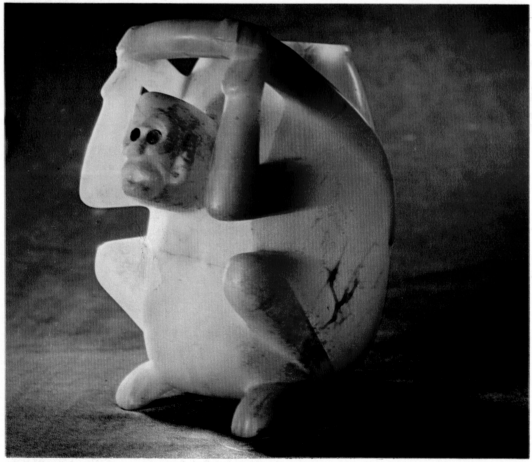

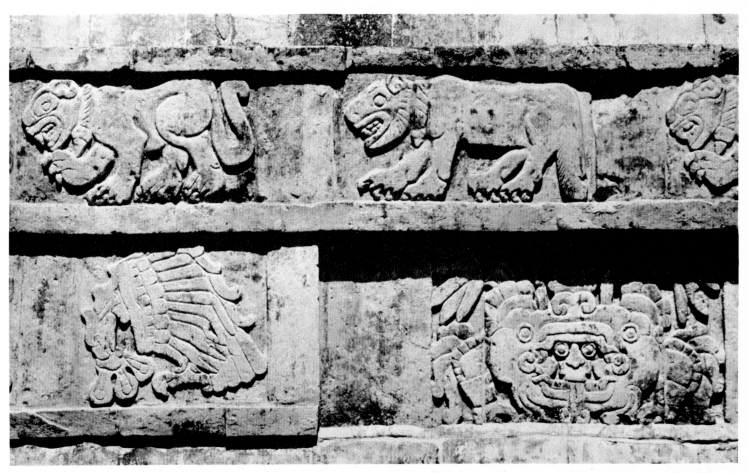

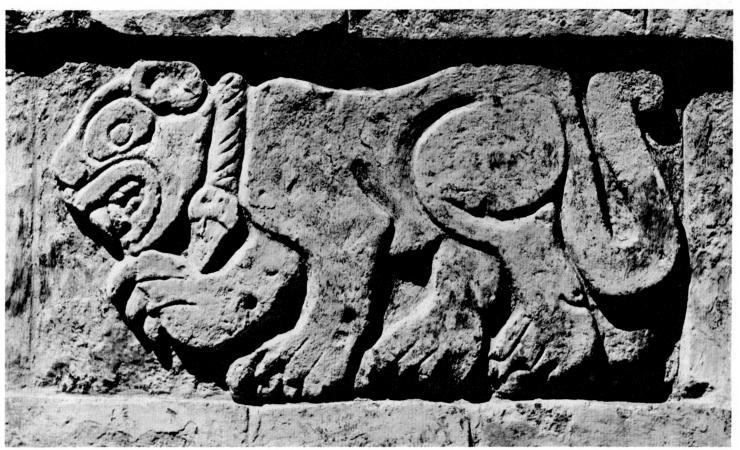

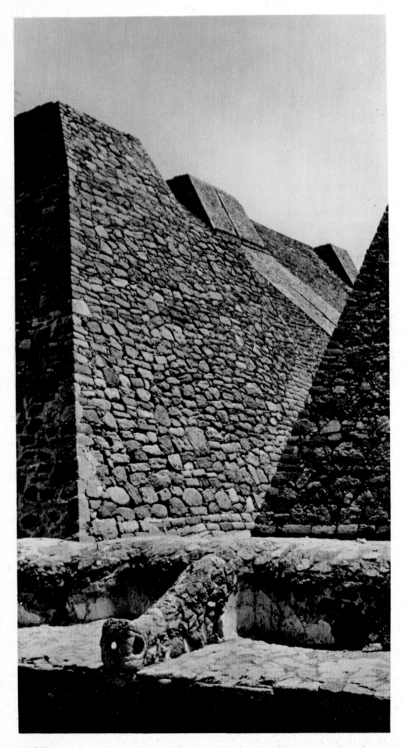

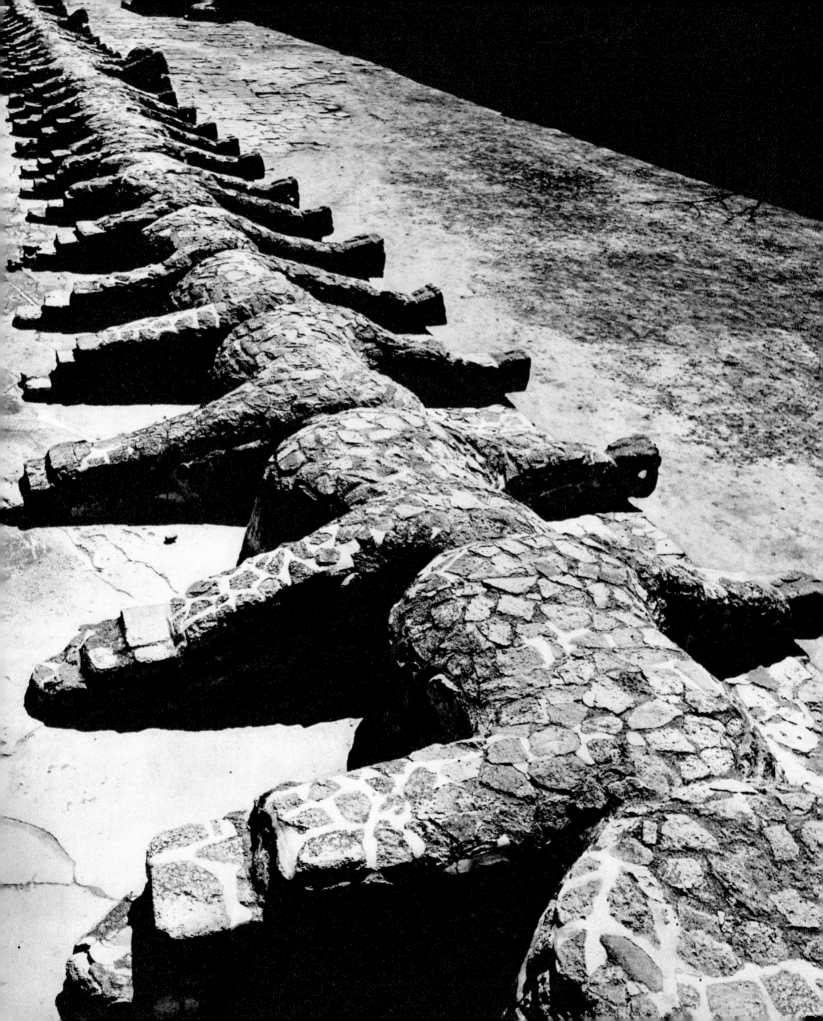

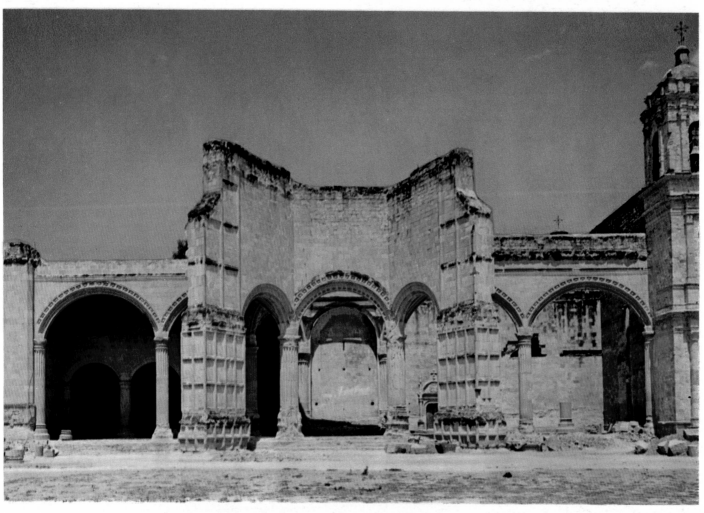

68

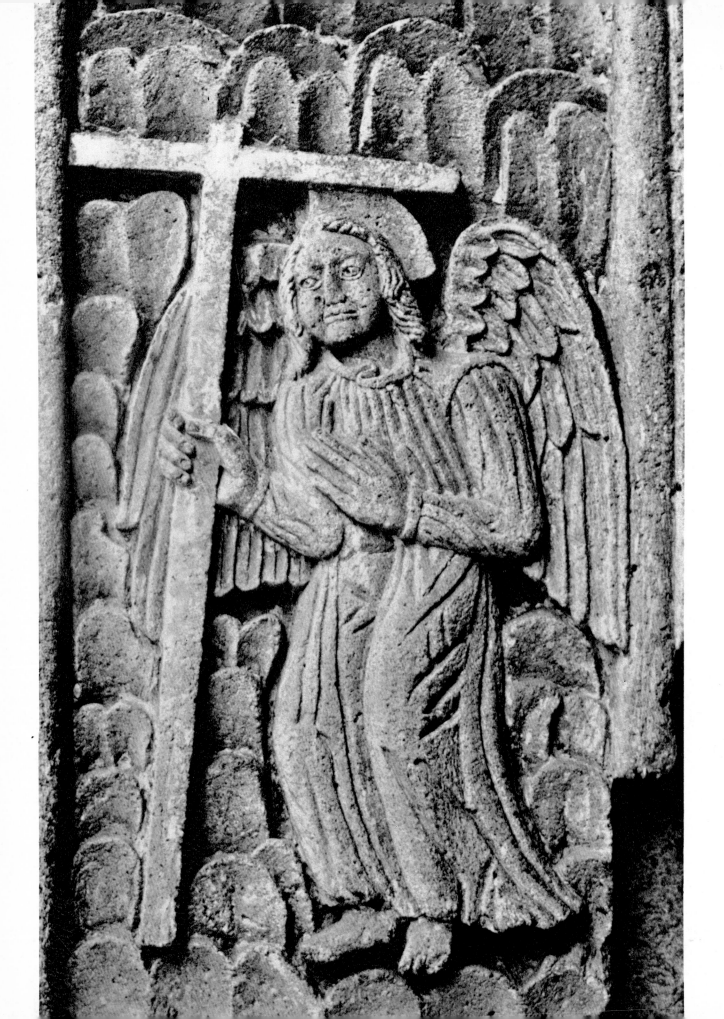

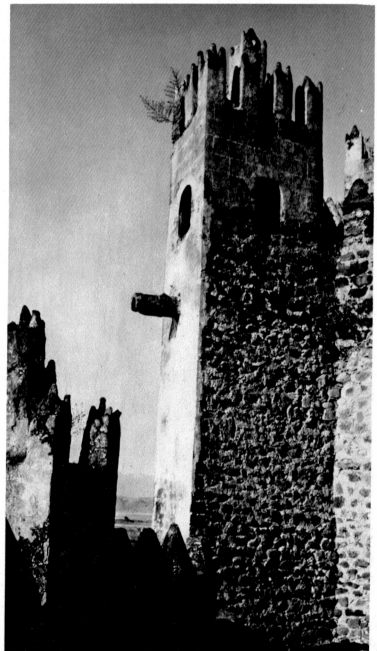

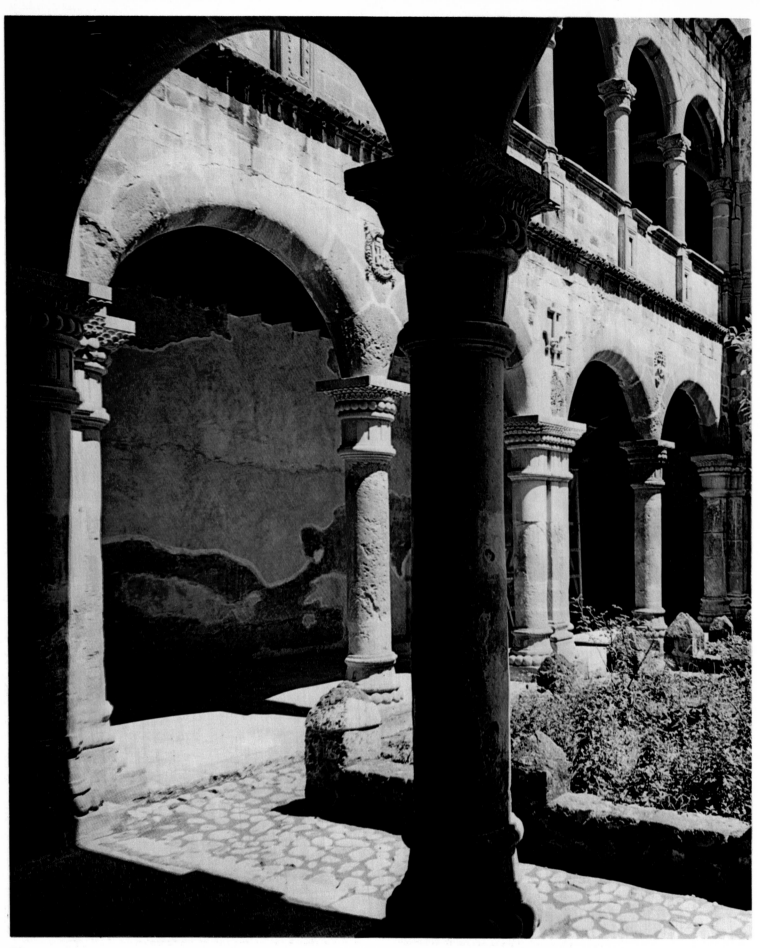

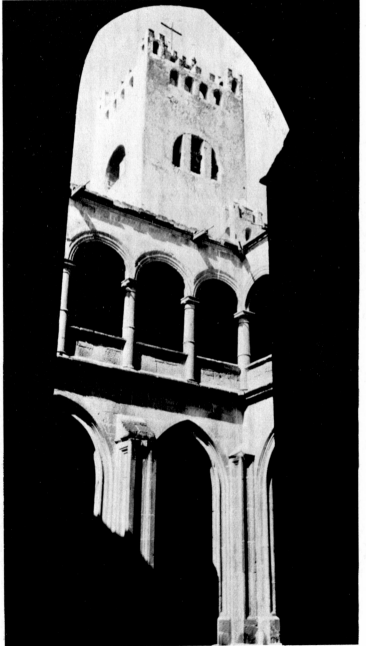

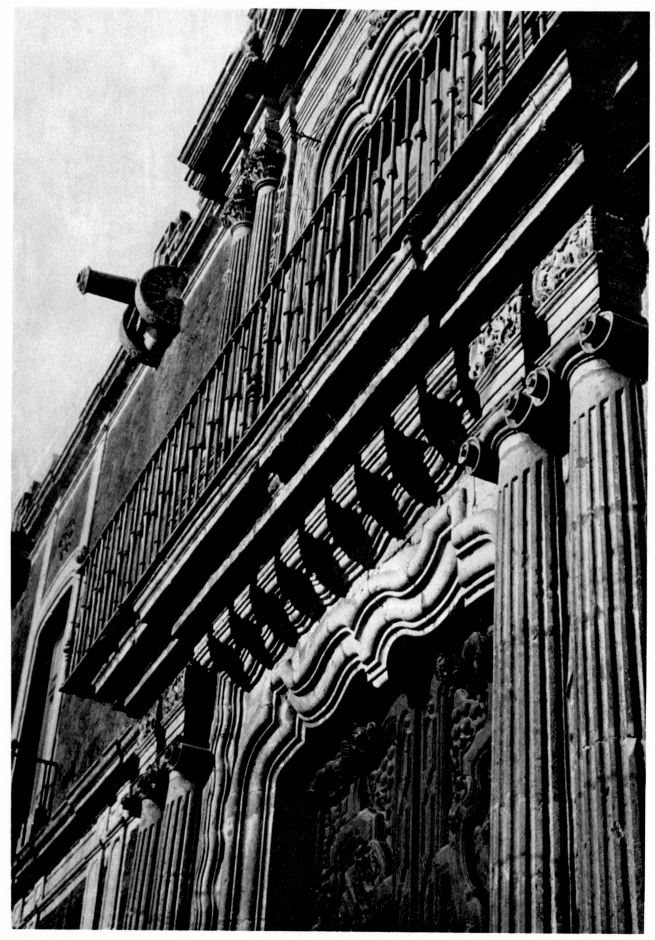

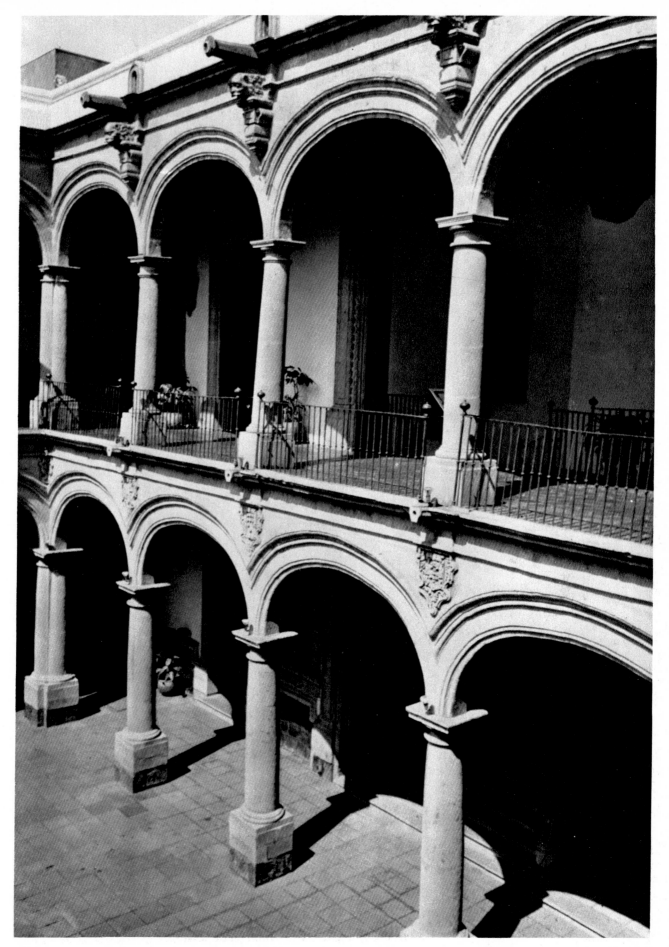

76/77/78

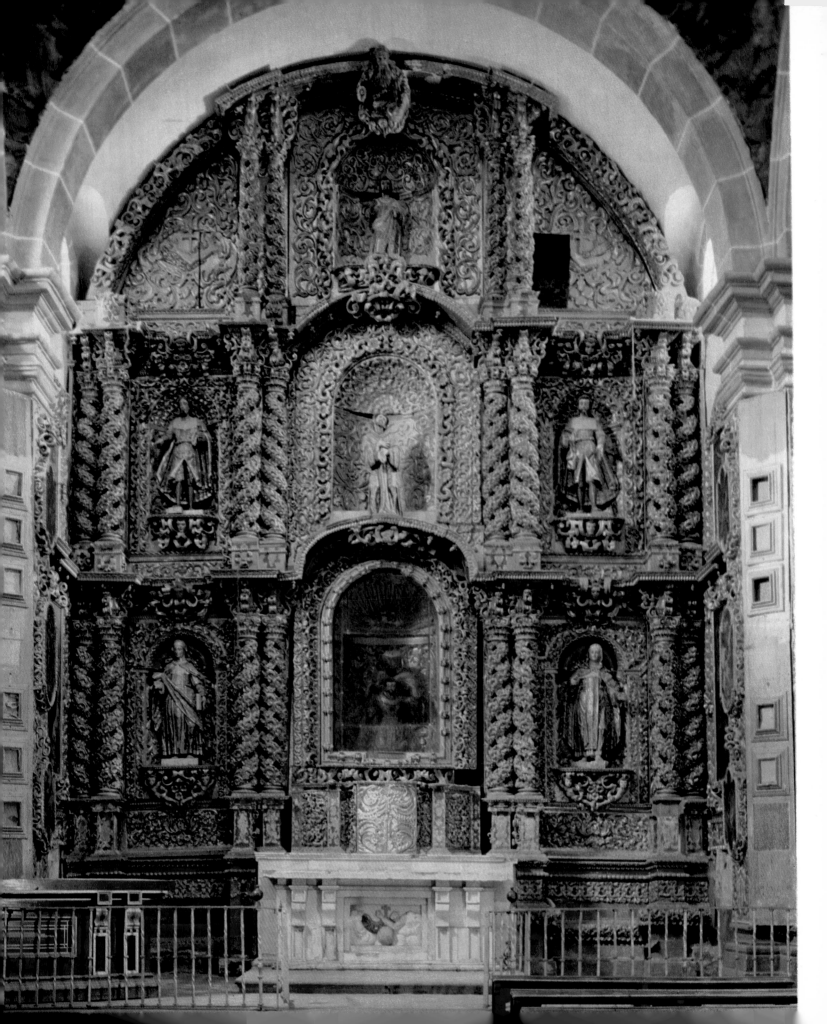

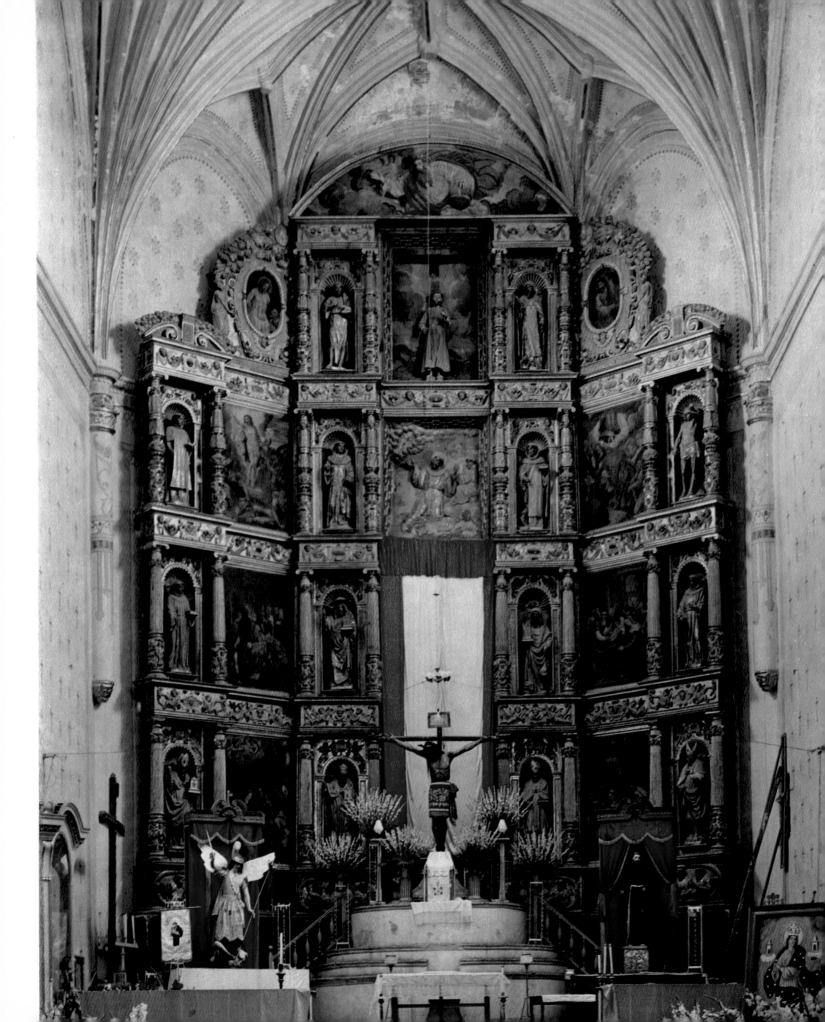

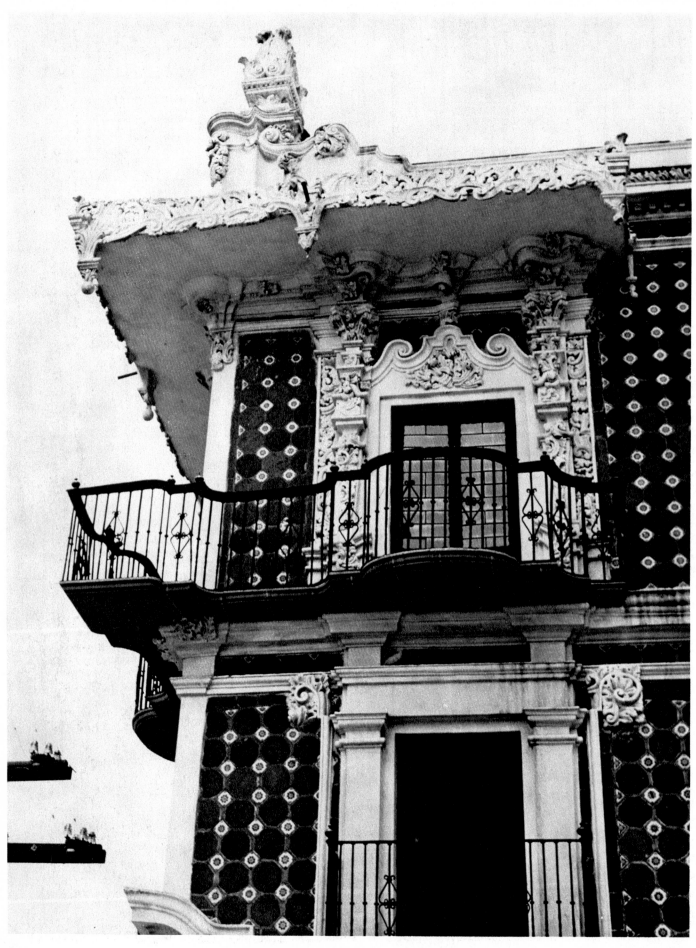

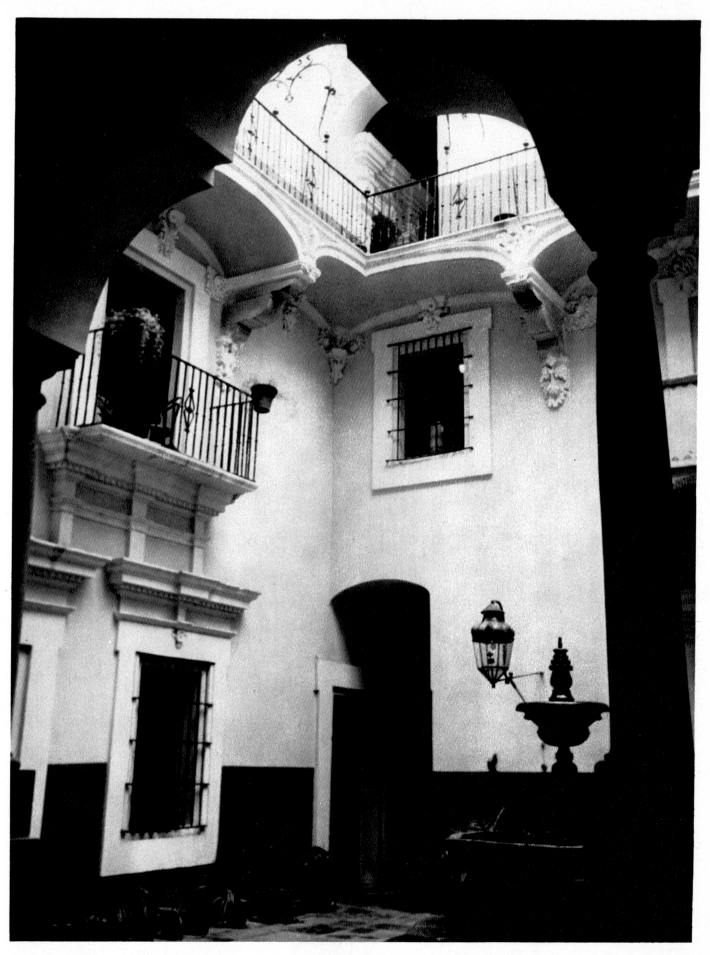

80/81/82/83/84

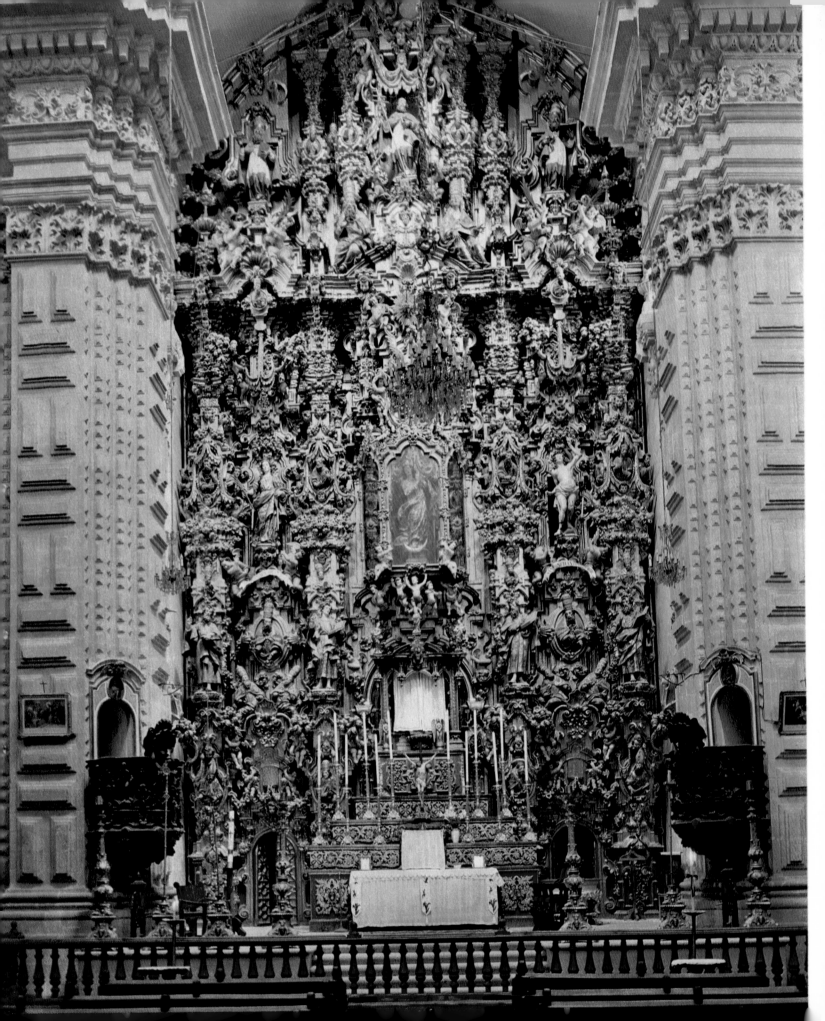

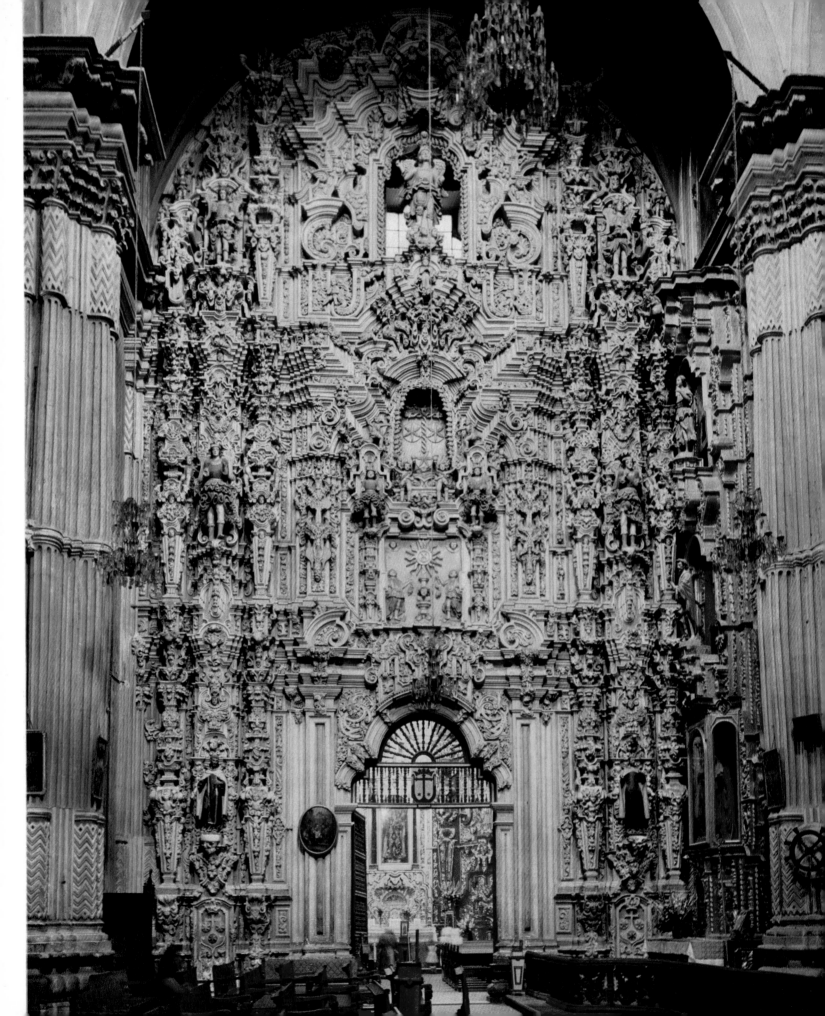

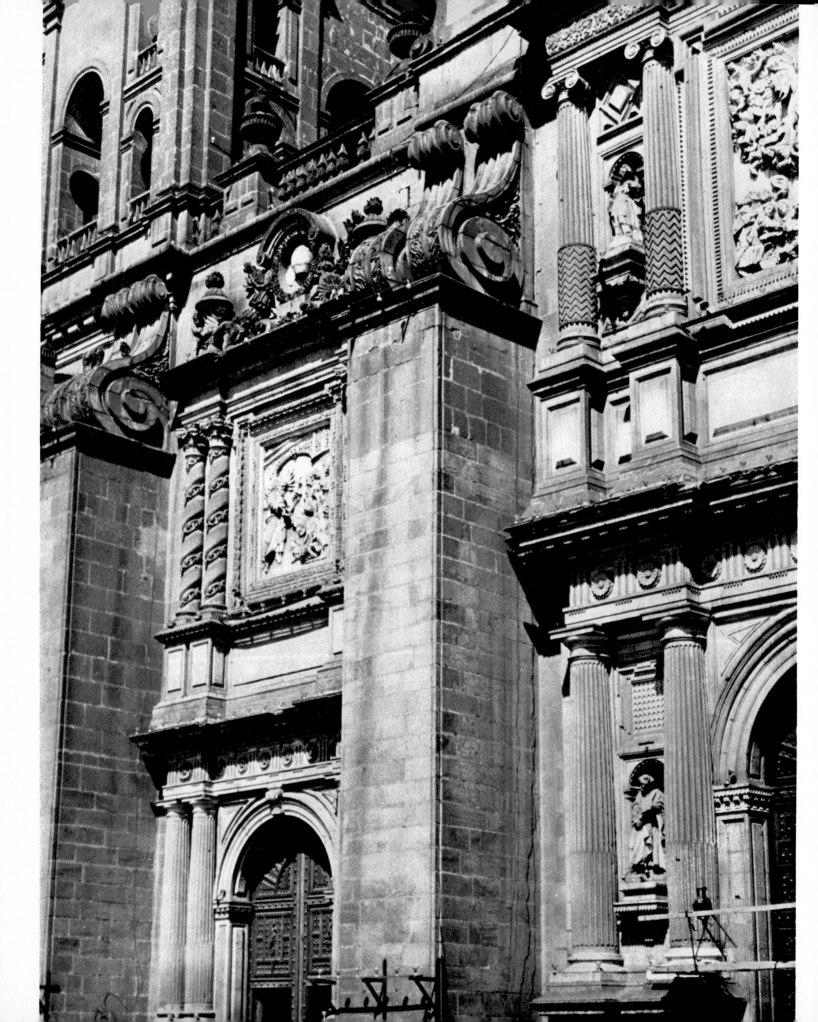

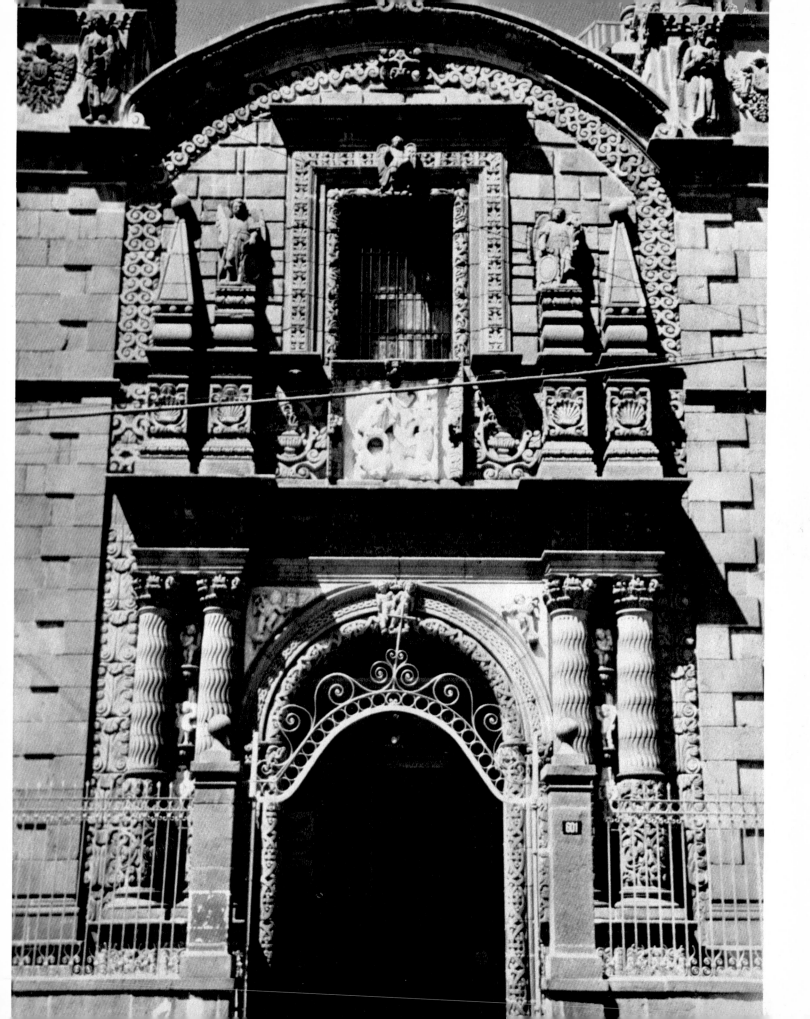

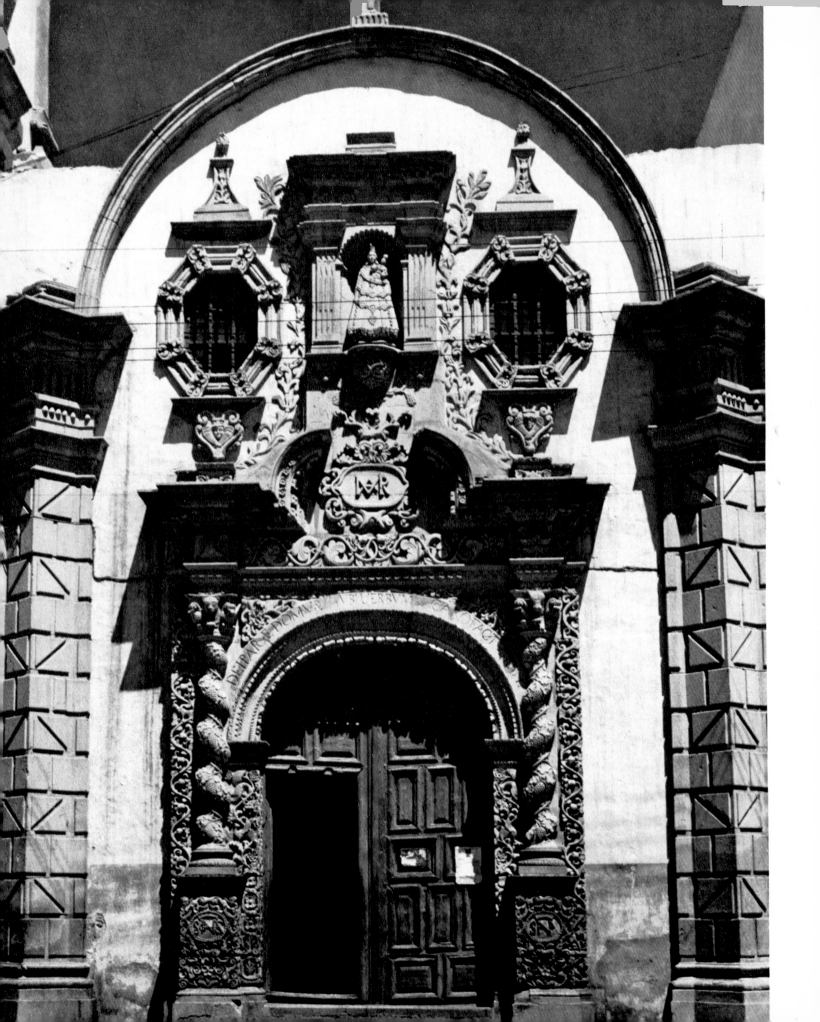

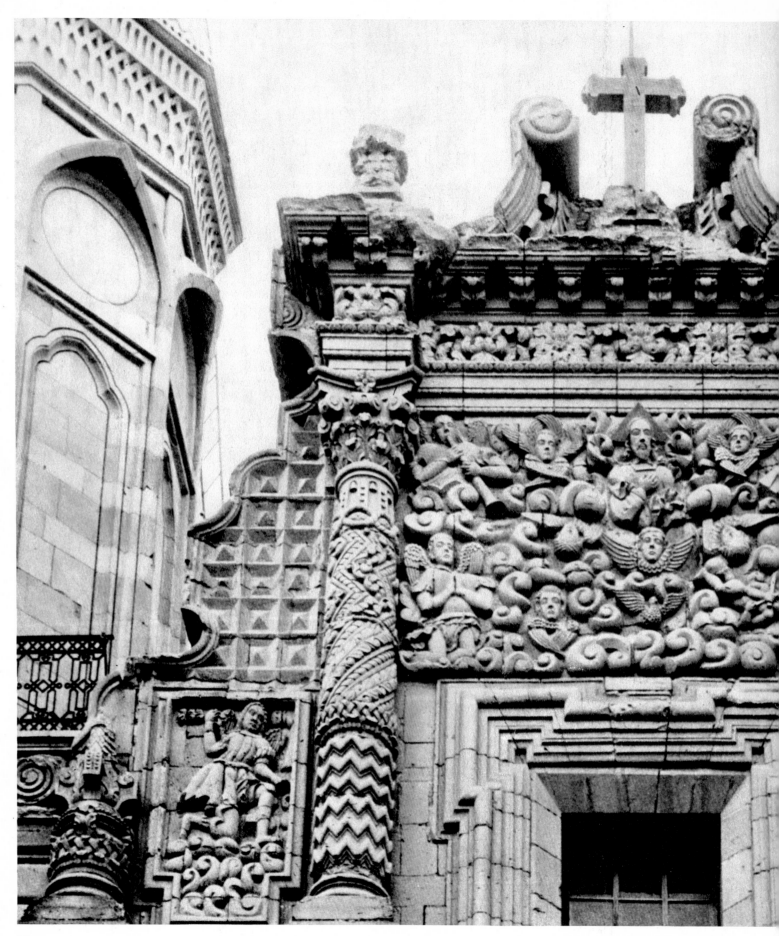

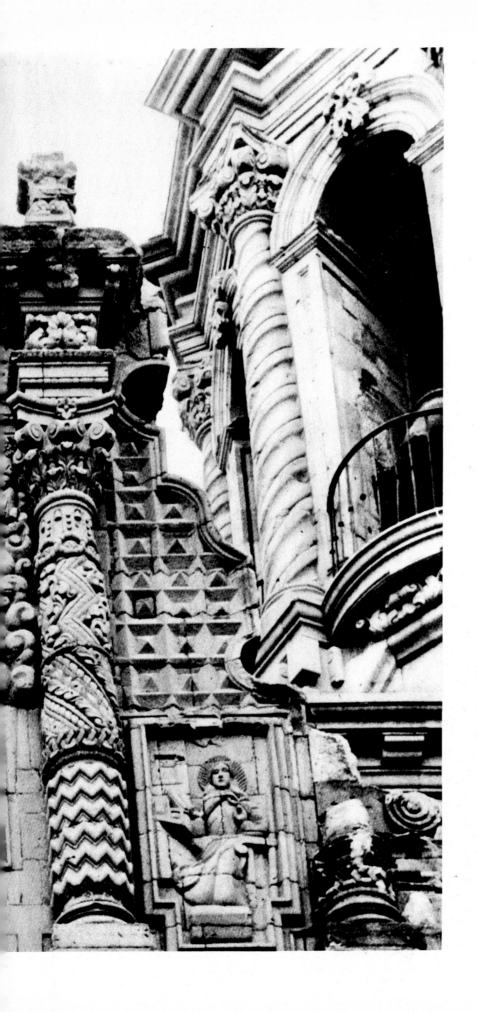

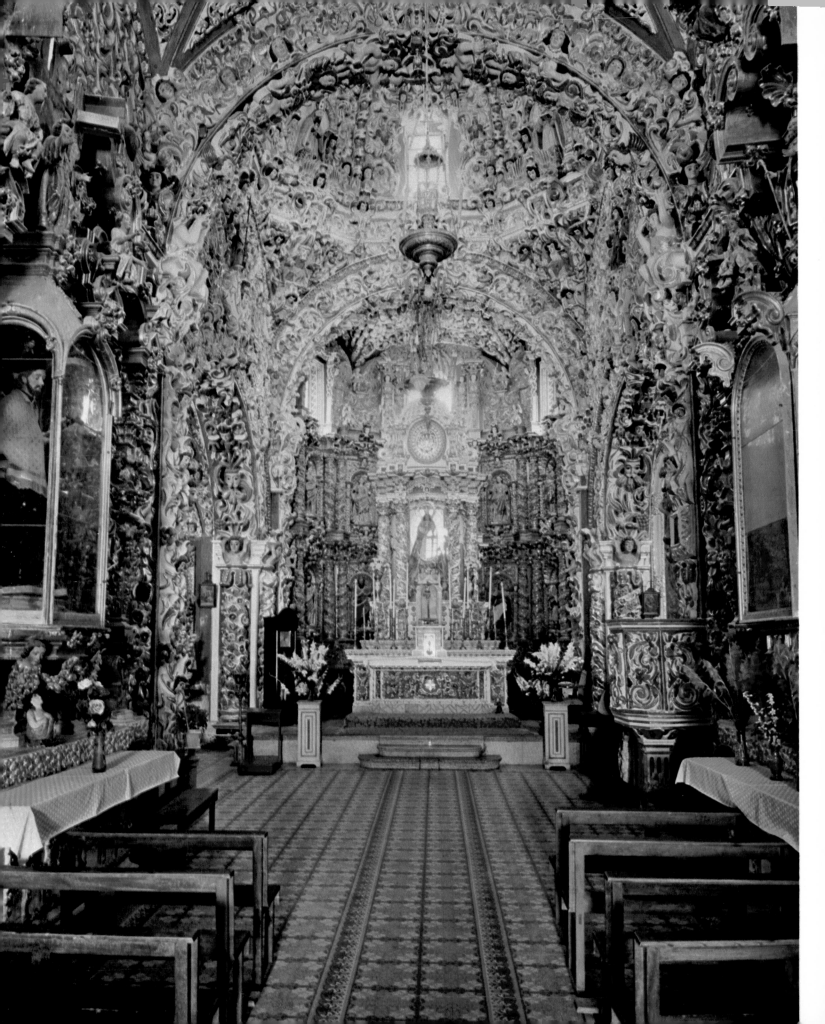

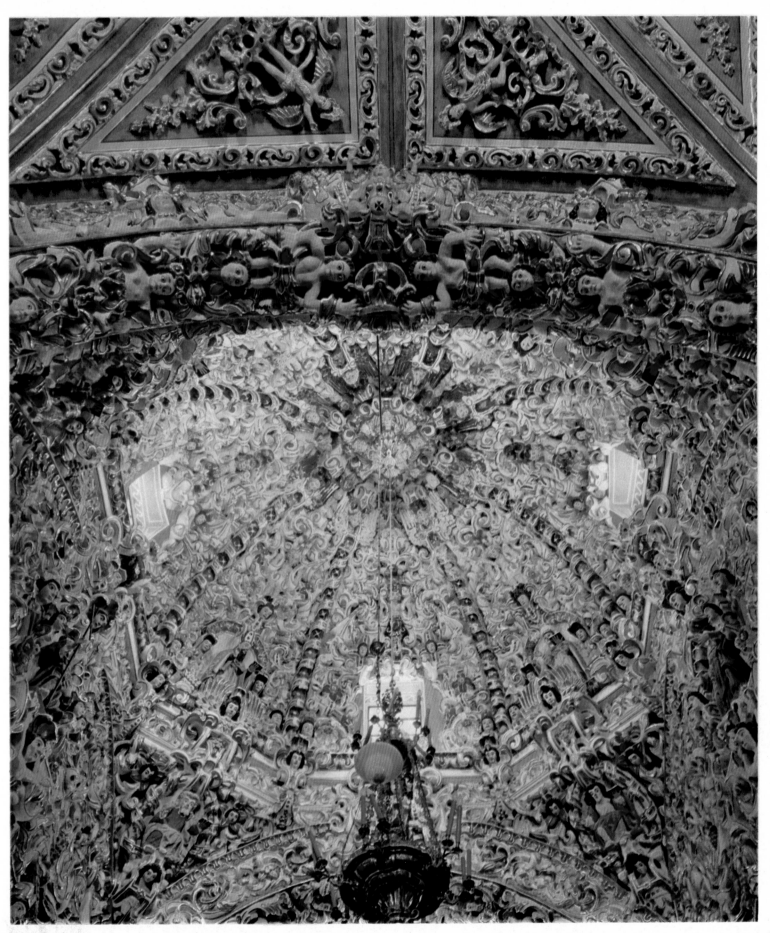

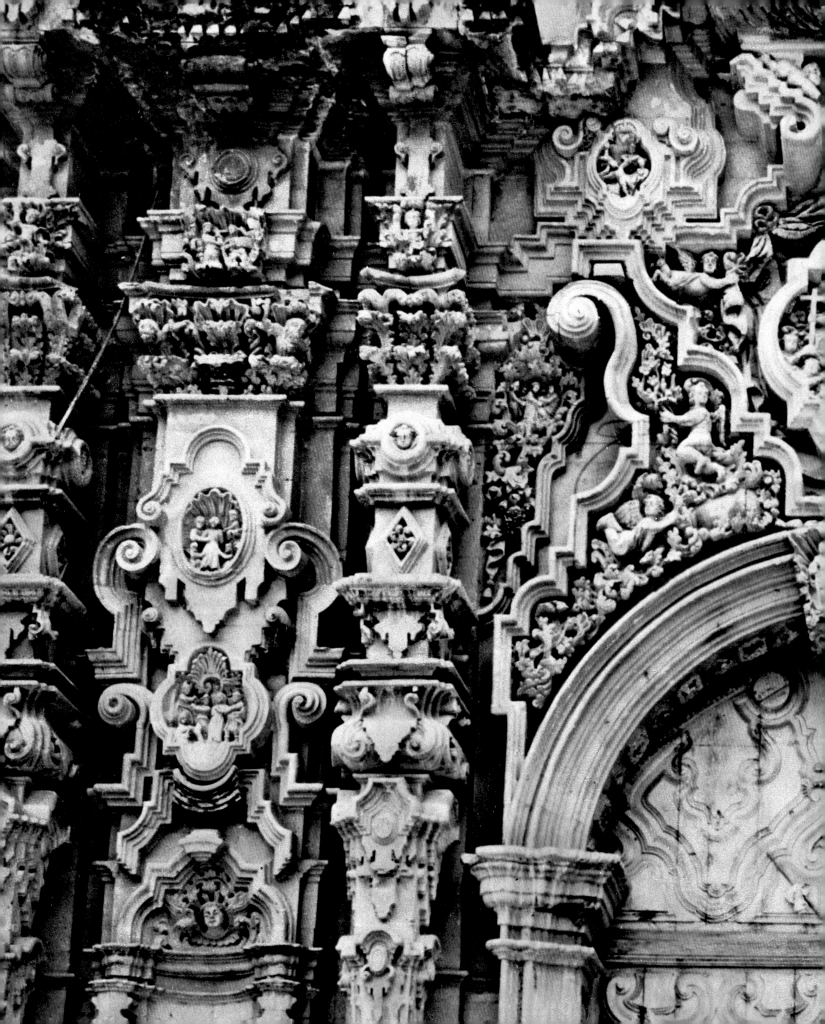

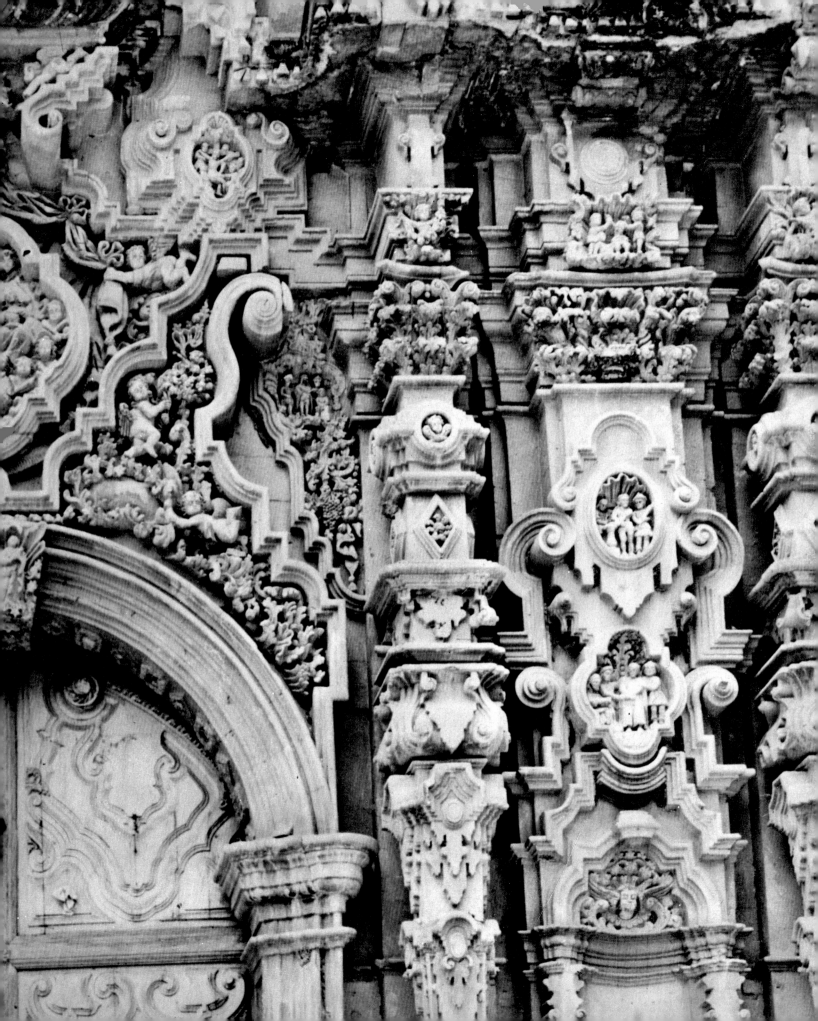

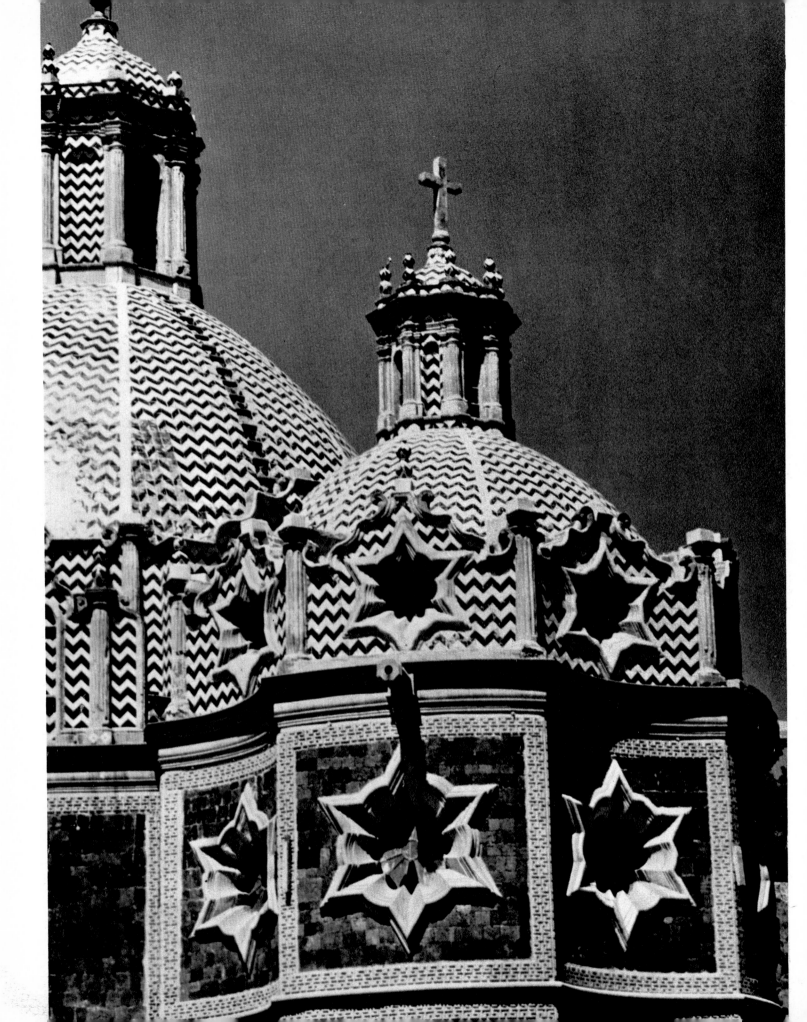

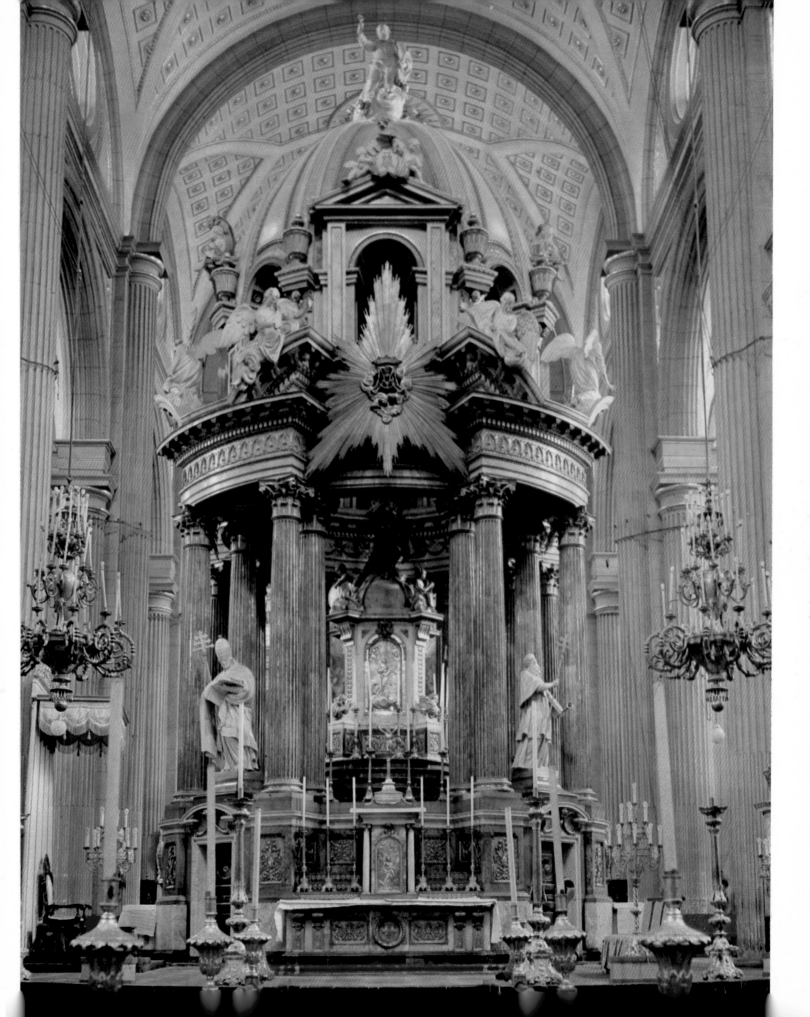

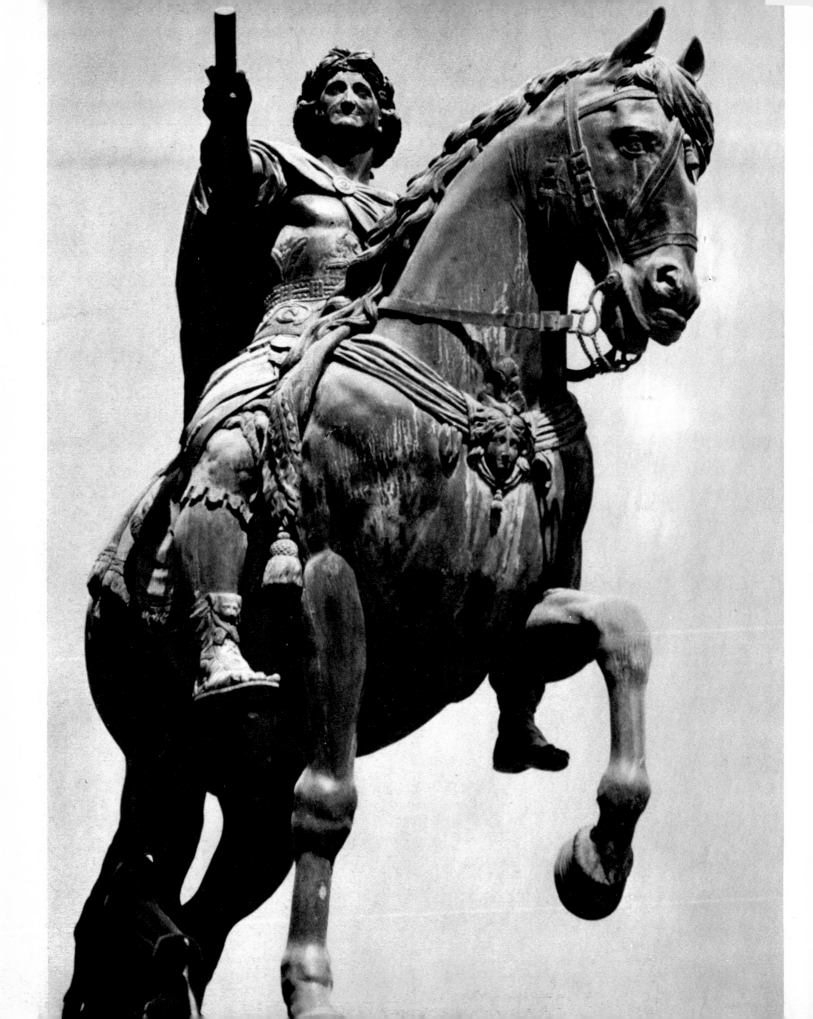

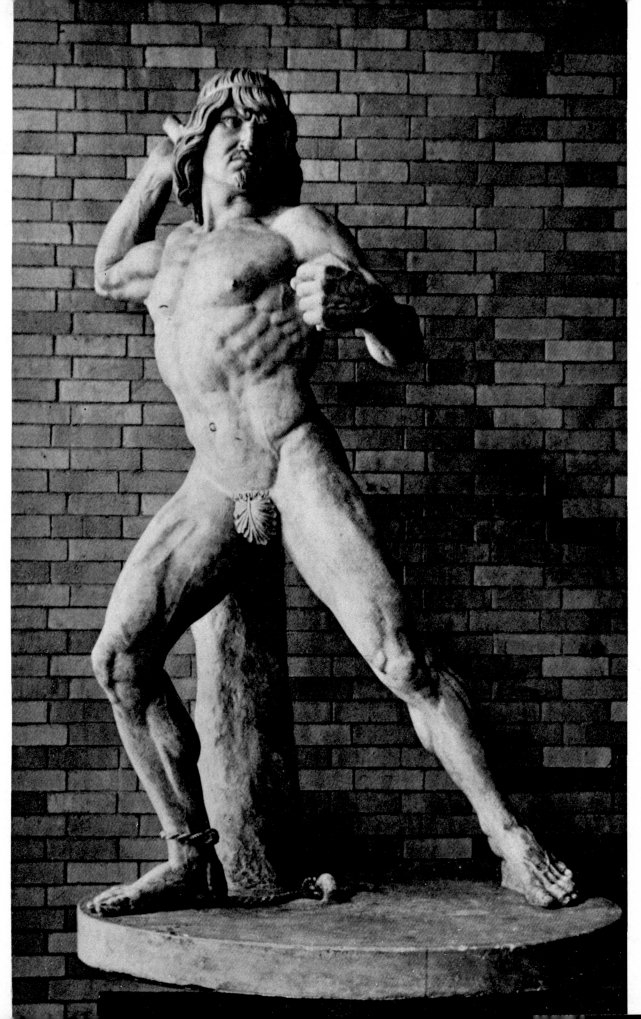

93/94

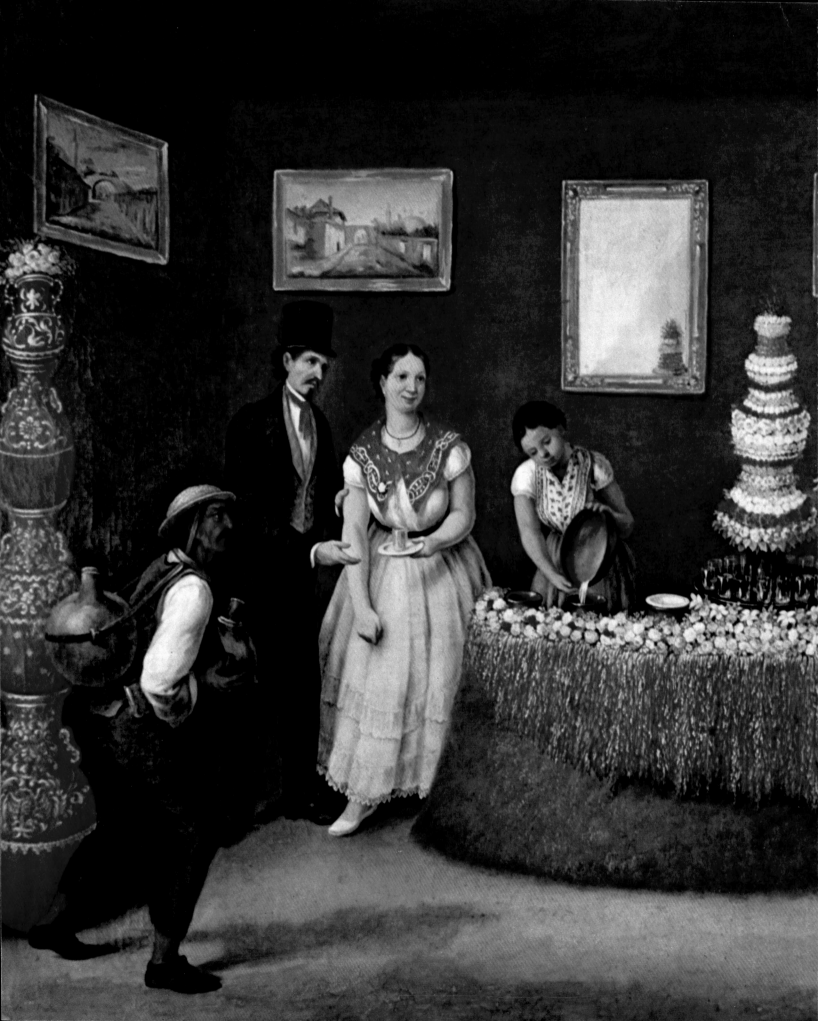

95

103

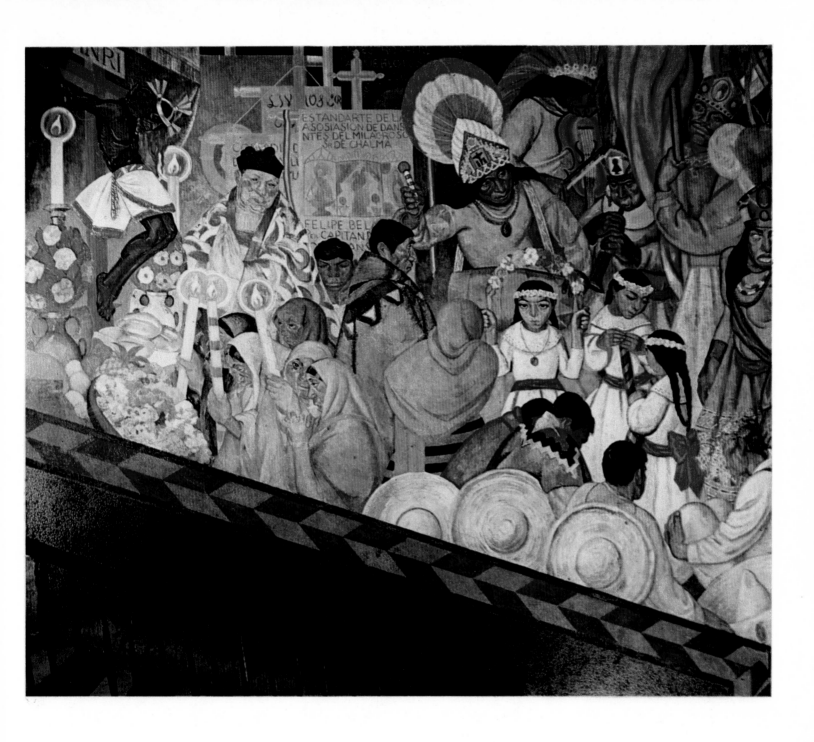

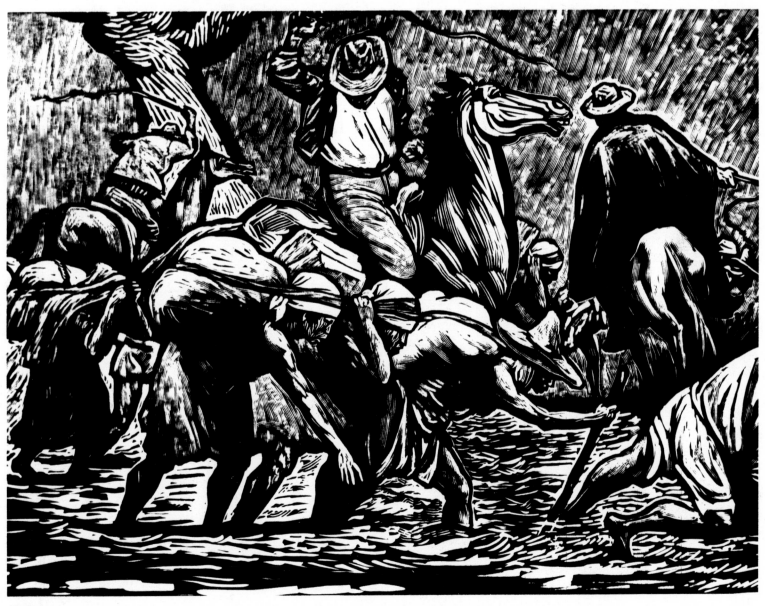

106

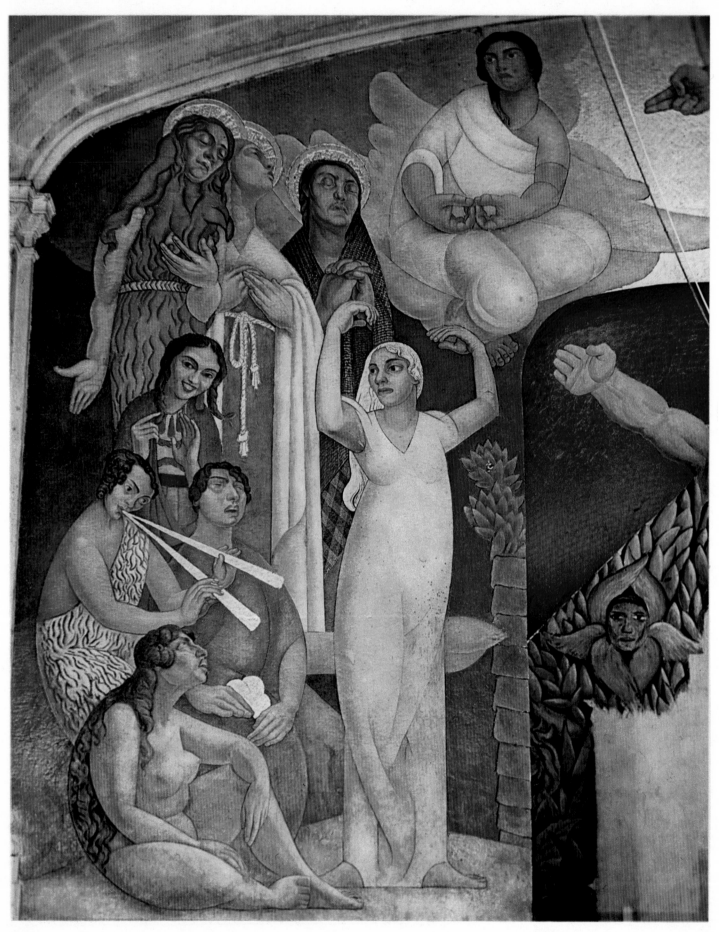

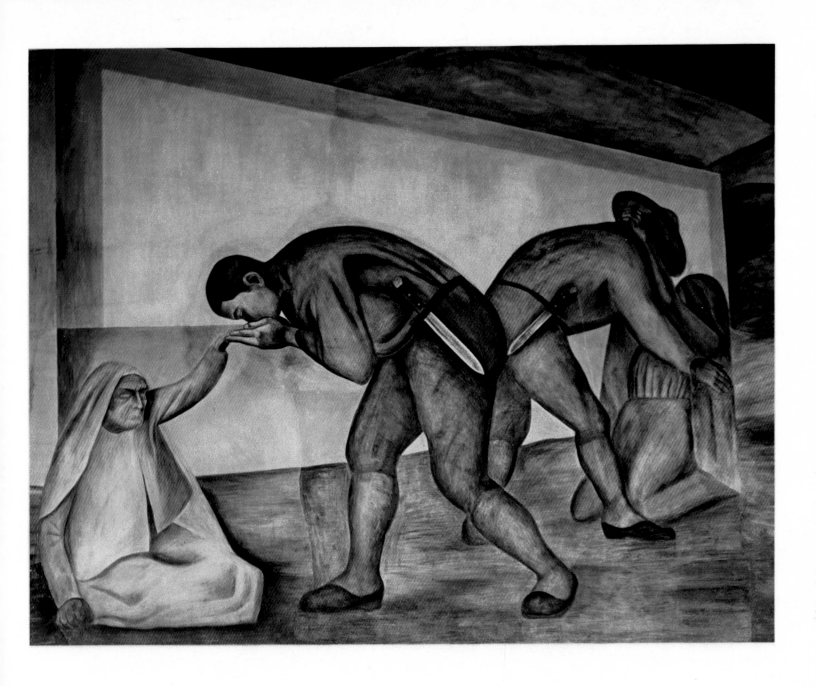

109

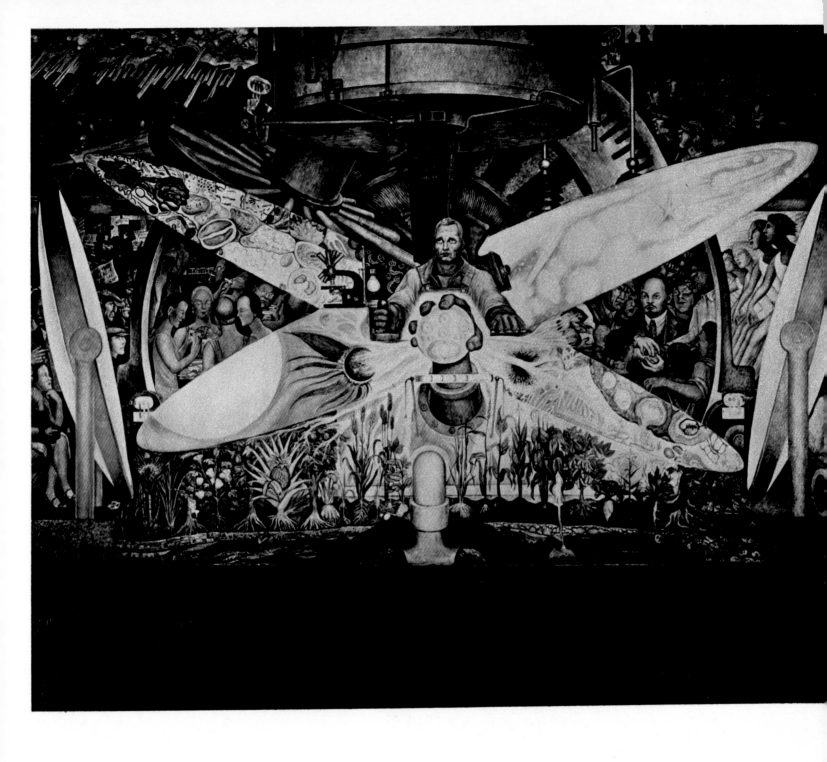

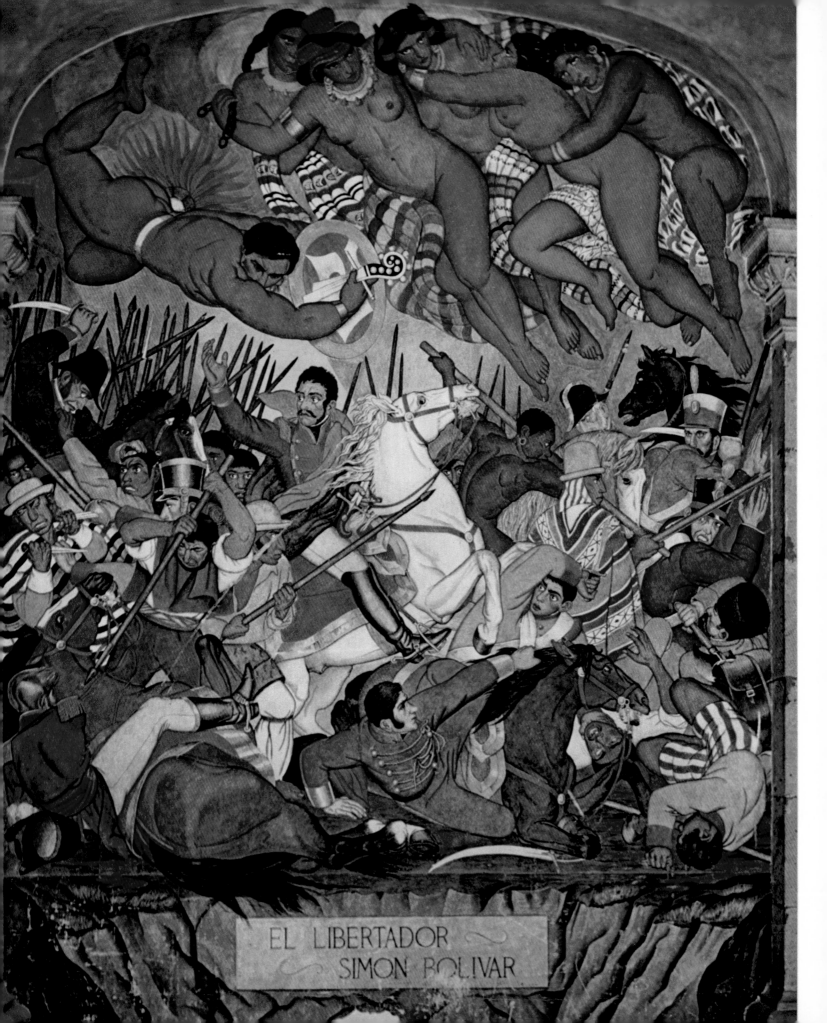

EL LIBERTADOR
SIMON BOLIVAR

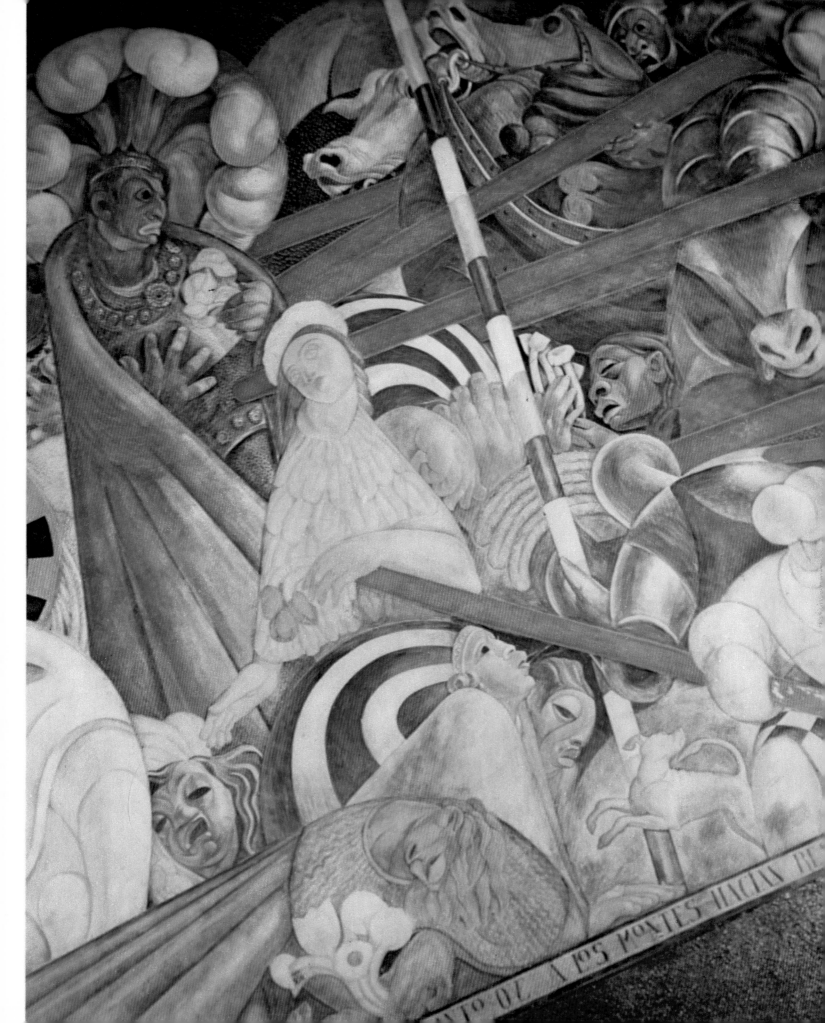

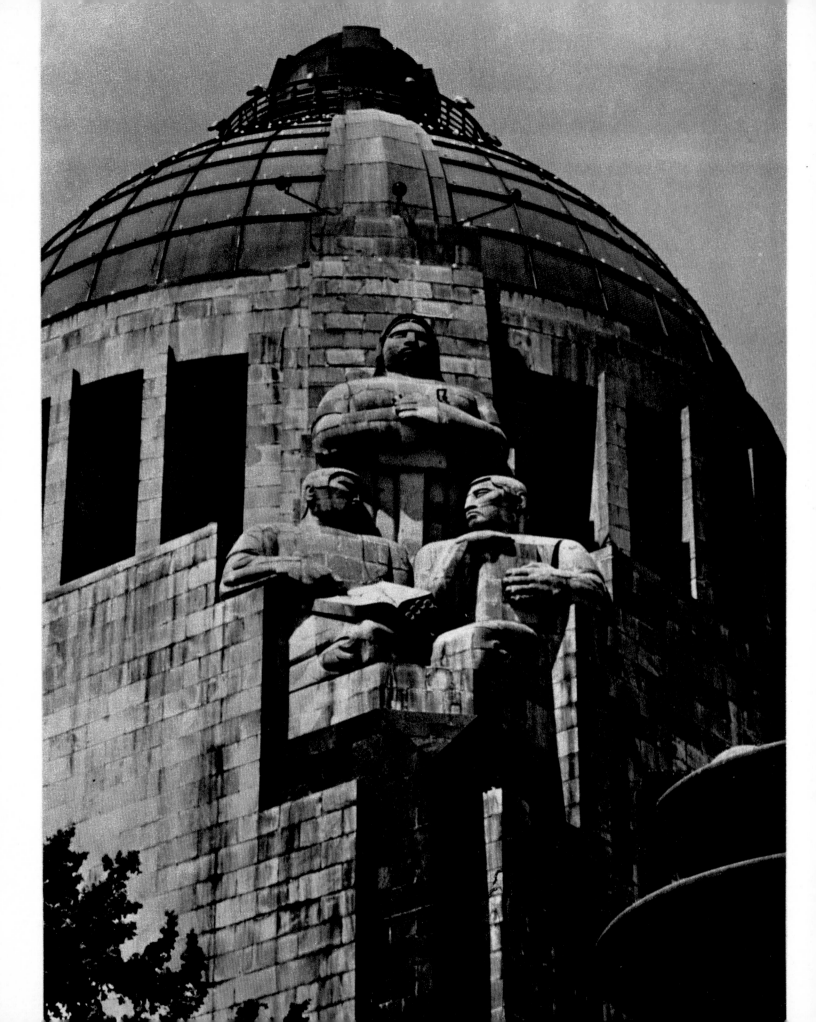

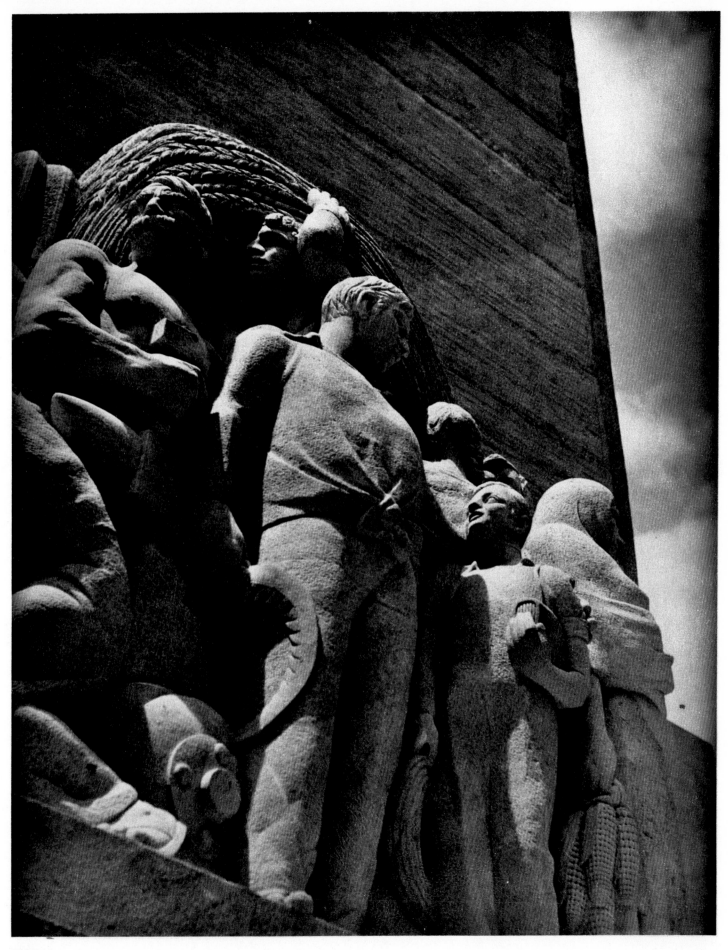

113/114

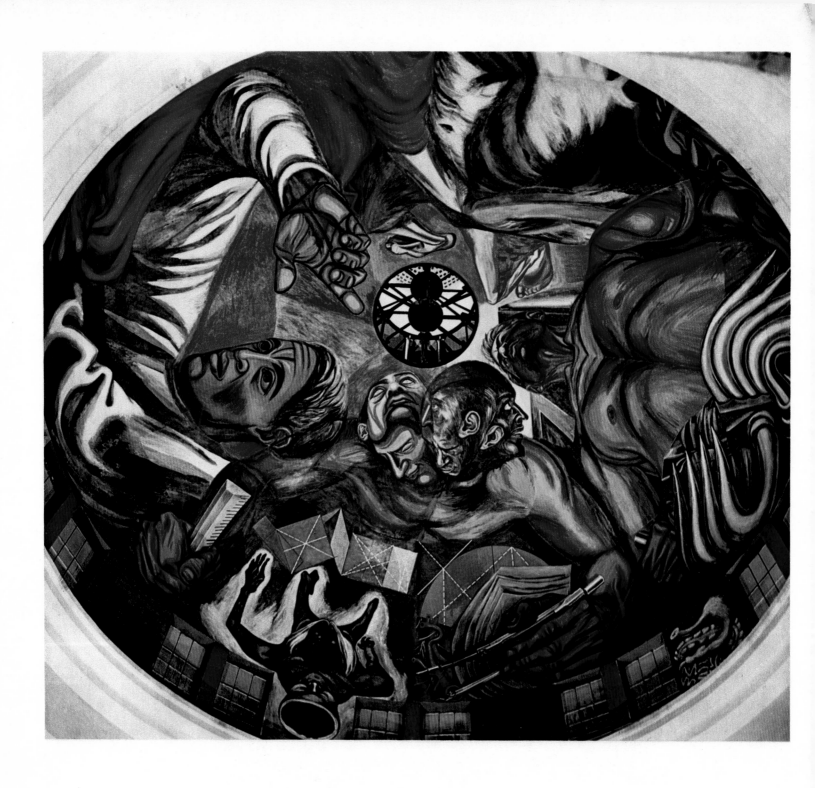

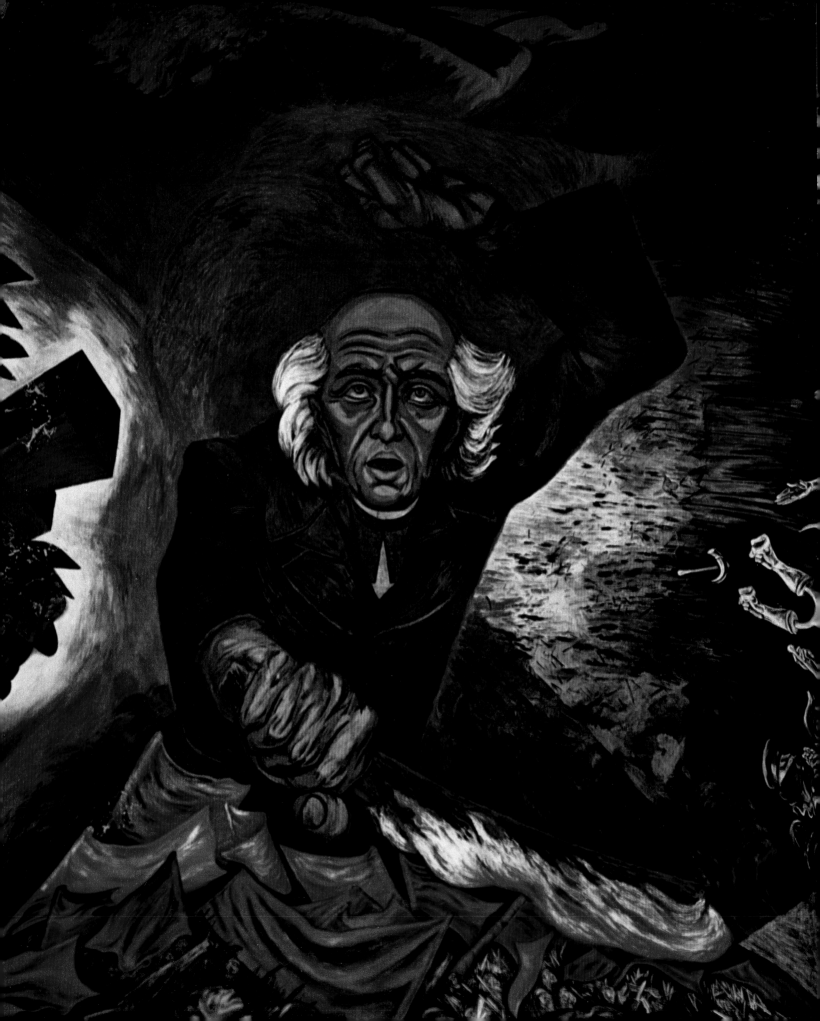

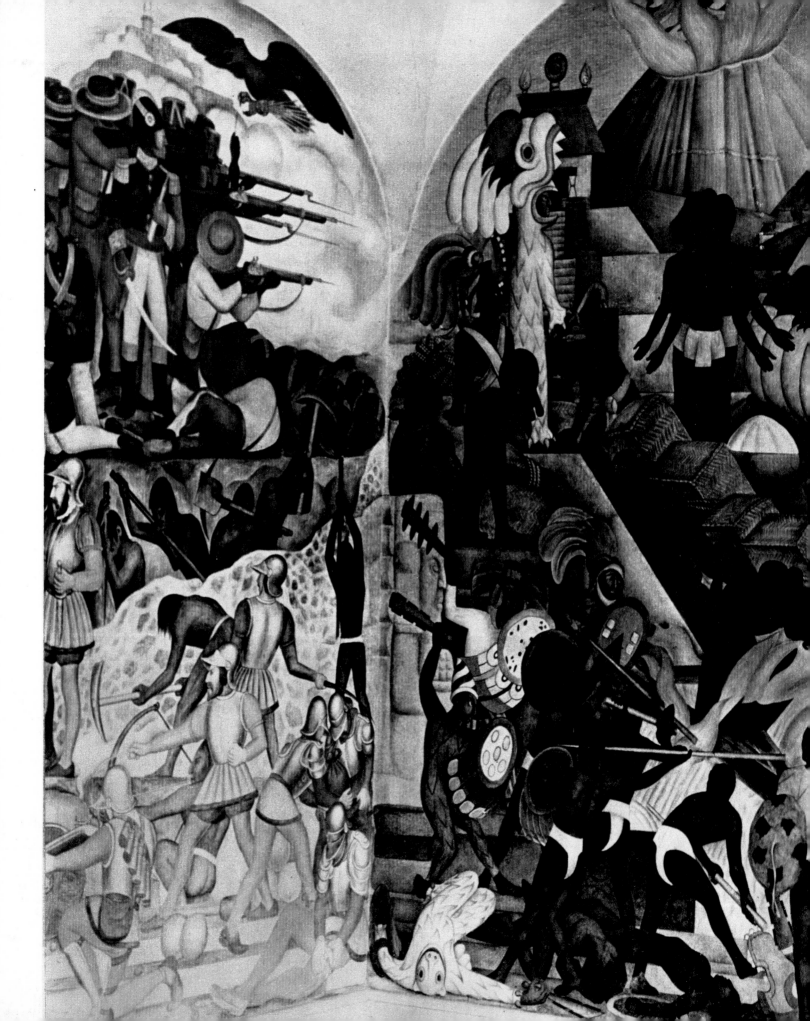

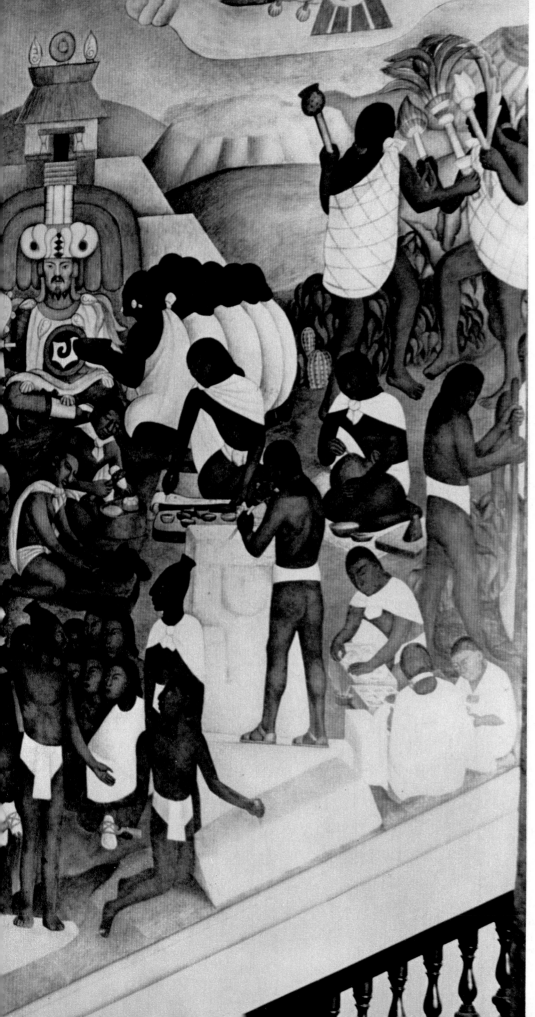

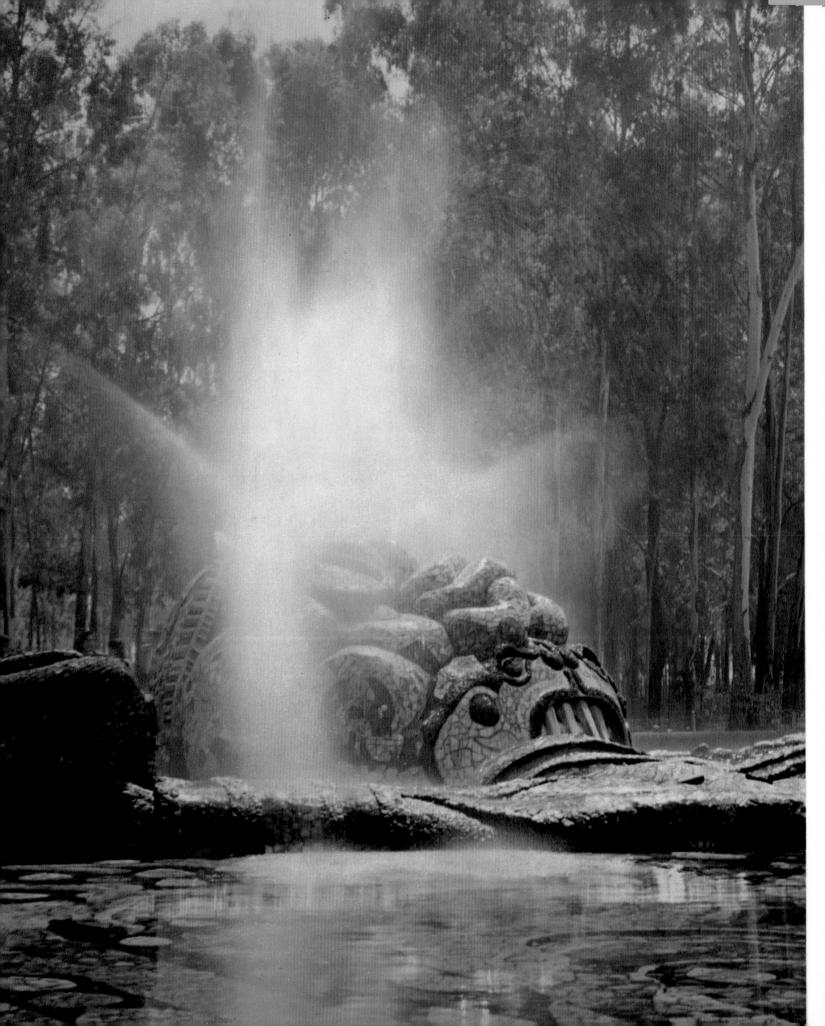

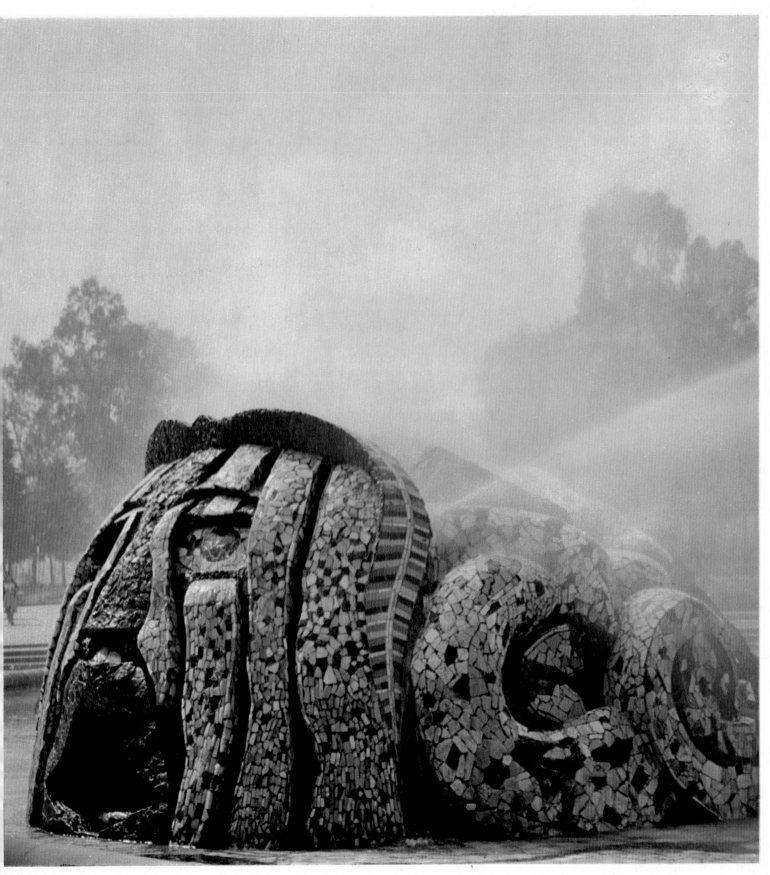

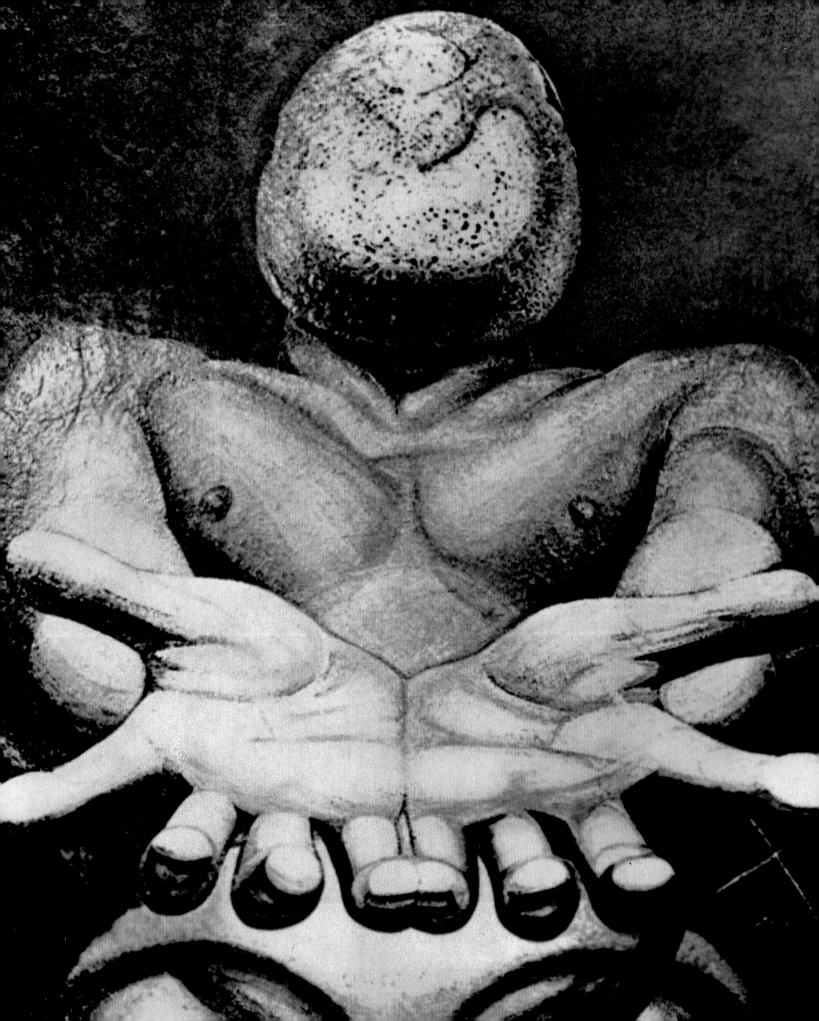

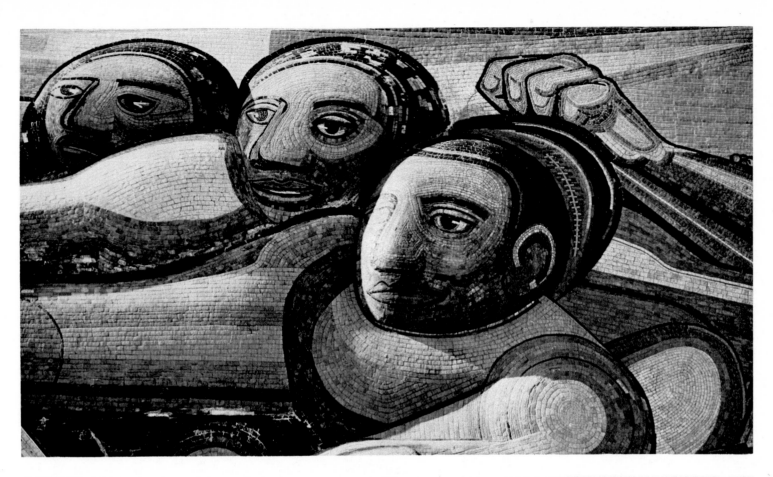

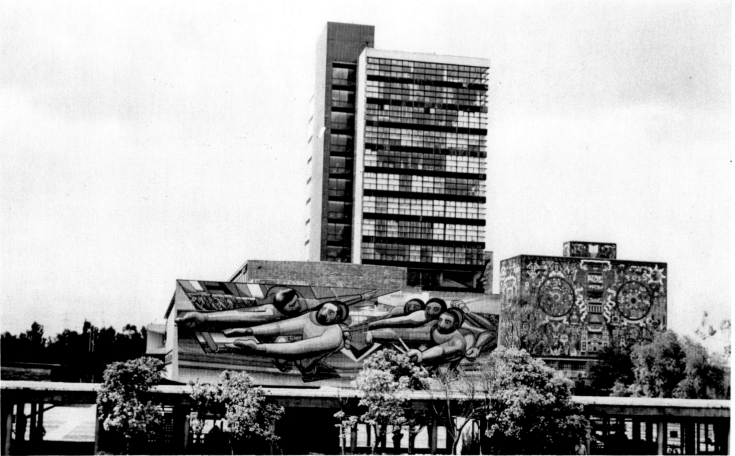

123

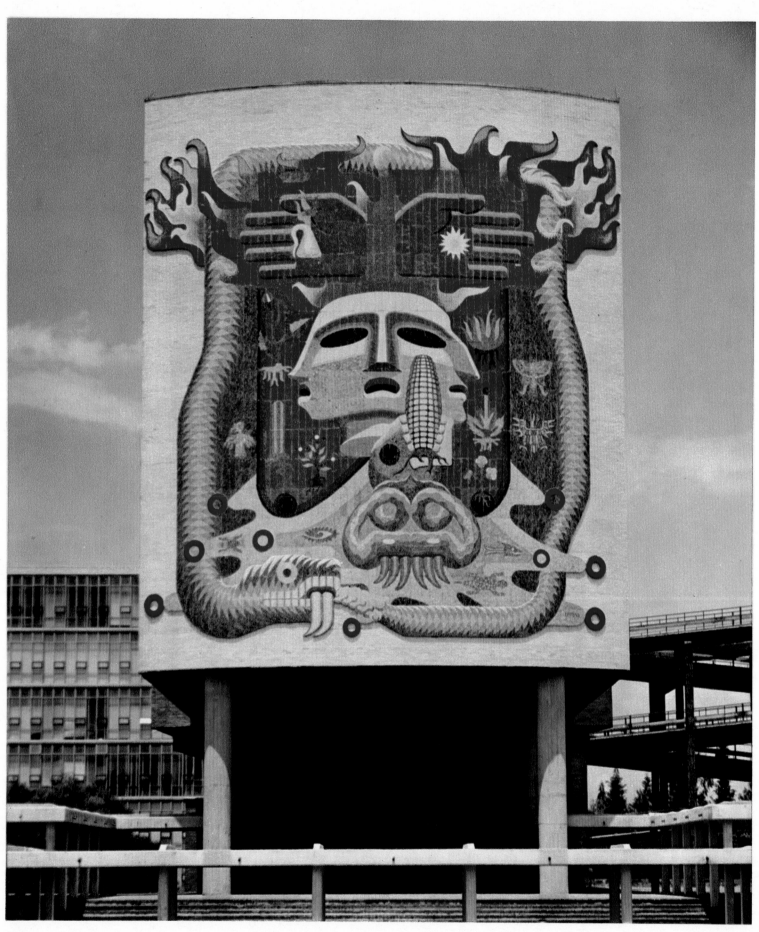

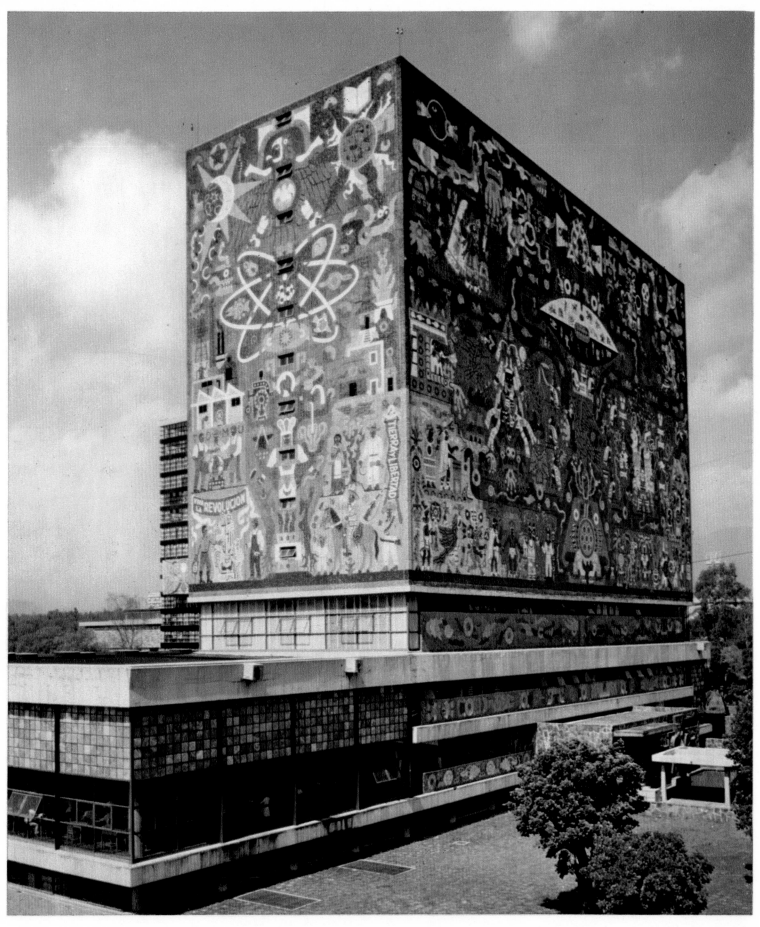

127

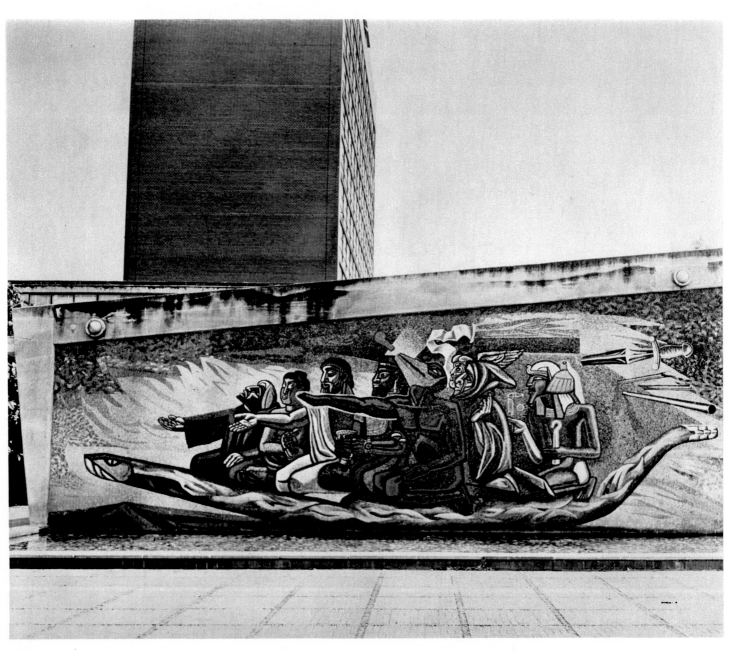

128

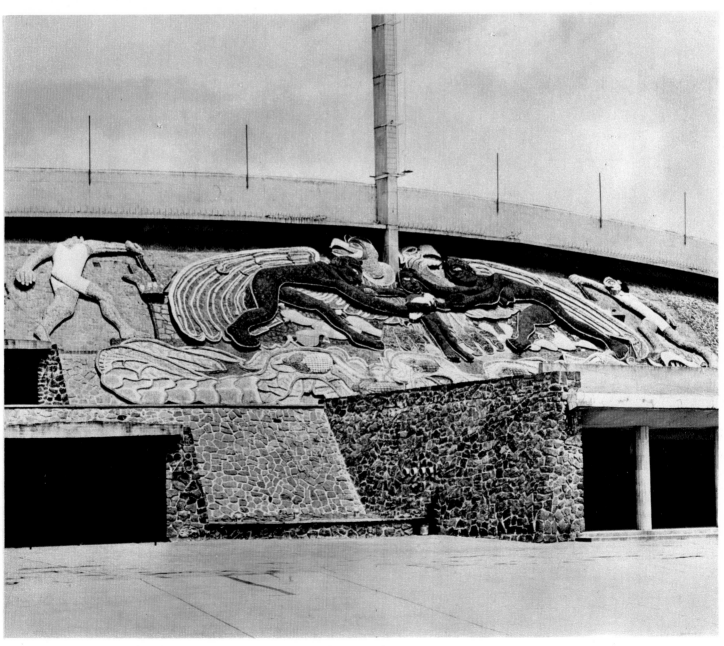

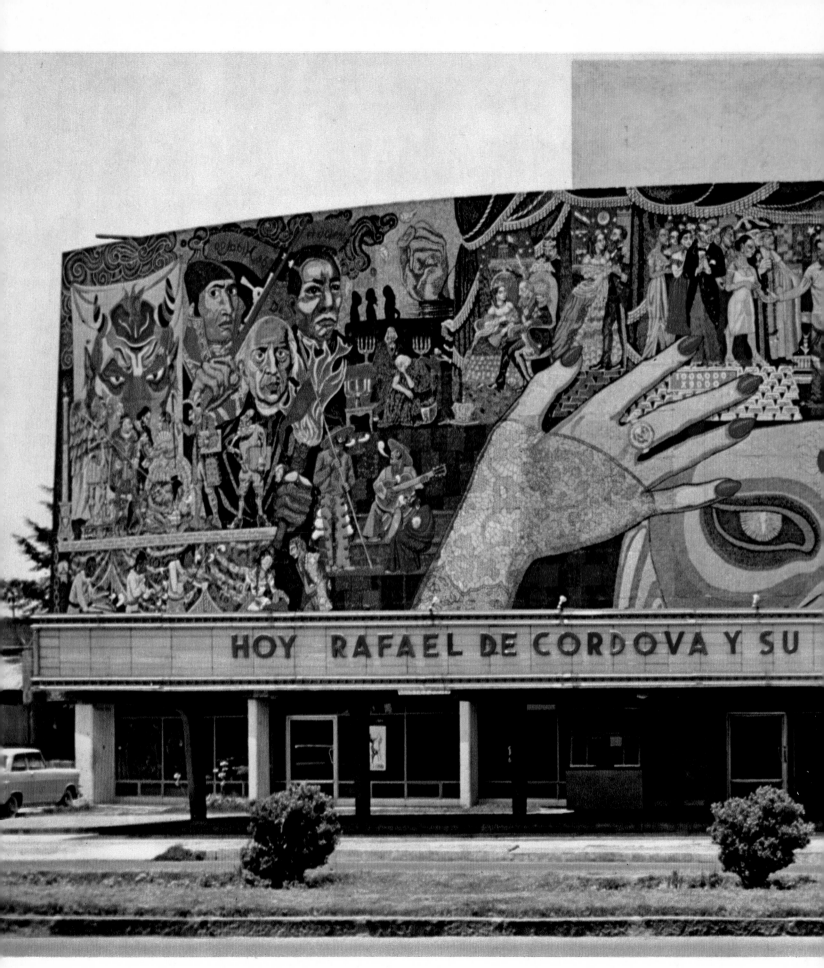

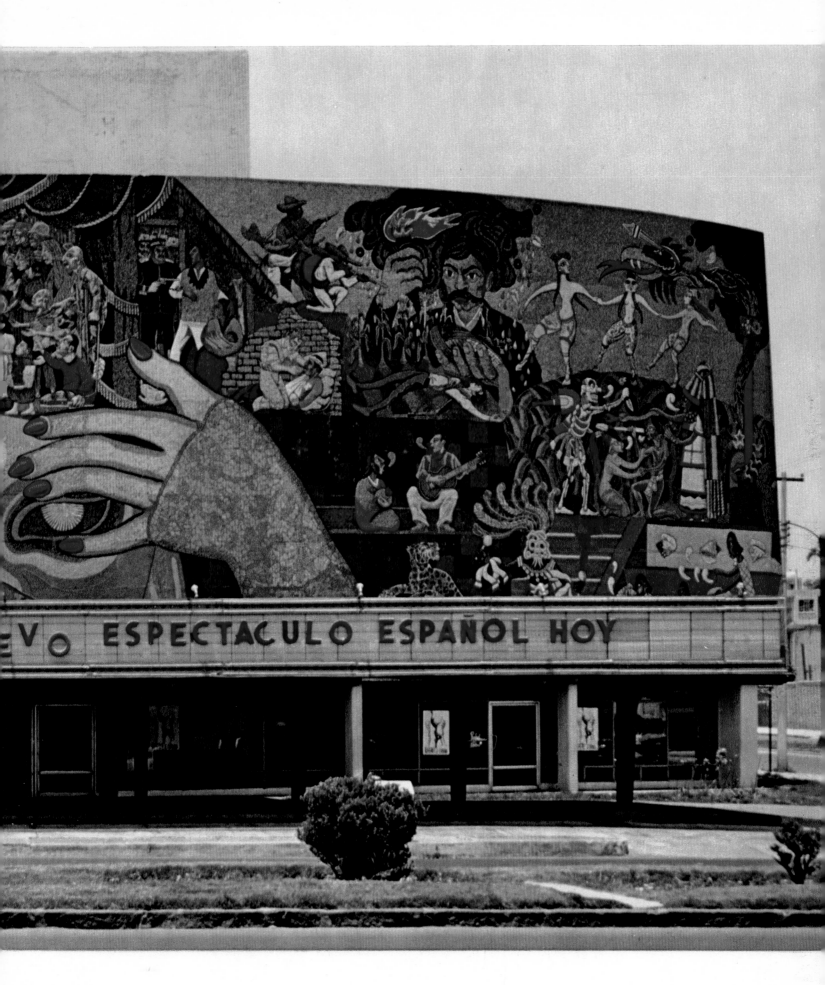

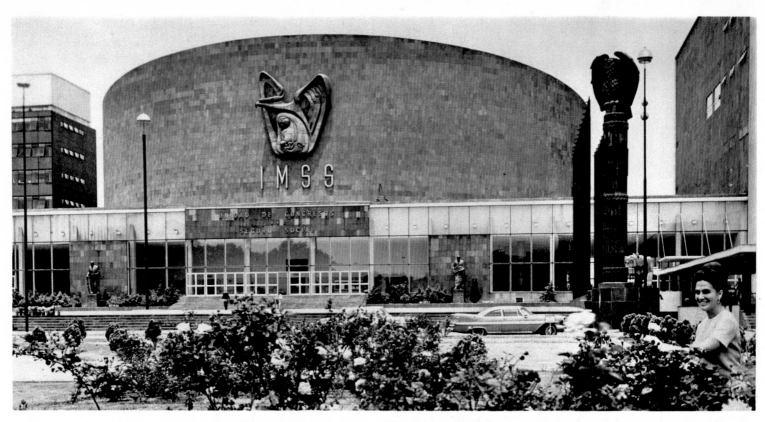

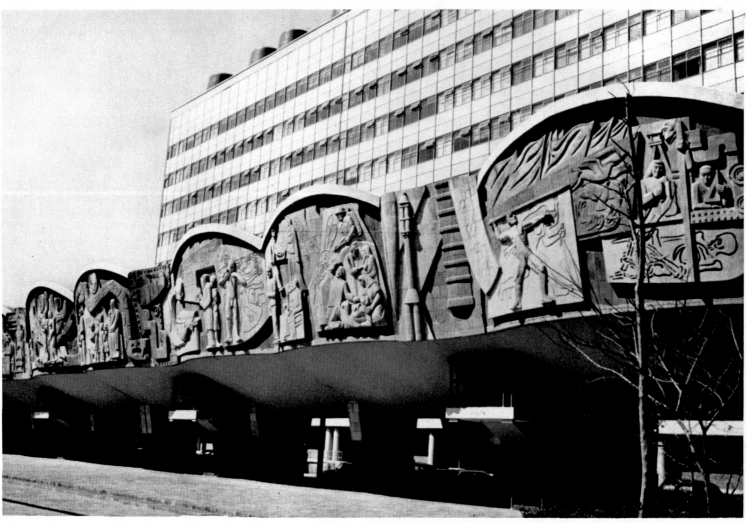

131/132

135

137

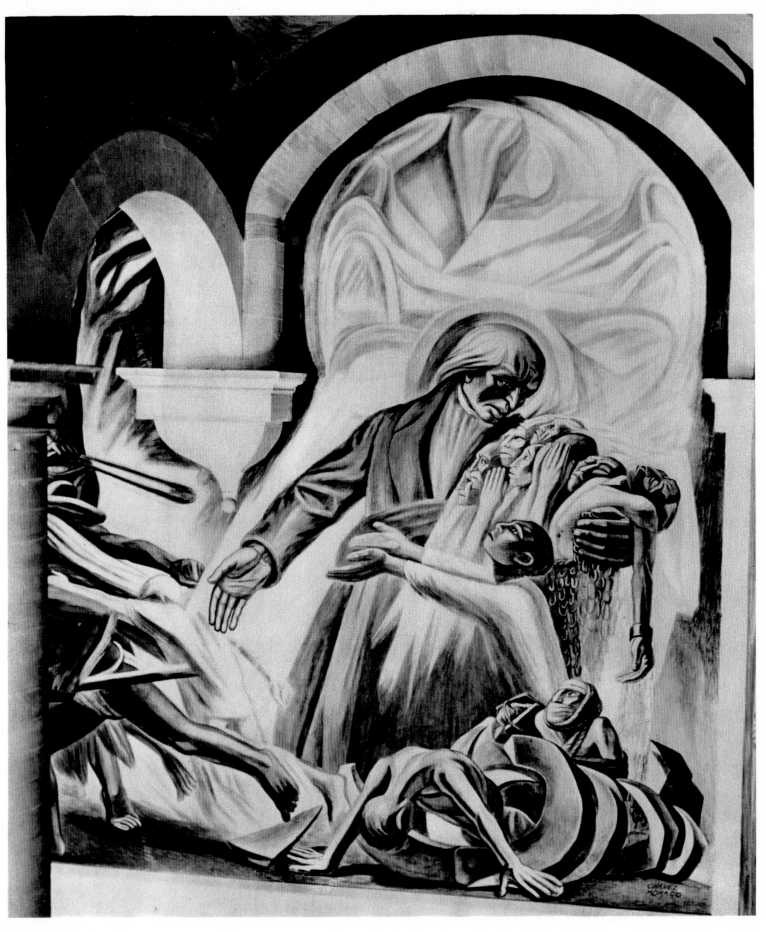

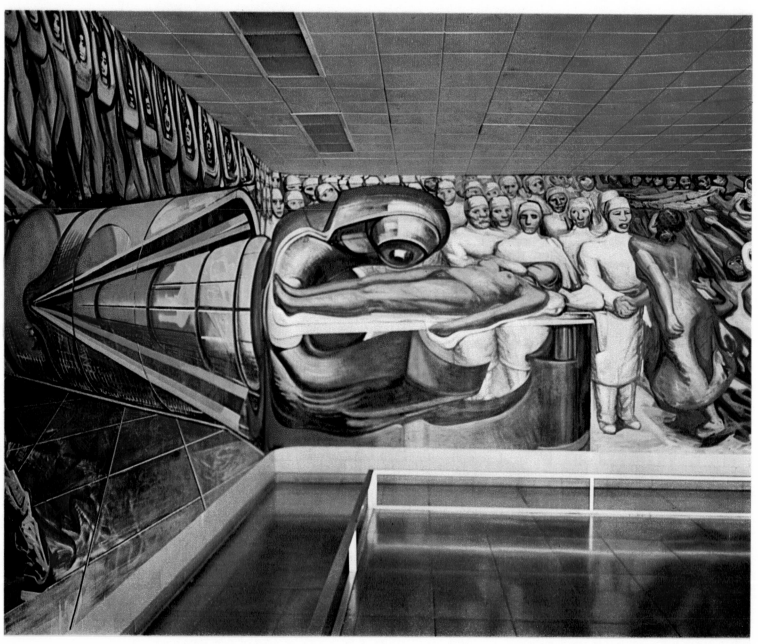

141

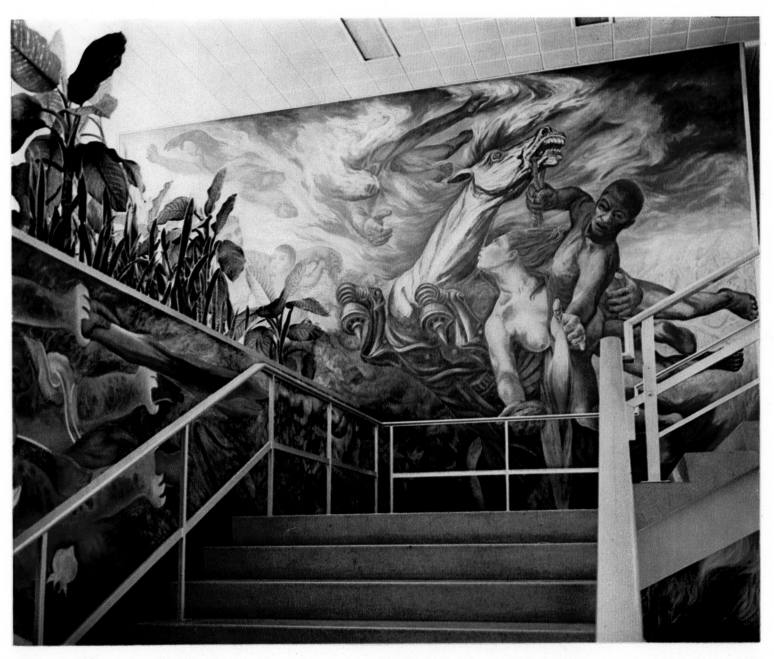

143

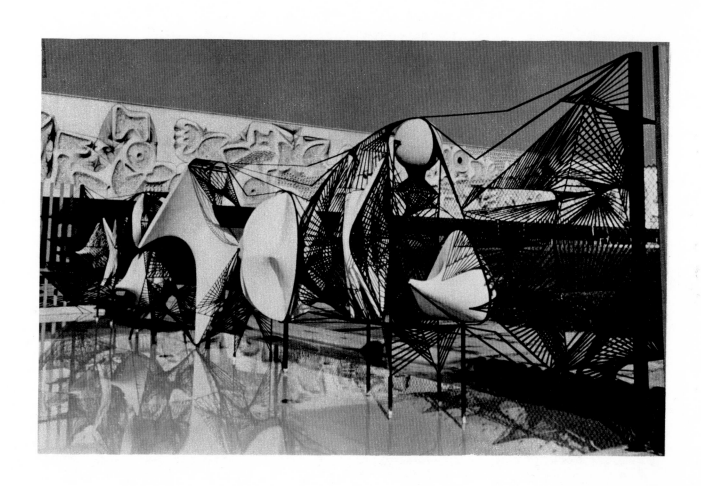

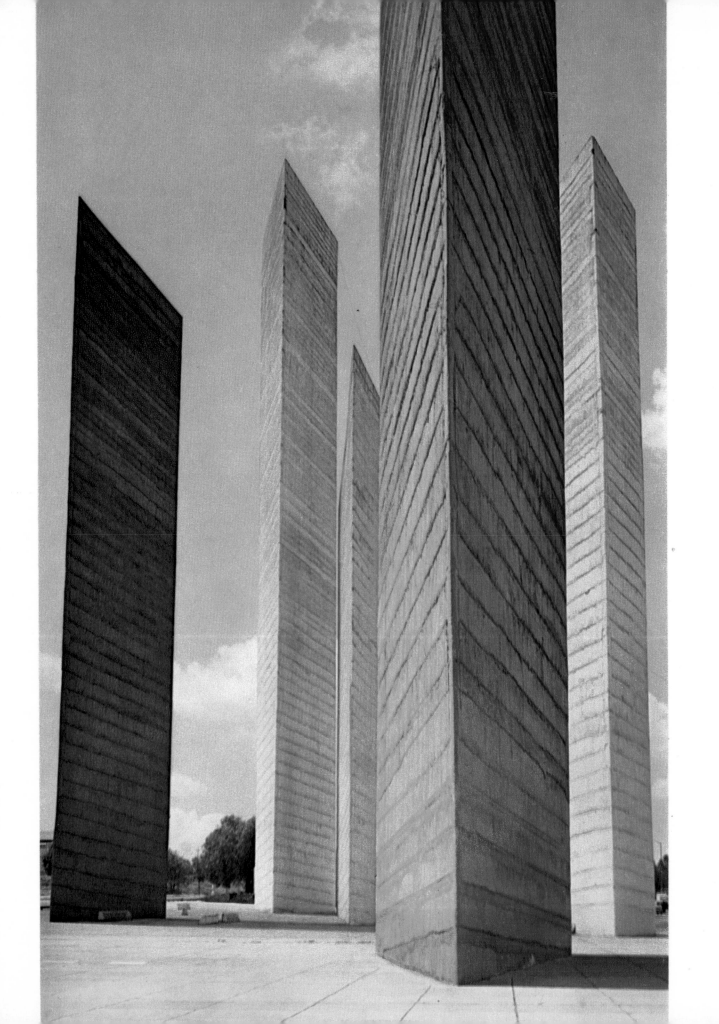

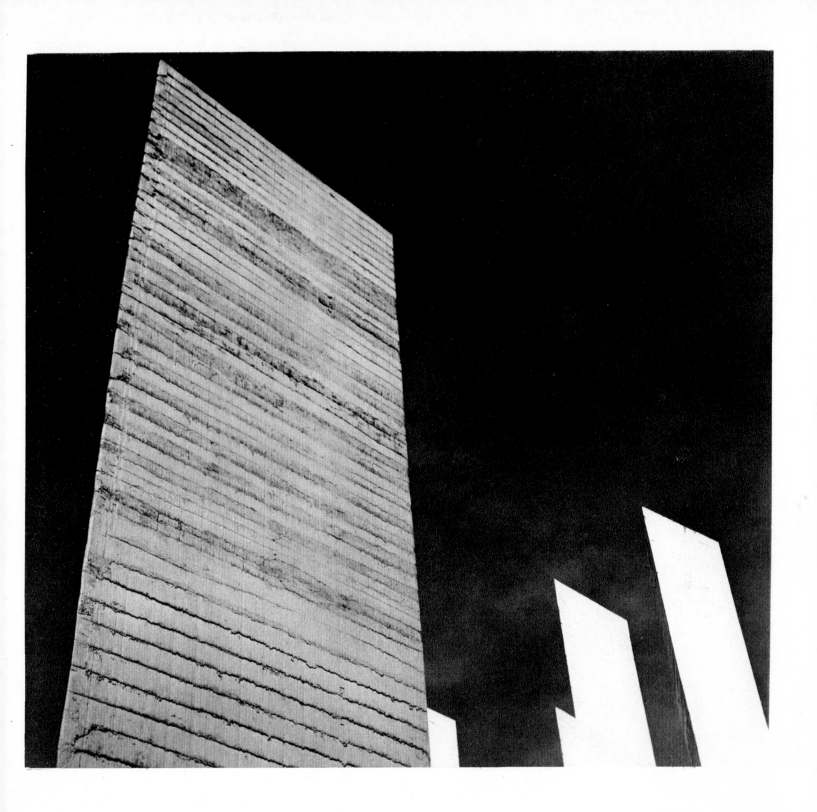